Where Dragon Veins Meet

# Where Dragon Veins Meet

## The Kangxi Emperor and His Estate at Rehe

STEPHEN H. WHITEMAN

University of Washington Press

SEATTLE

*Where Dragon Veins Meet* is made possible by a collaborative grant from the Andrew W. Mellon Foundation.

Publication of this book has been aided by a grant from the Millard Meiss Publication Fund of the College Art Association.

This publication was also supported by grants from the Australian Academy of the Humanities, the Chiang Ching-kuo Foundation for International Scholarly Exchange, the Courtauld Institute of Art, the Foundation for Landscape Studies, the Metropolitan Center for Far Eastern Art Studies, and the School of Literature, Arts, and Media at the University of Sydney.

UNIVERSITY OF WASHINGTON PRESS
uwapress.uw.edu

LIBRARY OF CONGRESS CATALOGING-IN-PUBLICATION DATA ON FILE
LC record available at https://lccn.loc.gov/2019018120t

ISBN 978-0-295-74580-0 (hardcover), ISBN 978-0-295-74581-7 (ebook)

FRONTISPIECE: Wang Hui et al., *The Kangxi Emperor's Southern Inspection Tour*, 1698, scroll 9, "Shaoxing and the Temple of Yu." Detail of handscroll, ink and color on silk, 67.8 × 2227.5 cm. Provided by the Palace Museum, Gu6302. Photo by Hu Chui.

"Record of Traveling at the Invitation of the Emperor" is excerpted by permission. © 2016 Dumbarton Oaks Research Library and Collection, Trustees for Harvard University. Originally published in *Thirty-Six Views: The Kangxi Emperor's Mountain Estate in Poetry and Prints*, Richard E. Strassberg and Stephen H. Whiteman. Translation of "Record of Touring the Rehe Rear Garden at Imperial Invitation" by Stephen H. Whiteman. A close version of chapter 2 originally appeared as "Kangxi's Auspicious Empire: Rhetorics of Geographic Integration in the Early Qing," in *Chinese History in Geographical Perspective*, edited by Jeffrey Kyong-McClain and Du Yongtao (Lanham, MD: Lexington Books, 2013).

*For my parents*

Even in my youth, I seem to have been seeking evidence
that the mind is a place best viewed from borderlands.

GERALD MURNANE, *Border Districts*

# Contents

*List of Illustrations*      ix
*Acknowledgments*      xiii
*Note to Readers*      xvii

Introduction: Historicizing the Early Qing Landscape      3

PART I: RECOVERING THE KANGXI LANDSCAPE
     *Excerpt from "Record of Traveling at the Invitation of the Emperor"*
         *by Zhang Yushu*      15
     1. Reconstructing Kangxi      20

PART II: ALLEGORIES OF EMPIRE
     2. Mountain Veins      59
     *"Record of the Mountain Estate to Escape the Heat"*
         *by the Kangxi emperor*      79
     3. Only Here in Rehe      81

PART III: SPACE AND PICTORIALITY
     4. Painting and the Surveyed Site      105
     5. Paper Gardens      151

PART IV: THE METONYMIC LANDSCAPE
     6. Touring the Rear Park      191

Conclusion: The Landscape of the Emperor      225

*Glossary*      231
*Notes*      235
*Bibliography*      247
*Index*      261

# Illustrations

## Figures

I.1 Anonymous, *Kangxi Reading*                                                7

1.1 Shen Yu et al., "*Lingzhi* Path on an Embankment to the
    Clouds"                                               21

1.2 Shen Yu et al., "The Entire Sky Is Exuberant"                            30

1.3 "Gold Mountain," from *Imperially Endorsed Complete
    Collection of Images and Writings . . .*               31

1.4 Plan of the Palace of Righteousness                                      34

1.5 Plan of the Garden of Joyful Spring                                      37

1.6 Shen Yu et al., "Scenes of Clouds and Mountains"                         39

1.7 Waterway connecting Lower and Mirror Lakes                               41

1.8 Shen Yu et al., "Sonorous Pines and Cranes"                             46

1.9 Shen Yu et al., "Sounds of a Spring Near and Far"                       47

2.1 *Map of a Complete Survey of Imperial Territories* (*Kangxi Atlas*)    61

2.2 "Mount Changbai," from *Imperially Endorsed Complete
    Collection of Images and Writings . . .*               73

3.1 Shen Yu et al., "Misty Ripples Bringing Brisk Air"                      87

3.2 Shen Yu et al., "Un-Summerly Clear and Cool"                            88

3.3 View across Lower Lake toward *Lingzhi* Path on an
    Embankment to the Clouds                              97

3.4 Shen Yu et al., "Orioles Warbling in the Tall Trees"                    98

3.5 Shen Yu et al., "Untrammeled Thoughts by the Hao and Pu
    Rivers"                                               99

4.1 Leng Mei, *View of Rehe*                                                106

4.2 Guo Zhongshu, attr., *Emperor Minghuang's Palace to Escape
    the Heat*                                            109

4.3 Wang Hui et al., *The Kangxi Emperor's Southern Inspection
    Tour*, scroll 7                                   110–111

4.4 Jiao Bingzhen, *Buildings in Landscapes*, leaf 9                        113

4.5 Qiao Zhongchang, *Illustration of the Second Prose Poem on the Red Cliff*                                                                    114–115

4.6 Leng Mei, "Emperor Tang Xuanzong"                                      116

4.7 Wang Hui et al., *The Kangxi Emperor's Southern Inspection Tour*, scroll 9                                                            117

4.8 Anonymous, *Fuling*                                                    119

4.9 *Ruyi* scepter in the form of a *lingzhi* fungus                       120

4.10 Concentric *ruyi* forms in Leng Mei's *View of Rehe*                  121

4.11 Zhang Hong, *Wind in the Pines of Mount Gouqu*                        124

4.12 Architectural orthogonals in Leng Mei's *View of Rehe*               125

4.13 Construction of the valley and the mountains in Leng Mei's *View of Rehe*                                                        126–127

4.14 Anonymous, *Gentlewomen in the Shade of a Paulownia Tree*            129

4.15 Kangxi, Jiao Bingzhen, et al., *Imperially Composed Images of Tilling and Weaving*, scenes 45 and 46                              131

4.16 Trajectories of sight of Leng Mei's *View of Rehe*                    135

4.17 Pierre d'Argent, *View of Besançon*                                   143

4.18 Nian Xiyao, "Illustrations of a progressive method for arranging things with a lateral aspect," *The Study of Vision*     147

4.19 Israël Silvestre, "View of the Château of Fontainebleau from the Garden Side"                                            148–149

5.1 Shen Yu et al., "Morning Mist by the Western Ridge"                   153

5.2 Matteo Ripa, attr., "Morning Mist by the Western Ridge"               157

5.3 Zhang Kui, "Clear Ripples with Layers of Greenery"                    157

5.4 Wang Yuanqi, *Ten Scenes of West Lake*                                 161

5.5 Wang Yuanqi, *Wheel River Villa*                                      162–163

5.6 Shen Yu et al., "Clouds and Peaks on All Sides"                       165

5.7 Wang Gai et al., "Huang Gongwang," *Mustard Seed Garden Painting Manual*                                                      166

5.8 Lu Hong, attr., *Ten Records of a Thatched Hut*, scene 1             167

5.9 Xie Shichen, *Ten Records of a Thatched Hut*, leaf 1                 168

5.10 Wang Yuanqi, *Ten Records of a Thatched Hut*, leaf 1                169

5.11 Wang Yuanqi, *Ten Records of a Thatched Hut*, leaf 2                171

5.12 Wang Yuanqi, *Ten Records of a Thatched Hut*, leaf 6                172

5.13 Wang Yuanqi, "Landscape after Jing and Guan"                         173

5.14 Shen Yu et al., "Clear Ripples with Layers of Greenery"              175

5.15 Shen Yu et al., "Southern Mountains Piled with Snow"                 175

5.16 Zhang Zongcang, "Southern Mountains Piled with Snow"                 176

5.17 Wang Yuanqi, "Landscape after Juran"                                 177

5.18 Shen Yu et al., "Verdant Isle of Green Maples"                       178

5.19 Wang Yuanqi, *Ten Records of a Thatched Hut*, leaf 7                179

5.20 Shen Yu et al., "Pine Winds through Myriad Vales"                    180

5.21 Zhang Zongcang, "Pine Winds through Myriad Vales"                    181

5.22 Wang Yuanqi, "Landscape after Wu Zhen"  183

5.23 Israël Silvestre, "Château neuf de St Germain en Laye from the River Side"  186

5.24 Dai Tianrui, *Lingzhi* Path on an Embankment to the Clouds"  187

6.1 Zhang Zeduan, *Capturing the Flag at the Reservoir of Metal's Luster*  194

6.2 Ming court artist(s), *Amusements in the Xuande Emperor's Palace*  194–195

6.3 Wang Yuanqi et al., *Magnificent Record of Longevity*  197

6.4 Qi Biaojia, "View of Allegory Mountain"  199

6.5 Wen Zhengming, "Many Fragrances Bank"  200

6.6 Qiu Ying, *Garden of Solitary Enjoyment*  202–203

6.7 Wen Zhengming, "Little Azure Waves"  205

6.8 Wen Zhengming, "Xiang Bamboo Bank"  205

6.9 Zhang Hong, "Complete View of the Garden to Rest In"  207

6.10 Zhang Hong, *Garden to Rest In*, leaf 9?  209

6.11 Zhang Hong, *Garden to Rest In*, leaf 15?  209

6.12 Scenes 24–29 from Kangxi et al., *Imperial Poems*  210–211

6.13 Leng Mei, *Images of Tilling and Weaving*, leaves 9 and 10  212

6.14 Shen Yu et al., "Moon Boat with Cloud Sails" and "Fragrant Islet by Flowing Waters"  213

6.15 Shen Yu et al., "Shapes of Clouds and Figures in the Water" and "Clear Spring Circling the Rocks"  214

6.16 Shen Yu et al., "Pine Winds through Myriad Vales," "Sonorous Pines and Cranes," "Scenes of Clouds and Mountains," "Clouds and Peaks on All Sides," and "Northern Post Linking Paired Peaks"  214–215

6.17 Shen Yu et al., "Pair of Lakes Like Flanking Mirrors" and "Long Rainbow Sipping White Silk"  216

6.18 Shen Yu et al., "Misty Ripples Bringing Brisk Air," "*Lingzhi* Path on an Embankment to the Clouds," and "Un-Summerly Clear and Cool"  216–217

6.19 Shen Yu et al., "Inviting the Breeze Lodge" and "Fragrant Waters and Beautiful Cliffs"  219

6.20 Shen Yu et al., "Warm Currents and Balmy Ripples" and "Fountainhead in a Cliff"  219

6.21 Shen Yu et al., "Morning Mist by the Western Ridge" and "Sunset at Hammer Peak"  219

6.22 Shen Yu et al., "Golden Lotuses Reflecting the Sun" and "Sounds of a Spring Near and Far"  220

6.23 Shen Yu et al., "Immense Field with Shady Groves" and "Clouds Remain as Water Flows On"  221

6.24 "Autumn Moon Over a Calm Lake," from *Extraordinary Views*
    *within the Seas*                                              223
 C.1 Anonymous, *Kangxi Reading*                                   229

## Maps

 I.1 Key sites in eastern China                                      2
 I.2 Stages of development at the Mountain Estate to Escape the
     Heat under Kangxi and Qianlong                                  5
 1.1 Topographic and hydrological features of the Mountain
     Estate to Escape the Heat                                      23
 1.2 Architecture of the Rehe Traveling Palace described by
     Zhang Yushu                                                    25
 1.3 Zhang Yushu's itineraries: "Northeastern Scenic Route" and
     "Northwestern Scenic Route"                                    27
 1.4 Public and private zones in the Mountain Estate to Escape
     the Heat                                                       29
 1.5 Architectural development at Rehe Upper Camp                   33
 1.6 Architectural development of the southeast section of the
     Mountain Estate to Escape the Heat                             35
 1.7 Visualization of possible water routes during the Kangxi
     period                                                         40
 1.8 Potential water flows in the western mountains of the
     Mountain Estate to Escape the Heat                             44
 1.9 Sites incorporating water at the Mountain Estate to Escape
     the Heat                                                       45
1.10 Religious structures built in Rehe (later Chengde) under
     Kangxi and Qianlong                                            53
 2.1 Key locations in Kangxi's auspicious geography of the
     empire                                                         69
 2.2 Linking Mount Changbai to sites in the Qing Northeast via
     mountain veins                                                 69
 2.3 Rehe at the continental crossroads                             77
 4.1 Architecture depicted in Leng Mei's *View of Rehe*            107
 4.2 The Rehe valley, with vectors illustrating vantage points in
     Leng Mei's *View of Rehe*                                     133
 4.3 Viewshed analysis from the southern vantage point            137
 4.4 Pictorialization of the viewshed analysis from the southern
     vantage point                                                 136
 4.5 Viewshed analysis from the southeastern vantage point        139
 4.6 Topography surrounding Verdant Isle of Green Maples          141

# Acknowledgments

AMONG THE GREATEST PLEASURES of research are the debts of gratitude it incurs, and the collegiality and friendships those debts recall. Across four continents, countless hours in museum stores, library stacks, and rare book rooms, and many joyful meals and garden walks, these relationships have sustained me and enriched my life and work beyond measure.

My first thanks are to my teachers. With his unfailingly perceptive eye and perhaps even more perceptive ear, Richard Vinograd never asked the expected question but always the most thought-provoking one. Ever curious, he taught me that a life of scholarship is a life of learning. Matthew Sommer not only guided me through the history and historiography of the Qing, he also empowered me to believe that an art historian is first and foremost a historian, that images document the past just as surely as texts, and that I was capable of achieving what I had set out to do. From my first lecture at university, Maggie Bickford instructed me to look and to challenge myself to describe what I see. Her most essential question— "How do you know?"—has shaped my research ever since.

Many colleagues have contributed directly and indirectly to this project. At Stanford University, Kenneth Koo, Lo Hui-chi, Ma Ya-chen, Mei Yun-chiu, Naomi Nagano, Pauline Ota, Shang Kela, Hilary Snow, Erica Yao, and especially Quinn Javers offered a rich intellectual and personal community. I have continually been inspired by the wisdom and camaraderie of my fellow Qing art historians, including Chen Kaijun, Wen-Shing Chou, Lisa Claypool, John Finlay, Philip Hu, Kristina Kleutghen, Yeewan Koon, Lai Yu-chih, Liu Lihong, William Ma, Michele Matteini, Wang Cheng-hua, Wang Ching-ling, Wang Lianming, and Roberta Wue. This project was truly born during my year as a Junior Fellow in Garden and Landscape Studies at Dumbarton Oaks Research Library and Collection, where I was immersed in the creative breadth of landscape studies as a distinct yet complementary field to art history. Grey Gundaker and Michael Lee were particularly important interlocutors and mentors for me.

My time at the Center for Advanced Study in the Visual Arts (CASVA) allowed me to develop many of the central arguments in this book in a rich conversation across disciplines. I am especially grateful to Caro Fowler and Meredith Gamer for their critical eyes and unfailing support. At Middlebury College, Anne Kelly Knowles and Rivi Handler-Spitz introduced me to ideas that fundamentally altered the direction of my research, and their intellectual and methodological influence on me runs throughout this book. Colleagues and friends throughout the University of Sydney have generously supported my research in a variety of ways, offering feedback and mentorship, and making periods of leave possible by covering my teaching and service. I owe special thanks to Donna West Brett, Mark De Vitis, Yvonne Low, and Adrian Vickers.

Access to collections and expertise around the world has been critical to my research. Christer von der Burg, Sören Edgren, and Raymond Yip all generously shared books in their personal collections. Stephen Allee of the Freer | Sackler, Chen Yunru and Hsu Yuan-Ting of the National Palace Museum, Katharina Kaska of the Dresden Kupferstich-Kabinett, Li Li of the Shenyang Palace Museum, Liu Ning of the Liaoning Provincial Museum, Frances Wood of the British Library, Yan Yong and Zhang Shuxian of the Palace Museum (Beijing), and Zhang Binchong of the Bishu Shanzhuang Museum allowed me to see works in their care and shared with me their research and expertise. My thanks also to the curatorial and library staffs of the Bibliotheca Nazionale di Napoli, Bibliothèque nationale de France, Bodleian Library, Dumbarton Oaks Research Library and Collection, Harvard-Yenching Library, Los Angeles County Museum of Art, Nelson-Atkins Museum of Art, New York Public Library, Osaka City Museum of Fine Arts, Philadelphia Museum of Art, Royal Asiatic Society, and the libraries of the Freer | Sackler, National Palace Museum, University of California, Berkeley, and Johns Hopkins, Princeton, Stanford, and Sydney Universities.

This book would not have been possible without the generosity of numerous research centers and foundations, including CASVA and Dumbarton Oaks, and the Chiang Ching-Kuo Foundation for International Scholarly Exchange, the Freeman-Spogli Institute for International Studies, and the Graham Foundation for Advanced Study in the Fine Arts, which each provided crucial early support. For supporting my work while I was a member of their respective faculties, I thank Middlebury College and the Courtauld Institute of Art, as well as the School of Literature, Arts, and Media and the Faculty of Arts and Social Sciences, University of Sydney. Audiences at the Australian National University, CASVA, Dumbarton Oaks, the Huntington Library, the Institute of Fine Arts, the Palace Museum, the College Art Association, the Society of Architectural Historians, and the Universities of Arkansas, Hong Kong, Pennsylvania,

and Sydney have all offered valuable feedback over the course of research and writing.

In various ways many others have invested themselves in helping me complete this book. Birgitta Augustin, Chen Yunru, Hu Yunjie, Lai Yu-chih, Lisa Claypool, and Stephen Little aided in obtaining images for publication. Chen Shuxia provided invaluable research assistance. Pen Sereypagna clarified arguments with key illustrations. Kirrily White and Daniel Huffman helped make my cartographic hopes for the book a reality. David Brophy, Roslyn Hammers, John Finlay, Stuart Lingo, Fresco Sam-Sim, Wang Lianming, Zhu Yanfei, and many others offered key pieces of advice along the way. Tim Benton, Patricia Berger, Peter Bol, Mark Elliott, Meredith Gamer, Steven Miles, Richard Strassberg, Anatole Tchikine, Eugene Wang, Stephen West, and Bronwen Wilson offered precious feedback on drafts of various chapters.

From reading and editing to writing in support of it, James Beattie and Amy Reigle Newland helped usher the manuscript forward. Marni Williams strengthened the writing and expression with her perceptive editing and served as sounding board in the final stages. Sussan Babaie, Mary Roberts, and Robert Wellington have been vital interlocutors, sharing research and ideas about early modern global exchange. Julie Nelson Davis and Paul Jaskot have challenged me through their extraordinary work, while supporting and encouraging me professionally and personally. Mark Ledbury has been the champion all early career scholars deserve. John Beardsley's vision of transdisciplinary landscape studies has fundamentally influenced my work since I arrived at Dumbarton Oaks, as has his example of generosity and service. Finally, Bianca Maria Rinaldi and Eddie Vazquez have supported this research—and me—even when very far away.

Deepest of all is the well of thanks owed to my family. My parents, Margery and Michael, have always encouraged and supported this path, however unlikely it must have seemed. My sisters, Bailey and Eliza, cheered as only people who have known you forever can. Annika and Callan patiently shared their father with some dead guy and his garden for far too long. Finally, to my partner, Tanya, whose sacrifices for this book have been no less than my own but whose belief in it and its author was often far greater—thank you.

# Note to Readers

THE WORD *JING* figures prominently in this book and thus deserves a brief moment of definition. A *jing* describes a space that is experienced holistically through the senses and imagination, drawing both on the immediately accessible environment and on historical, literary, and artistic tropes to which it makes reference.[1] In this book I have used "scene" rather than the more conventional "view" to translate *jing*. In large part, I did so because vision, its experience, and its representation play such a large role in my description of the landscape that the use of "view" to translate *jing* was causing confusion and preventing use of it to mean simply "what can be seen from a certain spot." Although in earlier publications I have used either "viewscape" or "View" (capitalized) to denote *jing*, these translations now seem both awkward and ultimately too one-dimensional and static. A "view" is something that is seen; it may stir an emotional response in the viewer but, whether seen through a painting or the landscape itself, it remains something that is set before one and taken in through the eyes. This does not adequately convey the meaning of *jing*, in which the multisensory, the intellectual, and the affective all inhere.

When referring to the imperial complex at Rehe by something other than one of its given names, I prefer the terms "park" or "park-palace" to "garden" or "garden-palace" used by other scholars. This is for two reasons. The first is to differentiate between the site as a whole—the park—and the individual gardens or gardenlike features that it contains. The second reason is to underline how different the Mountain Estate is from what we conventionally think of as a Chinese "garden." This is true in many regards, the most important of which is scale. The urban garden that most readers will think of first when conjuring a Chinese garden takes space—or, more properly, a relative lack of it—as both its most important design constraint and its greatest opportunity. The manipulation of space and its experience is at the heart of urban garden design. At the Mountain Estate there is no such constraint. Indeed, one of its most interesting design features is the

way in which the park's design draws on the same concepts and under-lying techniques as those used in urban gardens but without the same limitations.

Throughout the book I have made an effort to translate all names associated with architecture or landscape, despite the sometimes wordy or awkward results. The reason for this is straightforward: for Chinese speakers and nonspeakers alike, names rendered in romanization, but left untranslated, are simply abstracted from their original linguistic forms and remain relatively meaningless to all readers. Yet names applied to structures and natural features filled the landscape with meaning; indeed, it was by these names that the landscape was fully given shape and form by its occupants and interlocutors.[2] To render a name as poetically as possible in English is, for an English-language book and English-reading audience, to provide the best possible approximation of the court's intended experience of the site. As many scenes existed both as physical sites and as texts or images, I have used quotation marks when referring to a text or image, but not when referring to the place itself. Pine Winds through Myriad Vales thus describes an architectural compound at the southern end of the park-palace, whereas "Pine Winds through Myriad Vales" refers to that compound's representation in *Imperial Poems on the Mountain Estate to Escape the Heat*.

For natural and human-made features of the garden, including lakes, islands, valleys, and mountains, I have made every effort to identify Kangxi-era names in poems, archival records, and other sources. Very few survive, however, and in some cases it is unclear whether the name offered ought to be considered a proper noun or simply a descriptive expression (e.g., 澄湖, which could be read as Chenghu, Clear Lake, as it is known now, or simply as *chenghu*, a clear-watered lake). Whether this absence is due to a yet-to-be defined nomenclature, the loss of archives documenting names, or simply a failure to systematically record names that were widely in use, and that may have largely survived intact to the present day, remains unclear. In response, I have generally elected to use the name by which the feature is now known, offering additional information where available. For a book as concerned with uncovering past formations as this one, it is not an ideal solution; the reader is encouraged to keep this uncertainty in mind when thinking about the ways in which names may contribute to interpretations and understandings of the landscape.

Hanyu Pinyin romanization and complex-form (traditional) characters are used throughout the book, including standardization of quoted material originally rendered in other romanization systems; alternative romanizations of personal names are preserved where it reflects the preference of the original author. Qing emperors are referred to by their reign names (e.g., Kangxi or Qianlong). As these names strictly speaking refer to reign periods (e.g., the Kangxi era), "Kangxi" the person is really "the Kangxi

emperor." When used as an adjective (e.g., "Kangxi artistic practice"), the name thus refers to the reign period rather than the individual ("Kangxi's artistic practice"). Emperors of other dynasties are referred to by their most common names; for the Ming and some other regimes this is by reign period, while for the Han, Tang, and Song this is by temple name. Chinese dates are rendered as reign/year/month/day, such that "KX41/閏6/14," for example, denotes the fourteenth day of the intercalary sixth month of the forty-first year of the Kangxi era, or August 7, 1702. Translations of the titles and texts of the thirty-six *Imperial Poems* are taken or adapted from those by Richard E. Strassberg, in Strassberg and Whiteman, *Thirty-Six Views: The Kangxi Emperor's Mountain Estate in Poetry and Prints.* All other translations are my own unless otherwise noted.

Finally, maps of the site appearing in chapters 1 and 4 are based on the Bishu Shanzhuang Historical GIS, a database built in collaboration with Kirrily White over the course of researching this book to capture the architecture as well as the built and natural features of the Mountain Estate. Default dating is from Chen Baosen, *Chengde Bishu shanzhuang Waibamiao*; whenever possible, this dating is either corroborated or altered based on further research. Structures and walls are based on the site plan published in Hou Renzhi, ed., *Beijing lishi dituji*, pages 49–50, then adjusted in accordance with satellite imagery and on-site observation and measurement. Contours and hydrography in the original GIS were derived and rendered in ArcGIS from an ALOS PALSAR RTC high resolution (12.5 meter) digital elevation model (ASF DAAC 2015). The maps that appear in this book employ illuminated contours of variable depth. The elevation data were manually edited to conform to available hydrography data. Locations of certain structures have also been manually edited to conform with topographical data and on-site surveys. Maps in chapter 2 were produced based on relief data from viewfinderpanoramas.org and Natural Earth vector data. Cartography throughout the book is by Daniel P. Huffman, based on prior work by myself, Kirrily White, Benjamin Blackshear, and Kate MacFarlane.

Original Chinese texts translated in the following chapters, high-resolution maps, and other supporting materials for this book are available at the Art History Publication Initiative website (https://doi.org/10.6069/9780295745817.s01).

# Where Dragon Veins Meet

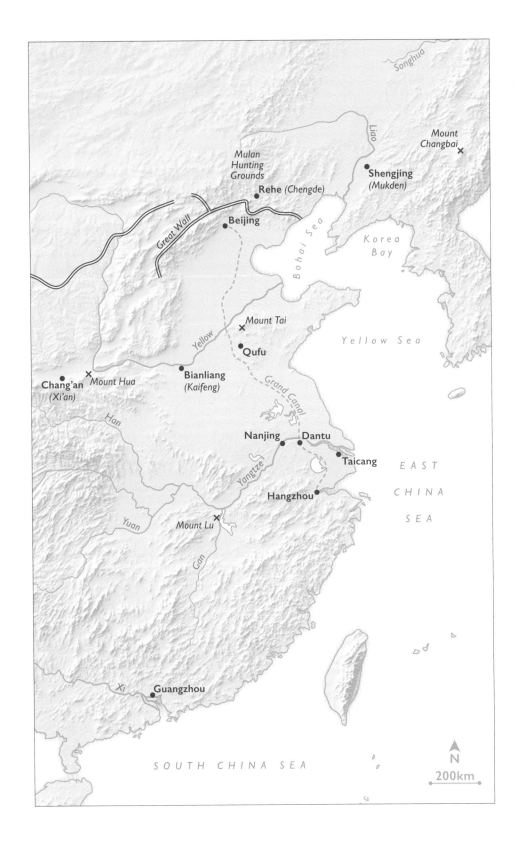

Songhua

Mulan
Hunting
Grounds

Liao

Mount
Changbai ✕

Rehe (Chengde)

Shengjing
(Mukden)

Great Wall

Beijing

Bohai Sea

Korea
Bay

Yellow

Mount Tai ✕

Qufu

Yellow Sea

Chang'an
(Xi'an)

✕ Mount Hua

Bianliang
(Kaifeng)

Grand Canal

Han

Nanjing

Dantu

Taicang

EAST

Yangtze

CHINA

Hangzhou

SEA

Yuan

Mount Lu ✕

Gan

Xi

Guangzhou

SOUTH CHINA SEA

N

200km

# Historicizing the Early Qing Landscape

TRAVELING NORTHEAST by train from Beijing today, you pass quickly through dense urban development and the city's hinterlands into the mountains that lie between the capital and Inner Mongolia (map I.1). Several hours later you arrive in Chengde, a provincial city that, at fewer than a half million people, is relatively small by the standards of contemporary China. In the eighteenth century, however, it was one of the most important centers of authority in the entire empire, home to the Qing court (1644–1912) for as much as half the year, and site of its largest palace and park complex, the Mountain Estate to Escape the Heat (Bishu Shanzhuang). Now a UNESCO World Heritage Site and major regional tourist destination, the park's three-hundred-year history has been distilled into a landscape of nationalist, touristic, and scholarly narratives, sometimes overlapping, sometimes intertwined.[1] Restored, rebuilt, and refashioned as a space at once timeless and quite specific in its temporality, today the park seeks to present a vision primarily of imperial glory under the Qianlong emperor (r. 1735–1796), collapsing decades and centuries of development, decay, and reappropriation into a selection of crystalized historical moments.[2]

Like all histories, this one is by definition only visible in retrospect. Gardens have long served as metaphors for dynastic fortunes in China, their flourishing and decline reflecting the inevitable ephemerality of a regime's authority. The Mountain Estate played a role in many of the late eighteenth and nineteenth centuries' most dramatic encounters between the Qing and outside forces, including Lord Macartney's (1737–1806) famous refusal to kowtow before Qianlong in 1793 and the death of the Xianfeng emperor (r. 1850–1861), who fled Beijing at the end of the Second Opium War.[3] Given such events, the imperial park seems particularly well-suited to such a dynastic scaffolding. Qianlong is an attractive narrative apex, as he ruled

the Qing for most of the eighteenth century and left seemingly endless documentary and material evidence of his reign. Although by no means the only Qing ruler of that period—the so-called High Qing (Da Qing shengshi) encompasses the reigns of Kangxi (r. 1661–1722), Yongzheng (r. 1722–1735), and sometimes Jiaqing (r. 1796–1820) as well—history and historiography have often combined to effectively collapse "Qing" into "Qianlong" and vice versa.

Histories of the Qing landscape frequently reflect this blurring. The geobody through which we generally picture the Qing represents the imperial territory at its most expansive extent, which it reached in the late eighteenth century under Qianlong.[4] He was the dynasty's most prolific garden builder but not its first, as he radically altered existing imperial installations while constructing new ones.[5] Inheriting the Mountain Estate from his grandfather, Kangxi—Yongzheng, Qianlong's father, preferred Beijing, never traveling north during his brief reign—Qianlong's significant development of the site over the course of his entire reign altered both the experience of the park-palace as a built environment as well as its fundamental design orientation (map 1.2). To view the park solely through the lens of Qianlong's vision for it, projecting a unified course of development over the transformations of nearly a century, risks (indeed, enacts) an act of historical erasure, subsuming the intentions of an earlier period under the actions of a later one.

The intersections of landscape, geography, ethnicity, and knowledge were central to the formation of the Qing dynasty and its authority. In 1696, after more than fifty years of war, Kangxi (fig. 1.1) brought to a close the first phase of Manchu conquest, which drew Ming China (1368–1644) and much of Mongolia, Taiwan, and other regions into a new, multiethnic empire composed of territories that were historically and culturally distinct. Despite being the second ruler of the Qing (and the fourth since the Manchus began the process of conquest and unification), he still faced many of the challenges of a newly founded state, seeking to establish the cultural and political legitimacy of Qing rule while articulating a distinctively Qing mode of emperorship. His principal concerns lay in creating a geographically and culturally cohesive empire out of highly disparate parts and establishing authority in the eyes of a diverse range of constituencies, including Han officials, Mongol and Manchu elites, and European rulers, whose emissaries, Catholic missionaries, brought novel scientific, artistic, and religious ideas to Beijing. The formulation of a new, fundamentally Qing landscape, through which the empire's simultaneous diversity and ideal unity were fashioned and articulated, was central to the Kangxi court's engagement with these challenges.

In 1702, Kangxi ordered construction of a new summer palace in Rehe (now Chengde, Hebei), the most substantial in a network of traveling

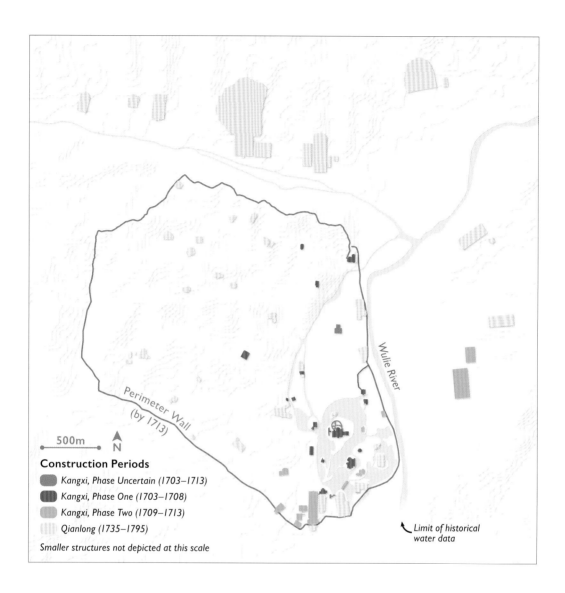

Construction Periods
- Kangxi, Phase Uncertain (1703–1713)
- Kangxi, Phase One (1703–1708)
- Kangxi, Phase Two (1709–1713)
- Qianlong (1735–1795)

Smaller structures not depicted at this scale

500m

N

Perimeter Wall (by 1713)

Wulie River

Limit of historical water data

MAP I.2
Stages of development at the Mountain Estate to Escape the Heat under the Kangxi and Qianlong emperors. Map by Daniel P. Huffman.

palaces (*xinggong*) that supported his annual tours north among the court's Inner Mongolian allies. The Mountain Estate to Escape the Heat, as the site would eventually be named, effectively served as a secondary capital, the emperor residing there from late spring through early autumn each year over the last decade of his life. Yet it was also decidedly not the capital. Freed from the architectonic constraints of the Forbidden City, Kangxi employed imperial parks and gardens as alternative spaces of rulership. Like his almost exact contemporaries in Europe and South Asia, Aurangzeb (r. 1658–1707), Louis XIV (r. 1643–1715), and Peter the Great (r. 1682–1725), Kangxi made designed landscapes central to his performance of authority.[6] In contrast to sociologist Norbert Elias's classic—if now dated—reading

of the court at Versailles, in which the palaces and gardens were used to reinforce hierarchies of proximity to the king's body, Kangxi's Mountain Estate was substantially a site of rituals of intimacy and exchange that performed a temporary elision of social difference between emperor and subject: roaming in the gardens, banqueting, entertainments, and gift giving.[7]

As the site itself reached a state of relative completion during this first phase of development—a bronze nameboard in the emperor's calligraphy was hung over the main gate in 1711, and the outer wall and two nearby temples completed two years later—the court extended the meaning and function of the Mountain Estate through a range of different forms. Written accounts of the park, composed by leading official Zhang Yushu (1642–1711) in 1708 and by the emperor himself three years later, circulated in various manuscript and printed forms. A monumental hanging scroll by the court artist Leng Mei (active ca. 1677–ca. 1742; see fig. 4.1) captured an image around the time of Zhang Yushu's visit, presenting a vision at once idealized and deeply inflected by contemporary understandings of space. Finally, an album of thirty-six scenes from the park, *Imperial Poems on the Mountain Estate to Escape the Heat* (Yuzhi Bishu Shanzhuang shi), offers a virtual tour framed by images and the emperor's own poetry, the garden placed in the palms of one's hands. Created in parallel painted, woodblock-printed, and copperplate engraved versions, the album's multiple iterations resonated with each other and with the park itself.

The recursive dialogue engendered among these different iterations of the landscape extends the site's construction of emperorship beyond what any one form of the Mountain Estate might offer, while enabling the park to function as both setting and medium for communicating a particular vision of the imperial to the court's diverse audiences. The central concerns of this book are the nature of this vision, the ways in which it was conveyed through landscape, and, in turn, the ways in which landscape may be thought of as an active medium for, rather than just a reflection of, ideological expression.[8] The chapters that follow engage the Mountain Estate not simply as a primary site and its secondary representations but as an interconnected network of landscape expressions through which the court constructed and conveyed different aspects of its ideology. As such, they may be best understood as "rhetorical landscapes," as described by David Hall and Roger Ames, in which each form of the landscape—garden, image, text, or map—constitutes "a world of its own," a meaning-bearing cultural construction of equal and reciprocal ontological status to the others.[9] These expressions drew upon a host of rhetorical and practical inputs from within and beyond China and the Qing to shape the idea, experience, and reality of the Mountain Estate. In so doing, they embody the fundamental nature of the Qing as an early modern global empire engaged with both history and the present; with the cultures and systems of knowledge

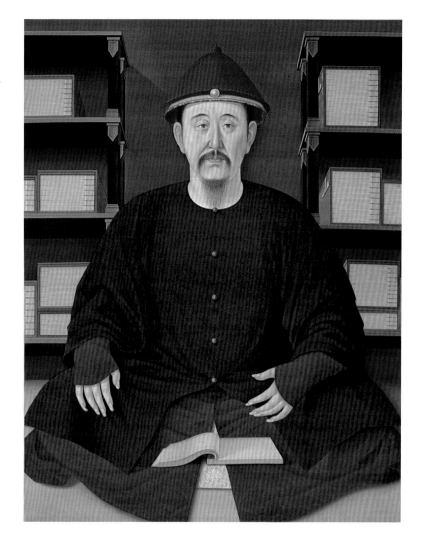

FIGURE I.1
Anonymous, *Kangxi
Reading*, ca. 1699–1704.
Hanging scroll, ink and
color on silk, 137 × 106 cm.
Palace Museum, Gu6411.
Photo by Hu Chui.

of its multiethnic populations and its foreign interlocutors; and with the
physical nature of its territory and its own efforts to transcend it.

By approaching the idea of landscape—specifically that of the Kangxi
emperor's Mountain Estate—in this manner, this book seeks to "set the
landscape in motion" in at least two senses. The first represents an effort to
imagine beyond the static remove of history and historical reconstruction
that generally coheres to the past, but especially to naturally changing sites
such as the Mountain Estate, which become more or less cast in amber.
This sense of motion exceeds simply that of botanical growth or movement
through the landscape, though both appear in the story that follows. Nor
is it a matter of relating representations of the garden back to the physical
site in order to in some sense animate them through a judgment of their
"truthfulness" to their subject. Rather, this reanimation emerges through

a form of "spatial intertextuality," by which a multivalent conception of a landscape emerges from the dynamic interchange between site, image, text, experience, and memory.[10]

This book expands upon this notion by inviting space to function as the point of mediation for understanding ways in which one form or experience of landscape gathers meaning through its dynamic resonance with another—regardless of, though fundamentally attentive to, medium or temporal relationship. The resulting motion emerges from the manifold and even rhizomatic ways in which the ideas embedded or encoded in the landscape circulate, evolve, and, in so doing, allow it to operate as an expressive medium on its own terms. Indeed, to stress the medial form of landscape is to interrogate this very process, to understand precisely how landscape becomes encoded with meaning in certain circumstances, whether through the conceptualization and creation of idealized spaces, the metonymic representation of the imperial, or perhaps the creation of the imperial itself—the idea that a landscape *of* the emperor *is* the emperor.[11]

While art historian W. J. T. Mitchell's formulation of landscape as medium underpins this argument, his emphasis on landscape exclusively as a "symbol of value" belies any material and embodied experiences of it. Such an elision risks rendering the specificities of audience as abstract participants in a conceptual transaction, rather than individuals whose active engagements with the landscape are essential to its continued, recursive accumulation of meaning. The material and formal representations of landscape are fundamental to understanding both the message and the means by which it is conveyed and thus figure centrally in this exploration of the Mountain Estate and the early Qing landscape more broadly. By attending closely to the ways in which "things-in-motion" can speak to the contexts of their creation and use, it is possible to bring the Kangxi landscape to life in a way that extends beyond Mitchell's theorization.[12] The Mountain Estate thus becomes more than a static architectural entity with a series of secondary representations; instead, it emerges as a space that through images, accounts, and records reflects the circumstances of its creation and deployment under the Kangxi emperor.[13]

From this a second form of motion in the landscape emerges. Less concerned with movement and mobility, and more with mobilization, it asks how landscapes, both designed and represented, can be made to speak—not only to their own immediate histories but to broader questions whose trajectories intersect with the garden or painting. What can a view of the Mountain Estate, not as it would become under Qianlong but as it was under Kangxi, tell us about the early Qing, the dynasty's political, cultural, and territorial evolution, and its position within the rapidly developing networks of the early modern world? Scant evidence remains that attests

to cultural production in the Kangxi court, particularly its intersections with political and ideological concerns and the construction of imperial identity, especially when compared to the documentary and pictorial riches of the Qianlong period. An imperial landscape of the scale and complexity of the Mountain Estate has the potential to speak eloquently to the specific and changing concerns of its occupants—only, however, insofar as its voice (namely, its sense of diachronic distinctiveness and change) can be recovered.

This book thus takes as its point of departure a sort of historical archaeology, seeking to pull apart the collapsed layers of the landscape and restore a degree of chronological stratigraphy to the Mountain Estate. This process begins with a reconstruction of different phases and aspects of the physical site under Kangxi, including not only the traveling palace's earliest architecture but also its itineraries, sensory experiences, and the imaginative flights its creators meant to engender. Such detailed engagement with the park, intended to recover not just its plan but how it functioned as a designed space, builds a clear foundation rooted in the Kangxi-era site. This diverse archive may then be utilized in subsequent explorations of the park: as geomantic pivot within the auspicious geography of the empire, or as an expression of the court's idealized visions of empire and emperorship. Excavations of the two surviving Kangxi-era pictorial instantiations of the Mountain Estate, Leng Mei's *View of Rehe* and Kangxi's *Imperial Poems*, show how the raw material of landscape lies in pictorial techniques and technologies as much as in architecture—painting and printing, as well as perspective and surveying, and the spatial and epistemological relationships across media these forms allow. These various threads are then drawn together in an exploration of how vision and experience are virtualized in *Imperial Poems*, a product of the ways in which the work simultaneously relates to and exceeds the embodied experience of rambling through the park-palace.

Central to this recovery has been a deliberate strategy toward the interrogation of sources, in terms of both inclusion and use. Previous studies of the Mountain Estate have relied predominantly on Qianlong and nineteenth-century materials, most particularly imperial gazetteers of the Rehe/Chengde region.[14] While the conventional view of such texts has taken them as primary sources capable of attesting to the Kangxi era, they are in truth no more primary than this book—more useful perhaps for their greater temporal and cultural proximity to the period in question but secondary nonetheless.[15] In response to this concern, I have made a deliberate choice to rely primarily on Kangxi-era sources, drawing judiciously on later materials where possible and appropriate. This is not because these earlier sources are "*ipso facto* more 'true'"—I am acutely aware of the subjective, problematic nature of Kangxi sources and the landscape they construct.[16] Instead, I seek to make this subjectivity—the fundamentally rhetorical

nature of the Kangxi landscape described below—the focus, arguing not for how the emperor or the Mountain Estate *was* but for how he sought to present himself and his empire to be.

This approach attempts to balance its inevitable constraints with the opportunities that arise through deep engagement with a chronologically coherent source pool. As a result, more attention is given below to method and process than might often be the case, as I argue not just for *what* can be seen but *how* it can be seen, with particular interest in the potential for historical ambiguity and uncertainty to expand understandings of the past. Mobilizing the landscape as evidence, working iterations of the Mountain Estate against one another and the broader context of intellectual and artistic production in the Kangxi court, allows us to ask what a history told through landscape reveals that a more text-based history elides.[17]

One result, I hope, is to further the case for the centrality of art history in the fields of Qing history and early modern imperial history more broadly. While cultural production and ideological expression are inherently intertwined, objects, images, and spaces play an especially important role in the articulation of early modern rulership. The Qing court developed a sophisticated regime of image making and dissemination through painting and print that complemented and augmented its use of space, ritual, and text. In each, the court's exploitation of the visual and material potentials of its mediums, as well as their capacity for interaction across media, presents a nuanced and evolving engagement with both received and newly introduced cultural discourses. Its capacity to address multiple and diverse constituencies in what I term "multivocal" artistic modes that were at once unified and particular to their different audiences further reflects the realities of early modern cosmopolitan empires and emperorship.[18] Partitioning the study of imperial cultural production from the broader questions of Qing history not only divorces much of what the court did from how it did it; this partitioning also creates an ahistorical separation between things that belies how objects, images, and spaces operated in the court's political and ideological activities.

This book thus argues for the potential of a connected history of Qing art in the early modern world. The Kangxi era offers fertile ground for such a project, as it was a period of political and artistic consolidation and development in which fundamental processes of experimentation and innovation can be observed in both arenas. The court's engagement with and incorporation of endogenous and exogenous cultural, artistic, technological, and epistemological inputs led to a multifaceted mode of ideological expression that, in its simultaneous diversity and coherence, reflects the nature of the Qing while also serving to define imperial identity for its audiences. Taking the multiple forms and iterations of the Mountain Estate as their primary focus, the following chapters seek to understand

both the production of space through landscape and the performance of emperorship within the landscape as forms of ideological expression. Although imperial ideology found many outlets—including ritual, religious, and scholarly patronage, war, touring, and cultural production more generally—the window offered by landscape on the particular concerns of the Kangxi period is especially useful.

Forging nature and culture into a coherent medium, landscape in the Kangxi court draws together contemporary understandings of space, technology, and representation to articulate an emergent Qing imperial identity. Landscape accommodates cross-pollination between the political, the material, the technological, and the spatial, all essential and interrelated elements in the court's articulation of authority. In this manner the landscapes of the Mountain Estate allow access to the ways in which court ideology operated physically, pictorially, and imaginatively in different moments and across different media for the court's various audiences, cohering into shifting images of Kangxi's approaches to the particular challenges of the early Qing and the early modern world.

PART I  Recovering the Kangxi Landscape

# Excerpt from "Record of Traveling at the Invitation of the Emperor"

## ZHANG YUSHU

ON THE SECOND DAY of the sixth month [July 19, 1708], the imperial entourage arrived by carriage at the Rehe Traveling Palace. On the eleventh day [July 28], I received an imperial edict commanding me to tour the rear park with senior Manchu officials and others. Entering at the main gate, we proceeded northeast, reaching a cliff. There was a three-bay hall, the name-tablet hung over the door lintel reading, "Pine Winds through Myriad Vales" [see fig. 5.20]. A couplet hung on columns by the entry reads: "The clouds roll up the color of a thousand peaks / The spring harmonizes with the sound of a myriad pipes."[1]

We climbed several tens of stone steps one set after another, then wound back around and descended. To the right, there was an eight-cornered pavilion from which one might drop a hook in the water [see fig. 5.20]. Crossing a bridge, we walked along a long dyke [see fig. 1.1]. At this point, His Majesty stood in a pavilion, and turning to address me and the other officials, said, "The form and appearance of this dyke is similar to that of a *lingzhi* fungus."[2] Now, the long dyke wound along in an unbroken line. Halfway, one branch extended out to divide the lake into three small bays, each forming a glorious realm. It is, in truth, comparable to a sort of *lingzhi*.

Translated by Stephen H. Whiteman. For an earlier, fully annotated version of this translation, see *Thirty-Six Views*, 279–85; for the full original text, see *Dongbei shizhi*, 3–6.

1. *Zhuangzi*, "Qiwulun," in which the myriad sounds of the Heavenly pipes are described as an expression of the *dao* in nature. See "The Adjustment of Controversies," Chinese Text Project, https://ctext.org/zhuangzi/adjustment-of-controversies, accessed July 7, 2018.

2. It is not clear to which pavilion Zhang is referring since there is no pictorial or extant physical evidence of a structure on the embankment.

To its east is Colorful Painting of Cloudy Mountains; to its west is the imperial princes' study.[3] We proceeded straight ahead for a *li* and more and came to the place where the emperor resides.[4] The name-tablet over the main gate reads: "Clear Ripples with Layers of Greenery." Beyond the gate, in the midst of the residence, stands the imperial bed. Gazing appreciatively over the broad and distant scene, a thousand cliffs and myriad valleys appeared within our sight.

Upon entering the gate, a short way to the west is Inviting the Breeze Lodge; the door-couplet reads: "Clouds stir the trees along the stream so that they invade the curtains of the study / Breezes bring grotto springs to moisten pools of ink." Behind the lodge, there is a Buddhist hall, its name-board reading, "Fragrant Waters and Beautiful Cliffs." The door-couplet reads: "There are mountains and rivers stretching to the Northern Pole Star / And a natural landscape to surpass that of West Lake."[5] To the side there is a multistoried hall whose name-board reads, "Moon Boat with Cloud Sails." The door-couplet reads: "I suspect I have boarded a painted vessel and risen to heaven / I want to raise a light sail to enter into the mirror." We wound around and arrived at the imperial throne. In front of the main hall a variety of flowers were planted in rows containing a great number of exotic varieties. There were five hydrangea bushes, each grafted with blossoms of five colors, something I had never seen before.

There is a stage opposite called A Sheet of Cloud, and at this time music was performed. Various Manchu officials sat in the eastern gallery, and I accompanied the various officials of the Hanlin Academy (Hanlinyuan), who were seated in the western gallery. Inside a small kiosk was placed a couch made of wood. We proceeded immediately to the banquet, during which His Majesty bestowed numerous dishes upon us, as well as specially granting us a vessel of an imperial dish, pheasant potage. When the midday banquet concluded, the group rose, expressed thanks for the emperor's favor, and went out. We thereupon boarded small boats and floated upon the lake. The broadest and most open part of the lake is generally similar to West Lake, yet its quiet seclusion and clear, pure beauty cannot be matched by West Lake.

On the bank were several towering trees, and an imperial attendant said that these were all saved at His Majesty's personal command. An embank-

3. Colorful Painting of Cloudy Mountains (Yunshan Yanhua) generally refers to the complex on Moonlight and the Sound of Rivers Island, which appears to the right in fig. 1.1; the name is now applied specifically to its northernmost gate. The imperial princes' study is the complex on Encircling Jade Island, to the left in fig. 1.1.

4. One *li* equals roughly a third of a mile.

5. *Zhuangzi*, "Dazongshi," in which the Northern Pole Star serves as a locative metaphor for things beyond human understanding, specifically, the *dao*. "The Great and Most Honoured Master," Chinese Text Project, https://ctext.org/zhuangzi/great-and-most-honoured-master, accessed July 7, 2018.

ment has been built along the trees, their dark and emerald greens shimmering back and forth, and their ancient trunks growing into even more gnarled shapes. Gazing into the distance from inside the boat, I cannot fully describe the glorious scenery. There are distant banks and winding currents that make the water feel supremely expansive; there are encircling cliffs and embracing rivers that create an ultimate sense of brilliant beauty. Ten thousand trees of concentrated green, vermillion towers like sunset's hue: one could say it is like a world within a painting, or like a world created by poetry, yet poems and paintings pale in comparison to this immortals' realm.

On the lake's eastern shore there is a sluice gate and the water of a hot spring enters from this spot. Where we went ashore, there is a lotus pond. By the edge of the pond there is a hall for enjoying cool air.[6] To the right of the hall is a pavilion, a place for floating goblets along a winding stream.[7] The name-board reads, "Water Clover Fragrance Bank," and the door-couplet reads, "The moon flows constantly on the pair of brooks / A thousand peaks naturally merge with the clouds." The sounds of springs from near and far are drawn here along a watercourse dredged according to the twists and turns of the land.[8]

Following the lake water around several bends, we arrived again at the boat landing where we had first climbed ashore. We crossed a bridge and went out along our original path. This is the path through the magnificent scenery extending from the center of the park to the northeast.

On the twenty-eighth day of the month [August 14], we again received an imperial command to tour the park, this time exploring the beauties of the northwest section. Proceeding north from the eastern side gate, we again passed Pine Winds through Myriad Vales, and from the long embankment came to Clear Ripples with Layers of Greenery. After a time, we set out from the main gate, going straight past Moon Boat with Cloud Sails and, walking underneath a covered passage, we reached A Sheet of Cloud. Taking our seats again in the western gallery, we were given an imperial banquet and watched entertainments, again receiving a special gift of a soup from the imperial table. When we finished eating, we rose.

His Majesty issued instructions that, as the lotus blossoms were in full bloom, we could all observe them together. We boarded boats and passed by the boathouse. When I looked into the distance, I saw a dividing embankment. The glimmering lake was a brilliant void that stretched without end. What is called A Pair of Lakes Like Flanking Mirrors can be seen from here.

6. *YZBSSZS*, scene 23.

7. *YZBSSZS*, scene 15.

8. "Sounds of a spring near and far" (*yuanjin quansheng*) was later assigned to complex near a waterfall northwest of the main lake (*YZBSSZS*, scene 25, fig. 1.19).

The lotuses in the western portion of the lake were burgeoning. Among them was one variety, the color of which was perfectly gorgeous. Its seeds were obtained from the Aohan Confederacy. Blossoms and leaves float together on the water's surface, reflected upside down in the lake, forming the most novel and beautiful scene. The remainder, whether closer or further away, grew in randomly distributed clumps, their delicate fragrance surrounding us. It was truly a grand sight.

We climbed ashore where the land was open and flat, with both cultivated fields and groves of trees. Crossing over a small bridge, we followed the winding base of the mountain. The mountain peaks are covered with dark green vines and ancient mosses, plants untold centuries old. Eventually, we arrived at a gate set in an opening in the mountains, beyond which is known as Lion Valley.[9] The gate spans across a ridge, which is called West Ridge. Below the gate is a small viewing pavilion, its name-board reading "Untrammeled Thoughts by the Hao and Pu Rivers."[10] There are two sets of couplets. One reads: "Through the window, the color of the trees joins with the purity of the mountains / Outside the door, the glistening mountain mist bears traces of the water's brilliance." The other reads: "In the still of the wilderness, the *qi*-energy of the mountains gathers / In the sparse forest, winds and dew endure." Sitting here to rest for a while, one truly feels that "this is another world, not the world of men."[11]

Behind this mountain are Hazelnut Glen and Pine Valley. We returned before having a chance to go there. Proceeding south we came to the Temple of the Dragon King, while still further south there is a path paved with stones with various grasses growing here and there. During the spring, pear blossoms appear here in great profusion, such that it is extolled as a seasonal scenic spot.[12] We walked in the mountains for roughly ten-odd *li*. The slope of the trail rose and fell and twisted and turned. Sometimes the trail broke off, sometimes it continued. These unusual precincts were formed by Nature.

We returned to the long bridge and the stone steps.[13] Along this northwestern route we gained a broad stretch of fine vistas. We once again climbed aboard a boat, headed to the western side gate and climbed ashore. We all expressed our gratitude for His Majesty's beneficence by the bank of the lake.

9. Presumably now Cloudy Pine Gorge (Songyunxia), which links the valley floor and the Northwest Gate (Xibeimen).

10. The name later assigned to *YZBSSZS*, scene 17, likely refers here to the hall later named Shapes of Clouds and Figures in the Water (*YZBSSZS*, scene 28).

11. From Li Bo, "Shanzhong wenda." *Quan Tangshi*, j. 178, "Shanzhong wenda," Chinese Text Project, https://ctext.org/text.pl?node=139006&if=en, accessed July 7, 2018.

12. Likely now Pear Valley (Lishuyu).

13. Presumably *YZBSSZS*, scene 34.

The so-called Sixteen Scenes are Clear Ripples with Layers of Greenery, which is the main gate to the imperial throne; *Lingzhi* Path on an Embankment to the Clouds, which is the long embankment; Long Rainbow Sipping White Silk, which is the long bridge; Warm Currents and Balmy Ripples, which is the place where the warm spring enters;[14] Pair of Lakes Like Flanking Mirrors, which is the place where two lakes are separated by an embankment; Pine Winds through Myriad Vales, which is the hall on the hill at the entrance to the park; Scent of Lotuses by a Winding Stream, which is the place for floating wine goblets; Morning Mist by the Western Ridge, which is the pass at the mouth of West Ridge; Sunset at Hammer Peak, which is a distant view of that peak to the west of the park; Fragrant Islet by Flowing Waters, which is a small pavilion next to the stone steps; Southern Mountains Piled with Snow, which is a range of peaks within the park; Golden Lotuses Reflecting the Sun, which is the several *mu* of golden lotus on the western banks that were seen; Pear Blossoms Accompanied by the Moon, which is where pear blossoms form a scene of surpassing beauty in springtime; Orioles Warbling in the Tall Trees, which is a place along the banks where there are many tall trees; Observing the Fish from a Waterside Rock, where one can fish with hook and line anywhere along a stone jetty; and An Immense Field with Shady Groves, which is a place of exceedingly luxuriant fields and trees.

Among the mountains and forests of the emperor's realm, there are none so extraordinary and magnificent as these; among the gardens of the emperor's realm, there are none so grand and vast. From first to last, every detail of the design was executed according to our Sagacious Emperor's instructions. When it was still unfinished, none knew of its unsurpassable scenic beauty. Now it is completed, and everyone maintains that not a thing could be improved upon. In its broad contours, the design follows what is natural in the place, and the construction proceeded without altering the landscape. It was designed in accord with the form of the land. Consideration was given to what was appropriate to the earth itself, and the places for human activities were situated within this.[15] In governing All Under Heaven, there is no other way than this.

14. The name "Warm Currents and Balmy Ripples" was later assigned to a hall at the northeast corner of the park (*YZBSSZS*, scene 19), but here refers to the place where Rehe Spring enters the central lakes.

15. See Liu Zongyuan (773–819), "Zhongshu Guo tuotuo zhuan," in which Liu's hunchbacked gardener Guo cultivates trees by attending to their natural inclinations—a metaphor for imperial rule that balances action and nonaction (*wuwei*).

# Reconstructing Kangxi

IN THE SUMMER OF 1708 the senior official and Hanlin academician Zhang Yushu traveled to Rehe as part of the imperial retinue during the emperor's first extended stay at his newly constructed traveling palace. Zhang recounted the journey in a short essay, "Record of Traveling at the Invitation of the Emperor," a portion of which describes two tours of the park-palace. Together with *Imperial Poems on the Mountain Estate to Escape the Heat* (Yuzhi Bishu Shanzhuang shi), which combines views of the garden with imperially composed texts, Zhang's account is the most substantial description of the site to survive from the Kangxi period. As the emperor and his guests moved through the landscape, Zhang's attentive eye took in both the designed and natural environments. He paid particular attention to textual architectonics—the names and poetic couplets bestowed by Kangxi on the site's earliest structures to frame the visitor's encounters with the park's landscape through carefully planned, multivalent scenes. Visitors' interactions with the emperor are likewise described, revealing moments of remarkably personal connection within the broader scope of more formal, often ritualized exchanges between the emperor and his subjects.

Read in concert with other textual sources, images, and the physical landscape itself, "Traveling at the Invitation of the Emperor" helps re-create a picture of the earliest iteration of the Mountain Estate under Kangxi— its conception, realization, and, perhaps most important, its operation as a material and rhetorical expression of imperial ideology encountered through experience of the site and its representations. Reconstructing the park-palace not simply as a static arrangement of structures but as a space defined by movement and experience reanimates the Mountain Estate from the perspective of its visitors while drawing on perceptual and embodied experience to inform an understanding of the site's earliest conception and design. The arrangement of halls, pavilions, and courtyards within the park's walls reflects the particularities of its topography and hydrology, the

FIGURE 1.1
Shen Yu et al., "*Lingzhi Path on an Embankment to the Clouds*," 1713, from Kangxi et al., *Imperial Poems*, scene 2. Woodblock print. Chinese Collection, Harvard-Yenching Library, © President and Fellows of Harvard College.

progressive extension of imperial presence in the landscape over time, and the logic of itineraries as the emperor and his guests enjoyed the marvelous scenery of their natural surroundings. In reconstructing the park in this manner, the landscape becomes mobilized as a source in its own right, a foundation from which to develop more conceptual understandings of landscape and ideology under Kangxi.

## Inner and Outer Circuits

Although the court had established seasonal hunting camps in the region of Rehe as early as 1681, development of a permanent imperial complex in the valley began in earnest in August of 1702.[1] That summer, Kangxi stayed in Rehe for eighteen days, during which time he hosted a number of elites,

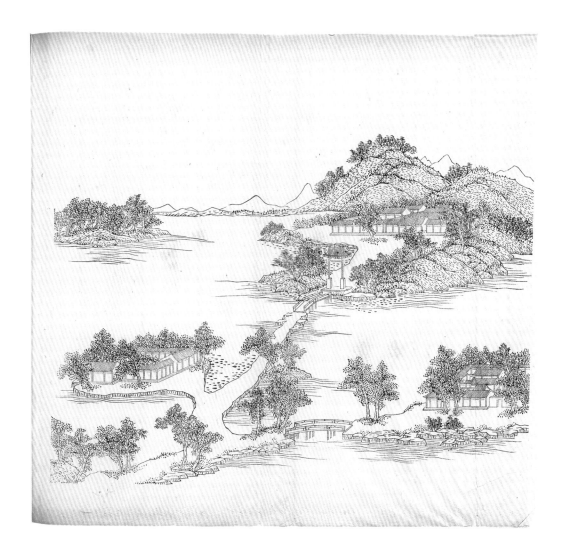

visited the surrounding countryside, and hunted.[2] Immediately following his departure from Rehe in late August, the emperor issued an edict to the Board of Works (Gongbu) directing surveyors to measure and stake out territory for a large complex. Officials also began to assemble workers and prepare materials, including recruiting corvée labor from Shandong and Zhili (roughly, modern Shandong and Hebei), harvesting wood from the Mulan Hunting Grounds (Mulan Weichang), identifying significant mountains and rocks at the site around which the complex would be designed, and constructing kilns.[3]

Beginning in early 1703, the Board of Works and the Imperial Household Department (Neiwufu) undertook these various assignments. Late that summer, Kangxi spent three days visiting the site, which was centered on a flood plain slightly north of Rehe Lower Camp (Rehe Xiaying), perhaps to inspect the planners' progress. The imperial landscape witnessed a considerable conceptual transformation that summer, even if the physical site remained relatively unaltered, as court documents assigned it a new name, Rehe Upper Camp (Rehe Shangying), which persisted throughout the first phase of development, until 1708.[4]

The focus during this period was on the central group of lakes and islands, the site of Kangxi's earliest public and private halls (map 1.1). Among the first tasks was dredging the original group of lakes and diverting a channel to feed the camp's water systems from the Wulie River, which entered the valley from the northeast and ran along the eastern side of the park. Earth excavated from the lakes formed the backbone of the area, the dyke known as *Lingzhi* Path on an Embankment to the Clouds (Zhijing Yundi; fig. 1.1) and the six central islands. The complex of buildings on the lakes' largest island, commonly known as Ruyi Island (Ruyizhou), including Un-Summerly Clear and Cool (Wushu Qingliang), Inviting the Breeze Lodge (Yanxun Shanguan), and Fragrant Waters and Beautiful Cliffs (Shuifang Yanxiu), comprised the first "palace" at Rehe.[5] As Zhang Yushu's description attests, their completion no later than 1708 permitted the emperor's first extended sojourn at Rehe that summer—forty-five days, as compared to seven to eighteen days in each of the previous five years.[6]

Beyond these several courtyards, determining precisely what architecture was erected during Kangxi's first phase of development, from 1703 to 1708, is more challenging. In his description of the park, Zhang Yushu names a series of buildings and other geographic features, including Pine Winds through Myriad Vales (Wanhe Songfeng), a compound just inside the main entrance to the park offering a commanding view north from atop a hill overlooking the park; the compounds of Ruyi, Encircling Jade (Huanbi), and Moonlight and the Sound of Rivers (Yuese Jiangsheng) Islands, which together formed the *lingzhi*-like landscape described by both Kangxi and Zhang; a cluster of halls and pavilions in the northeast

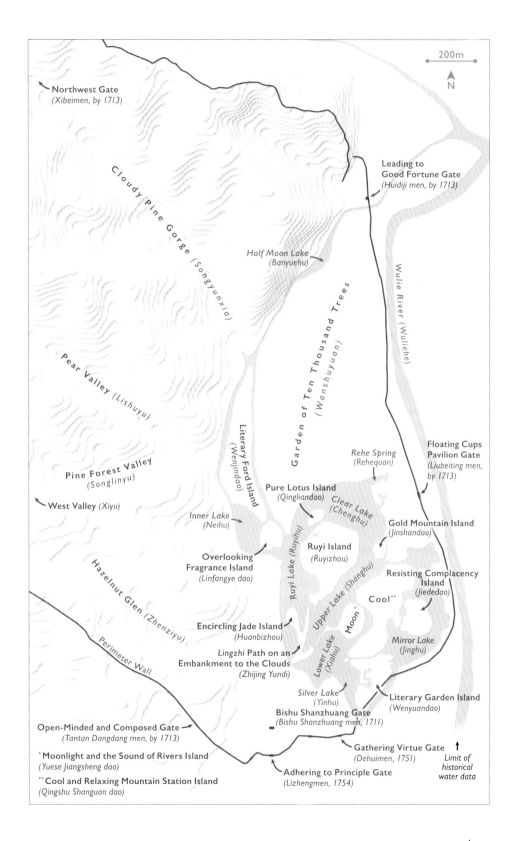

200m

N

Northwest Gate
(Xibeimen, by 1713)

Leading to
Good Fortune Gate
(Huidiji men, by 1713)

Cloudy Pine Gorge (Songyunxia)

Half Moon Lake
(Banyuehu)

Wulie River (Wuliehe)

Garden of Ten Thousand Trees (Wanshuyuan)

Pear Valley (Lishuyu)

Pine Forest Valley
(Songlinyu)

West Valley (Xiyu)

Literary Ford Island
(Wenjindao)

Rehe Spring
(Rehequan)

Floating Cups
Pavilion Gate
(Liubeiting men,
by 1713)

Pure Lotus Island
(Qingliandao)

Clear Lake
(Chenghu)

Inner Lake
(Neihu)

Gold Mountain Island
(Jinshandao)

Overlooking
Fragrance Island
(Linfangye dao)

Ruyi Lake (Ruyihu)

Ruyi Island
(Ruyizhou)

Resisting Complacency
Island
(Jiededao)

Hazelnut Glen (Zhenziyu)

Upper Lake (Shanghu)

Cool**

Encircling Jade Island
(Huanbizhou)

Moon

Mirror Lake
(Jinghu)

Lingzhi Path on an
Embankment to the Clouds
(Zhijing Yundi)

Lower Lake
(Xiahu)

Perimeter Wall

Silver Lake
(Yinhu)

Literary Garden Island
(Wenyuandao)

Open-Minded and Composed Gate
(Tantan Dangdang men, by 1713)

Bishu Shanzhuang Gate
(Bishu Shanzhuang men, 1711)

Gathering Virtue Gate
(Dehuimen, 1751)

Limit of
historical
water data

* Moonlight and the Sound of Rivers Island
(Yuese Jiangsheng dao)

** Cool and Relaxing Mountain Station Island
(Qingshu Shanguan dao)

Adhering to Principle Gate
(Lizhengmen, 1754)

corner of Ruyi Lake containing a lotus pond and a pavilion for drinking and composing poetry (*liubeiting*) known as Scent of Lotuses by a Winding Stream (Qushui Hexiang); and a number of pavilions and halls situated along the lake shores and in the nearby mountains.

Comparison with the more extensive list of architecture that is commonly attributed to this phase of development raises several interesting questions (map 1.2). Drawing on a combination of the Qianlong-era *Imperial Gazetteer of Rehe* and uncited sources, Shanzhuang scholar Chen Baosen ascribes the majority of Kangxi-era construction to 1703–1708, including those sites mentioned by Zhang Yushu, the island temple known as Gold Mountain (Jinshan), and a Buddhist temple on Ruyi Island, Forest of the Law Temple (Falinsi); several scenic compounds on the islands of Inner Lake (Neihu); Pear Blossoms Accompanied by the Moon (Lihua Banyue), a compound located a short distance up Pear Valley (Lishuyu) where the emperor's concubines lived when in Rehe; significant compounds at the north end of the park, one situated atop a cliff overlooking the Garden of Ten Thousand Trees (Wanshuyuan) and the other adjacent to the northeast sluice gate; a number of pavilions located deeper in the mountains; and various functional buildings scattered around the central lakes and the park's perimeter.[7] While no Kangxi-era sources survive that permit reliable, specific dating of these structures, chronological milestones such as Zhang Yushu's visit begin to give shape to the landscape in ways that allow reconstruction of both the site's early development and something of its design intentions.

Zhang Yushu's account of engagement with the park-palace speaks not only to the plan of the site in 1708 but also suggests ways in which movement and mobility are key to understanding its broader development under Kangxi. The itineraries traced by Zhang Yushu and his cohorts in 1708 followed established scenic routes to the northeast and northwest (*dongbei/xibei yilu shenggai*) of the park's central area (map 1.3). On neither occasion did the group stray far from the main lakes: on their first visit, the emperor and his guests remained entirely within the lakes; during the second, they walked as far north as the top of Inner Lake, entered only a short way into the mountains at Cloudy Pine Gorge (Songyunxia), and worked their way back south, passing the Temple of the Dragon King (Lingze Longwang-miao) along the way.

From both the perspective of a visitor's experience of the landscape and its overall scenic plan, the scope of the park in 1708 remained fairly limited and close to the main lakes, its architectural nodes linked by established itineraries or short side trips. Judging from the sites Zhang Yushu identified by name, his two routes traversed most of the architecturally developed portions of the park at the time. Of the "so-called Sixteen Scenes" (*suowei Shiliu Jing*) Zhang names, all were either on one of the two tour routes or

MAP 1.2
Architecture of the Rehe Traveling Palace described by Zhang Yushu ca. 1708, contrasted with other architecture known or believed to have existed at that time. Map by Daniel P. Huffman.

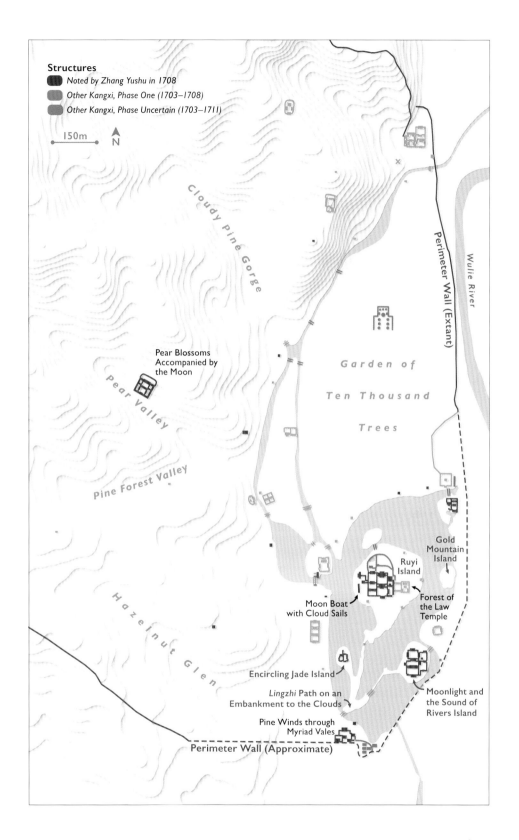

connected to them by short spurs of road or path. For instance, although the officials did not visit Southern Mountains Piled with Snow (Nanshan Jixue), it is only a short climb north of the entrance to Cloudy Pine Gorge (map 1.4). Similarly, Pear Blossoms Accompanied by the Moon and Sunset at Hammer Peak (Chuifeng Luozhao) are both just west and uphill from the route leading south from Cloudy Pine Gorge past the Temple of the Dragon King.

The logic of this itinerary-based link may be extended to those structures and compounds dated by Chen Baosen to this first period of development that do not appear in Zhang Yushu's narrative. A number of these lay well beyond the reach of the tours' routes but may be connected, through both design and experience, to the central zone. Continuing north past Southern Mountains Piled with Snow, one first descends into a saddle where the garden compound Verdant Isle of Green Maples (Qingfeng Lüyu) is nestled before climbing again to one of the park's highest points, the site of Northern Post Linking Paired Peaks (Beizhen Shuangfeng). It is clear that at least by 1712 and the production of *Imperial Poems*—in which all three appear—the trio was understood as a group strung along a single route, as the depiction of each includes one of the other two (see figs. 5.15, 5.18, and 6.16, left, respectively). Continuing past Northern Post Linking Paired Peaks leads to the small Temple to the Mother of the Dipper (Doumuge). Its presence on this itinerary suggests that Verdant Isle of Green Maples may in part have served as a place to rest along the rather arduous uphill journey to the park's very northern end. Similarly, Clouds and Peaks on All Sides (Simian Yunshan), the westernmost structure built within the park walls during the Kangxi period, lies above Pear Blossoms Accompanied by the Moon and the Temple of the Dragon King at the top of Pear Valley.

Although well beyond Zhang Yushu's perambulations, both in terms of distance and physical effort, these more distant sites are connected to the park's scenic core through the lived experience not of the garden's outside visitors but of its regular residents. Put differently, Verdant Isle of Green Maples, Temple to the Mother of the Dipper, Pear Blossoms Accompanied by the Moon, and Clouds and Peaks on All Sides all lie on established itineraries for experiencing the park similar to those traveled by Zhang's cohorts of officials, yet reserved for the emperor and his household. Understanding these structures as linked by design features (a path) and experience (an itinerary) suggests first that they may all date to the same or similar periods, a notion borne out by later phases of construction in which Qianlong developed particular sections of the mountains along circuits. More significant, perhaps, it describes an overall plan for the site that may be conceived of as divided into inner and outer, or public and

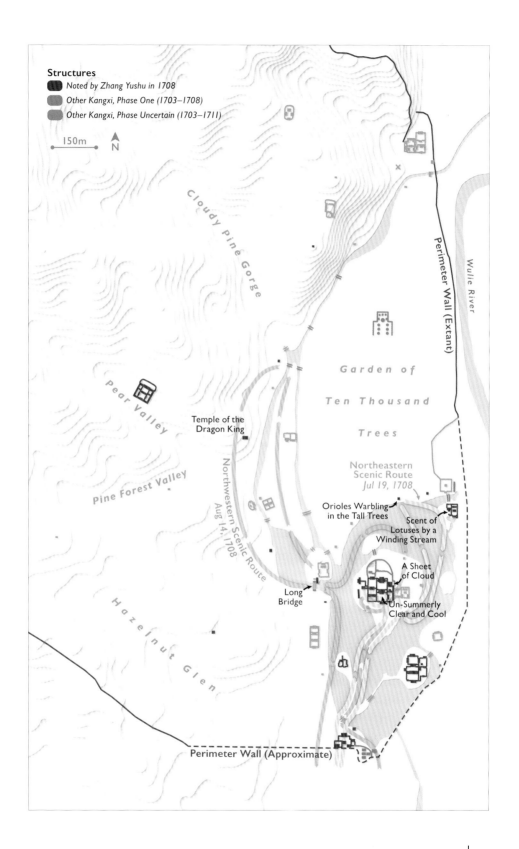

private, defined in part by topography and proximity to the center but also by access and degrees of familiarity or intimacy with the throne.

Another means for distinguishing inner and outer is found in the naming and appreciation of certain areas of the park, such as the cluster of gates, pavilions, and halls at the park's northeast corner, where the diverted Wulie River enters the precincts. Turning east from Northern Post Linking Paired Peaks, rather than northwest to the Temple to the Mother of the Dipper, leads one down a steep path to the northern extent of the park's plain where it meets the mountains; the area could also be reached through the Garden of Ten Thousand Trees or by boat up the narrow waterways running along the western edge of the valley floor. The scenic draw of this area was the sound and sight of the water as it passed through a sluice and into the park's lake system.[8] A hall stands atop the water gate, while a small pavilion sits beside the inlet (see fig. 6.20, right). Both offer views of not only the water but also a cliff opposite into which the characters *quanyuan shibi* 泉源石 壁 ("Cliff at the Spring's Source") are carved in the emperor's calligraphy (see fig. 6.20, left). On the north side of the inlet stream, opposite the pavilion, is a larger compound that may have included a library and halls for relaxation.[9] In 1708, however, the scenic qualities of this area were not formally recognized within the park's naming: Warm Currents and Balmy Ripples (Nuanliu Xuanbo), the name eventually applied to the hall atop the northern water gate, is connected (in Zhang Yushu's account) to the small sluice gate in the northeast corner of Ruyi Lake that controlled the flow of Rehe Spring into the main lakes.[10] Nor does Zhang mention either the monumental example of the emperor's calligraphy nor the pavilion from which one would view it—the entire northern group lay outside the scope of a visitor's experience in 1708.[11]

Like the itineraries that connected certain structures physically to the center, naming and scenic appreciation help to define a public center and private periphery. The shift in names and the incorporation of the northern zone into the public program of scenic sites through *Imperial Poems* may indicate a later date of construction for this group. At the same time, it may also reflect their existence in an outer, private zone that lay beyond the visitor's experience. Such divisions between inner and outer, and public and private, are central to domestic and imperial architecture, including homes, palaces, and city plans. In both the court and the capital, however, "inner" typically correlates to private and "outer" to public; in Rehe this formulation is reversed. Instead, in all cases "public" space is encountered first, while "private" zones lay architecturally or topographically beyond the center.

Outside shifts in naming, the most notable disjunction between Zhang Yushu's account and the more conventional dating of early architecture at the Mountain Estate occurs with one of the park's most iconic sites,

MAP 1.4
Visualizing public and private zones in the design and use of the Mountain Estate to Escape the Heat, ca. 1708. Map by Daniel P. Huffman.

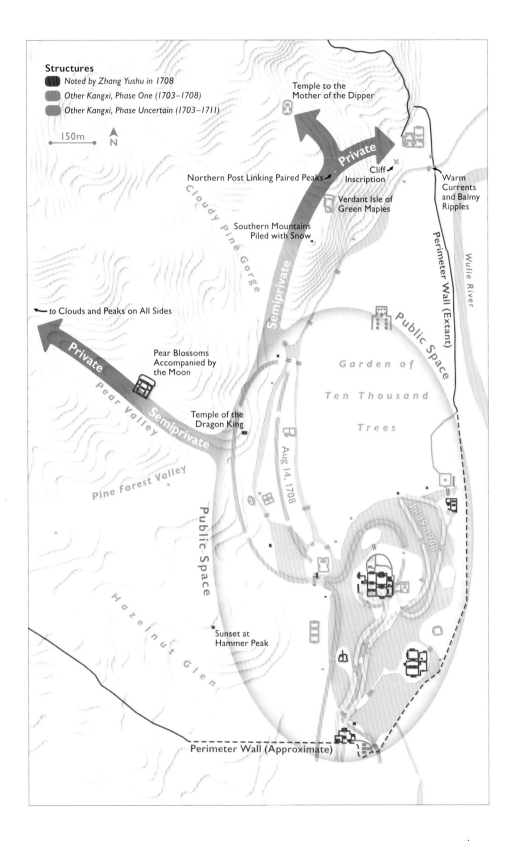

**Structures**

- Noted by Zhang Yushu in 1708
- Other Kangxi, Phase One (1703–1708)
- Other Kangxi, Phase Uncertain (1703–1711)

150m

N

Temple to the
Mother of the Dipper

_Private_

Cliff
Inscription

Northern Post Linking Paired Peaks

Warm
Currents
and Balmy
Ripples

Verdant Isle of
Green Maples

Cloudy Pine Gorge

Perimeter Wall (Extant)

Wulie River

Southern Mountains
Piled with Snow

_Semiprivate_

_to Clouds and Peaks on All Sides_

Public Space

_Private_

Garden of

Pear Blossoms
Accompanied by
the Moon

Pear Valley

_Semiprivate_

Ten Thousand

Aug 14, 1708

Temple of the
Dragon King

Trees

Pine Forest Valley

Jul 19, 1708

Public Space

Hazelnut Glen

Sunset at
Hammer Peak

Perimeter Wall (Approximate)

29

the island temple of Gold Mountain. Featuring a three-story tower, the Pavilion of the Supreme God (Shangdige), atop a small artificial mountain (fig. 1.2), Gold Mountain was easily the most visible site in the Kangxi-era garden and perhaps the most dramatic. The complex re-created a syncretic island temple in the Yangzi River outside Nanjing (fig. 1.3), one of the "Three Mountains at the Entrance to the Capital" (Jingkou Sanshan).[12] The Gold Mountain complex plays an important role in various imaginings of the site, particularly in Kangxi's *Imperial Poems*, where it features twice: scene 18, "The Entire Sky Is Exuberant" (Tianyu Xianchang), and scene 32, "Clouds and Peaks in the Mirroring Water" (Jingshui Yuncen). In "The Entire Sky Is Exuberant," Kangxi writes as if at the top of the Pavilion of the Supreme God. From there, standing "near the boundary of heaven, he gains a panoramic, 'grand view' (*daguan*) of the entire Mountain Estate and observes with satisfaction that the world is in a perfect state of animation."[13]

Chen Baosen dates Gold Mountain to 1703, and the temple would have been on the route taken by Zhang Yushu and his fellow officials following their banquet; the visitors would certainly have passed it on their return from the floating cups pavilion, if not before. Yet Zhang makes no mention

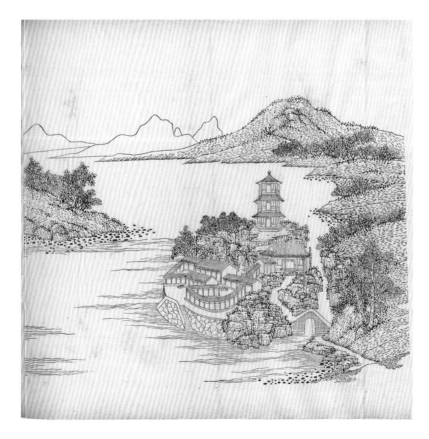

FIGURE 1.2
Shen Yu et al., "The Entire Sky Is Exuberant," 1713, from Kangxi et al., *Imperial Poems*, scene 18. Woodblock print. Chinese Collection, Harvard-Yenching Library, © President and Fellows of Harvard College. The three-story Pavilion of the Supreme God stands at the summit of Gold Mountain Island.

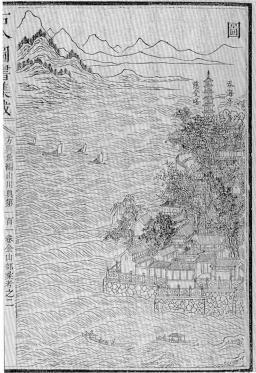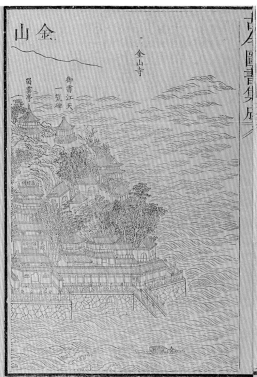

FIGURE 1.3
"Gold Mountain," from
*Imperially Endorsed
Complete Collection of
Images and Writings from
Antiquity to the Present*,
1700–1726. Woodblock
print. Chinese Collection,
Harvard-Yenching Library,
© President and Fellows of
Harvard College.

of it, a fact that is particularly surprising given that his hometown of Dantu, Jiangsu, lies roughly 10 kilometers from the original Jinshan temple upon which the emperor's was modeled.[14] It seems unlikely that this otherwise meticulous observer of the Rehe landscape would fail to note such a striking piece of architecture so closely tied to his native place. This strongly suggests that the Jinshan complex belongs to the second phase of Kangxi development between 1709 and 1711.

Together, these accounts make it possible to propose a new layout for the Mountain Estate circa 1708, at the conclusion of the first phase of building at the park (map 1.5). What emerges is a comparatively modest architectural plan focused on the park's most experientially striking areas—the central lakes, foothills of the mountains, and select elevated vantages offering views down into the Wulie valley and across the undulating mountains to the east. The patterns of development and naming during this period can perhaps be best understood by recognizing a division in the park's access and usage between inner and outer, or public and private, realms.[15] The inner circuits, which surround the central lakes and are roughly described in Zhang Yushu's accounts, offered elite visitors access to specific spaces associated with the emperor, including both official and private quarters, as well as select scenic spots nearby. Beyond this inner circuit, however,

was a landscape that appears to have been reserved for use by the emperor and his household. Some of these sites, such as those on the secondary islands of the central lakes, could be seen but perhaps not visited by guests; others lay out of sight but were nonetheless linked to the center by paths and itineraries. A number of these outer sites were also not part of the early commemorated scenery of the park, Zhang Yushu's "so-called Sixteen Scenes." Yet all this would change with the completion of construction within the Mountain Estate's walls in 1711 and the publication of *Imperial Poems* the following year. The private now became public through print, as the Sixteen Scenes expanded to thirty-six and no portion of the developed park lay clearly beyond the bounds of its printed experiences.

MAP 1.5
Architectural development at Rehe Upper Camp (subsequently Rehe Traveling Palace), 1703–1708. Map by Daniel P. Huffman.

## Lenticular Landscapes

Beginning in 1709, the imperial landscape at Rehe underwent a second major phase of development, which culminated in 1711 with the hanging of a gilt-bronze plaque above the newly constructed main gate of the park-palace. Displaying four characters in Kangxi's calligraphy, it bore the site's formal name: 避暑山莊 (Bishu Shanzhuang).[16] In addition to the halls and tower of Gold Mountain Island, this period brought two major architectural transformations to the landscape of the Mountain Estate. The first was the expansion of the park to the southeast and the dredging of two new "lakes"—Silver (Yinhu) and Mirror (Jinghu) Lakes—while the second was the construction of a far more substantial series of palace halls, the Palace of Righteousness (Zhenggong), to the south of the site's original entrance. These changes necessitated the expansion of the perimeter wall to the southeast as well, one of the last sections of the entire wall to be completed circa 1713 (map 1.6).

The momentous transition of 1711 was also marked by the composition of the emperor's "Record of the Mountain Estate to Escape the Heat," a text that circulated in various manuscript versions while also serving as the preface for *Imperial Poems on the Mountain Estate to Escape the Heat* in 1713. The publication of the *Imperial Poems'* thirty-six scenes in one sense altered the division between inner and outer that characterized the site's first phase, as the entire park's scenic itinerary became accessible to the virtual visitor, if not the emperor's actual guests. Along with the inscriptions affixed to the buildings themselves, the emperor's published texts describing the site extended the accessible landscape into new media, constructing meaning for its audiences through the interplay between its different forms. The architectural expansion of the site in the second phase capitalized on this interplay by focusing on sensory experience, physical movement, and visitors' imaginations to extend the landscape beyond its immediate physical and temporal bounds. The architectural means for

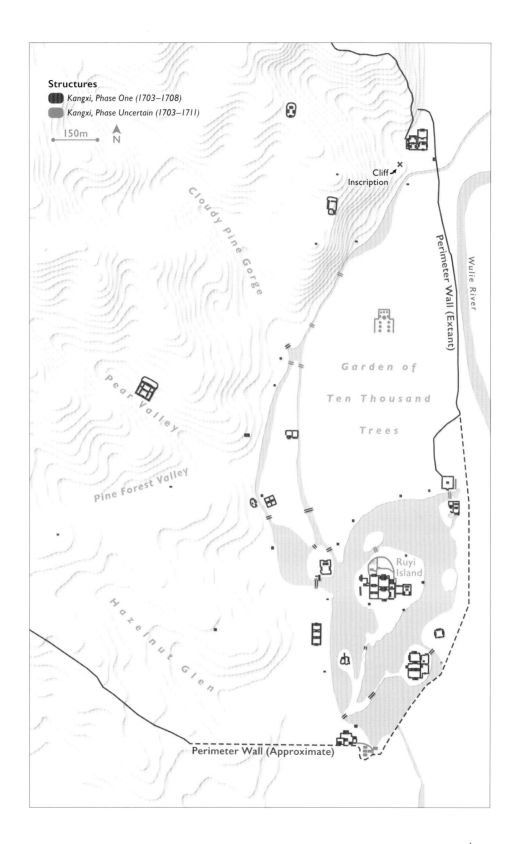

**Structures**

▓ Kangxi, Phase One (1703–1708)
▓ Kangxi, Phase Uncertain (1703–1711)

150m

N

Cloudy Pine Gorge

Cliff
Inscription

Perimeter Wall (Extant)

Wulie River

Pear Valley

Garden of

Ten Thousand

Trees

Pine Forest Valley

Ruyi
Island

Hazelnut Glen

Perimeter Wall (Approximate)

these perceptual inversions, including "borrowed views" (*jiejing*) and textual para-landscapes, were well-established in garden design. Yet their particular expression and effect at the Mountain Estate was shaped by the radically greater scale of the site compared with other premodern Chinese gardens, as well as by the transcendent imperial authority such scale reflected.

Symbolically as well as practically, the most significant addition to the park's architecture during this period was the Palace of Righteousness, which replaced the buildings on Ruyi Island as the formal halls of state and imperial residence (fig. 1.4).[17] The construction of a formal palace in Rehe signals the degree to which the Mountain Estate effectively served as the imperial seat of government during the emperor's time on tour.[18] It also underlined Confucian modes of governance as a substantial element within Kangxi's vision of the site, its regular arrangement and halls of reception

MAP 1.6
Architectural development of the southeast section of the Mountain Estate to Escape the Heat, ca. 1708 and ca. 1713. Map by Daniel P. Huffman.

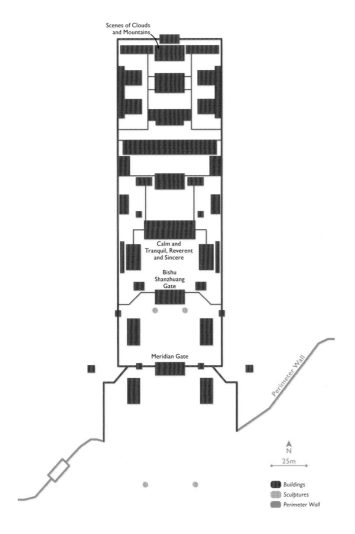

FIGURE 1.4
Plan of the Palace of Righteousness, ca. 1709–1711. Drawing by Pen Sereypagna and Daniel P. Huffman.

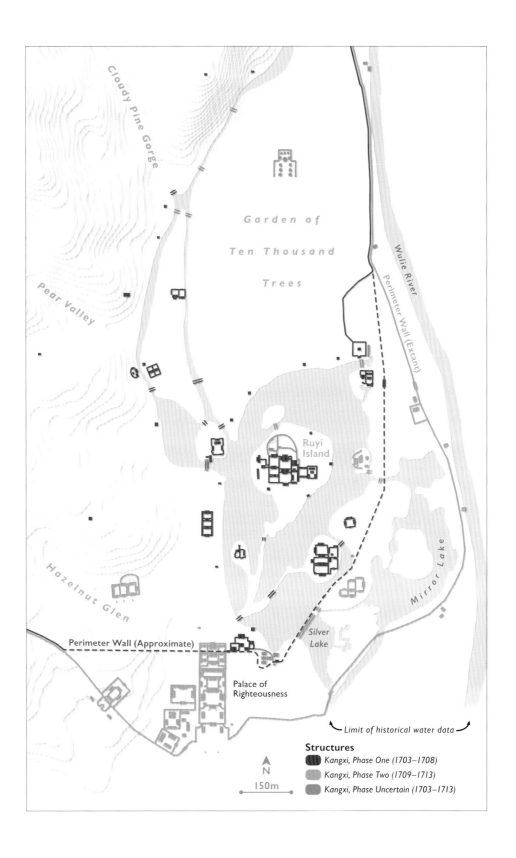

Cloudy Pine Gorge

Garden of

Ten Thousand

Trees

Wulie River

Perimeter Wall (Extant)

Pear Valley

Ruyi
Island

Hazelnut Glen

Mirror Lake

Silver
Lake

Perimeter Wall (Approximate)

Palace of
Righteousness

Limit of historical water data

N

150m

**Structures**
Kangxi, Phase One (1703–1708)
Kangxi, Phase Two (1709–1713)
Kangxi, Phase Uncertain (1703–1713)

offering a clear counterpoint to the less rigidly structured landscape and activities that characterized touring the "rear garden" (*houyuan*).

The addition of an axial palace was unique among the mature imperial gardens of the Qing, such as the Garden of Perfect Brightness (Yuanming-yuan) or Pure Ripple Garden (Qingyiyuan; later Nourishing Harmony Garden, or Yiheyuan). It may have been characteristic of Kangxi's early constructions, however, specifically the Garden of Joyful Spring (Chang-chunyuan) in suburban Beijing (fig. 1.5). Like the Mountain Estate, the plan of the Garden of Joyful Spring centered on a series of interconnected lakes and interspersed islands. The palace, oriented north to south, led to a central island on which a further group of axially oriented buildings stood. Although the Palace of Righteousness had not yet been constructed when Zhang Yushu visited in 1708, his reference to the park as the "rear garden"— "rear" in relation to the front palace—refers to this well-established design for imperial gardens.[19]

In plan and structure Kangxi's Palace of Righteousness resembled a large mansion as much as it did either of the major Qing imperial palaces in Shengjing or Beijing. While Shengjing employed a tripartite division— with Banner, court, and residential divisions roughly side by side—the Mountain Estate's strict axiality more closely resembled that of the For-bidden City. It opened with a succession of gated forecourts leading to a series of official, semipublic halls and ultimately the imperial residence at the rear. Yet the Palace of Righteousness did not embody the same ritual organization or emphasis that characterizes the Beijing and Shengjing com-plexes. It comprised a single axis in which each courtyard progressed to the next, rather than the multiple lines of often nested courtyards found in the more elaborate palaces. The buildings themselves were similarly modest by comparison. The newly constructed throne room—Calm and Tranquil, Reverent and Sincere (Danbo Jingcheng), though grander than Un-Summerly Clear and Cool—was of an entirely different nature to its counterparts in Shenyang and Beijing, having neither their scale nor their lacquer and brightly glazed tiles.[20] Formulated by the emperor as a matter of imperial modesty and economy appropriate to a ruler concerned first and foremost with his people, the relatively reduced scale of the Palace of Righteousness also served to create a less formal environment.[21] Absent or reduced were the immediate visual and material cues of imperial maj-esty recognizable to courtiers, kinsmen, and others familiar with the more imposing palaces of the capitals.[22]

The mansion-like qualities of the Palace of Righteousness were rein-forced by its relationship with the landscape beyond its walls. As in Beijing, the rear of the Rehe palace incorporated a small garden. Rather than being self-contained as with the Forbidden City's gardens, however, which were isolated from the city beyond the palace walls, the garden of the Palace of

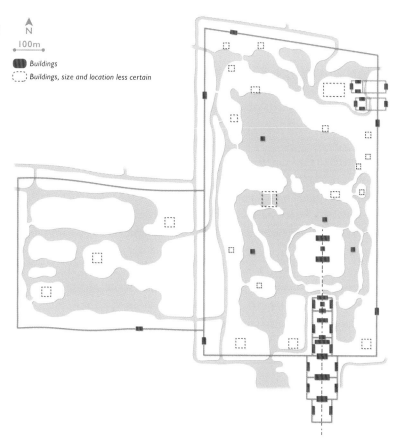

FIGURE 1.5
Plan of the Garden of Joyful
Spring (early eighteenth
century). Drawing by Pen
Sereypagna, after Wang
Juyuan, *Zhongguo gudai
yuanlin shi*, I:425, fig. 9-42.

N
100m
◼◼ Buildings
⬚ Buildings, size and location less certain

Righteousness incorporated a two-story hall, Scenes of Clouds and Mountains (Yunshan Shengdi; fig. 1.6, right). This offered a view out onto the park itself, connecting residence and garden in a manner akin to a private mansion. Ascending to the hall's upper gallery by means of an artificial rockery set in the garden's courtyard, the visitor gained an elevated vantage point looking north. Coupled with the sharp drop in elevation from rear of the palace to the lakes and valley floor, this view gave a sense that "the forested peaks and misty waters stretch without end," the world transformed into a "garden of a myriad acres."[23]

Such a manipulation of depth and space, in which the intervening foreground or middle ground is visually elided in order to join the viewer's own space and the distance into a single landscape, is an effect frequently employed in smaller garden spaces. In particular, it underpins the perspectival disjunction of the "borrowed view," in which the garden environment incorporates scenery from beyond its walls into a single sensory realm. Given the scale of the Rehe park-palace, however, seen from the heights of the site's southern promontory, the reality of the Mountain Estate as both bounded space and imperial precinct was momentarily suspended, the

material and conceptual distinctions between garden and the world beyond elided, and the landscape lenticularly augmented to appear as the world itself. Rhetorically framing the space outside the Palace of Righteousness as the limitless world, instead of a delimited garden, had the inverse effect on the palace itself, as its relative smallness and function as portal onto something much larger became highlighted by comparison.

The expansion of the lakes that occurred during this same period similarly reflects ways in which the manipulation of movement and perception were integral to the intended experience of the Mountain Estate. Although true of many Chinese gardens, the tension in design and construction between the natural topography and human intervention is arguably greater at the Mountain Estate than in other, particularly riverine, garden contexts. Water was an abundant and readily available building element in low-lying Jiangnan gardens, which were often situated on islands or near the banks of the region's honeycomb-like delta of lakes and rivers. Naturally flowing water was typically diverted to feed the lake systems of private gardens, channeled in and back out again via sluice gates, ensuring that the water within the garden remained fresh and suitable for plants and fish. This basic technique was also used at the Mountain Estate, but it was only the start of a much more elaborate and carefully engineered system that ensured flowing water for both practical and aesthetic purposes throughout the park-palace's grounds.

The primary water system of the park-palace consists of a series of artificially constructed lakes dredged on the western edge of the valley's flood plain (see map 1.1). Fed by diverting the Wulie River through a sluice at the northeastern corner of the park, the current first flows south-southwest along the foot of the western mountains in a channel linking two small bodies of water.[24] To the north is what is now known as Half Moon Lake (Banyuehu), over which rises the imperially inscribed cliff marking the source of the park's waters. Further south, the stream divides to accommodate two islands and create Inner Lake, which Zhang Yushu crossed via the "Long Bridge." Below Inner Lake's second, smaller island, the waterway opens up into a large, round lake. In reality this is a single body of water separated by design and nomenclature into four areas; proceeding clockwise from the southwest, they include Ruyi Lake (Ruyihu), Clear Lake (Chenghu), Upper Lake (Shanghu), and Lower Lake (Xiahu).[25]

At the time of Zhang Yushu's visit to the park in 1708, this represented the extent of the site's central water system. A sluice gate in the park's southeastern corner served as the primary point of controlled drainage from the park (see map 1.6). This off-flow rejoined the Wulie River just southeast of the site, as it does today. From 1709 the site was expanded to encompass what are now Mirror and Silver Lakes. Although the reason for this expansion is not documented, it may have been grounded in hydro-

FIGURE 1.6
Shen Yu et al., "Scenes of Clouds and Mountains," 1713, from Kangxi et al., *Imperial Poems*, scene 8. Woodblock print. Chinese Collection, Harvard-Yenching Library, © President and Fellows of Harvard College.

logical as much as aesthetic concerns. The park's topography is such that water from the mountains and the northern plain, as well as from the lakes, flows to the southeast. This newly incorporated land thus sat between the original lakes and the Wulie River at the bottom of a large drainage area. As a result, Mirror and Silver Lakes may have originally been a practical concession to a swampy reality, a hypothesis further supported by the near absence of Kangxi-era architecture in this zone.

The lakes provided not only scenery and the opportunity for recreation, such as fishing and boating, but also a complement to the routes and itineraries found on land (map 1.7). The main and southeastern lakes are all navigable, and there was at least one boathouse on the central lakes during the Kangxi period, located on the small island at the mouth of Inner Lake.[26] A second boathouse located to the northeast near Rehe Spring may date

to this period as well.[27] In his *View of Rehe* (see fig. 4.1), Leng Mei depicts several boats tied at Ruyi Lake Pavilion, near the footbridge leading to the central islands. Moreover, based both on pictorial and physical evidence, numerous waterside pavilions and compounds had some provision for visiting via boat. Among the clearest are those on Gold Mountain Island, which could be approached by water from both the west, where a two-sided stair is built into the island's retaining wall (see fig. 1.2), and the north, where a small pavilion-covered pier extends. Similarly, the plan of Moonlight and the Sound of Rivers is properly oriented for an approach from the water, as the south-facing main gate directly faces a small landing; the now more familiar footbridge and path connecting the island to the main branch of the central embankment leads the visitor to the compound from an oblique angle. Waterside pavilions also doubled as landings, as is apparent at both Clear Ripples with Layers of Greenery (Chengbo Diecui) and Cherishing Munificence Pavilion (Hanrunting) on the north and southeast shores of Ruyi Island.[28] Other more modest landings, consisting of several flat rocks

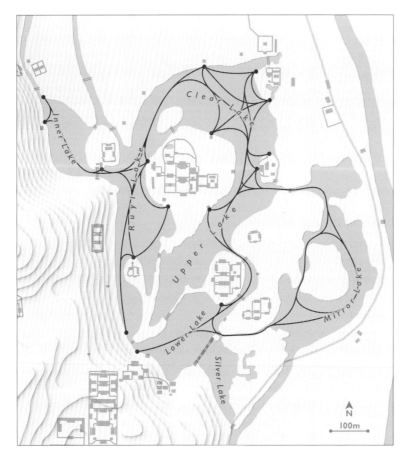

MAP 1.7
Visualization of possible water routes during the Kangxi period (ca. 1703–1722). Map by Daniel P. Huffman.

FIGURE 1.7
Waterway connecting
Lower and Mirror Lakes.
The steps on the left are a
small boat landing. Photo
by the author.

arranged at the water's edge, further extended the accessibility of the park from the water (fig. 1.7).[29]

Recognizing this water-oriented infrastructure renders the substantial potential for movement, travel, and vision by or from boats within the central area of the Mountain Estate apparent. In Zhang Yushu's narrative of his visits, he clearly describes this expanded field. During his first tour the assembled guests traveled by water several times (see map 1.3). Following their banquet in the imperial theater, A Sheet of Cloud (Yipianyun), they boarded boats from a nearby landing and rowed to a point on the lake's north shore shaded by a stand of mature trees, perhaps Orioles Warbling in the Tall Trees (Yingzhuan Qiaomu). After another short row, the group alighted near the Rehe hot spring, before boarding once more for a trip along the lake's edge and back to their original embarkation point. On this first visit the boat trips themselves were, in Zhang's description, primarily functional, intended to transport guests from one scenic spot to the next in the most direct manner possible. By contrast, on the occasion of Zhang's second visit, when the guests again boarded boats after their midday meal, travel by water granted access to a scenic experience unattainable from the shore. Leaving once more from Ruyi Island, the group floated past the northwestern boathouse toward the "Long Bridge." As the boats drifted

among the lotuses across separate portions of Inner and Ruyi Lakes, separated by an embankment, it appeared to Zhang as though they were a single group reflected in a mirror ("Pair of Lakes like Flanking Mirrors" [Shuanghu Jiajing]; see fig. 6.17, right). Here, boats functioned not just as a means for transport but also as a medium for engaging with landscape features and scenic experiences specifically designed to be appreciated from water level.

Recognizing the significance of being on and moving across the water to the design of the Mountain Estate augments, even inverts, the conventional framing of the landscape found in familiar sources. The beauties of water—its sound, its light, the fragrance and appearance of its flowers—figure prominently in both the emperor's *Imperial Poems* and Leng Mei's *View of Rehe*; they are presented, however, as experiences to be enjoyed largely from land. In many cases the architecture and landscape have been designed to elide the distinction between land and water, just as the view from Scenes of Clouds and Mountains merged the palace garden with the broader landscape. Pavilions that sit at water's edge, sometimes even extending out into the lake, offer a sense of floating on the water, as do those set on small islands. Moon Boat with Cloud Sails (Yunfan Yuefang; see fig. 6.14, right), a hall intended to look like a boat, sat directly on the eastern shore of Ruyi Island; looking out from its second-story gallery was intended to cause those inside to feel as though they were floating on the water.[30]

Beyond these perceptual tricks, the design of the landscape, the orientation of architecture, and the profusion of landings suggests how often boats were likely used by the park-palace's occupants and visitors. Not just a matter of practicality, they ought to be understood as integral to the illusion that the lakes sought to create. While in even the largest of private urban gardens a boat would have essentially served as a folly, at the Mountain Estate the scale of the landscape meant that its lakes lay somewhere between a private pond and a scenic site such as Hangzhou's West Lake, to which Zhang Yushu directly compared it. Extensive literature attests that travel by boat was central to the lives of the Southern elite, and many garden paintings clearly indicate riverside entrances.[31] The pleasures of boating, particularly on West Lake, are equally well described; a number of the Ten Scenes of West Lake, including "Autumn Moon over a Calm Lake" (Pinghu Qiuyue; see fig. 6.24), are centered on the experience of water.

Boating on the park's central lakes extends the lenticular illusion of the landscape, moving between enclosed, discrete space and a world without walls. Being on the water alters the visual experience of the landscape in ways that are exploited in the design of the Mountain Estate. Sitting in a small boat dictates a lowered point of view relative to that experienced while ambulatory, both because one is seated as opposed to standing and

because the level of the water is lower than that of the surrounding land. The illusion of looking in a mirror described by Zhang Yushu resulted from this vantage: not only was each group looking across a divide at the other, but they were relatively cut off from the world outside their immediate surroundings. This sense of isolation could also be used to create worlds within the park. When traversing the narrow waterways dividing one lake from another, as between Lower and Mirror Lakes (see fig. 1.7), the comparatively high ground and confined space through which the boat passes helps engender a sense of transition. This feeling of having passed into another realm is reinforced by the trees and hills of the intervening islands dividing the two lakes from one another, which from the water block any sensory connection between the spaces.

Like the interplay between garden and the broader world, here too the water helps extend the visitor's experience of their surroundings. Imaginative leaps between the space of the garden and that of another environment are common in Chinese garden design, requiring only that the visitor suspends awareness of their actual position. Such effects are often achieved through the spatial limitations of the enclosed urban site, so that artificial rockeries appear as towering mountains and small ponds as great seas, for example. In the Mountain Estate, however, limitations of scale are not generally available as vehicles for conceptual flights, as the expansive environment, so celebrated by Zhang Yushu and others, deprives the garden designer of the constrained spaces characteristic of smaller gardens. Instead, by invoking movement through larger landscapes and altering the visitor's point of view, boating on the lakes triggers these perceptual plays, thus compelling different bodily and visual experiences of the landscape than those enjoyed from land.

## Engineering Nature

Although the Mountain Estate's most visible hydrological engineering lies on the valley floor, evidence of planning and intervention in the mountainous western portion of the park is also quite extensive. Beyond the natural accumulation of water from springs, rain, and seasonal runoff (map 1.8), stone-lined channels, artificial reservoirs, and other architectural accommodations to water bespeak the regular presence of more reliable and substantial flows as well as their engineered control for particular effects (map 1.9). The controlled flow of water not only contributed to focused scenic effects but also forged imaginative connections within and beyond the park's precincts to extend the landscape's design and experience beyond its strict physical parameters.

The plan of the western mountains' hydrology is now largely lost to architectural decay and arboreal regrowth, yet the design, naming, and

position of certain buildings and compounds helps reconstruct both its layout and its intended function in shaping experience of the landscape. For instance, several buildings situated above and along Hazelnut Glen (Zhenziyu) illustrate the careful control and supplementation of water that would have naturally descended the valley. Sitting atop the ridge where Hazelnut Glen and Pine Forest Valley (Songlinyu) meet, Source of the Waterfall Pavilion (Puyuanting) offers an expansive view east. Its eponymous "waterfall" coursed down Hazelnut Glen and past a pair of adjacent compounds, Sonorous Pines and Cranes (Songhe Qingyue; fig. 1.8), the residence Kangxi constructed for his mother, and Clear Sounds of a Spring in the Breeze (Fengquan Qingting).[32] The stream then continued downhill, passing Looking Out upon Deer Pavilion (Wangluting) before feeding eventually into Ruyi Lake. A number of decades later, Qianlong further exploited the stream's scenic qualities by constructing Jade Peak Temple (Bifengsi, 1764) astride it. The rear or upslope entrance to the temple, which takes the form of a large tower, is a water gate that channels

MAP 1.9
Examples of sites incorporating water as a scenic and architectural element at the Mountain Estate to Escape the Heat. Map by Daniel P. Huffman.

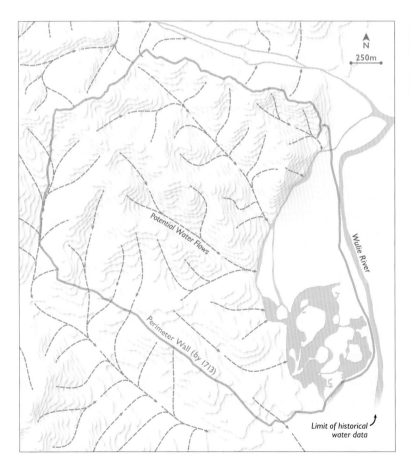

MAP 1.8
Major potential water flows in the western mountains of the Mountain Estate to Escape the Heat. Map by Daniel P. Huffman.

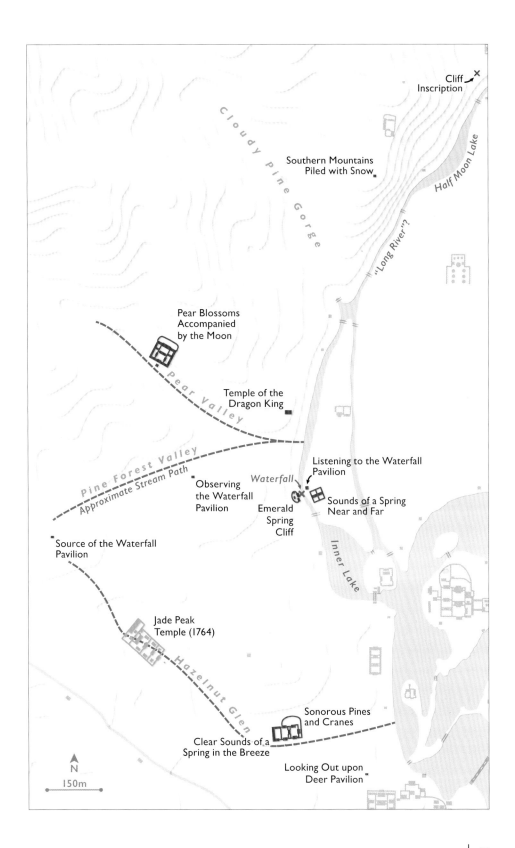

Cliff
Inscription ✗

Cloudy Pine Gorge

Half Moon Lake

Southern Mountains
Piled with Snow ▪

"Long River"?

Pear Blossoms
Accompanied
by the Moon

Pear Valley

Temple of the
Dragon King ▪

Pine Forest Valley

Approximate Stream Path

Observing
the Waterfall
Pavilion

Waterfall

Listening to the Waterfall
Pavilion

Sounds of a Spring
Near and Far

Emerald
Spring
Cliff

Source of the Waterfall
Pavilion

Inner Lake

Jade Peak
Temple (1764)

Hazelnut Glen

Sonorous Pines
and Cranes

Clear Sounds of a
Spring in the Breeze

Looking Out upon
Deer Pavilion ▪

▲
N
150m

the stream inside the compound where it winds through the landscaped grounds before exiting near the main gate.

While these watercourses would naturally have captured runoff from both rain and snowmelt, such sources would have been insufficient for any sustained flow. Largely forgotten today, springs were an important source of flowing water in the Mountain Estate, evidenced in part by the numerous poems that make reference to them.[33] One example appears to have formed the carefully engineered waterfall located near the top of Inner Lake. Now dry, it flowed from within an artificial rockery built into the face of a low bluff to create the appearance of a craggy cliff, atop which sits a small Buddhist temple, Emerald Spring Cliff (Yongcuiyan). Although presumably constituting the waterfall's primary source, this spring was supplemented by water gathered from the slope immediately above Emerald Spring Cliff. Evidence of a streambed and sluice gate at the rear of the

FIGURE 1.8
Shen Yu et al., "Sonorous Pines and Cranes," 1713, from Kangxi et al., *Imperial Poems*, scene 7. Woodblock print. Chinese Collection, Harvard-Yenching Library, © President and Fellows of Harvard College. Looking Out upon Deer Pavilion appears at the right edge of the composition.

FIGURE 1.9
Shen Yu et al., "Sounds of a
Spring Near and Far," 1713,
from Kangxi et al., *Imperial
Poems*, scene 25. Woodblock
print. Chinese Collection,
Harvard-Yenching Library,
© President and Fellows of
Harvard College.

temple suggests an underground system channeling the flow from the hill
behind the temple underneath the compound to openings in the rockery.
The scene was designed to be viewed primarily from below and across
the upper branch of Inner Lake, which passes by the cliff's base. There,
two structures—Sounds of a Spring Near and Far (Yuanjin Quansheng;
fig. 1.9) and a small island pavilion, Listening to the Waterfall Pavilion
(Tingputing)—emphasize not only the site's aural qualities but also the
water's supposed origins within the cliff.[34]

Not all parts of the network relied on such a presumably consistent
water source as a spring, however. Archival documents also point to a num-
ber of artificial reservoirs constructed at strategic points that would have
collected larger volumes of water.[35] Such a system suggests that at least

portions of the water system were not in constant flow, but rather that some scenes designed around water were actuated on command through controlled releases. This would allow the landscape to be fully realized whenever the emperor happened to be visiting a particular compound, while conserving water when sites were unoccupied.

The complexity of these systems is apparent not only from the architectural plan that reveals them but also from evidence of their failings. In one of the few documents to survive from the Kangxi era dealing with design and maintenance at the Mountain Estate, a lengthy memorial from late April 1718 describes the Imperial Household Department's extensive efforts to combat the silting up of the system.[36] A number of points proved particularly problematic, including the mouth of Cloudy Pine Gorge; four reservoirs in Pine Forest Valley; the area beneath Kangxi's cliff inscription; Pear Blossoms Accompanied by the Moon, in front of which flowed a stream that also fed a small pond in the compound's main courtyard; the northern channel of Cloud Falls (Yunpu), a name no longer extant at the site but which may refer to a large waterfall just north of Cloudy Pine Gorge that appears in Leng Mei's *View of Rehe* (see fig. 4.1); the "long river," most likely the waterway between Half Moon Lake and the entrance to Cloudy Pine Gorge; the river below the Temple of the Dragon King, a stretch of waterway just below Cloudy Pine Gorge that connects to Inner Lake; fourteen drainage gates along the western portion of the park-palace wall; the outer sluice gate at the northeastern entry to the site; and twelve different points in the water system feeding the floating cups pavilion, Scent of Lotuses by a Winding Stream. Moreover, there were problems with flooding along the road that led down Cloudy Pine Gorge from the park's northwestern gate.

Too little of the original hydrologic system survives to utilize this information meaningfully from an engineering perspective; some of the sites can no longer be specifically identified, and repeated filling and redredging of various parts of the rivers and lakes have fundamentally altered those structures. Yet the variety of sites described—inlets and outlets, reservoirs that acted as sources and the ornamental streams that flowed from them—indicates the intricacy of the network, its breadth across the entire park, and the degree to which water management was both a carefully controlled means for creating scenic elements within the landscape and a practical necessity for maintaining the physical integrity of the park.

Water also flowed through more imaginative dimensions, extending the hydrological system through naming, poetics, and images. For instance, Source of the Waterfall Pavilion and Listening to the Waterfall Pavilion are linked by name to a third—Observing the Waterfall Pavilion (Guanputing)—to suggest a watercourse that did not actually exist. The three are situated at roughly the top, middle, and base of Pine Forest Valley.

Despite their geographic and nominal relationship to one another, however, each draws its scenery from an entirely different watercourse. Source of the Waterfall Pavilion sits at the top of two streams—one flowing down Hazelnut Glen to connect with Jade Peak Temple and Sonorous Pines and Cranes, the other down Pine Forest Valley. Observing the Waterfall Pavilion sits beside the middle reaches of Pine Forest Valley, overlooking a current that drains into the bottom of Pear Valley. Finally, Listening to the Waterfall Pavilion refers to the spring emerging from Emerald Spring Cliff. Despite physically relating to distinct streams, the pavilions are linked by name to create an imagined progression between the three that exceeded the possibilities of the actual landscape.

Although the physical siting and design of architecture often indicates, by necessity, the presence of water, its reception and interpretation found outlets through more literary means. In *Imperial Poems*, text and image complemented one another to draw out the sensory and imaginative qualities of the water for the visitor. From Sounds of a Spring Near and Far, one can hear the "gushing and gurgling" of a distant spring, while "to the west" there is "a waterfall like the Milky Way splashing down, a crystalline curtain reflecting the cliffs." The winds blow the falling water like "a spray of pearls," and the scent of white lotuses in the ponds on either side combines with the sounds of springs to transport one to a distant hermitage evoked through reference to a poem by the Tang dynasty (618–907) poet Li Bo (701–762).[37] The accompanying image (see fig. 1.9) reinforces these ideas both through its illustration of the key landscape elements, including the waterfall and the lotus, and its composition, which emphasizes a sense of peaceful isolation, the encircling mountains embracing the compound while limiting visual access to a world beyond.

Although the depiction of water is less elaborate in "Sonorous Pines and Cranes" and "Clear Sounds of a Spring in the Breeze" (see fig. 1.8 for both structures), it still features prominently in the composition. Flowing in front of the two compounds, the stream is highlighted by a series of simple bridges that lead directly from the foreground banks to the gates of the halls. The viewer thus has no doubt as to what spring Kangxi is referring in his texts or to the significance of the water as an element in the experience of the spaces. In his preface to "Clear Sounds of a Spring in the Breeze," Kangxi describes the water in almost sublime terms: "A flowing spring gushes forth from between two peaks and is stroked by a light breeze. As it trickles down over the rocks, it sounds like zithers responding to the calls of cranes and rustling pines. The water's taste is sweet and fragrant, delighting the spirit and enhancing longevity."[38]

While the image focuses on the water as it passes before the compounds, Kangxi's preface takes the reader beyond the confines of the composition to the stream's source, a spring emerging "from between two peaks."

This extension of the landscape through words beyond what would be immediately visible in either the image or from the actual site is analogous to the imagined waterway created by the three "waterfall" pavilions. The emperor's poem draws in yet more distant spaces, evoking mythical and divine waters and distant peaks:

> A Turquoise Pond, a palace with *lingzhi*,
>     and the filial heart of Master Laocai.
> A new spring gushes forth
>     amidst nature's myriad chants.
> I stand by a railing where fragrance surges
>     as vapors from divine liquid rise,
> Pointing out nearby South Mountain
>     as clear sounds of music play.[39]

The poem describes Kangxi's thoughts as he contemplates the sounds of water in a moment of repose. The Turquoise Pond of Mount Kunlun, the Western paradise, the *lingzhi* fungus of the Han Emperor Ming, and the legendary Daoist Transcendent Master Laocai all represent wishes of longevity for the empress dowager, to whom the emperor has come to pay his respects. The spring is a symbol of regeneration, "nature's myriad chants" a sign that heaven and earth are in balance, and a reflection of dynastic renewal and sage rule. So, too, are the "clear sounds of music," which the emperor can hear as he points out "South Mountain," or the "southern peak" (*nanshan*). This is yet another reference to longevity: Kangxi recalls the Six Dynasties (220–589) poet Tao Yuanming (365?–427), who in a number of poems speaks of the sacred peak Mount Lu as *nanshan*, in what came to be understood as a reference to long life.[40] These are not simply auspicious invocations. Although it is not visible from Clear Sounds of a Spring in the Breeze because of intervening terrain, there is a "South Mountain" in the Mountain Estate as well, a ridge of peaks to the north that is surmounted by the pavilion Southern Mountains Piled with Snow. Here and throughout *Imperial Poems*, Kangxi links specific sites within the Mountain Estate to culturally significant landscapes, whether of the distant past, the poetic tradition, or religious belief, extending the park's landscape beyond the limitations of text, image, or individual experience.

The waters and peaks of the park-palace became one means by which the landscape was defined physically through design and engineering, and imaginatively through literary, sensory, and even mnemonic reference. By exploiting the possibilities and limits of what could be seen, and therefore known from a given vantage point, the park's design created imaginative connections between places both within and beyond its boundaries. Although largely absent from the Mountain Estate today—the mountains'

channels are dry and only the main lakes remain navigable, primarily by tourists in pedal-boats—water was once central to the itineraries and networks that shaped the experience of, and engagement with, the site. Thinking of the water in some sense as the contrasting "negative space" of the park's plan draws out unnoticed patterns and connections in the "positive space" of the architecture and its use, another way of seeing the site from a lenticular perspective.[41]

## Coming to Court

The final phase of construction under Kangxi came to a close in 1713 with the completion of the perimeter wall and the dedication of two Buddhist establishments on the far side of the Wulie River, east of the Mountain Estate: the Temples of Universal Benevolence (Purensi) and Universal Charity (Pushansi).[42] It has been argued that Buddhism was central to the conception and design of the Mountain Estate during both the Kangxi and Qianlong periods, and that the two emperors shared a vision for the site as a mirror reflecting the empire and the Buddhist cosmos.[43] For human geographer Philippe Forêt, this singular vision for the site was in keeping with the fact that "the geography of the Qing empire during the eighteenth century was intimately intertwined with Tibetan Buddhism."[44] For others, the connection between the Kangxi and Qianlong emperors' Buddhistic plan is most clearly manifested through the so-called Eight Outer Temples (Waibamiao), the name now assigned to the monumental temples that ring the park to the north and east, of which Kangxi's temples of 1713 were the earliest exemplars.[45] Although all but two were constructed under Qianlong, as a group the outer temples have been held to demonstrate the explicit continuation of Kangxi's "temple policy," as "Qianlong had too much respect and veneration for his grandfather Kangxi to neglect his policies."[46]

These and other interpretations of the Mountain Estate raise a number of concerns not only about the place of Buddhism in the early design of the Mountain Estate but also about the historiographic presumption of continuity between the two major reigns of the High Qing. First and foremost, they assume (or posit) that the Kangxi and Qianlong emperors shared a vision for the role of Buddhism in statecraft and imperial ideology.[47] Moreover, they are based primarily on the final state of the landscape in the late Qianlong period and on Qianlong sources, creating a sense of continuity in the expansion of the valley's Buddhist infrastructure that naturally is not present when viewed from a Kangxi perspective. Neither Kangxi-period sources nor the landscape that may be deduced from them support the thesis of a single or continuous design conception for the site centered on Buddhism. In many cases the structures central to these readings, such as

the outer temples and Gold Mountain Island, either did not exist during the Kangxi period or seem to have held very different meanings for Kangxi than those they acquired under his grandson.

A reexamination of religious architecture in the two periods calls these interpretations into question, suggesting in their stead a more varied range of meanings associated with temples and shrines under Kangxi while redirecting attention from abstracted symbolic formations to more practical intentions. Comparing religious establishments built under Kangxi and Qianlong illustrates the degree of transformation that occurred under the latter (map 1.10). Kangxi's temples within the park's walls were limited in number but broad in scope. They comprised the Buddhist Forest of the Law and Daoist Pavilion of the Supreme God; an altar to the Dragon King, a folk deity associated with water; and the Temple to the Mother of the Dipper, a Daoist goddess originally derived from Marici, a manifestation of the bodhisattva Guanyin.[48] By contrast, Qianlong's temples were far more numerous, including substantial installations in both the lower and high mountains as well as in the Garden of Ten Thousand Trees. With the exception of two small folk altars, they were entirely Buddhist.[49]

Among the outer temples, Qianlong's investment again dwarfed that of Kangxi, as he established ten major Buddhist sites to his grandfather's two. Moreover, even a cursory glance indicates that their relationship to the Mountain Estate was quite different. While Kangxi's temples are aligned essentially north-south, as is normally true for Buddhist temples, nearly all of Qianlong's are instead oriented toward the park with two—the Temples of Universal Happiness (Pulesi) and Far-Reaching Peace (Anyuanmiao)— quite conspicuously so. At the least this points to an architectural dialogue between Buddhist architecture and the Mountain Estate under Qianlong that was not present during Kangxi, when the emperor used the establishment of temples in Rehe and throughout the region as a means for diplomatic patronage of his Inner Mongol allies. The visualization of the stages, degrees, and foci of development of religious architecture at the Mountain Estate makes clear that the two rulers were pursuing distinct agendas that demanded quite different scales of building.

This is not to say that Buddhist structures, however defined, were not significant elements within the park's built environment under Kangxi. The architectural landscape of the Mountain Estate during the Kangxi period bears out the notion that Buddhism was an integral part of the emperor's personal and political economy. Religious structures seem to have functioned primarily for personal devotion, as components within the court's broader strategy of Inner Asian relations, or as scenic evocations of famous landscapes, rather than as monuments within a holistic Buddhist design conception for the site. For instance, by the end of Kangxi construction in 1713, the park contained several halls and compounds dedicated to pri-

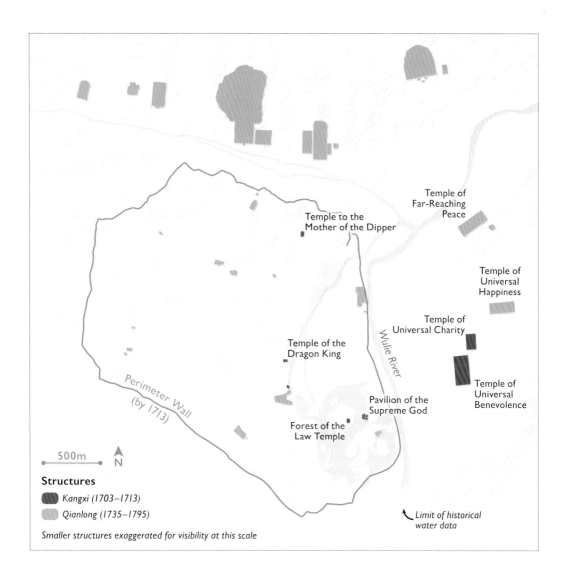

Temple of
Far-Reaching
Peace

Temple to the
Mother of the Dipper

Temple of
Universal
Happiness

Temple of
Universal Charity

Temple of the
Dragon King

Wulie River

Temple of
Universal
Benevolence

Pavilion of the
Supreme God

Perimeter Wall
(by 1713)

Forest of the
Law Temple

500m

N

**Structures**

Kangxi (1703–1713)

Qianlong (1735–1795)

Smaller structures exaggerated for visibility at this scale

Limit of historical
water data

MAP 1.10
Religious structures built in
Rehe (later Chengde) under
Kangxi and Qianlong, ca.
1703–1780. Map by Daniel
P. Huffman.

vate prayer and study, including Fragrant Waters and Beautiful Cliffs (the "Buddhist hall" mentioned by Zhang Yushu) and Forest of the Law Temple, adjacent to the park-palace's original imperial residence.

The immediate proximity of both to the emperor's most frequently visited spaces on Ruyi Island suggests their importance to his daily life, yet their presence within "public" circuits enabled these built spaces to simultaneously function as testament to particular aspects of imperial identity. Kangxi averred to be a practicing Buddhist, and the variety of temple forms and practices within and outside the walls of the park-palace represented by the Temples of the Forest of the Law, Universal Benevolence, and Universal Charity allowed this notion to be conveyed in distinct ways to different audiences. At the same time, meditation rooms and other

structures nominally related to Buddhist practice were common elements in many private gardens of China proper, even when they were not used in this manner. As such, some halls could also speak to the emperor's awareness of cultures of elite spaces, particularly Southern gardens and famous places. For instance, although the compound atop Emerald Spring Cliff may, by dint of its Buddhist altar, be considered a temple or shrine, no mention of it as such appears in extant sources. It was, however, a key compositional element in the experience of two sites nearby, Sounds of a Spring Near and Far and Listening to the Waterfall Pavilion, described earlier in this chapter (see fig. 1.9). Similarly, while Rehe's Gold Mountain and its main structure, the Pavilion of the Supreme God, may have held a periodic ritual function under Kangxi—again, the archival record is silent on this question, though the missionary Matteo Ripa associates the island with its Daoist "idol"—the entire complex appears to have been valued as much for its cultural and geographic associations and its scenic virtues as for any religious links.[50]

This emphasis on scenery reflects the importance of such sources as Kangxi's *Imperial Poems* in constructing the imperial rhetoric of the landscape. The absence of religious activities from these and more documentary sources, like the *Diaries of Activity and Repose*, does not mean that they did not occur, of course. It suggests, however, that Buddhism did not occupy a significant place in those rituals of state that predominate in the daily diaries, particularly the "coming to court" (*laichao*) of allies and tributaries that occupied much of the emperor's time in Rehe. Rather than extrapolating from the outer temples to focus on Buddhism in particular, the continued evolution of the Mountain Estate between 1709 and 1713 ought to be read more broadly to understand the maturation of its utilization as a center for state activity and Inner Asian diplomacy under Kangxi.

While the *Diaries of Activity and Repose* are generally silent on the type of activities recounted by Zhang Yushu, they are meticulous in chronicling the emperor's movements and the business of governance and diplomacy. From 1711 to 1717—the final years of Kangxi's rule for which the *Diaries* survive—the emperor spent between ninety-five and one hundred sixteen days in Rehe, primarily in two substantial blocks each year. The season beyond the passes opened with a stay of between eighty-three and ninety-four days at the Mountain Estate, sometimes interrupted by a brief trip to the nearby hot springs at Tangquan. The emperor then departed for Mulan Hunting Grounds, where he toured and hunted for thirty-five to forty-seven days, followed by an additional six to twenty-two days in Rehe before returning to Beijing. Most years concluded with an additional tour north in the eleventh and twelfth months, during which time the imperial party would generally stay two days in Rehe.[51]

The Mountain Estate was the principal seat of governance when Kangxi

toured the north. During the emperor's stays in Rehe, the *Diaries of Activity and Repose* record frequent, often daily audiences with officials to conduct affairs of state or bestow gifts upon them.[52] Such audiences are likely in addition to other more prosaic official activities that went unrecorded in the *Diaries*, including study with his tutors.[53] These audiences largely ceased during the late summer tours to Mulan, underlining the particular function of Rehe and the Mountain Estate as a secondary seat of government.[54] Even more frequent were visits from leaders across the Inner Mongolian Banners who came to court to perform rituals of obeisance to the emperor (*laichao* or *chaojin*). Central to these was *silai*, the unilateral giving from emperor to subject without expectation of material return that was integral to tributary relations with the court.[55]

At Rehe such gifts were wide-ranging, including livestock and meat (especially venison and fish), horses, melons and other fruit, fine furs and textiles, precious metals, and other refined goods.[56] Banqueting was also part of these visits, as were other pleasurable activities, such as touring the park and archery demonstrations.[57] In addition to many of these same gifts, court officials also occasionally received pieces of imperial calligraphy, paintings, books, or other more literary objects.[58] Like meat from the emperor's hunts, these gifts constituted performative demonstrations of cultural competency as much as objects of exchange. Access to imperial precincts through admission to the Mountain Estate and the giving of such gifts was intended to instill a sense of intimacy with the throne; collectively, these interactions constituted a more personal relationship that bound ruler and subject together.[59]

As a source, the *Diaries of Activity and Repose* is quite constrained in its accounts of imperial life at Rehe, generally chronicling in formulaic language the action (audience, visit, gift giving), the individuals present, and the objects given. When viewed against the landscape of the Mountain Estate as it emerges in this period, however, a richer understanding of the architectural program emerges. Although the park was a setting for imperial performance, and thus required a grandeur and richness befitting the emperor, much of that performance was oriented not around remote majesty and high ritual but on the staging of private life and rituals of intimacy and access: imperially led tours to the inner court, the giving of gifts, the sharing of meals, and the enjoyment of entertainments such as drama and archery. The expression of monumentality through modesty and reserve allowed the architecture to communicate imperial authority without overwhelming its capacity to foster more intimate connections.[60] At the center of these connections was not architecture per se but the landscape as a whole: passing into and through the park's precincts as well as being in and experiencing the designed environment with others, including the emperor. These priorities are reflected in the intimate spaces, a dramatic

or scenic siting, and an overall design that facilitated touring, all of which characterize early architectural development at the Mountain Estate.

## Learning from Rehe

The relative dearth of Kangxi-era primary sources prevents definitive answers to many questions about the first decades of the Mountain Estate, including the precise sequence, detailed design, and original function of much of its earliest architecture. The Qianlong archive, though richer, is historically and historiographically problematic. Eliding change over time and creating a sense of continuity between Qianlong's Mountain Estate and that of his grandfather, it obscures the relationship between politics and space that help define both the site and emperorship under Kangxi.[61] Considering these circumstances, the limited body of Kangxi images and texts, together with the site itself, provide crucial if fragmentary evidence essential to recovering the now obscured early Rehe landscape. Visualizing such early formations provides a physical basis for understanding the landscape through which the Kangxi court sought to create meaning, thus facilitating exploration of possible pasts.

Reconstructing the Mountain Estate as it existed under Kangxi also establishes a foundation upon which other forms of the landscape—most notably, the pictorial, textual, and imaginative—may be activated. Although the physical site of the park-palace was in some sense primary, the various formations and iterations of the site intersected with and drew upon one another, a transmedial interplay of forms by which imperial ideology was constructed and conveyed through the landscape. Put differently, reconstructing the earliest architectural formations of the site paradoxically allows the buildings themselves to recede in significance, and with them the questions of archival and typological significance that often accompany such research.[62] What emerges in the literal and figurative spaces in between are ways of understanding the Mountain Estate through embodied, sensory, and imaginative dimensions of the landscape. While such experiences often originate in individual buildings or discreet scenes, they are activated and experienced through an interplay across architectural and environmental scales, nested within and extending beyond the walls of the park-palace. Through these spatial dialogues the design of the Mountain Estate produced a form of spatial lenticularity akin to the perspectival plays of private urban gardens, but without the scalar constraints found in those smaller landscapes. The Mountain Estate's plan thus created worlds within worlds and a garden without walls, a landscape extending beyond its physical and temporal confines to articulate and reflect a vision of Qing emperorship under Kangxi: interconnected, all-encompassing, and historically transcendent.

PART II   Allegories of Empire

CHAPTER 2

# Mountain Veins

I N 1718 A TEAM of European and Qing surveyors and cartographers in service to the Kangxi court presented *Map of a Complete Survey of Imperial Territories* (Huangyu quanlan tu) to the throne (fig. 2.1).[1] The product of more than a decade's work, the map—frequently known as the *Kangxi Atlas*—offered an image of the early Qing empire through evolving cartographic techniques that integrated European mathematics and endogenous methods of land measurement.[2] Despite its seeming objectivity, however, the imperial territory imagined by the atlas was a fundamentally rhetorical one, simultaneously presenting a unified empire while revealing the fractured nature of its once disparate parts.

Details within the *Kangxi Atlas* suggest the often difficult course of conquest during the first decades of the Qing. Territorial control remained a significant concern for the Qing decades after the establishment of the dynasty in 1644. Kangxi continued to fight wars of suppression, expansion, and border consolidation on all fronts into the mid-1690s.[3] Inaccuracies in the delineation of Korea and blank areas in the southern province of Guizhou, eastern Taiwan, and along the western frontier, for instance, reveal regions that remained inaccessible to the state and its surveyors more than seventy years after the fall of Beijing. The use of Manchu for labeling toponyms in the Northeast and Mongolia, in contrast to Chinese through the remainder of the atlas, similarly speaks to tensions between territory and ethnicity inherent in the creation of the Qing polity.

Territorial consolidation represented only the first phase of establishing Qing rule, however. What followed, the integration of *guannei* and *guanwai*—"within" (*nei*) and "beyond (*wai*) the passes (*guan*)"—into a single, cohesive empire was perhaps even more challenging. As seventeenth- and eighteenth-century emperors sought to shape and define the Qing population and territory, the reconciliation of mutually foreign regions into a coherent polity was a constant project. Ming China, the Northeast, Mongolia, Tibet, Xinjiang, Taiwan, and the South and Southwest were

variously joined to form a single empire. The cohesiveness of this state depended upon the naturalization of each component part with all the others, engendering a semblance of unity, if not of equality. Qing foreign policy was simultaneously enmeshed in global geopolitics of increasing complexity. Delineating borders, claiming territorial sovereignty, and asserting the right to control foreign trade, immigration, travel, and alliances were all pressing matters throughout the dynasty's term. Integral to these processes was the creation of landscapes and ideas that served to reinforce the idea of "Qing" as a meaningful way of defining people and geography.

Despite its divisions and blind spots, the *Kangxi Atlas* did not simply reflect the nature of the Qing state. Read as a type of landscape image with a rhetoric of its own, the atlas helped create the new territorial reality envisioned by the court. In the emperor's atlas, geographic distinctions between the fallen Ming dynasty (1368–1644) and the northeastern and Central Asian territories of the Qing's multiethnic conquest elite were dissolved in favor of a single, cohesive empire, the Qing, through the imperatives of cartographic technology and visual representation.[4]

Rhetorics of territorial integration—whether political, conceptual, or representational—contributed powerfully to the establishment and legitimization of the early Qing state. The boundary between inner and outer, far more a cultural construct than a physical reality, served as a marker of historic sociogeographical distinctions between the "civilized" within China proper and the "barbarian" beyond.[5] Inexact terms at best, "China proper" refers broadly to the territory that was historically held by "Chinese" dynasties since the Han (206 BCE–220 CE). The specific borders of this land mass changed over time, but the northern frontier was consistently defined conceptually, if not physically, by the Great Wall and the mountain passes that it in many places defended, even as both the de jure and de facto borders extended further north. Then, as now, the idea of the Great Wall contributed to "a way of thinking about China that sees the state not only as clearly bounded, but also as culturally cohesive, and historically continuous," implying geopolitical and cultural stability and clarity where little in fact existed.[6]

That fact made it no less important to the Kangxi court's efforts at territorial integration, and the heuristic persistence of the conceptual border echoed in court texts of the Kangxi period. Interestingly, these works did not seek to elide the division. Rather, they sought to reconceive the imperium as one that encompassed both *guannei* and *guanwai*. This conceptual integration of inner and outer took many forms: cartographic, of course, but more broadly in ritual, political, and cultural performance as well, each essentially ideological in nature. Each form operated in certain fundamentally similar manners, linking the territories of the empire first and foremost with the emperor and the throne, while not totally divorcing those regions

FIGURE 2.1
*Map of a Complete Survey of Imperial Territories,* 1718. Frequently known as the *Kangxi Atlas* and originally prepared by a team of European and Qing surveyors and cartographers as forty-one individual sheets, this illustration visualizes the atlas digitally knitted together. Courtesy of QingMaps.org.

NORTH
↑

and their occupants from their respective historical connections. Through imperial performances such as touring, hunting, palace-building, writing, and image-making, the territorial landscape of the Qing empire was defined and presented in terms legible to each of the court's various constituents.

In reading these distinct performances, a multivocal approach to the construction of imperial identity becomes apparent, one in which both Chinese and non-Chinese vocabularies were deployed in overlapping manners that allowed the court to address multiple constituencies at once in terms that were ethnically distinct but still projected the Qing's imperial vision as a unified imperium. Combining elements of the Altaic landscape, Manchu and Mongol cultural memory, the legacy of past conquest dynasties, and Han principles of ritual and geomancy, the emperor engaged the landscape to articulate a vision of the Qing that was both comprehensible to different audiences and reflected a vision of the empire that transcended ethnic divisions.[7] Through texts, maps, and images, the Kangxi court deployed interrelated approaches to territorial integration involving the reframing of Chinese and non-Chinese practices in terms that reflected the diverse nature of the Qing.

## Kangxi Imperial Touring in Context

Following the suppression of the Rebellion of the Three Feudatories (Sanfan zhi luan, 1673–81), the last major resistance to Qing rule within China proper, the Kangxi court became unusually mobile. In 1681 the emperor spent roughly half the year in the Forbidden City while taking extended journeys north of the Great Wall, including to the Qing ancestral tombs near the last predynastic capital of Shengjing (also known by its Manchu name, Mukden). By 1714, Kangxi's time in the Forbidden City was down to a mere 18 days, with an additional 131 days in the Garden of Joyful Spring in suburban Beijing and a northern journey to Rehe and the Mulan Hunting Grounds totaling 139 days.[8] At its core, touring was a way of occupying land and reinforcing the status of the state.[9] The emperor reaffirmed his control of the territory through which he passed, displaying wealth, power, and prerogative through his traversing of exclusive roads, his consumption of local resources, and his reservation of camping and hunting grounds. Touring also served as a means for practicing and demonstrating both civil and military capability.[10] Leading enormous retinues on extended itineraries mimicked many of the logistical and practical realities of war, while presenting the emperor with frequent opportunities for interaction with officials and local populations.

Early Qing rulers thus found themselves in an uncertain, often contentious, political and cultural environment regarding imperial touring.[11] Kangxi's father and predecessor, the Shunzhi emperor (r. 1644–1661),

regularly left Beijing for the suburbs to avoid the threat of smallpox, the disease that ultimately claimed his life.[12] This was less of a concern for Kangxi, who acquired immunity to the illness as a child, but travel early in his reign was nonetheless highly circumscribed.[13] Prior to the defeat of the Rebellion of the Three Feudatories in 1681, Kangxi undertook only one significant tour outside a military context, a journey north in 1671 to Shengjing.[14] The transition from military to civil tour following the major military victories of the early 1680s signaled a key shift in the Qing's political and territorial security. This was reflected in a concomitant transformation in the terms through which the landscape was occupied and integrated. Although military and pseudo-military presence continued, ritual, cultural, and diplomatic practices became central to imperial touring.

In 1681, Kangxi began a remarkable series of tours, undertaking more than one hundred and twenty-five over the next thirty years. Following historical precedents of "directional touring" from both Chinese and non-Chinese dynasts, these journeys included six each to the south and west, three to Shengjing, three more to Mount Tai and the ancestral home of Confucius, and more than fifty north to the hunting grounds and traveling palaces of Inner Mongolia, particularly those in Rehe and Mulan.[15] As a structural approach to touring, directional touring realized the imperial goal of symbolically possessing the territory through occupation of the five directions—ritual organization of space according to the four cardinal directions and the center.[16] It also offered the most effective itinerary for politically acceptable touring, which included evidence of virtuous civil rule, such as sacrifices and ritual performances at tombs and mountains, and acts of generosity toward the populace.[17] These activities legitimized Qing touring within the broader historical context of touring and statecraft, and their attention to the populace signaled "a sharp antipathy" toward the excesses of late Ming culture that rhetorically substantiated the Ming's loss of the Mandate of Heaven (Tianming), by which Chinese dynasts claimed the right to legitimate rule.[18]

Kangxi's best-known directional tours are those to the south—grand affairs that left substantial impressions on the territory through which the court traveled, in both propagandistic and economic terms. Of greater interest here, however, are his tours to the most sacred mountains of China proper and the Northeast, Mount Tai (Taishan) and Mount Changbai (Changbaishan). Tours to these sites represented a sort of ritual trialectic, balancing the performance of historic Chinese rituals of state at Mount Tai with the elevation of Manchu heritage at Mount Changbai and, en route, the execution of filial obligations in Shengjing. Through rhetoric and practice, these mountains became venues for the incorporation of the Northeast and China proper into a common sacred geography, one that replaced Mount Tai with Mount Changbai as the source of the

empire's geomantic energy and established Kangxi as its supreme ritual practitioner.

Mount Tai, located in central Shandong not far from Confucius's birthplace in Qufu, had been revered by Buddhists, Confucians, and Daoists since at least the Zhou dynasty (1046–256 BCE). Over the course of his reign, Kangxi visited Mount Tai three times—in 1684, 1689, and 1703. His first visit in particular emphasized proper ritual practice in historic terms. Climbing by foot to the summit, the emperor directed key rites in the site's chief temples. The most politically significant of China's many revered mountains, Mount Tai, and the imperial rituals performed there, constituted a vital element in an emperor's claims to legitimacy. Kangxi thus asserted his primacy in the contexts of Chinese sacred space and imperial performance, signals of authority that would have also been received by non-Chinese audiences.[19]

Central among these rituals, at least in principle, were the *fengshan* sacrifices (*fengshansi*), rites of unclear origin and meaning practiced inconsistently over time that nonetheless were "the most important legitimizing rite the emperor could perform, as it symbolized his reception of the Mandate of Heaven."[20] Yet in 1684, when he first traveled to Mount Tai, Kangxi declined to perform the *fengshan*. Instead, he attacked the sacrifices as evidence of dynastic self-aggrandizement, couching his decision in terms of imperial restraint and an emphasis on the welfare of the people, recurrent themes in his rhetoric of legitimacy.[21]

Although some scholars have interpreted this choice as a rejection of "superstitious practices," Kangxi's decision may in fact have been at the heart of a process of ritual recentering through which he sought to shift the sacred wellspring of the empire from Mount Tai to Mount Changbai.[22] The emperor's demurral at Mount Tai was likely in part due to the fact that he had already performed the *fengshan* at Mount Changbai two years previously.[23] In doing so, he elevated Mount Changbai to a status on par with the Five Sacred Mountains (Wuyue) of China proper, part of a twofold process of territorial integration that involved shaping the landscape of the Northeast and establishing it as the sacred source of the new Qing landscape.[24]

## Mount Changbai and the Centering of Qing Geography

In his study regarding the creation of a Manchu homeland in the Northeast, historian Mark Elliott explored the process and significance "of grounding the identity of the imperial lineage to a specific place," notably in connection to the establishment of Shengjing and Mount Changbai as the points of origin for the Manchu people. This "geographic grounding" was significant in forming a stable history and tradition sufficient for legitimate claim to

the throne.[25] Kangxi's sacred and cultural mapping of the Northeast went beyond establishing a homeland for the Manchus, however. Through occupation of the territory, ritual performance, and cultural accretion, the Qing court marked the landscape of the Northeast in manners that elevated it on par with the landscapes of China proper, inspiring a Qing landscape with the Manchu emperor at its center.

Identification of a place of origin was an essential part of the creation of a Manchu identity.[26] Emerging from a larger ethnic group, the Jurchen, Manchus historically had no independent status, culture, or identity; rather, they developed and institutionalized markers of ethnic identity as part of the process of state formation in the late sixteenth and early seventeenth centuries.[27] Underlying many of these criteria was a link to geography, as the Qing court tied itself and the Manchu population to ancestors, political institutions, and cultural practices of the Northeast.[28] Like other aspects of the Qing construction of identity, the imagination of Manchu geography was carefully conceived to highlight the political and ideological position of the court vis-à-vis its constituencies. For this region to serve the ideological functions of the Manchu homeland adequately, it had to be invested with a formal network of significance. This is not to say that the Northeast was culturally virgin territory before the rise of the Qing; on the contrary, it is simply that the oral tradition that characterized historic Northeastern culture was structurally inadequate in the Chinese context. Therefore the most expedient elements of predynastic mediation were formalized by the court and new layers of meaning were inscribed, giving rise to a complex cultural landscape akin to those enshrined in China proper.

The early Qing court employed various means to establish the Manchu homeland and incorporate it into the empire, including several strategic and ideological mapping projects.[29] For instance, in 1646, Dorgon, regent to the Shunzhi emperor, ordered a cadastral survey as part of an effort to reform land-based taxation, at the time based on mid-sixteenth-century Ming records. Although ostensibly focused on promoting fairness in tax and labor assessment, the survey naturally strengthened the court's understanding of (and reach into) territory and regional populations.[30] Kangxi expanded significantly on this precedent later in his reign, commissioning the *Map of a Complete Survey of Imperial Territories* and the *Imperially Endorsed Complete Collection of Images and Writings from Antiquity to the Present* (Qinding Gujin tushu jicheng), an imperial encyclopedia and gazetteer that included highly detailed geographic information down to the local administrative level complemented by 216 maps based on the *Kangxi Atlas*.[31]

Each of these projects reflected different ways of ordering territory administratively and conceptually. While the imperial encyclopedia followed generic conventions in comprehensively recording the human,

historical, and physical geographies of local places within the empire, multiple logics of Qing territory were reflected in the organization of the atlas. As a whole, the atlas organized the empire by cardinal directions, in the same manner as tours. Although it eventually covered the entire empire, the *Kangxi Atlas* project started by mapping the Northeast, suggesting the court's view of its geographic preeminence and its contemporary strategic importance. Beginning with the map of Shengjing, the atlas progressed northeast along the coastline and borders, laying claim to the strategically vital Jilin coastline and the border with Russia.[32] The maps then moved along the Qing-Mongolian border, stretching across the desert to Tibet. Electing to begin with Shengjing may have reflected symbolic as much as practical needs, as the province itself shared only a short stretch of border with Joseon Korea, historically demarcated by the Yalu River and thus not much in dispute. After the northeastern and western sections the maps returned to the center, including Beijing and the surrounding provinces, followed by Jiangnan, the coastal provinces, the distant south and southwest.[33]

Imperial presence within the Northeast further inscribed the landscape with political and especially ritual significance. In 1671, Kangxi made the first of three trips to Shengjing, performing rites at the tombs of his ancestors, Nurhaci (r. 1616–1626), the dynastic founder, and Hong Taiji (r. 1626–1643), Nurhaci's successor.[34] Following his stay in Shengjing, Kangxi explored the regions northeast of the old capital for seventeen days before returning to the capital.[35] The itinerary included a visit to Mount Changbai, which just a few years later was assigned a program of ritual sacrifices and designated as a sixth Sacred Peak, equal to the five of China proper.[36]

Changbai, which designates both a single peak and a chain of mountains along the border of modern Jilin and North Korea, had been identified with origins of the Jurchen as early as the Han dynasty (206 BCE–220 CE).[37] The Jurchen ruled northern China and the Northeast as the Jin dynasty (1115–1234), a conquest regime that the Qing took as one of its more significant precedents for legitimacy. In *History of the Jin* (Jinshi), Emperor Shizong (r. 1161–1189) described Mount Changbai as part of Jurchen territory since the people's emergence. He recognized it as a site worthy of constant veneration through rituals and the building of temples: "Only Changbai can convey the virtue of the Jin; looking up upon its heights, it is truly Our ancient state's one talisman [zhen]."[38]

Building on this history, early Manchu rhetoric marked Mount Changbai as a sacred landscape. The first lines of *Veritable Records of the Manchu* (Manzhou shilu), which recount the rise of the Manchus from mythic origin through the rule of Nurhaci, refer to the site's revered and auspicious geography: "[Mount Changbai] is 200 *li* in height and 1,000 *li* in circumference, and at its summit there is a lake called Tamun, measuring 80 *li* in

circumference. There are three rivers flowing out from that mountain: the Yalu river, the Songhua river, and the Aihu river. . . .[39] The Manchu state originated from a lake called Bulhuri beside the mountain called Bukuri to the east."[40]

Lake Bulhuri and Mount Bukuri were the supposed home of Bukuri Yongson, the miraculously conceived progenitor of the Manchus, specifically the imperial Aisin Gioro line.[41] From Bukuri Yongson the story followed the imperial lineage vaguely but directly to the historically verifiable Möngke Temür, a powerful regional leader in the fifteenth century connected to the legitimate ancestors of the Manchus, who were eastern Jurchens of the Jianzhou Garrison (*wei*).[42] Mount Changbai thus came to play a pivotal role in the geography of pre-Qing Manchu legitimacy: claiming the emergence of the imperial clan from a site long sacred to Jurchens served to reinforce the Manchus' assertion of their preeminence among Jurchen groups.

Kangxi continued the sacralization of Mount Changbai through tours, ritual practice, and literature. The emperor's actions were often founded on evidence ostensibly gathered through inspection and scholarly analysis of the site's auspicious topography and environment. In the summer of 1677, Kangxi sent the imperial clansman, Gioro Umuna, to chart the hitherto unmapped mountains. Umuna's report to the throne clearly expressed the peak's sacredness, emphasizing auspicious natural features and miraculous events in his description of the landscape.[43] Upon reading the report, Kangxi issued an edict formally establishing the sacrality of the mountain: "Mount Changbai is the important place where the ancestors originated. There are many marvelous traces there; the mountain spirits should receive investiture and permanent sacrifice to reflect the intentionality of the gods in the prosperity of the state."[44]

The Board of Rites (Libu) followed by recommending semiannual sacrifices to the spirit of Mount Changbai, in response to which the emperor commanded that the rites should be conducted with the same protocols as those employed in sacrificing to the Five Sacred Mountains.[45] Five years later, in 1682, Kangxi added the weight of his own presence to this shift in the empire's ritual center of gravity. After traveling first to Shengjing, where he again performed sacrifices at the Qing ancestral tombs, Kangxi hunted his way up the Sungari River to one of the predynastic Manchu capitals, Girin Ula. There he performed obeisance to the distant peaks and confirmed their ritual supremacy, writing: "We prepare the *fengshan* in your honor, making offerings as we pay our respects."[46] By conducting the *fengshan* sacrifices at Mount Changbai rather than at Mount Tai, the emperor made the Manchu peak the sacred site of origin for his people and the conduit for Heaven's blessings. Thus the peak became the font of legitimacy in both Jurchen and Chinese terms.

## The Auspicious Chorography of the Northeast

Key to the imperial interpretation of Mount Changbai was its auspicious landscape, indicative of the position to which Kangxi ultimately elevated it as the sacred and geomantic foundation of the empire. In a poem composed on his 1682 Eastern Tour, the emperor described the "cerulean mists" and "carmine clouds" of Mount Changbai: "Whence eternal rises the augur of fortune, we revere with one generation's rites / Craning our heads toward the sky, your towering majesty overawes the imperial gates."[47] At some point in the ensuing years, Kangxi composed the essay "Mount Tai's Mountain Veins Originate in Mount Changbai" ("Taishan shanmai zi Changbaishan lai"), in which he located the source of the empire's geomantic force and thus its sacred and auspicious geography at Mount Changbai.[48] The emperor began his essay by recounting the traditional understanding of China's geomantic topography, "mountain veins" (*shanmai*), anchored in the west by the "tiger" (Mount Hua) and in the east by the "dragon" (Mount Tai) (map 2.1). According to the emperor, Mount Tai in particular offered topographic shelter through its veins, which traced a protective geomantic web across China. But how, the emperor wondered, could the true course of Mount Tai's powerful reach be appreciated without knowing "from whence [its] veins emerge?"

"In truth," Kangxi declared, "Mount Tai's dragon emerges at Mount Changbai." Following mountain ranges and watercourses closely, the emperor proceeded to detail the connection between the two mountains, tracing the flow of geomantic energy as though from a river's source to its mouth (map 2.2):

> Mount Changbai extends in an unbroken chain to the south of [Mount] Wula. A hundred springs rush down from all sides of the mountain, forming the sources of the three great rivers, the Songhua, the Yalu, and the Tumen. At its southern foot, [Mount Changbai] divides into two trunks. The trunk that points to the southwest extends east to the Yalu River and to the Tongjia River on the west. Its greatness supports the mountains of Korea, which are all its branched progeny. The other trunk begins in the west and goes north to Naluwoji, [where] it again divides into two branches.[49]

One of the two new branches enters the former capital from Naluwoji to become Mount Kaiyun, then turning south, "overlapping peaks and ridges extend to Jinzhou and Lüshun" before passing into the sea.[50] The branch stretches across what is now the Gulf of Bohai, marked at several points by islands, and ultimately reemerges on the Shandong coast. From there "it runs southwest more than 800 *li*, where it ends, becoming Mount

MAP 2.1
Key locations in Kangxi's description of the Qing's auspicious geomantic topography. Map by Daniel P. Huffman.

MAP 2.2
The linking of Mount Changbai to key sites in the Qing Northeast via mountain veins as described by Kangxi, including Mount Tai. Map by Daniel P. Huffman.

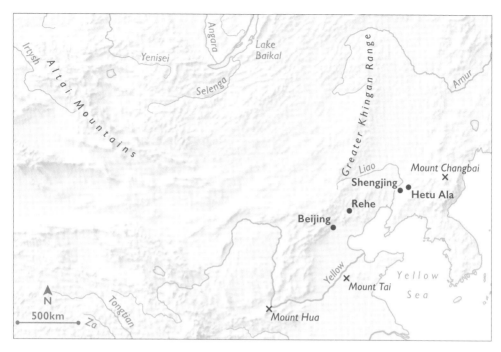

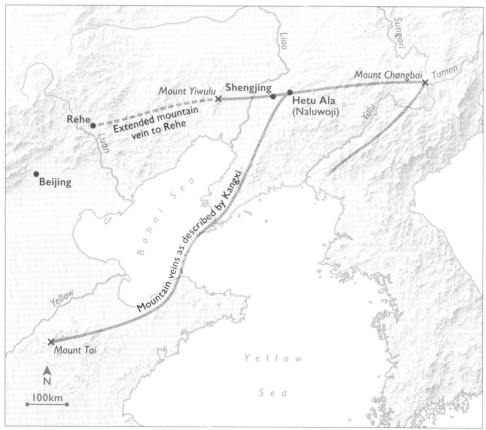

Tai, [rising] sublimely into the sky, coiled and crouching, first among the Five Sacred Mountains." The emperor's careful mapping of Northeastern topography, which culminates in a seemingly triumphant Mount Tai, so engages the reader that his last phrase is almost lost. Mount Tai is "first among the Five Sacred Mountains"; Mount Changbai, source of Mount Tai's mountain veins, new site of its most significant rituals, and ancestral home of the Manchus, is now above it.[51]

The emperor's essay focuses principally on the relationship between Mount Changbai and Mount Tai, yet the second branch that emerged from Naluwoji is also of interest. It presents a landscape invested with potent symbols of imperial legitimacy parallel to, but entirely distinct from, those linking Mount Changbai and Mount Tai. After dividing from the vein that leads to Mount Tai, "the northern branch goes to Shengjing, forming Tianzhu and Longye, [then] turns to the west, forming Mount Yiwulu."[52] As the first Manchu imperial capital, Shengjing was central to Kangxi's construction of Northeast and Qing geography through directional rule, and it officially held the designation of the northern capital of the Qing. Furthermore, the Tianzhu and Longye mountains each represented significant monuments in the same project, as they were sites of imperial tombs belonging to rulers essential to the legitimization of the Qing: Nurhaci's tomb, Fuling (see fig. 4.8), is at Tianzhu, while Longye is the site of Hong Taiji's tomb, Zhaoling.[53]

Mount Yiwulu's importance as a site for locating imperial legitimacy was more distant in time, if not in memory. *The Imperially Commissioned Gazetteer of Shengjing* (Qinding Shengjing tongzhi), first published in 1684, placed two specific Liao dynasty (916–1125) imperial tombs near Yiwulu: Xianling, the burial place of Emperor Shizong (r. 947–951), and Qianling, belonging to Emperor Jingzong (r. 969–982).[54] The Kangxi imperial encyclopedia recorded the designation of Yiwulu as an exclusive and sacred precinct by the Jin emperor Taizong (r. 1123–1134), with later decrees forbidding the gathering of wood at the Liao imperial mausoleums and declaring their looting a crime punishable by death.[55] Thus Kangxi delineated a second geomantic branch coequal with the one that stretched to Mount Tai. This linked Mount Changbai to culturally significant sites that were tied not to Chinese history and ritual, as Mount Tai was, but to the history of non-Chinese regimes from which the Qing also derived legitimacy, the Liao and Jin, as well as to the emperor's Manchu ancestors.

Naluwoji is a noteworthy place for these two branches to split, given its associations with both Manchu history and the auspicious landscape set out by the emperor. A dense forest stretching to the north and east of the predynastic Manchu capital Hetu Ala (known in Chinese as Xingjing), Naluwoji constituted the territorial heart of the Jianzhou Garrison, who became the Manchus. The language in which it was frequently described

evoked the same sort of auspicious mystery witnessed by Umuna's scouting party at Mount Changbai, where the clouds miraculously parted and closed as the emperor's delegates arrived and departed.[56] According to the *Imperially Endrorsed Complete Collection of Images and Writings from Antiquity to the Present*, Naluwoji was "a forest that screened out the sky and hid the sun," "deep with lush trees."[57] Moreover, like Mount Changbai, "all the rivers within the boundaries of [Hetu Ala had] their sources here."[58]

This last element, river sources and by extension water more generally, echoes a repeated theme in other descriptions of the region's auspicious topography. To Yang Bin, a member of Umuna's party, Lake Tamun atop Mount Changbai was an object of wonder: "The mountains are about one hundred *li* high and there is a lake on top, surrounded closely by five peaks. The water is green and extraordinarily pure, the waves playing on the surface."[59] Upon arriving in Girin Ula in 1682, Kangxi composed a poem asserting Mount Changbai's importance as the source of great rivers: "Famed mountain," the emperor wrote, "surpassing excellent, you are the true source of the two rivers."[60] Although the emperor spoke here of only two rivers, sources such as *Veritable Records of the Manchu* and *Complete Collection of Images and Writings* generally discuss three principal waterways: the Yalu, the Sungari, and the Tumen. Depictions of the mountains in these documents likewise emphasize the rivers as important features to the landscape, as the landscapes fairly teem with water. Waterfalls descend from every direction in the *Veritable Records*, crashing down before turning into quick-running rivers, while the six rivers illustrated in the *Complete Collection of Images and Writings* offer a mountain in which every gully seems filled with water (fig. 2.2).[61]

Imperial descriptions of the rivers of the Northeast reinforce the connection between Mount Changbai, Naluwoji, and Hetu Ala, one in which rivers parallel the geomantic significance of lakes and the links created by mountains. Like Mount Changbai, Naluwoji brimmed with water and was the source of numerous rivers that carried geomantic energy outward.[62] Three of these rivers—the Santun, the Tumen, and the Huifa—join the Sungari from the west in its descent from Mount Changbai.[63] Thus, in descriptions of Mount Changbai's geomantic flow, water and mountains join each other to disperse the mountain's auspicious energies. The passage of the veins through Naluwoji created a geomantic node within the forest as the waterways came together with further sources of riverine energy before continuing south to Mount Tai or west to Shengjing and beyond.

In summarizing his argument connecting Mount Changbai and Mount Tai via dragon veins, Kangxi confirmed exactly this geomantic dualism:

> If there are those who doubt that the strength of a mountain can be continuous even through the realm of the sea, or that a mountain's form

and essence can be compared to and called a dragon, they have no basis [for their doubts]. . . . Wei Xiao of the Song dynasty [960–1279] states in his *Explanation of Geography* (Dilishuo) that "[dragons] can be attached to rivers or enter the sea." Thus, that Mount Changbai's dragon enters the sea and becomes Mount Tai is assuredly so. . . . Therefore [our] reasoning is clear and intelligible.[64]

Although his explanation was dedicated to reassuring the reader that the veins could pass through the sea, the emperor generally underlined the close relationship between mountains and water in the geomantic landscape. By drawing attention to waterways, particularly their sources, as well as to mountains, and identifying both as conduits of geomantic energy and auspicious sites of Heaven's powerful and sometimes mysterious interaction with earth, Kangxi organized the Northeastern landscape in terms that paralleled historic readings of China proper.

## The Northern Hitching Post

Through his essay "Mount Tai's Mountain Veins," Kangxi presented a detailed explication of the geomantic relationship between China proper and the newly incorporated territories of the expanded Qing. By identifying a Manchu site, Mount Changbai, as the ultimate source for the geomantic energy that flowed from the ritually most important mountain in China, Mount Tai, and delineating a second geomantic path that elevated Northeastern history on par with that of China, the emperor framed Qing legitimacy in terms that derived from both conqueror and conquered.

In the case of the latter mountain vein, which terminated at Mount Yiwulu, the Liao mausoleums located there are of a piece with the major sites through which the emperor's first vein to Mount Tai passed, nodes in a shared geomantic web joining *guannei* and *guanwai* that derived its power from Manchu mythohistorical monuments. The equation of Mount Yiwulu and Mount Tai as geomantic end points, while intriguing, seems somewhat incongruous, however. Were this northernmost vein to stop at Mount Yiwulu, the symbolic significance of Mount Changbai, the former Manchu capitals, and Naluwoji would culminate in a place that was already invested with non-Chinese political authority, rather than carrying the strength of meaning gathered through these sites to China proper, as was the case with Mount Tai. This poses an interesting question: Did Kangxi end his description of this westward-flowing vein simply because it was not the focus of his essay? If so, where might that vein lead? Following the line extending from Hetu Ala to Shengjing and Mount Yiwulu, which skirts the southeastern edge of the Mongolian steppe (see map 2.2), the mountains lead naturally to Rehe and the Mountain Estate—a site that at once fits

within the ideological construct of the Mount Changbai veins and stands outside it as distinctively Qing, a pivot unto itself.

Kangxi clearly envisioned the park-palace as an auspicious landscape within a powerful geomantic web. His earliest writings on the site present it as such, as the opening lines of "Record of the Mountain Estate to Escape the Heat" (Bishu Shanzhuang ji) indicate: "From the Gold Mountains [Jinshan], mountain veins issue forth, their warm currents dividing into springs. . . . Nourished by Heaven and Earth, one returns here to the essences of Nature."[65] This is a landscape blessed by Heaven, fertile, lush and at peace, benefits deriving from the mountain veins of "Gold Mountain," just as the empire as a whole was protected by Mount Changbai.

Perhaps intentionally, the emperor did not make the identity of the Gold Mountains entirely evident. This ambiguity presents opportunities for both topographic and metaphoric interpretations that together expand the emperor's auspicious geography in interesting ways.[66] For instance, *Complete Collection of Images and Writings* records a Gold Mountain relatively near the Mountain Estate originating on the north bank of the Liao River, 350 *li* northwest of modern Kaiyuan, Liaoning.[67] These would seem like

a possibility for Rehe's mountain veins, as the course of the peaks points essentially toward the imperial park, much as the ranges extending from Mount Changbai lead to their respective endpoints. It is a small range, however, without any obvious significant history from the point of view of the Qing court. This is their only mention in the whole of the imperial encyclopedia, a description quoted entirely from the Ming imperial gazetteer, *Unified Gazetteer of the Great Ming* (Da Ming Yitongzhi), rather than from a predynastic Manchu or Qing source.

There is also the Gold Mountain within the Mountain Estate itself, site of the Pavilion of the Supreme God. Noting that the island had two routes of approach, one by water and the other via a rocky path, Philippe Forêt has suggested that the former might "symbolize the travels along the Grand Canal to Jiangnan," the latter "expeditions into the Changbai mountains."[68] Although speculative, this interpretation fits well with many of Kangxi's ideas about auspicious landscapes, including the interplay of water and mountains, the importance of ritualized passage through the landscape to a sacred terminus, and the centrality of Mount Changbai in the empire's geomantic organization. For Kangxi, however, the significance of Gold Mountain within the landscape of the Mountain Estate appears to have primarily been as a landmark and evocation of a famous site, rather than one of particular spiritual or geomantic meaning, making it an equally unlikely candidate.

The proposition that the emperor's dragon vein might extend from Shengjing and Mount Yiwulu to the Mountain Estate naturally leads back to Mount Changbai. Although Gold Mountain was not among the alternative names applied to Mount Changbai, as the place of Manchu origin, it was essentially a "gold mountain." Aisin Gioro, the name of the Qing imperial clan, literally means "gold belt," a reference to the colored sashes that distinguished different pre-Qing Jurchen clans. The color gold, furthermore, had a history of association with the imperial, both in the Northeast and among Mongols.[69] Reading Mount Changbai in this way—as an imperial mountain, the mountain of the Aisin Gioro—inflects its identity as the source of the Qing's geomantic energy: the emperor has become a mountain and the mountain is the emperor, wellspring of the empire's harmony.

Kangxi's own writings about the Mountain Estate offer a final possibility. In *Imperial Poems on the Mountain Estate to Escape the Heat*, the name Gold Mountain appears only twice. The first is in "Record of the Mountain Estate to Escape the Heat," quoted earlier, which serves as the preface to the *Imperial Poems*; the second is in the emperor's description of the tenth scene in that work, "Northern Post Linking Paired Peaks," which describes a viewing pavilion perched atop the park's northernmost peak (see fig. 6.16, left). In his introduction to the scene, Kangxi departed from

the pattern set in other prefaces for the *Imperial Poems*, which situated their subjects within the park. Instead, he located the pavilion relative to the world beyond the Mountain Estate: "The Mountain Estate is encircled by mountains. The forms of mountains extending north are especially high. To the northwest of the kiosk there is a peak that rises steeply, its form craggy and undulating, long and winding into the distance; this is Gold Mountain [Jinshan]. To its northeast, there is a peak that bursts forth, heroic and strong, precipitous and lofty; this is Black Mountain [Heishan]. The two peaks shelter and embrace, with this kiosk together forming a ritual tripod, standing erect."[70]

Kangxi thus envisioned Northern Post Linking Paired Peaks as the Mountain Estate's geomantic pivot, itself one focal point in the larger auspicious geography of the empire. Although the emperor uses the word "peak" (*feng*) in referring to the mountains, it is apparent from his description that he is referring to long mountain chains, the titular peaks serving as the geomantic sources of their veins, just as Mount Changbai and Lake Tamun did for the mountains and rivers of the Northeast. Two long and rugged mountain ranges stretch from their distant sources into the imperial estate, joining at the mountaintop pavilion. The relationship between the three points is first suggested in the pavilion's name, Northern Post Linking Paired Peaks (Beizhen Shuangfeng). Most often translated as "pillow," *zhen* refers here to a hitching post or peg to which animals could be tied. The intended image is of two peaks tied to, and therefore connected through, the same unifying pole.[71] That these three mountain points are ritually significant is made evident by the emperor's likening of them to a *ding*, or ritual tripod. Central to state sacrifices, the *ding* stood as a symbol of dynastic legitimacy, a key instrument in the rituals essential to the performance of Confucian emperorship.

In the poem "Northern Post Linking Paired Peaks," Kangxi goes on to explain the nature of the two mountain ridges and thereby describe the focal point of their junction:

> Lofty and jagged, ridge and peak form a gate into the imperial
>     precincts,
> Gold Mountain is the earthly manifestation of *qian*, Black Mountain
>     is *kan*.
> Bitterly hot, clouds rise between these two ridges,
> The basin's overflow ceases in a blink, falling [water becoming]
>     a pool in a mountain stream.[72]

In parallel couplets the emperor characterizes the mountains in cosmological and geomantic terms, illustrated through the metaphor of a sudden mountain storm. The opening line establishes the Mountain Estate as

hallowed ground revealed in the opening between two mountain ranges. Gold Mountain and Black Mountain are then framed in cosmological terms, using concepts rooted in divination and geomancy.[73] One of the Eight Trigrams (Bagua) from *The Book of Changes*, qian is associated with the northwest and gold and is therefore the proper cosmological descriptor for Gold Mountain. *Qian* also epitomizes *yang* characteristics, such as the sun, the masculine, and, most important, Heaven.[74] Gold Mountain is therefore the earthly essence of Heaven. *Kan*, another of the Eight Trigrams, is in many respects the opposite of *qian*. Dark, void, mysterious, it is *yin* to *qian*'s *yang*.[75] Representing true north and water, itself associated with the color black, *kan* matches *qian*, standing in for Black Mountain. Together, they construct the Mountain Estate as the resolution of complementary elements, *yang* and *yin*, and the juncture between Heaven and earth.

The image of a rainstorm in the second couplet illuminates the relationship further. Between the two mountains storm clouds rise and rain suddenly bursts forth. Metal, the progenitor of water in *The Book of Changes*, is embodied by the heavenly basin; the water that flows from it forms the mountain streams and lakes of the imperial estate. Here, as in the ridges and river valleys of Mount Changbai and Shengjing, the relationship between mountain and water is geomantically vital, as the two combine to constitute an auspicious landscape. The emperor's heavenly storm may also be read as a metaphor for the auspicious energy produced by the "shelter and embrace" of the two mountains, as complementary forces combine to generate a flow of energy that pools in the Rehe valley. That the focal point for this creation should be a four-sided viewing pavilion encircled by mountains seems most fitting: architecture and landscape together symbolize the universe, a square earth under the round heavens.

The names Gold Mountain and Black Mountain were not used for any mountains in Rehe save that of the Gold Mountain temple, and there are no suitable "ranges" within the walls of the estate. It is possible, however, that Gold Mountain and Black Mountain may refer here to the Altai and Greater Khingan mountains, the major ranges of northeast and northwest Asia (see map 2.1). Originating in Central Asia, the Altai mountains (known as Jinshan in Chinese) run southeast, dividing the Mongolian steppe from the Gobi desert. Similarly, the Greater Khingans (known as Heishan in Chinese) defined the eastern border of the steppe, separating it from the grasslands of the Northeast. Viewed on a continental scale, this image was not just a creative vision for the site. Rising and falling like the dragon veins of Mount Tai, the Altais and the Greater Khingans seem to meet in the mountains around Rehe, a fact not only known through geographical studies of the past but also, and much more definitely, thanks to Kangxi's ongoing interest in mapping the empire.

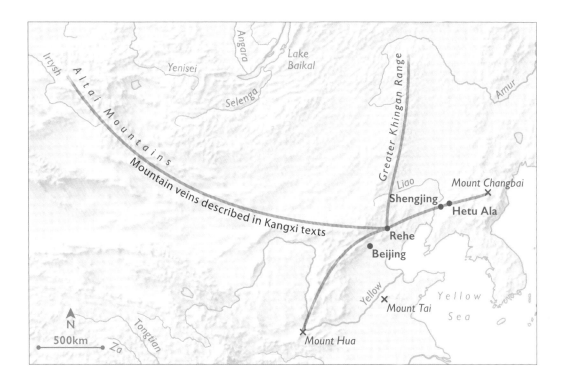

MAP 2.3
Rehe at the continental
crossroads. Map by Daniel
P. Huffman.

It is possible to extend this vision of Rehe as geomantic axis further to encompass the empire as a whole (map 2.3). In his essay on Mount Changbai's mountain veins, the emperor presented Mount Tai as part of a sacred pair with Mount Hua, the dragon and the tiger. Following the Greater Khingans from the north-northeast, they wind and curve their way south, through Rehe and beyond, to Mount Hua; likewise, the Altais become the western end of a great arc that ends at Mount Changbai. Rehe, it seems, might be read as the hitching post of the four directions, the axis of Qing geography, joining *guannei* and *guanwai* into a single entity.

## Recentering Qing

After nearly twenty years of war and political maneuvering, Kangxi shifted his attention from consolidating the empire to integrating its territory into a new geographic body, the Qing—the landscape of which naturally reflected the polity's diverse populations, histories, and cultures. He did this through the marking and interpretation of the land in activities comprehensible to multiple audiences, including touring, mapping, and engaging in geographic and geomantic studies.

In elevating Mount Changbai above the Five Sacred Mountains of China proper, Kangxi established a new ritual wellspring for the Qing. Joining the

origins of the Manchus with the site of sacrifices confirming the Mandate of Heaven, Kangxi at once claimed the mantle of legitimacy on Chinese terms and invested the territorial source of his clan's regional power with new authority. Similarly, by shifting the source of the empire's geomantic flow, through which Heaven's blessings were manifested on earth, to the Northeast, the court simultaneously asserted Manchu supremacy. The result was the formulation of a new geographic vision of the empire, bound together by a cohesive web with the emperor at its multivalent symbolic center.

Through various writings, Kangxi defined an exceptional place for Rehe within this new imperial landscape. At the node of three mountain veins—those of Mount Changbai, the Altais, and the Greater Khingans—the Mountain Estate occupied a privileged position within the geomantic construction of Qing geography. Like Mount Hua and Mount Tai, the park-palace received the energy from powerful veins; like Mount Changbai and Naluwoji, it was also the place where veins met and divided. Descending from the far north, the Northeast and Mongolia, connecting these territories to China proper, Rehe was a point of junction and passage, the pivot in the emperor's creation of a new empire linked physically and conceptually by imperial occupation, cartographic knowledge, sacred chorography, and rhetorical explication.

# "Record of the Mountain Estate to Escape the Heat"

## THE KANGXI EMPEROR

FROM THE GOLD MOUNTAINS, mountain veins issue forth, their warm currents dividing into springs. Broad streams run clear and deep through cloud-enshrouded valleys; purple mists linger over rocky marshes. The area is expansive, the grasses fertile; it has never suffered the harm of fields and cottages. Clear winds and refreshing summers nurture the health of the people. Nourished by Heaven and Earth, one returns here to the essences of Nature.

We have taken several tours to inspect the riverbanks and are deeply familiar with the elegant beauty of the South. Twice, we have toured Qin and Long, and the signs of exhaustion in the lands of the West are increasingly clear to Us. To the north, We have crossed the Dragon Sands; to the east, We have traveled to the Changbai Mountains. The magnificence of the mountains and rivers and the simple honesty of the people cannot be fully expressed, [yet] none of these are the place that We have chosen.

Only here in Rehe is the road close to the Celestial Capital (*shenjing*); going or returning takes no more than two days. We may build upon the land, open fields grown wild. How can embracing this in Our heart interfere with affairs of state? Therefore, We surveyed the contrasts between the heights and the plains, the near and far, revealing the natural formations of the peaks and mountain mists. We built studios amid the pines, the landscape embellished with caves and cliffs. We have diverted water to the pavilions, so that mist will curl among the trees and rise out of the gorges. These are things that cannot be made through the power of men [alone], depending on the verdant land for support.

This text was composed by the Kangxi emperor in 1711. It circulated in numerous manuscript copies and was used as the preface for *Imperial Poems on the Mountain Estate to Escape the Heat*, printed in 1713. Translation by Stephen H. Whiteman.

Without the expense of carved rafters and lacquered columns, We delight in the pleasure of springs and forests, cherishing simplicity. Peacefully, We look out upon the myriad things. Looking down, We study all the varieties of life. Brightly colored birds play on the green waters without fleeing from Our presence; deer reflect the setting sun, gathering in a herd. There are kites soaring and fish leaping, each according to Heavenly natures, above and below. There are distant colors and purple mists, together revealing the rising and falling of a vernal scene. Touring in the spring and inspecting in the autumn, We are not deceived about the joys and sorrows of the farmer's labors. Whether late in the evening or yet before dawn, We never forget the admonitions of the Classics and Histories. We encourage tilling the southern acres in expectation of a bountiful harvest from which the baskets overflow. The ripening of an abundant crop and the completion of the autumn harvest is a happy time, in keeping with the blessings of rains and clearing skies.

This is an overview of living at the Mountain Estate to Escape the Heat. When it comes to enjoying irises and orchids, then We love virtuous acts. Gazing upon pines and bamboo, We are led to ponder moral rectitude. Looking down into clear currents, We thus prize incorruptibility. We inspect the thick, creeping vines and despise the corrupt and immoral. All this is in keeping with the ancients, who relied upon things in order to express ideas through comparison with natural principles or give rise to emotional responses; through these means, there is nothing that may not be understood.

That which the ruler receives is taken from the people. One who does not love them is deluded. Because of this, We have composed a record of Our thoughts. Morning and evening, We will not falter. The essence of respectfulness and sincerity is this.

Written in the last third of the sixth month of the fiftieth year of the Kangxi era.

CHAPTER 3

# Only Here in Rehe

Composed in early August 1711, during Kangxi's long stay in Rehe that summer, "Record of the Mountain Estate to Escape the Heat" is an integral part of the park's "completion" that year, as significant to the framing of the site as the bronze name-tablet over Bishu Shanzhuang Gate or any of the other para-landscapes created around this time.[1] In it, the emperor engages a long-standing genre of garden writing among both imperial and private garden owners to present a brief account "of living at the Mountain Estate." Embedded within this description of a designed landscape is a declaration of imperial aspirations and Kangxi's philosophy of rulership, one that situates Rehe within, and as a key element of, literal and conceptual constructions of a new Qing empire. The text represents a crucial articulation of the emperor's concerns in the later decades of his reign, including territorial integration, the welfare of the populace, and the legitimacy of Manchu rule—themes that also emerge in a number of other contemporary works. As "Record of the Mountain Estate" shows, landscape—both the specific landscapes of the Mountain Estate and other imperial sites as well as the more abstract landscapes of literature and religion, nature, and the territory—was for Kangxi a medium by which these issues could be understood, negotiated, and conveyed.

The turn of the eighteenth century and construction of the Mountain Estate marked a significant transition in Kangxi's reign. As wars of conquest drew to a close in the 1680s and 1690s, the court began to shift its focus to "softer" forms of ideological expression, seeking legitimation in political and cultural terms. A wide-ranging policy of scholarly patronage served simultaneously to legitimate claims to the Mandate of Heaven and bring greater numbers of Chinese scholars into the Qing fold.[2] Although only moderately successful at first, these efforts over time evolved into a robust enterprise that comprised not only literary and scholarly work but also artistic and scientific efforts. Nor were such activities limited to Han or Chinese-speaking audiences. The court undertook an extensive

Manchu- and, to a lesser degree, Mongol-language publication program, while annual hunting and touring north "beyond the passes" allowed the emperor opportunities to interact with border populations, especially key Qing allies among the Inner Mongolian Banners.

As a physical site for interaction with diverse audiences, and through its multiple, multivocal constructions in park, text, and image, the Mountain Estate drew upon (and drew together) many of these ideological tactics. Rehe was conceived and presented as an exceptional landscape, a key symbolic and physical focal point for conveying a new imperial geography. Through "Record of the Mountain Estate to Escape the Heat" in particular, Kangxi imagined Rehe as pure and unspoiled, a canvas upon which the cultural landscape of the Qing could be painted. This negation of existing culture operated in tension with another, equally strong impulse encoded in the park—that of the emperor as a humane ruler, concerned for the welfare of his people. As an expression of Kangxi's conception of the Qing empire, both demographically and territorially, Rehe was at once historically charged and entirely new, conveying geographic, architectural, cultural, and rhetorical aspects of Qing rule, while constructing both ideal emperor and ideal empire through a reimagined landscape.

## Open Fields Grown Wild

Descriptions of the land around Rehe abound in Kangxi's writings. In "Record of the Mountain Estate" and in the verses of *Imperial Poems* the emperor invoked idyllic, auspicious, and mystical landscapes to construct Rehe's special place within physical and conceptual geographies of the Qing. He described an open, unmarked landscape free of barriers to his "palace to escape the heat." Yet the historical realities of long-term occupation and claims to the land by Mongols, Chinese, Jurchens, and the Ming and Qing states potentially complicate this picture. Summer palaces, pasturage, and imperial hunting marked the territory in historical and contemporary terms seemingly at odds with the emperor's rhetorical construction of the site. Closer reading finds that the emperor's own words express this very tension, indication that such disjunctures between rhetoric and reality are central to understanding his conceptualization of Rehe as an exceptional landscape defining the Qing in new cultural and geographic terms.

Kangxi's description of Rehe in the opening lines of "Record of the Mountain Estate" presents the territory as an embodiment of dynastic virtue. Emphasizing "mountain veins," "purple mists" (*qing'ai*), and "cloud-enshrouded valleys" (*yunhe*), Kangxi echoes the language of auspicious geography used to describe the Changbai mountains, Naluwoji, and other sacred sites, embedding the valley within geomantic networks while stressing its isolation and serenity. Acknowledging the region's inhabitants, who

live in peace in a place of "fertile grasses," "clear winds and refreshing summers," their "simple honesty" is a reflection of their physical environment. Rehe is at once the epitome of virtue and its inspiration: the landscape itself is humane, a reflection of Heaven's blessings upon the dynasty, protecting and nurturing those who live harmoniously within it. Enumerating his many travels, Kangxi conveys his deep knowledge and understanding of the empire and the importance of imperial touring to understanding the lives of his subjects. Yet he argues that for all the empire's virtues, Rehe remains a place apart. Here, the "essences of Nature" become the "essences of Rehe," and the valley is established as a space of unique meaning and value. Offering a direct, nourishing connection with the fundamental forms of the universe, the landscape's beneficial effects upon the emperor are central to his justification for building there.

The duality of being unmarked and separate, yet also tied to "the capital" and all it represents, is intrinsic to Rehe's exceptionalism. Kangxi's choice of words—"open fields grown wild" (*huangye*)—reflects the tension at the heart of ethnic and territorial integration during this period. Often understood as "wastelands and wilderness," *huang* and *ye* are more complex than this.[3] Specifically, they define space relationally rather than in absolute terms: peripheral, not isolated, Rehe could exist as a space at once untouched and connected. The clearest connotations of *huang* and *ye* are to ways of defining the human landscape, especially fields and boundaries. Following *The Kangxi Dictionary* (Kangxi zidian), published by the court in 1716, the terms first suggest open expanses of space. *Huang* space is, or has become, unproductive: farmland overgrown with weeds (*tianchou huangwu*), land overgrown by grasses (*caoyandi*), or discarded (*fei*).[4] Topographically, *ye* refers primarily to open and expansive space (*kuangyuan zhi chu*). It was often used to describe agricultural land: *tianye*, a field, or *zhangye*, a sort of municipal hinterland where grain reserves were grown.[5]

Not all its meanings denoted productivity, however. At times, *ye*'s connection to the city was more distant, as in the gloss *jiaowai* ("beyond the suburbs"). In these contexts *ye* bore a direct hierarchical relationship with the city as the outermost in a series of concentric districts that still lay within the state's control—city (*yi*), suburb (*jiao*), *ye*.[6] Similarly, *ye* also denoted administrative structures, as a class of land governed by the state (*zhangbang zhi ye*) and at least two official titles: *yesi*, an archaic term for a type of local magistrate, and *yeyu*, essentially a forester with purview over both fields and forests.[7] *Ye* was thus simultaneously in opposition and related to what the city represented in terms of civilization and incorporation. It was the "not-city," external but engaged. Finally, while *ye* generally referred to the land and its maintenance, it also sometimes described the character of people. To the extent that *ye* means "wild," it is most often a comment on the nature of its inhabitants. In early texts "wildness" or

"rudeness" essentially amounted to being "uncivil" or "uncivilized." If you have knowledge but no righteousness, you are *ye*; if you mourn inappropriately, you lack propriety, and thus are *ye*.[8] *Ye* defined an Other to the civilized person, serving as a rhetorical device through which the "gentleman" (*jun*) might be defined.

These meanings of *huang* and *ye* refer to unproductive space that once was, or has the potential to become, productive; as land removed from, yet clearly linked to, the city; and as land occupied by the uncivilized or barbaric. They simultaneously point to the periphery, offering a sense of the unmarked land understood in modern English as "wilderness," while also reinforcing the territory's connection to civilization. Such connotations were central to the rhetorical framing of Rehe through "Record of the Mountain Estate" and to Kangxi's intended interpretation of his traveling palace, his activities, his empire, and himself. The social, cultural, and political histories of the region, at once conceptually "beyond the passes" yet deeply entangled with both China proper and Inner Asia, mirror the tensions present in *huangye*.

By the rise of the Qing, the area around Rehe already had a long history of occupation, with literary descriptions as early as the Northern Wei dynasty (386–535).[9] Historically it was a power base and site of economic strength for so-called conquest dynasties, including the Liao and the Jin, who exploited proximity to pasturage and agricultural land in their rise to regional dominance.[10] Although tradition clearly marked the northern border of China proper with a conceptual, if not physical, Great Wall, the region around the Wall, including Rehe, is better understood as a shifting series of "border zones" in which various ethnic populations interacted and intermingled, whether through trade or permanent settlement.[11] The "constant movement" of Mongol, Jurchen, and Chinese populations over long periods resulted in a fluid cultural identity for the area and its population.

Political authority in the region was similarly ambiguous during the Ming. Mongols and Jurchens organized themselves into discreet subgroups focused around kinship ties, each occupying a particular territory. While Rehe itself was controlled directly by Ming forces, Jurchen territories further east were ostensibly under imperial control by way of local elites, part of a system of garrisons through which the imperial court sought to integrate non-Chinese neighbors into the Ming bureaucracy.[12] By the mid-sixteenth century, however, Ming control of the Northeast had substantially weakened, as the Haixi and Jianzhou Garrisons emerged as the most powerful among Jurchen confederacies. In the ensuing decades, the Jianzhou became the Manchus under the leadership of Nurhaci, who established the Later Jin dynasty in 1616. For the postconquest Qing court the connection between the Manchus and the Jianzhou region, which ranged

from the forests east of Shenyang through the Mudan River valley to Mount Changbai and north into modern Jilin, was central to dynastic origins and identity.

Rehe, however, was not. As such, the emperor could paint a picture of Rehe as physically and culturally open, a valley in which he could develop a distinctly Qing landscape. Yet by the turn of the seventeenth century, Rehe was clearly associated with the Manchu regime, as the emperor's annual hunting and touring among the regime's Inner Mongolian allies ultimately determined the need for a permanent establishment in the region. This state of ambiguous simultaneity is captured by the tensions inherent in *huang* and *ye*, and more broadly those at the heart of Qing territorial integration, in which areas long held to be beyond the pale, including Rehe, were recast as part of a new empire. These "open fields grown wild" are thus a metaphor for the empire as a whole—a place Kangxi could, and did, transform into a distinctively Qing space. Moreover, the view of territory conveyed by Kangxi's development of land characterized as *huangye* carries a moral dimension as well. Once fertile, *huang* land can be redeemed, turned again to good use, whether for agriculture or an imperial retreat. Similar valences underpin the integration of territory at the scale of empire, as both land and people from "beyond the passes" come under the righteous gaze of the emperor.

## Carved Rafters and the Southern Acres

Through a variety of means this investment of the land and territory with moral qualities was extended to the emperor, intertwining both his person and his rule with the landscape. Focusing on the hardships of agricultural life, imperial frugality, and the preservation of state and local resources, "Record of the Mountain Estate" described a park whose very fabric was constructed by and through the emperor's virtue. Employing references to historical paragons and cultural tropes, the text rooted those qualities in legitimate succession to both Chinese and Inner Asian pasts and extended the mandate they affirmed from Rehe to the rest of the empire.

Kangxi's descriptions of Rehe and his travels "beyond the passes" linked the imperial territory, its development, and his passage through it with Confucian values of humane and righteous rule and the bestowal of the Mandate of Heaven upon the Qing. Having brought nearly a century of warfare within and beyond China proper to an end, Kangxi sought to emphasize signs of peace and prosperity throughout the empire. In the first of the *Imperial Poems*, which accompanies a depiction of the emperor's private quarters in the park's main palace, the Palace of Righteousness (fig. 3.1), auspicious natural features mark the landscape, signaling the emergence of a new era:

I often come to the Mountain Estate to escape the heat.
Here is peace and quiet with hardly any noise.
It controls the North, where distant wars have ceased
And faces south, near beautiful vales.
When spring returns, fish leap from the waves;
At autumn harvest, geese stretch across the deserts.
Immortals' grasses can be seen everywhere;
Spreading forth from the windows are medicinal flowers.
Northeast breezes bring brisk air by day;
While a gentle rain falls deep in the night.
The soil, so rich, yields double headed grain;
The spring water is so sweet, we can cut open green melons.
In the past, armed men fortified this area;
Now, soldiers no longer sound the martial flute.
Farmers and merchants attend to life's needs,
And the people have increased to myriad households.[13]

Here, Rehe serves as an idealized synecdoche for the empire. Positioned at the juncture between China proper and the Mongol and Manchu territories to the north, the Mountain Estate offers the emperor a poetic vantage from which he sees that signs of war have passed, while those of peace have emerged. The landscape is bountiful once again, and the return of seasonal order—fish in spring, geese in autumn—reveals human harmony reflected in nature, reinforced by the abundant presence of auspicious flora. Heaven's approval of the Qing is manifested in Rehe, which in turn encapsulates the empire.

Heaven's mandate did not appear passively, however. In poems and other documents, Kangxi repeatedly stressed the importance of pursuing humanity and righteousness, while guarding against inattentive governance. Without proper care, peace would be fleeting, a concern expressed in the second of the *Imperial Poems*, "*Lingzhi* Path on an Embankment to the Clouds" (see fig. 1.1), which visually guides the reader to Ruyi Island, site of the park's original halls of state:

How could I ever build a Great Wall
    and rely on border guards?
History has well recorded
    those cruel and profligate rulers.
This is a reason to urge myself
    towards caution and restraint.
Then I can become a model for all,
    comforting near and far.[14]

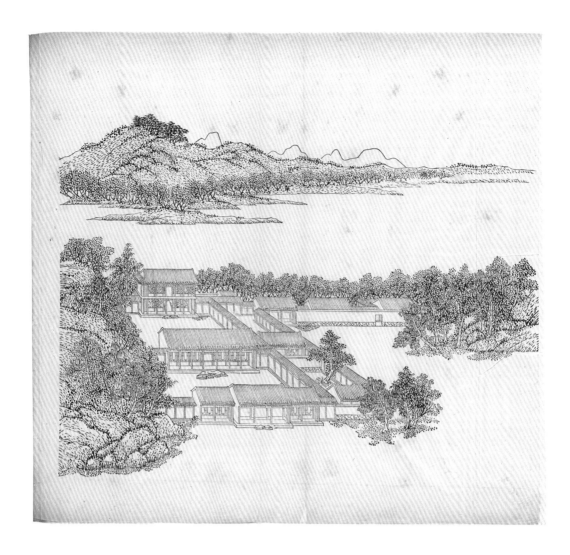

FIGURE 3.1
Shen Yu et al., "Misty
Ripples Bringing Brisk
Air," 1713, from Kangxi
et al., *Imperial Poems*,
scene 1. Woodblock print.
Chinese Collection,
Harvard-Yenching Library,
© President and Fellows of
Harvard College. This scene
illustrates the rearmost
section of the Palace of
Righteousness.

An emphasis on attentive rule was particularly significant given the symbolic import of the Mountain Estate as a permanent investment in the resumption of imperial touring. The emperor's "Record" sought to reassure his readers that affairs of state would be handled no differently in Rehe than they were in Beijing. Pledging that "whether evening or night [*huogan huoxiao*], I never forget the counsel and warnings of the Classics and Histories," Kangxi evoked the model of a ruler so singly focused on affairs of state that he is unable to eat until late at night and rises to dress before dawn.[15]

As a venue for, rather than an escape from, diligence, Rehe's natural environment was acknowledged as its most significant distraction and was thus reframed as its greatest asset. Kangxi, whose extensive travels reveal a personal love of the outdoors, promised he would balance enjoyment with

work.[16] He wrote: "Despite myriad affairs, I find a little time / to leave my gated palace. / With my passion for streams and mountains, / it is hard not to linger on the way."[17] Escaping the heat was not only a personal pleasure but also facilitated effective rule, the argument made in "Un-Summerly Clear and Cool" (fig. 3.2), fourth of the *Imperial Poems*, which depicted the emperor's first throne room on Ruyi Island:

> Here in high summer the heat subsides
> as refreshing breezes arrive.
> Encountering coolness in this season,
> I appreciate the beauty of things.
> Constantly mindful of
> the ideal of addressing affairs of state from morning to night,
> Pacing back and forth, I ponder
> how to rule in these times.[18]

FIGURE 3.2
Shen Yu et al., "Un-Summerly Clear and Cool," 1713, from Kangxi et al., *Imperial Poems*, scene 3. Woodblock print. Chinese Collection, Harvard-Yenching Library, © President and Fellows of Harvard College.

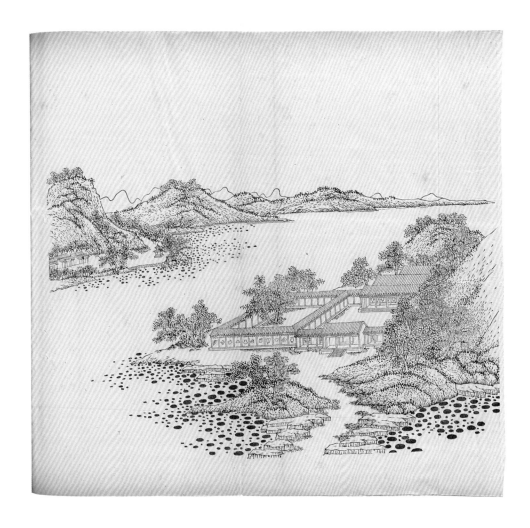

According to Kangxi, the attraction was less physical than mental, a rhetorical concession perhaps again meant to address concerns surrounding an overly mobile or militaristic ruler. In the preface to "Fragrant Waters and Beautiful Cliffs" (see fig. 6.19, left), which depicts a Buddhist meditation hall also on Ruyi Island, Kangxi developed this relationship between a pure landscape and a mind cleansed by his surroundings and quiet reflection: "When water is pure, it emits a fresh fragrance; if mountains are tranquil, they possess a refined beauty.... Here, I can intone poetry and nurture my vitality undisturbed by affairs. I can wash away cares and delight my own nature."[19]

This sense of restraint extended beyond an assertion of engagement and concerted self-preservation over mere leisure to find a regular and revealing voice in the importance of imperial frugality. Exemplified by the eschewal of "carved rafters and lacquered columns" (*kejue danying*), architectural elements associated with imperial largesse and dynastic decline, Kangxi framed himself as a ruler whose concerns lay beyond the material perquisites of power.[20] Not only did excessive decoration sully the elegance of the architecture, it interfered with one's ability to gain clarity and focus through a connection with the natural world. Rejecting such finery made "taking pleasure in springs and forests and cherishing simplicity" possible; a simple shelter "attains the elegance of a mountain home. Open the northern doors to let in a cool breeze, and one almost forgets that it is the sixth month."[21]

According to imperial rhetoric, an equally strong motivation for the emperor's modesty was a concern for the common people, whose delicately balanced lives would be threatened if the court's demands overly strained human or natural resources. The emperor used *Imperial Poems* and other texts to convey this injunction from the start. In the memorial ordering construction of the Rehe Traveling Palace, officials were urged to "economize labor, economize time, economize capital," a concern reiterated in *Imperial Poems*.[22] Part of what made Rehe ideal was how little human intervention was required:

> There was no need to destroy fields
> or cut down any trees.
> For the land conforms in shape
> to Heaven's natural design.
> It needed no human labor
> for artificial constructions ...
> Mindful always of straining the people
> when traveling for pleasure,
> I also feared burdening them
> to obtain construction workers.[23]

Writing that "the Chamberlain was not to use government treasury funds. / I preferred the rustic and rejected flamboyance to be in harmony with the people," modest design became a route to both fiscal responsibility and expressing empathy with imperial subjects.[24]

Labor and expense were conserved through intentional approaches to production and natural resource harvesting. In the stele erected at the Temple of Universal Benevolence commemorating the temple's construction in 1713, the emperor described the careful means by which building materials were secured: "Bricks were made in the fields, materials were taken from the mountain, so that there was neither the labor of hauling and moving long-distance, nor the monetary cost of excessive luxury."[25] Perhaps in response to endemic shortages of timber in the early Qing, the emperor insisted that wood be harvested locally. In this, Kangxi's rhetoric again suggests a response to cautionary tales of the past, as Han emperors, whose vast imperial parks were considered harbingers of imperial excess and dynastic decline, were known in several cases to have imported exotic woods for use in their palaces and gardens.[26] Similarly, the emperor claimed to avoid occupying arable land in establishing an imperial presence in Rehe. His description of the park's "open fields grown wild" extended to the Temple of Universal Benevolence, approving of its site "because the area to the east of the Mountain Estate is a wasteland uninvolved with agriculture."[27]

Rhetoric surrounding the preservation of productive land echoed broader expressions through the landscape of the emperor's moral responsibility for agriculture. Here, too, virtue and dynastic stability were linked, such that "promoting farming in accord with the seasons is my imperial ambition / So that the beacons of war will no longer burn for a myriad autumns."[28] Connections between agriculture and other ritual practices broadened the means by which Kangxi identified with his subjects. The court linked touring to farming, for instance, by referencing the mythical ruler Shen Nong, progenitor of Chinese agriculture, who toured the empire inspecting the welfare of the people and teaching agricultural techniques.[29] In "Record of the Mountain Estate," Kangxi bolstered arguments for seasonal touring and its necessary infrastructure through repeated references to bountiful harvests and a ritually observant, harmonious populace, reflections of sage rule and a peaceful era.[30] Shen Nong's influence is also reflected in the Manchu continuation of the emperor's role as chief ritual agriculturist, including the personal cultivation (qin'geng) of symbolic plots. Although these practices were not annualized until the reign of Kangxi's son, the Yongzheng emperor, Kangxi followed the model initiated by his father, Shunzhi, in diverse ways.[31] Most famously, perhaps, he commissioned an album of Images of Tilling and Weaving (Gengzhi tu; see figs. 4.15, 6.13), an iconic series originally by the Song artist Lou Shou

(1090–1162) that articulated an imperial vision of agricultural ritual and benevolent rule through emulation of historical models.[32]

Farming played an important ritual and practical role in several early Qing gardens, including the Mountain Estate, the Garden of Abundant Benevolence (Fengzeyuan), located just west of the Forbidden City, and the Garden of Joyful Spring (Changchunyuan), in suburban Beijing. In "Record of the Garden of Joyful Spring," Kangxi described the landscape in terms quite similar to those used for the Mountain Estate, both in imagining an auspicious landscape and the metaphoric relationship between agriculture, imperial morality, and the welfare of the people:

> Layer-upon-layer of hillocks reveal distant water shores, and morning haze is followed by evening mists. Fragrant flowers bloom in all seasons, and rare birds sing among the people. When crops yield a rich harvest, and the fields are fragrant with sweet smells, I can engage with beautiful scenes coming from all directions, and my heart projects into the distance. But sometimes, when crops are ruined and sun and rain come at the wrong time, I stand on a footpath in the fields feeling compassion for the farmers, or open the window to check the ditches irrigating the fields. I look for signs of rain with ardent hopes and pray anxiously to the sky.[33]

At the Garden of Abundant Benevolence, Kangxi physically realized this rhetoric in the form of a small silkworm nursery and a model rice farm, where he grew a strain of early harvest rice newly developed by the court.[34] This reenactment of *Images of Tilling and Weaving*—later echoed in Yongzheng's literal insertion of himself into another version of the album and Qianlong's construction of an idealized rural homestead at Pure Ripple Garden (Qingyiyuan)—invested Kangxi's rhetorical dedication to the abundant harvest with his person through labor and ritual.

In Rehe, architecture and practice similarly complemented textual descriptions in articulating the emperor's agricultural morality. Farming at the Mountain Estate, at least at a symbolic scale, echoes broader concerns about agricultural sustainability and the effect of infrastructural development on the immediate region. Although by no means self-sufficient, the park-palace contained a variety of productive spaces during the Kangxi period. The best known of those was the emperor's so-called "melon patch" (*guapu*)—a term not necessarily meant literally that described a small plot of land farmed for pleasure and personal productivity akin to a kitchen garden. Under Kangxi this was a sizable enclosure located along the southeastern edge of the Garden of Ten Thousand Trees (Wanshuyuan) that stretched north along the park's perimeter wall from Rehe Spring to roughly where Blessings of Spring Studio (Chunhaoxuan) was later built.[35]

A second garden plot existed for a time near the floating cups pavilion, just south of Rehe Spring.[36]

In addition to the regular planting of trees to maintain the landscape scenery—a thousand pines were planted in 1716, for instance—fruit trees such as cherry, peach, and pear were also cultivated.[37] By 1718, if not earlier, there was a rice field to the east of Bishu Shanzhuang Gate.[38] No record survives of how large it was, but the areas in which Qianlong later constructed Pine and Cranes Retreat (Songhezhai) and the Eastern Palace were essentially open at the time (see map 1.1). Rehe was also the site of a significant granary, one of a number in the region that provided rice, millet, and *gaoliang*, at least, to garrisoned troops and local relief efforts; it presumably supplied grain to the emperor and his retinue as well, supplementing stores grown at the park-palace.[39] Finally, chicken and small livestock were raised at the Mountain Estate, complementing deer and fish, both of which would have been stocked as part of the scenery and for hunting or catching.[40]

Although the court could not have grown enough in these spaces to support the Mountain Estate's summer population, their presence indicates that Qing court gardens were intended in part as productive spaces, as both imperial and private gardens had long been.[41] No account survives of annual yields from the Mountain Estate, but a series of undated reports from Tangquan, another of the traveling palaces on the Imperial Road from Beijing to Mulan, indicate the degree to which even this small compound was turned to productive use. Official records boast of a flourishing vegetable plot, rice, millet, and wheat, watermelon, livestock, ducks, three types of lotus, and two of water caltrop.[42] Reeds from the garden's ponds were reaped in significant quantities, while vats of pickled cabbage and mustard greens were produced.[43] Even ice was a target at various Qing compounds, harvested in winter for use during the emperor's summer stays.[44] Besides contributing to Kangxi's table during his residence, such produce also supported the near constant flow of gifts that the emperor bestowed upon visitors and courtiers. These varied depending on the time of year and recipient: in late spring, chickens and sheep were particularly common; in late summer and early autumn, melons were symbolic of a plentiful crop for both the Mountain Estate and the empire as a whole.[45]

However incremental, the attention to utilizing available resources for building and growing reduced the strain of imperial presence in the region on local economies. These policies had both practical and symbolic dimensions, as they represent acts of a moral ruler invested in the welfare of his people. Building on historic models of frugality, diligence, and ritual labor, the physical fabric of the Mountain Estate was invested with imperial virtue. By the emperor's hand the landscape was made productive, both literally and figuratively, a transformation that extended from Rehe to the empire within which it was now incorporated.

## Center and Periphery

Following the conclusion of treaties with Mongol groups over the 1680s and 1690s, the frequency with which the emperor entertained steppe elites beyond the passes increased. In his edict of late 1702 ordering construction of a summer estate in Rehe, Kangxi described the political motivation in these terms: the Qing approach to "pacification of the northern borders," one "cherishing those from afar and nurturing [all] peoples," was historically unique.[46] Its realization required unprecedented means, including a permanent infrastructure consisting of a network of traveling palaces, temples, and other sites throughout the region. In his dedicatory text at the Temple of Universal Benevolence, the emperor outlined his approach to ruling the Mongols as a central constituency within a multiethnic empire and the significance of Buddhist architecture to this philosophy:

> The fifty-second year of the Kangxi era [1713] was my sixtieth birthday. The multitude of Mongol groups descended, and when all reached the gates of the court, they performed their congratulations. Without consulting on common language, they prepared statements sincerely pleading their desire that I construct a temple in order that I might pray for the blessings of good fortune. When I ponder the Way of ruling All Under Heaven, it is not about receiving good fortune for myself, but taking good fortune as being in accord with the good fortune of All Under Heaven; it is not about personal peace for myself, but taking peace to be peace everywhere under Heaven. Be kind to the distant and help the near—from ancient times, this has been doctrine. My imperial ancestors were noble, my forebears virtuous, tending to those as far away as *yao* and *huang*, with a deep well of benevolence and generosity extending to their very marrow. In the past, when Mongol groups descended, the Three Kings could not rule them and the Five Emperors did not help them. Now, there is no differentiation between the center and the periphery. Discussing Our customs and sensibilities, We are upright and brave. Over the past hundred years, We have come to practice Buddhism devoutly, such that there is no second Way. Guarding the laws and institutions of the empire carefully, We do not dare to neglect our duty. Without awareness or knowledge, a peaceful age has taken form, for which We are daily joyful. Reflecting their loyalty, We are respectful of that which they request.[47]

Here, Kangxi framed alliance with the Mongols in terms that incorporate elements of historical tributary relations while also engaging the Confucian rhetoric of benevolent and humane rule. The Mongol elites who traveled to express their good wishes on the emperor's birthday were

participating in the biannual obligation of "presenting oneself before the throne" (*chaojin*), which was often timed to coincide with important events, such as weddings and birthdays.[48] In return, the visiting nobility requested the construction of a great temple in which the emperor could celebrate Buddhist rites to their benefit. By accommodating this request, the court continued to develop a growing imperially sponsored ritual infrastructure paralleling the one already extant in China proper. Here, it was based not upon the Confucianist, Daoist, and Buddhist practices of China, however, which were represented within the Mountain Estate's walls, but upon the Lamaist beliefs of Inner Asia. In doing so, the emperor demonstrated Qing rulers' commitment to "practice Buddhism devoutly," indicating to Mongols that there was indeed "no second Way."

Though responding primarily to Inner Asian audiences, the Temple of Universal Benevolence, which combined a Han-style plan with Lamaist practices, represented a form of cultural admixture that rendered it generally intelligible to Chinese constituents as well.[49] The language with which the emperor described his treatment of Mongol subjects, inscribed on bilingual steles in Manchu and Chinese, likewise echoed Confucian models of humane and righteous rule while resetting the definition of those entitled to such governance. In taking his own good fortune as "in accord with the good fortune of All Under Heaven" and his peace to be "peace everywhere under Heaven," the emperor no longer saw "All Under Heaven" (*tianxia*) as consisting of China proper, as traditional rhetoric would have had it under the Ming. Instead, it included Manchus, Mongols, and all others who came into the fold. No longer Chinese and non-Chinese, "All Under Heaven" were now the Qing. In their relations with Mongols, the Qing succeeded where sage rulers of the mythohistoric past, the Three Kings and Five Emperors, failed. In supplanting these paradigms of Chinese imperial wisdom, Kangxi reclaimed aspects of political statecraft from Chinese philosophical sources much as he shifted the ritual and geomantic center of imperial geography from Mount Tai to Mount Changbai. Kangxi framed this approach as "unique," befitting a new and unprecedented polity.

The Mountain Estate expressed similar forms of cultural simultaneity, if not outright resolution. In the years leading up to 1708 and completion of the first phase of building at Rehe, the emperor continued his practice of sojourning with Inner Asian elites at traveling palaces along the Imperial Road. In 1707, for instance, the emperor was abroad for forty-one days before arriving in Rehe, including stays of ten and twenty-one days in Huayugou and Kalahetun, respectively—the latter being the earliest and most important Inner Mongolian traveling palace prior to construction of the Mountain Estate. These visits involved gift giving, archery demonstrations, and a wedding as well as receiving Mongol leaders and attending to state affairs. After ten days in Rehe, Kangxi toured and hunted for an additional

seventy days, during which time he moved from camp to camp almost daily, before returning to Beijing late in the ninth month.[50]

From 1708 these activities largely shifted to Rehe, although the extended autumn hunts and associated audiences continued. Travel time from Beijing was shortened to roughly a week, and the emperor's extended summer residence allowed a variety of contexts in which imperial grace (*en*) could be bestowed upon favored visitors. Such occasions helped to distinguish between imperial officials, regardless of ethnicity, and Inner Asian elites, both in terms of their participants and the gifts that were given. In general, only officials received imperial calligraphy, for example, while Inner Asian guests were far more likely to be granted snakeskins and other garments associated with the hunt. Such items were frequently given during intimate audiences consisting of only a few named recipients.[51] Other imperially hosted events brought court officials and steppe elites together, however, either symbolically through common gifts, such as melon and venison, or literally, at banquets, shooting matches, and other activities. The entire empire was represented by synecdoche at these events, as senior officials from court and the seven provinces, imperial princes and kinsmen, Mongol princes, and ambassadors from further afield assembled together before the emperor.[52]

The coming together of elites from across the empire was only one way in which the imperial park symbolically dissolved differences between center and periphery. Contemporary scholars have frequently interpreted the plan of the Mountain Estate as representing "an empire in miniature," the imperial territory given literal form via broad reconstitution in four "districts": "palace," "lake," "steppe," and "mountain."[53] Another, more conceptual reading suggests that the design of the park-palace under Qianlong manifested the Qing imperial impulse toward the "archive," drawing parallels between not only territory and the garden but also encyclopedic knowledge and conceptualizations of universal emperorship.[54] While neither formulation is explicitly supported in Kangxi-era texts, they offer a useful point of departure for reading the park's landscape as modeling an idealized Qing territory.

Returning again to the emperor's 1702 edict, Kangxi directed officials to "closely study famous gardens of the North and South, provide draft plans, construct models, and submit them for imperial review."[55] This instruction, though ostensibly limited to gardens, found expression in the park through more or less literal quotations of famous landscapes, especially in the area of the central lakes. Here, the evocation of Hangzhou's West Lake landscape is immediately evident as one looks across Lower Lake toward the willow-lined banks of *Lingzhi* Path on an Embankment to the Clouds (fig. 3.3), which from a distance resembles Su Dyke (Sudi), named for the Song literatus and erstwhile magistrate of Hangzhou, Su Shi (1037–1101).[56]

Nor were these constructions limited to the physical landscape. In describing "kites soaring and fish leaping" (*yuanfei yuyue*) in "Record of the Mountain Estate," the emperor invoked an established metaphor for a free and natural state of being while linking the park to two other famous sites in China proper, the Fangsheng Pavilion (Fangshengting) at West Lake and Huilan Rock (Huilanshi) in Huangzhou, Hubei, where an inscription of the words attributed to the Tang poet Li Bo is carved.[57] Many references sought to associate Rehe with significant cultural landscapes in this way, invoking or directly employing the processes of accreted mediation and collective memory by which such spaces are formed. For visitors like Zhang Yushu, the scale of the park precincts would have blurred the lines between enclosed garden and unenclosed landscapes, a sense reinforced by landscape elements such as cliff carvings that immediately evoke peaks around China that bear inscriptions by famous visitors.[58]

Drawing on histories of popular and elite engagement with landscapes, *Imperial Poems* as a whole furthered this construction. Among other sources of inspiration, the volumes are particularly indebted to records of famous sites, an important genre of literature and picture-making that emerged in the Northern Song period.[59] Works depicting famous sites, especially those of the South, proliferated over the course of the Ming and early Qing, aided by the printing boom of the sixteenth century. In combination with the garden itself and other accretions—such as visitors' accounts, steles, architectural inscriptions, associated texts, and paintings—*Imperial Poems* constituted an originary monument in the creation of a cultural landscape at Rehe analogous to those of China proper. *Imperial Poems* represented the primary literary and artistic interpretation of the site with which subsequent visitors would at some level engage, and which superseded all previous marks of cultural mediation. Through terms founded in the Chinese cultural past, Rehe served as a tableau for the articulation of a cultural landscape that referred particularly and distinctively to Kangxi and his vision of emperorship. He then invited his viewer-guests to share in this landscape through the pages of *Imperial Poems*, just as he did when taking them through the halls and mountains of the park itself.

The landscape of the Mountain Estate did not just reference China proper, however. It also evoked that of the Northeast and Inner Asian steppe. In some cases this involved quite literal incorporation of landscape elements, such as plantings. While floating on the lakes during his second visit, Zhang Yushu described a variety of lotus, "the color of which was perfectly gorgeous," growing at the southern end of Inner Lake. The blossoms were a gift from the Aohan, Inner Mongolian allies who made annual pilgrimages to Rehe under Kangxi.[60] Elsewhere, Kangxi recorded that interspersed among this colorful array were white lotuses from China proper (*neidi*), the two varieties forming "an intricate brocade."[61] Like the

FIGURE 3.3
View across Lower Lake
toward the willow-lined
*Lingzhi* Path on an
Embankment to the Clouds.
Photo by the author.

late summer banquets staged at the park, the landscape itself assembled the diversity of the empire into a coherent if still differentiable whole.

On a larger scale the Garden of Ten Thousand Trees has customarily been read as representing the steppe. Though never explicitly stated, the emperor's own description of it clearly evokes Inner Asian ways of life: "North of the pavilion for floating cups and west of the melon patch are grounds as flat as the palm of a hand, where plants abound and trees flourish. It is filled with deer, pheasants, and rabbits, all dwelling together. When the brisk autumn weather tightens bow strings and strengthens arrows, a multitude of followers is assembled, and we encircle the animals on foot. It is indeed a choice hunting ground."[62] This incorporation of the steppe landscape into the framework of famous places by which *Imperial Poems* helped define the Mountain Estate constituted a recasting of the conceptual territory of empire through the lens of genre. Territories from "beyond the passes" were presented, both specifically and more broadly, as part of the same raw material of cultural landscape found in China proper.

If the lakes evoke the South, and the plain, the Mongolian steppe, what then of the mountains filling the western portions of the park? Generally taken to represent the mountainous regions of China proper, another, more compelling comparison may be drawn. Although Rehe was never designated an imperial capital, the emperor's extended annual presence there rendered it a de facto one.[63] Like earlier steppe regimes, including the Liao, Jin, and Yuan, which all figured prominently in the Qing's rhetorics of dynastic legitimation, the Qing had more than one official capital: Shengjing, the last of the Manchus' predynastic centers, was designated

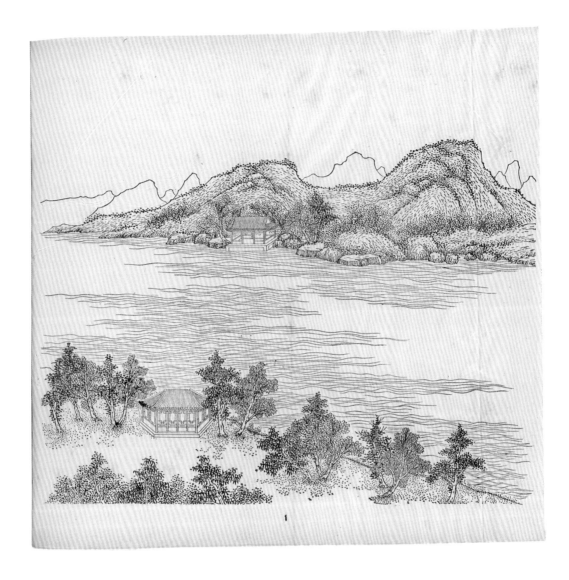

FIGURE 3.4
Shen Yu et al., "Orioles
Warbling in the Tall
Trees," 1713, from Kangxi
et al., *Imperial Poems*,
scene 22. Woodblock
print. Chinese Collection,
Harvard-Yenching Library,
© President and Fellows of
Harvard College.

the eastern capital, although it served a primarily ritual function.[64] Rehe
is proximate to capitals of both the Liao and Jin—Zhongjing and Beijing,
respectively—in keeping with historic practices of constructing new seats
of power on or near the sites of earlier ones.[65] Moreover, the spatial arrange-
ment of Qing imperial camps while on tour resembled that of the capital.[66]

In plan, however, the Mountain Estate is not similar to conventional
Chinese capital cities, which generally do not have outer walls that encom-
pass or, more pointedly, traverse nearby mountains, as the park-palace's
does. In this regard, the plan of the Mountain Estate more closely imi-
tates those of predynastic Manchu capitals, particularly Fe Ala and Hetu
Ala.[67] This comparison suggests that the park's mountains may relate to
the Manchu's Northeastern homeland rather than to the western regions

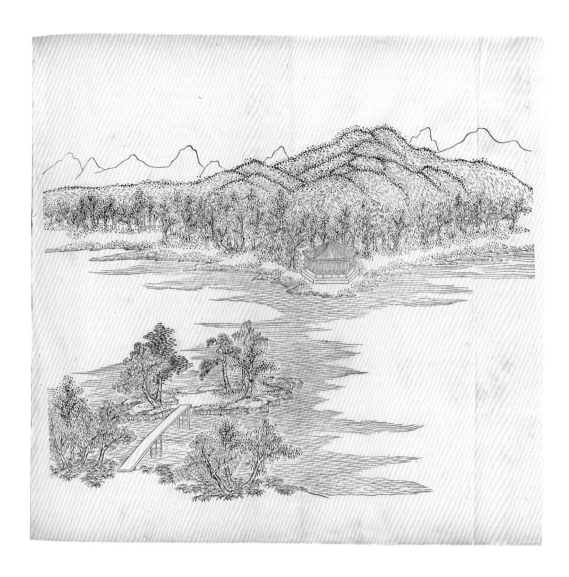

of China proper. In this light the elaborate hydrological engineering of the area takes on new significance: not simply scenic features of the garden, these channels recall the multitude of rivers descending Mount Changbai (see fig. 2.2) and flowing through the forests of Naluwoji, drawing in the numinous qualities of those auspicious areas and directly re-creating the landscape of Manchu origins within the walls of the park-palace.

The park's capacity to evoke or represent something larger than itself involves manipulations of scale through design, perception, and imagination. Such effects are linked to conceptions of gardens as landscapes that blur the distinctions between nature and artifice. Re-creations of nature that are nonetheless physically enclosed, the ambiguity of gardens' construction and representation denies or effaces their delimitation. This lenticularity

allows the Mountain Estate to simultaneously operate on two scales, one physical (the park as bounded space, metaphor *for* the empire), the other, conceptual, a "garden without walls" in which boundaries are elided—the garden *as* empire. The Mountain Estate's perimeter wall simultaneously doubles and supplants the outer walls of the compounds and gardens that lie within it, such that the park's individual structures exist as independent landscapes unto themselves *and* as discrete parts of a larger whole. Moreover, the perimeter wall's final, crenelated design is strongly suggestive of both city walls and the Great Wall, which had been substantially restored under the Ming.[68]

As such, the park's outer wall delimits a space operating on three different scales—garden, urban, and imperial—that share physical parameters but are conceptually nested within each other: a single landscape concentric unto itself.[69] The aesthetic evocation of the Great Wall is especially important here, as it speaks directly to reading the Mountain Estate as an epitomization of an idealized imperial territory. From this perspective the park's perimeter wall comes to represent a new Great Wall, one that encompasses rather than divides *guannei* and *guanwai*. Harnessing the imagined role of the Great Wall as demarcating civilization and defining a cohesive cultural territory, the wall around the Mountain Estate serves to symbolically define a new Qing.

This merging of distinct territories through the symbolic refiguring of the Great Wall is supported by a particular architectural feature inside the park. Four pavilions stretch across the northern shore of the lakes and the southern edge of the wooded plain (see map 1.3). They form a "border" between the central lakes, associated with China proper, and the steppe-like Garden of Ten Thousand Trees. Rather than dividing, however, this imagined barrier remains porous—the pavilions are separated by largely open space, while the structures themselves can be opened on at least two, if not all four, sides. All four appear in *Imperial Poems*, where the representation of the central pair, Orioles Warbling in the Tall Trees (fig. 3.4) to the east and Untrammeled Thoughts by the Hao and Pu Rivers (Hao Pu Jianxiang; fig. 3.5) to the west, reinforces the pavilions' architectonic symbolism as both demarcating and permeable.

Formally, each of the thirty-six images in *Imperial Poems* describes two points of view: that of the print's viewer and that of the hypothetical occupant of the architecture being depicted, the latter reinforced by the imperial text with which it is paired. In most instances these two points of view are essentially the same, as the purpose of the scenes is to offer the book's readers access to the experience of being in the garden. In the cases of the two pavilions, however, this form of shared perspective is upended, as the viewer looks in at the scenes' hypothetical actors and the landscape beyond, while those imagined actors gaze back at the picture plane. In "Untram-

meled Thoughts by the Hao and Pu Rivers," the viewer, positioned to the south on Ruyi Island, gazes north across Clear Lake onto the eponymous pavilion; the scene's name and its poetic description refer to the water, not to the trees and mountains in the image's background. "Orioles Warbling in the Tall Trees" presents just the reverse. This time, the viewer looks south across Clear Lake at Ruyi Island, while the sensorial focus of the scene is on the cool shade and bird songs of the Garden of Ten Thousand Trees.

Together this string of pavilions may be seen as standing in for the "real" Great Wall while simultaneously modeling changing contemporary understandings of the Wall as a symbolic, rather than actual, barrier.[70] By incorporating two views—one explicit, the other implied and reinforced through textual description; one oriented to the north, the other to the south—each scene captures both lake and steppe, *guannei* and *guanwai*, in a single landscape. Just as Kangxi described the Mountain Estate as a watchtower from which he could look both north and south onto an empire at peace, the four kiosks represent beacons along a now permeable border, its two sides having become one.

## Purple Mists Parting

Like the measured contrasts of the land, the built amid the forest, and the rising and falling of the vista, the construction of emperor and empire at the Mountain Estate reflects the simultaneous resolution and persistence of dualities. At the center of these stood the site's ambiguous geographic status. In describing Rehe as *huang* and *ye*, Kangxi was at one level referring to its lack of inhabitants and corresponding availability for imperial use. His choice of terms, however, underlined the potential for acculturation. Rehe was a barren landscape that could, in multiple senses, be redeemed.

Here an interesting parallel emerges between the rhetorics of early Qing immunology and conquest. In contemporary parlance, someone with acquired immunity to smallpox was referred to as "cooked" (*shu*) as a result of the disease's fever, whereas those still susceptible were termed "raw" (*sheng*).[71] The "cooked" traveled to Beijing to see the emperor, while the "raw" were the primary audience for the northern hunts.[72] In another context these same terms were applied to indigenous populations, such as native Taiwanese and the southwestern Miao, before and after the "civilizing influence" of Qing conquest.[73] One reason for the Mountain Estate's construction was to provide Kangxi a venue for meeting with those whose immune systems could not withstand the germs of the capital, as well as with those whose could; as such, it became a site at which the division between raw and cooked was elided, even resolved.

The same essential distinction surfaces repeatedly in the emperor's description of Rehe: though initially "wilderness," beyond the literal and

metaphoric pale, it becomes part of the empire through the presence of the Mountain Estate and the integration of its territory into the annual circuits of imperial touring. "Open fields grown wild"—a metaphor that from the Qing's perspective might be extended to the empire as a whole under the Ming—are turned productive through the emperor's virtue and labor. In this formulation of empire both China proper and Inner Asia were to be mutually accommodated under the Qing, a resolution for which the Mountain Estate was simultaneously conceived as the paragon and the pivot. A landscape of exception, standing outside the Qing while epitomizing it, the Mountain Estate resembled the four pavilions stretching along the northern bank of Ruyi Lake, both fixed and immaterial. Rehe had become, in the emperor's words, "the junction of the center and the periphery" (*nian Rehe zhi di wei zhongwai zhi jiao*).[74]

The Mountain Estate thus constitutes two forms of imperial unity—on the one hand, a vantage point located at the pivot of the new Qing, rather than at the border of disparate regions, and on the other, a *sacromonte*, capturing the physical and conceptual whole in miniature.[75] Yet this duality necessarily leads to the site's own elision. Standing at the junction of the parts, the Mountain Estate draws them together into a whole, while simultaneously serving as a metonymic construction of that same whole. Nested one inside the other, the unified empire and its landscaped instantiation blurred the scale and boundedness of the Mountain Estate as a physical and rhetorical landscape, evoking the ambiguity of the garden without walls and creating a new duality for Rehe.

# Painting and the Surveyed Site

Rising over 2.5 meters high and nearly 2 meters wide, Leng Mei's painting *View of Rehe* opens, corolla-like, before the viewer (fig. 4.1). The emperor's traveling palace lays nestled in a protective ring of bluish-green mountains climbing in layered forms from the valley floor. Each courtyard and hall is carefully depicted, precisely arrayed around the lakes and in the hills along the left, effectively western, edge of the composition. In courtyards and among the trees, cranes and deer stand singly and in pairs, while a pair of geese, birds of the steppe, fly northwest across the lower lakes. The landscape is otherwise devoid of living creatures; several boats, a few garden tools, and a lantern and banner hung outside a hall are the only signs of human habitation, as if the garden awaits its royal occupants.

In the lower right the signature of the artist appears, together with two of his seals. The painting is highly unusual for Leng Mei (active ca. 1677–ca. 1742), a court artist best known for figure painting in divine or mythohistorical narratives, often in small album formats.[1] The work is untitled and undated: the Qianlong-era catalogue of the imperial collection, *Precious Records of the Stone Moat* (Shiqu baoji), records it as *View of the Mountain Estate to Escape the Heat* (Bishu Shanzhuang tu), and with the exception of Leng Mei's own, the painting's seals all date from this period or later.[2] The dates and titles assigned by modern scholarship have largely hinged on scholarly opinions about the state of architectural development depicted in the painting (map 4.1), a compelling but problematic interpretative approach reliant on the assumed internal consistency of Leng Mei's highly specific portrayal of the site. Yang Boda refers to the painting as *Bishu Shanzhuang tu* and places it between 1711 and 1713, concluding that it was produced as an auspicious picture for the celebration of Kangxi's sixtieth birthday.[3] Others, noting the absence of the Palace of Righteousness, conclude that the painting must predate its construction circa 1710, and thus see it as illustrating the park in its earlier formation as the "Rehe Traveling Palace" (i.e., *Rehe xinggong tu*).[4]

In either case, this attention to *what* the picture literally depicts has missed more significant questions about *how* it depicts. Leng Mei's composition reflects an admixture of stylistic modes, generic leitmotifs, and parapictorial references drawn from Chinese painting and the court's own evolving landscape manner. It reveals a complex approach to the construction of pictorial space based in both established, endogenous modes and European techniques acquired through missionaries at the court. Integrating aspects of idealized place-making with maplike qualities and even cartographic methods, the work underlines important characteristics of landscape in the Kangxi court. In addition to architectural and textual expressions, the

MAP 4.1
Architecture depicted in
Leng Mei's *View of Rehe*
contrasted with other
Kangxi-era development.
Map by Daniel P. Huffman.

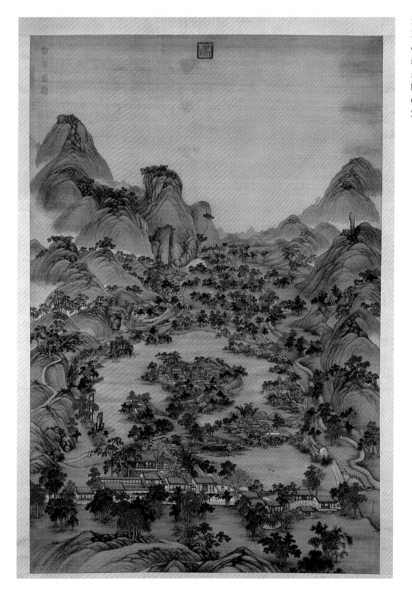

FIGURE 4.1
Leng Mei, *View of Rehe*,
ca. 1709. Hanging scroll,
ink and color on silk,
254.8 × 172.5 cm. Provided
by the Palace Museum,
Gu8210. Photo by Liu
Zhigang.

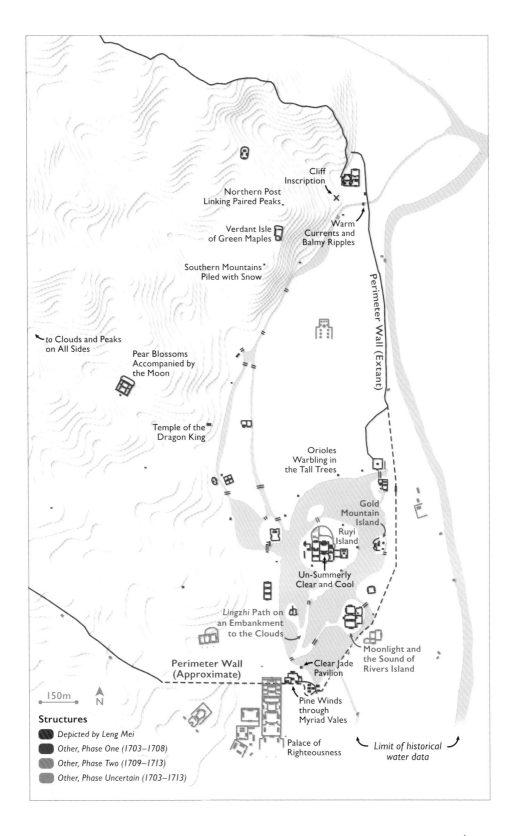

Cliff
Inscription

Northern Post
Linking Paired Peaks

Warm
Currents and
Balmy Ripples

Verdant Isle
of Green Maples

Southern Mountains
Piled with Snow

*to* Clouds and Peaks
on All Sides

Pear Blossoms
Accompanied by
the Moon

Temple of the
Dragon King

Orioles
Warbling in
the Tall Trees

Gold
Mountain
Island

Ruyi
Island

Un-Summerly
Clear and Cool

*Lingzhi* Path on
an Embankment
to the Clouds

Moonlight and
the Sound of
Rivers Island

Perimeter Wall
(Approximate)

Clear Jade
Pavilion

150m

N

Pine Winds
through
Myriad Vales

Palace of
Righteousness

*Limit of historical
water data*

Perimeter Wall (Extant)

**Structures**
Depicted by Leng Mei
Other, Phase One (1703–1708)
Other, Phase Two (1709–1713)
Other, Phase Uncertain (1703–1713)

formation of landscape and its social and political valences relied integrally on emerging understandings of pictures and technology. This situation was by no means unique to the Qing: measurement and representation defined the land and its mediation across early modern Eurasian societies.[5] The Qing—and specifically the Kangxi court—offers an especially compelling example of the role of transcultural encounter and exchange in this process, however. Pictorial techniques and the applied mathematics of space, understood by both Chinese and Europeans in the court as related processes, engendered new approaches to spatial representation.

These dualities reflect a moment in which Chinese and European practices were engaged experimentally and strategically to achieve particular effects.[6] Thinking about the resulting method or style not as "hybrid" but as a technology unto itself—one that, as with any technology, could be developed, transmitted, adapted, and repurposed—allows it, and pictorial rhetorics more generally, to be seen as tools that served a particular end, communicating visually in response to specific needs and audiences. Understanding the formal and technical underpinnings of Leng Mei's *View of Rehe* situates the painting as more than a mimetic record of the primary site. It embodies the court's evolving triangulation of landscape, technology, and emperorship within the currents of ideas moving back and forth across early modern Eurasia.

## A Kangxi Synthesis

Whatever its methods and constituent parts, Leng Mei's work appears as a coherent, multifaceted composition, legible on formal and symbolic levels to its intended audiences.[7] The painting is an image of the park as the emperor wishes it to be seen and understood, one that combines the veristic qualities required to make the site recognizable with a pictorial rhetoric drawn from contemporary court practice layered with vocabularies of historicity and auspiciousness. In this sense it acts as a sort of portrait, communicating through the tension between objective portrayal and subjective presentation.[8]

Generally speaking, *View of Rehe* fits within the tradition of palace paintings, a subgenre of history painting often invested with mythohistorical qualities.[9] *Emperor Minghuang's Palace to Escape the Heat* (Minghuang Bishugong tu; fig. 4.2), traditionally attributed to the tenth-century court painter Guo Zhongshu (d. 977), is a quintessential example of the type. Ascending the right side of the composition are the serried halls of the Palace of the Nine Perfections (Jiuchenggong), an imperial retreat located in the hills outside the Tang capital of Chang'an. Already by the tenth century a remembered landscape interweaving history and legend, the palace—supposedly so massive that a horse was needed to navigate

its lengthy corridors—suggests the glories of the Tang and was identified by Kangxi as a paradigmatic example of retreat as strategy for sage and effective rule.[10]

The two palace views by Guo Zhongshu and Leng Mei share certain pictorial elements—architecture and landscape, specifically—and similar compositions but deploy them in very different ways. In *Emperor Minghuang's Palace*, clear compositional focus is on the towering forms of the imperial halls, their elaborate eaves and endless colonnaded corridors carefully rendered in *jiehua* ("boundary painting")—the precise,

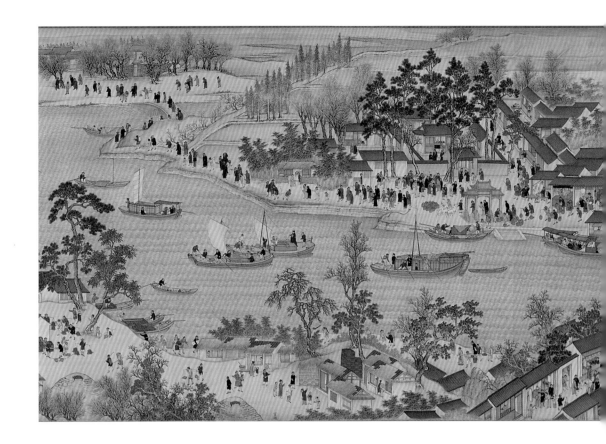

measured technique for which Guo Zhongshu is best remembered. The soaring mountain forms in the distance echo the heights of the palace, perhaps linking the two through understandings of great peaks as a metaphor for the hierarchies of Confucian society.[11] Landscape also serves to locate the palace physically and conceptually, emphasizing its position beyond the distractions of the city, suggesting the elegance and refinement of remoteness, and drawing upon associations with mountains as liminal spaces between mundane and immortal realms.

In *View of Rehe*, by contrast, the relative importance of these pictorial elements is essentially reversed. The architecture of the park-palace appears almost jewel-like, set within a much grander but still meticulously constructed landscape. Like Guo Zhongshu, Leng Mei employs a form of *jiehua*, albeit one less exhaustively detailed and more naturalistic than that seen in the earlier painting. Each building is carefully and, at least to a point, accurately rendered but without the grand scale of *Emperor Minghuang's Palace*. Instead, Leng Mei's depiction of the Mountain Estate's halls seems to reflect the sense of modesty with which the emperor sought to imbue the park by eschewing, as he wrote in his "Record of the Mountain Estate," "carved rafters and lacquered columns."[12]

FIGURE 4.3
Wang Hui et al., *The Kangxi Emperor's Southern Inspection Tour*, 1698, scroll 7, "Wuxi to Suzhou." Detail of a handscroll, ink and color on silk, 67.7 × 2220 cm. Mactaggart Art Collection, University of Alberta Museums, Gift of Sandy and Cécile Mactaggart, 2004.19.75.1.

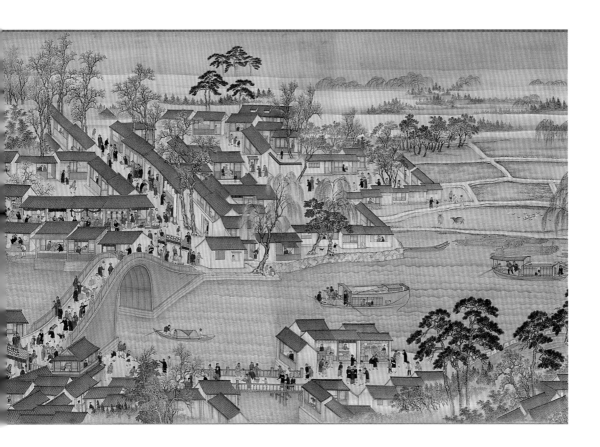

Precise architectural rendering emerged in Buddhist painting of the Six Dynasties and Tang, if not before, and was used in illustrations of divine and royal palaces, associations that persisted with the style. Executed with straightedges, compasses, and squares—tools of measurement and regulation—*jiehua* was established as a formal technique by the Song dynasty.[13] Its use in architectural manuals and technical renderings of complex structures led to a link with imperial power through the control of technology as well as human and material resources.[14] These connotations naturally extended to *jiehua*'s use in depictions of urban scenes and the built environment, such as *Going Upriver at Qingming Time* (Qingming shanghe tu, twelfth century). Attributed to Zhang Zeduan (fl. twelfth century), the handscroll offers a detailed record of the bustling Northern Song capital of Bianliang that has long been interpreted as an image of prosperity and harmony, and thus the virtue of Song imperial rule.[15]

Alert to such connections, Kangxi and Qianlong court painters explicitly quoted *Qingming*'s composition, iconography, and architectural style in creating their own images of the Qing empire at peace.[16] The series of twelve monumental handscrolls titled *The Kangxi Emperor's Southern Inspection Tour* (Kangxi Nanxuntu; fig. 4.3), executed by the Orthodox

(*zhengpai*) master Wang Hui (1632–1717) and a bevy of assistants, describes the Qing South as vibrant, ordered cityscapes buoyant with commerce. Recording the emperor's 1689 tour, the series suggests an urban analog to Kangxi's vision of a productive and harmonious agriculturalism expressed through the Rehe landscape. Wang Hui's construction of space combines shifting points of view and ground planes to create a sense of compositional continuity within the progressive, almost cinematic, handscroll format.[17] Although it results in a less consistent, stable representation of architecture than that seen in *View of Rehe*, this dynamic approach to space, together with Wang's use of an aerial, three-quarter vantage characteristic of *jiehua* in the Kangxi court, is a key model for understanding Leng Mei's composition.

Leng, his teacher Jiao Bingzhen (ca. 1660–1726), and others in the Kangxi court continued to refine this manner, as architectural painting became an essential component in representing real and idealized spaces of myth, history, and the court—subjects central to the visual construction and documentation of imperial legitimacy from the Kangxi period on. With a stable angle of vision and an aerial, informative point of view, the architecture in *View of Rehe* is closely related to the manner displayed in an album of ten architectural studies by Jiao Bingzhen, *Buildings in Landscapes* (Shanshui louge tuce). In one leaf (fig. 4.4) a complex system of buildings, walls, and pathways, precisely delineated with straightedges in carefully gradated ink tones, sits astride a stream flowing from a lake ringed with pale mountains. The compositions demonstrate the court's newly developed approach to architectural perspective, joining the visual access of a more or less elevated axonometric vantage with the dramatic spatialization of vanishing-point convergence. Moreover, the album can be considered a sort of pictorial manifesto for subsequent court treatments of architecturalized environments, combining *jiehua* with more stylized landscape elements.

Jiao's album may have been the model for a series of hanging scrolls produced in the early Yongzheng period that depict the pleasures of the twelve months in an imperial garden.[18] Believed to be set in the Garden of Perfect Brightness, Yongzheng's retreat in suburban Beijing, the connection between these two groups has raised the question of whether the album should be dated to the late 1710s or early 1720s, as has generally been the case, or closer to 1707, when Kangxi bestowed the garden upon his son.[19] The earlier date, of course, would put it quite close to *View of Rehe*, and although the two employ different modes of sight—Leng Mei's higher and more distant than Jiao Bingzhen's—there are strong similarities in the manners of drawing and in the buildings themselves. The buildings may speak more to common architectural styles across Qing imperial gardens than to a shared pictorial vocabulary or common subject matter, but the stylistic connections attest to a growing technical standardization that occurred in court painting during the late Kangxi period.

FIGURE 4.4
Jiao Bingzhen, *Buildings in Landscapes*, Kangxi period (1661–1722), leaf 9. Album, ink on paper, 26.2 × 26.4 cm. The Collection of the National Palace Museum, Guhua3217-9.

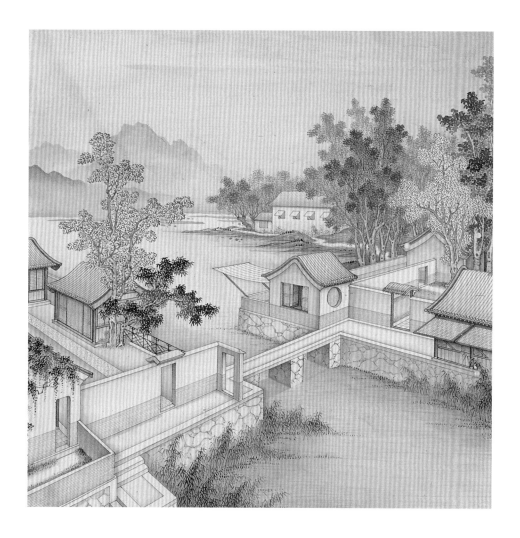

Leng Mei's treatment of the landscape in *View of Rehe* similarly combines reference to long-standing pictorial conventions and contemporary developments at court. His manner draws on that of the so-called Orthodox School, which dominated late Kangxi court painting theory under Gao Shiqi (1645–1703) and Wang Yuanqi (1642–1715), and emerged as the dominant mode in court landscape beginning with Wang Hui and the *Southern Inspection Tour* project.[20] In particular, *View of Rehe* follows Wang Hui's efforts toward a "Great Synthesis" (*dacheng*) of the Orthodox lineage and his adaptation of this manner to the pictorial demands of the ideologically maturing Kangxi court.[21] Leng Mei combines elements of Song monumentality and an archaizing blue-and-green (*qinglü*) palette with brushwork and compositional strategies derived particularly from Huang Gongwang (1269–1354), held by both Wang Hui and Wang Yuanqi to be the greatest of the Yuan masters. The peaks that rise up both sides of *View*

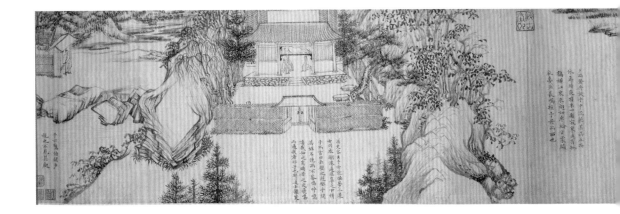

FIGURE 4.5
Qiao Zhongchang,
*Illustration of the Second
Prose Poem on the Red
Cliff*, late Northern Song
period (960–1127). Detail
of a handscroll, ink on
paper, 29.5 × 560.4 cm. The
Nelson-Atkins Museum of
Art, Kansas City, Missouri.
Purchase: Nelson Gallery
Foundation, F80-5.

*of Rehe* are formed from a succession of graduated mounds given shape by colored washes and the delicate layering of dry "hemp-fiber" strokes (*pimacun*), which build upon one another to create winding chains that move simultaneously up and back into pictorial space.

At the same time, like the mountains that stand mistily in the distance beyond Guo Zhongshu's Palace of Nine Perfections, both composition and scale in Leng Mei's *View of Rehe* evoke the so-called monumental landscapes of the Five Dynasties (907–979) and Song courts. Although less current during intervening periods, when smaller, more intimate compositions and formats based on Yuan models predominated, under the influence of Wang Hui and Wang Yuanqi, interest in earlier masters, including Juran (active ca. 960–985), Fan Kuan (ca. 960–ca. 1030), Jing Hao (active ca. 870–ca. 930), and Guan Tong (active ca. 907–923), enjoyed a resurgence.[22] As such, the court style developed by Wang Hui and the Orthodox School bridged court and literati manners across a range of dynastic periods: it may be thought of as synthesizing not only the history of painting but history itself, the merging of artistic paragons into a single, coherent composition serving as an effective metaphor for the Qing's own interest in legitimacy through diverse cultural, political, and territorial precedents.

## The Auspicious Landscape

The Qing court style developed by Wang Hui, Leng Mei, and others was not limited to an abstracted expression of Qing legitimacy through stylistic and compositional reference, however. Late Kangxi painters combined formal and thematic elements to construct images of auspicious landscapes that functioned as metaphors for imperial virtue and the empire, particularly through connections with mythohistorical themes. Blue-and-green style, which originated in the Tang, if not earlier, was by the Song clearly associated with portrayals of immortal realms and, by extension, paradisiacal

retreats such as Peach Blossom Spring, a site of fleeting escape from chaotic times described in the writings of Six Dynasties poet Tao Yuanming (365–427).[23]

Drawing on related connotations found in *jiehua*, the two manners were often used in tandem, including in the Qing, when monumental depictions of mythohistorical themes and immortal realms were popular in courtly and commercial painting.[24] The blue-and-green palette adopted by Leng Mei, Wang Hui, and others in the court generally relied on thinner washes rather than the dense mineral pigments used by earlier practitioners and often incorporated other hues, especially light browns and pinks. Formally, these variations may be partially indebted to the influence of Huang Gongwang, whose use of pale color was frequently referenced by late Ming and early Qing adherents to his style.[25] In practice, however, like the less rigid *jiehua* style seen in *View of Rehe* and elsewhere, they contributed to an increased sense of naturalism in the image.

Leng Mei's use of blue-and-green and *jiehua* in illustrating the Rehe park-palace creates an image of a place apart, a site evoking not only historical paradigms of legitimate and sage rule but also an auspicious space standing on the border between mundane and sacred worlds. This status is reinforced by the presence of cranes and deer throughout the composition. Because of their extremely long lifespans, cranes were linked with immortality, a fact echoed in the name of the Empress Dowager's residence at Rehe, Sonorous Pines and Cranes (see fig. 1.8).[26] Daoist adepts often flew about on cranes; seen singly, the birds were understood either as markers of sacred space or as transmogrified immortals. In the Northern Song literatus Su Shi's "Latter Prose Poem on the Red Cliffs" (Hou Chibifu), for instance, the crane that swoops over Su Shi's head in the text's climactic scene transforms itself into a pair of Daoist immortals at the end, as illustrated in a nearly contemporary work by Qiao Zhongchang (active late eleventh–early twelfth century; fig. 4.5).[27] Though less common in Chinese painting, deer

enjoy similar associations, both for their reputedly long lives and for the belief that they, alone among animals, possess the ability to locate *lingzhi*, the fungus of immortality.[28]

This combination of motifs and styles can be found elsewhere in early eighteenth-century court painting, reinforcing the associations they bring to *View of Rehe*. In *Nurturing Uprightness* (Yangzheng tuce; fig. 4.6), an album datable to the first decade of the Qianlong era, Leng Mei portrays ancient emperors in idealized palace settings.[29] The blessings of Heaven and the auspiciousness of the space are marked by the presence of coupled cranes, *jiehua*, and a blue-and-green palette. Like the court's *Imperially Composed Images of Tilling and Weaving* (see figs. 4.15 and 6.13), a pictorial project to which Leng Mei also contributed, *Nurturing Uprightness* was based on a didactic theme dating to the Song. These paragons of benevolent and righteous rule were meant to reflect by analogy upon Qing emperorship.[30] In Leng Mei's *View of Rehe*, as in Wang Hui's *Southern Inspection Tour* (fig. 4.7), this pictorial vocabulary was extended to the territory of the Qing itself, depicted in a manner suggestive of reading both imperial precincts and the empire as a whole as "paradises" on earth.

FIGURE 4.7
Wang Hui et al., *The Kangxi Emperor's Southern Inspection Tour*, 1698, scroll 9, "Shaoxing and the Temple of Yu." Detail of a handscroll, ink and color on silk, 67.8 × 2227.5 cm. Provided by the Palace Museum, Gu6302. Photo by Hu Chui.

FIGURE 4.6
Leng Mei, "Emperor Tang Xuanzong," ca. 1741, from *Nurturing Uprightness*, leaf 9. Album leaf, ink and color on silk, 32.2 × 42.3 cm. Provided by the Palace Museum, Gu6135-9/10. Photo by Liu Zhigang. Beijing.

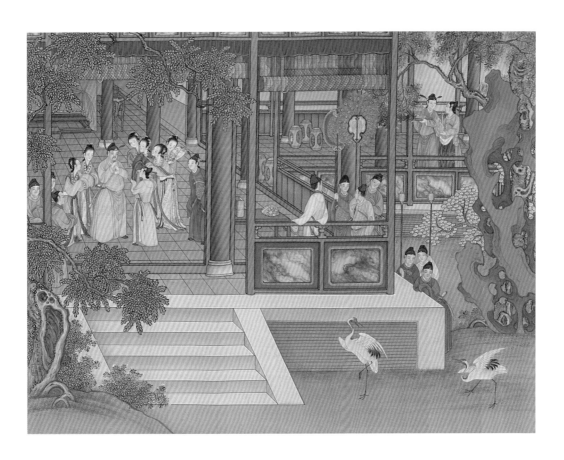

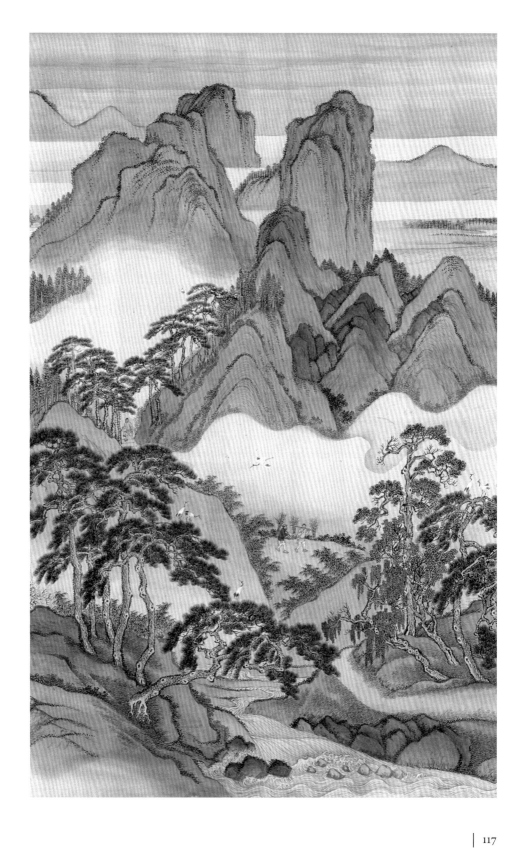

The auspiciousness of the Rehe landscape is highlighted through Leng Mei's deliberate, almost literal use of another formal element of Orthodox painting, the "dragon vein" (*longmai*). Referring originally to a particular type of geomantic mountain vein, in the painting theory of Wang Yuanqi current in the early eighteenth-century court, dragon veins describe chains of mountains that "rise and fall" (*qifu*) and "open and close" (*kaihe*) to give a painting compositional and perhaps metaphysical energy.[31] In *View of Rehe*, a long dragon vein of mountains frames the composition along each side of the painting. Beginning in the foreground, near the valley floor, the veins ascend, twisting and turning, disappearing and reappearing, to a distant peak near the top of the picture plane. While primarily a compositional device in Wang Yuanqi's own practice, in certain Qing court works, such literal veins appear to connote the presence of geomantic energy in particular topographical contexts.[32] An anonymous, undated court painting of Fuling (fig. 4.8), the imperial tomb of Kangxi's grandfather, Nurhaci, serves to illustrate this.[33] With close formal affinities to *View of Rehe*, a succession of tiered mountains, painted in dark blue-green tones, encircles the tomb. Rising in angled parallel, they lift the tomb up, tilting it toward the viewer, rather than rising around it, as in Leng Mei's work. The purpose is ultimately the same, however, as each composition highlights the embrace of significant imperial compounds within an auspicious web of geomantic energy defined by mountain veins.

Geomancy may also have factored into the composition of *View of Rehe* in another way. Comparing the painting to a topographical map of the valley (see map 4.1), the mountains along the left side of the painting appear closer to the eastern wall of the park than they are in reality, in effect narrowing the valley and encircling it in a nearly continuous horseshoe of mountains. One product of this composition is the elision of a key geomantic problem with the site—its openness toward the "ghost's gate" (*guimen*) of the northeast.[34] At the same time, it allowed the inclusion of a key scenic feature of the immediate area, the columnar rock formation known as Chime Hammer Peak (Qingchuifeng).

Ghost's gate notwithstanding, much about the landscape and topography of the Mountain Estate was unquestionably auspicious. Following classical principles for fortuitous siting of homes, cities, tombs, and the like, the Rehe valley possessed numerous desirable attributes, including south-flowing rivers, northern protective mountains, a gentle downward slope from north to south, and, with the early dredging of the lakes, a beneficial balance between mountains and water.[35] Court experts on natural phenomena played a central role in the park's planning, particularly as the project progressed, since officials from the Board of Rites joined those from the Board of Works to ensure an auspicious design.[36] The emperor's description of the natural landscape similarly highlighted signs of positive

FIGURE 4.8
Anonymous, *Fuling*, eighteenth century. Hanging scroll, ink and color on silk, dimensions unknown. Collection of the First Historical Archives of China, Yu1809.

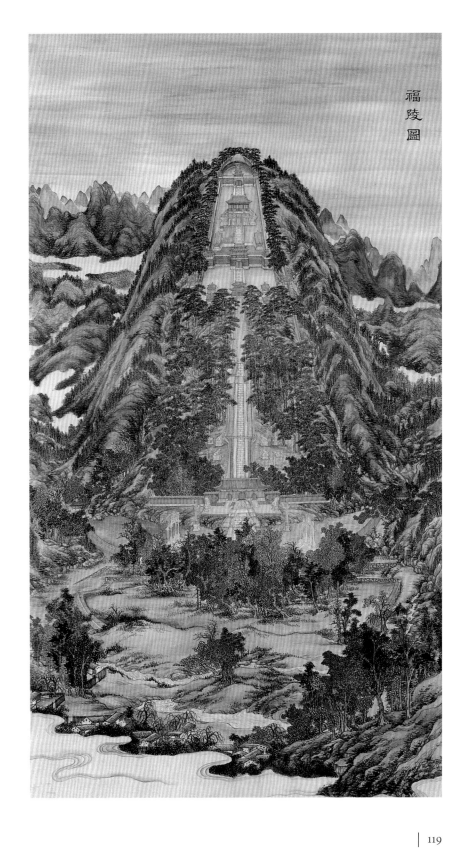

福陵圖

geomantic energy, including "clear winds and refreshing summers," "purple mists," and the fertility of the land.[37]

Auspicious signs also manifested literally at the park-palace through landscape formations, particularly within the central lakes. In Zhang Yushu's account of his first visit to the Traveling Palace, he recalled the emperor comparing the lakes' system of dykes and islands to "a sort of *lingzhi* fungus," a resemblance preserved in the area's name, *Lingzhi* Path on an Embankment to the Clouds. This image was echoed in *Imperial Poems* (see fig. 1.1), where the emperor described "an embankment, flanked on both sides by water, [that] winds and curves as it divides into three paths leading to three islands, large and small. They are shaped like a *lingzhi*, or like a cluster of cloud-flowers, or like a *ruyi*."[38] Much like tiles shaped like bats (*fu* 蝠) that line the eaves of garden roofs, bringing good fortune (*fu* 福) through a pun, the artificially shaped lakes and islands of the park conveyed the propitious properties of the *lingzhi* fungus, specifically longevity, and the *ruyi* scepter, a symbol of sagacity and authority especially popular in the Qing court (fig. 4.9).

Leng Mei's composition draws out many of these natural and built elements, particularly the mountains against which the palaces are positioned and the flow of water through the site, features it shares with the painting of Fuling. More subtly, *View of Rehe* emphasizes the *ruyi* forms in the landscape, even creating ones where they did not naturally occur. Through a combination of the overall composition and the sense of spatial foreshortening, Leng Mei's painting exaggerates the central lakes and islands compared to the rest of the valley, focusing on the northernmost island, now called Ruyi Island. Comparison with the topographical map (see map 4.1) shows that while Ruyi Island and *Lingzhi* Path on an Embankment to the Clouds do resemble a *ruyi* scepter—a shape echoed in Leng Mei's

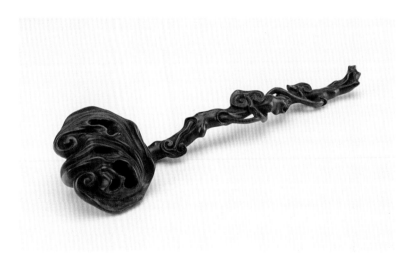

FIGURE 4.9
*Ruyi* scepter in the form of a *lingzhi* fungus, Qing period. Birchwood. Provided by the Palace Museum, Xin91910. Photo by Ma Xiaoxuan.

FIGURE 4.10
Concentric *ruyi* forms
in Leng Mei, *View of
Rehe*. Drawing by Pen
Sereypagna.

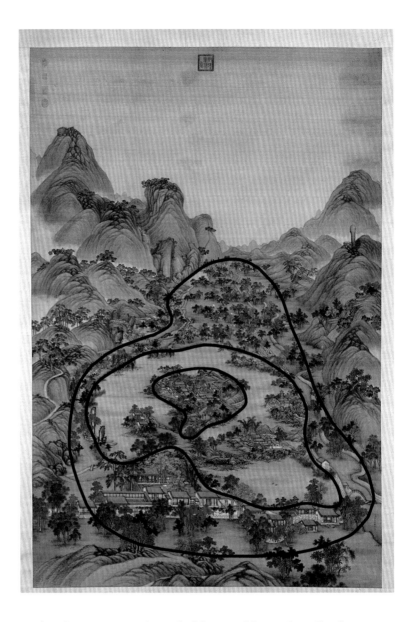

work—the same cannot be said of the main lakes or the valley floor. Yet in Leng Mei's rendering, the island, lake, and valley appear to form a series of concentric *ruyi* (fig. 4.10), a literal layering of auspiciousness.

Emphasizing the islands at the center of the park also serves to draw attention to the site's imperial status. Prior to the construction of the Palace of Righteousness, the compounds on Ruyi Island were the emperor's primary residence and, as such, the earliest center of imperial authority in Rehe. That there were three such islands in a single body of water echoes auspicious design in imperial gardens of the past. Known generically as the "one pond, three mountain" (*yihai sanshan*) plan, this arrangement had its

roots in Han Wudi's (r. 141–87 BCE) Jianzhang Palace gardens. In his pursuit of immortality through elixirs and other magic, a surrogate paradise was created in the garden's primary lake, Taiye Pond, which contained three islands in imitation of Fangzhang, Penglai, and Yingzhou, mythical islands of the immortals believed to lie off the eastern coast of China.[39] Taiye Pond became the model for many subsequent imperial gardens, including those in the Tang capitals of Chang'an and Luoyang as well as in the successive capitals of Jin, Yuan, Ming, and Qing Beijing.[40]

Upon moving their capital north from Nanjing to Beijing, the court of the Ming Yongle emperor (r. 1402–1424) almost immediately recognized the significance of this design in establishing imperial identity. In the early 1410s, Yongle commissioned a handscroll, *Eight Scenes of Beijing* (Beijing Bajingtu), that recorded the most famous sites in the capital city in verse, prose, and image. "Crystal Clear Waves at Taiye Pond" (Taiye Qingbo) and "Spring Clouds at Qionghua Island" (Qiongdao Chunyun), two sites in the imperial garden just west of the Forbidden City, comprised the third and fourth scenes in the scroll. In his description of the latter, the official Yang Rong (1371–1440) likened Qionghua to a palace of the immortals.[41] In so doing, Yang defined West Garden, as the park was then known, in terms confirming its succession to the history of imperial garden building. Within the context of a pictorial program that was "clearly part of the efforts of the Yongle emperor's supporters to endow the area in and around Beijing with a heritage worthy of an imperial capital," this affirmation highlights the potential significance of the landscape in general and imperial garden building in particular to dynastic legitimization.[42] For Kangxi, one significant aspect of garden building was the opportunity to follow this historical line, to do as emperors before had done, constructing landscapes that were both auspicious and clearly associable with legitimate regimes of the past.[43] Among the Mountain Estate's visitors, those familiar with historical garden designs would have understood multiple meanings in the three islands branching off from the central path. The *lingzhi*, the *ruyi*, and the Islands of the Immortals all suggested wishes for longevity, symbols of wisdom and refinement, and the succession of imperial states to which the Qing was now the true heir.

At one level, immortals' realms and mythohistorical paradises such as Peach Blossom Spring seem to run counter to the contemporary politics of Kangxi's late reign. As the emperor of a relatively young dynasty, Kangxi and many of his subjects had lived through the wars of conquest, much like those Tao Yuanming imagined his poor fisherman escaping. Kangxi's rhetoric of rulership thus strongly emphasized the Qing's claim to the Mandate of Heaven, particularly through demonstrations of active and attentive governance. Peach Blossom Spring and other paradises, by contrast, suggest retreats from the problems of the world, a disengagement

with the times. Yet beyond the pictorial evidence, the emperor's choice of descriptors in his "Record of the Mountain Estate," including purple mists, great mountains and deep gorges, and pavilions amid streams and caves, all feature in later commentaries on Peach Blossom Spring, making the connection explicit.[44]

By framing the park-palace in these terms, Leng Mei's *View of Rehe* allowed the site to function as a metaphorical landscape for the Qing. Rather than seeing the site simply as a place to which the emperor might escape, it may be read as a metonym for the dynasty; the landscape then becomes one not only of place but also of time—in the Peach Blossom Spring of the Qing, Kangxi's subjects have escaped from the chaotic and perilous world of the Ming. Through its idealized topography, historiographic formal elements, auspicious denizens, and tranquil environment, *View of Rehe* embodied this vision of empire, framing the emperor's park-palace as epitomizing, instead of endangering, righteous and humane rule and a harmonious realm.

## Perspectival Encounters

Drawing on certain well-established modes of picture-making in China, *View of Rehe* also reflects innovative approaches and techniques circulating in the Kangxi court, particularly around methods of spatial construction. In the painting, Leng Mei devised a solution to integrating aspects of perspectival representation within the broad formal and technical framework of monumental landscape painting. This included not only diminution into distance but also compositional structure that defines and constitutes the position of the viewer relative to the painting. While Leng Mei's mountains generally seem to follow known Chinese models, the valley most certainly does not. The viewer looks down on an essentially level, continuous ground plane that stretches away from the picture plane and into the distance in a manner almost unprecedented in Chinese painting. Several works by the late Ming painter Zhang Hong (1577–ca. 1652), most notably *Wind in the Pines of Mount Gouqu* (Gouqu songfeng tu; fig. 4.11), in which a narrow valley winds into the distance between the walls of a steep ravine, offer a rare comparison.[45] Zhang Hong's valley is soon lost in mist, however, having carried the viewer only a short way into its depths. Leng Mei's viewer, by contrast, is transported into the image, visually carried from the nearest foreground structures to the valley floor's furthest reaches.

Nor is this the only feature of *View of Rehe* that conveys a particular relationship between the painting and vision. The composition as a whole is shaped through three separate lines of vision: one looking up the valley, the second defining the depiction of the architecture, and the last directed at the mountains on either side. The valley floor is constructed with a

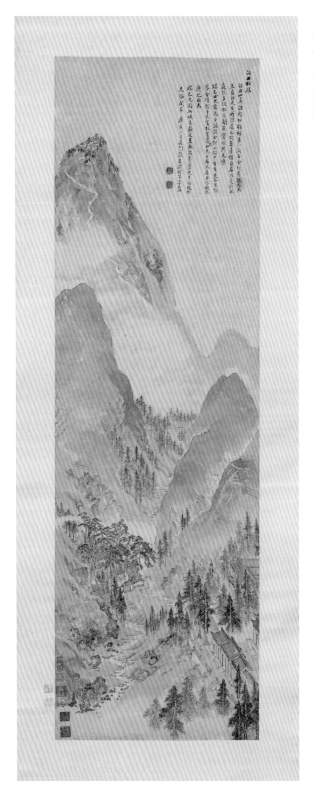

FIGURE 4.11

Zhang Hong, *Wind in the Pines of Mount Gouqu*, 1650. Hanging scroll, ink and color on paper, 148.9 × 46.6 cm. Museum of Fine Arts, Boston, Keith McLeod Fund, 55.464.

FIGURE 4.12
The architectural
orthogonals in Leng Mei's
*View of Rehe*. Drawing by
Pen Sereypagna.

loose single-point perspective that grounds the composition as a whole
and guides the eye inward while also effectively describing diminution into
space. Most clearly evident in the edges of the valley itself, the orthogonals
by which this recession is broadly defined meet atop a low mountain in the
distance. Converging just right of center, they describe a slightly angled
line of vision that cuts across the overall frontality of the composition.
The second line of sight, defined by the perspectival diminution of the
architecture, originates from the lower right of the composition. Its orthog-
onals meet outside the composition, to the upper left (fig. 4.12). Together
with the upward movement of the mountains, the leftward pull of the

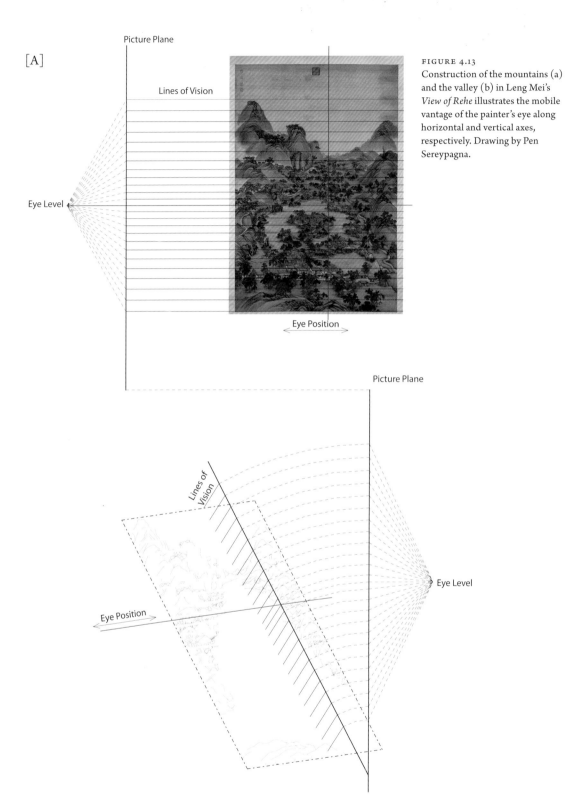

[A]

Picture Plane

Lines of Vision

Eye Level

Eye Position

Picture Plane

Lines of Vision

Eye Level

Eye Position

FIGURE 4.13
Construction of the mountains (a) and the valley (b) in Leng Mei's *View of Rehe* illustrates the mobile vantage of the painter's eye along horizontal and vertical axes, respectively. Drawing by Pen Sereypagna.

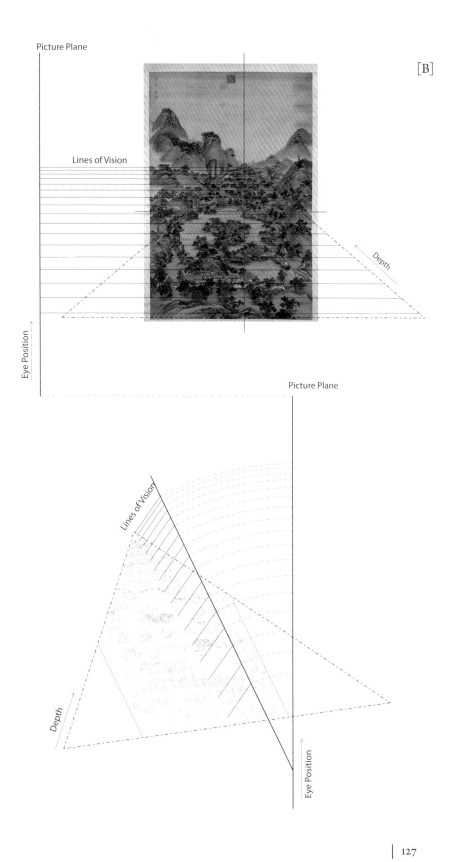

Picture Plane

[B]

Lines of Vision

Depth

Eye Position

Picture Plane

Lines of Vision

Depth

Eye Position

architectural orthogonals and the depth of the valley create compositional tension through three intersecting, albeit diverging, visual imperatives that destabilize the composition's presumptive point of view.

The valley and verticality of the high peaks define a frontal viewing position, leading to a perception that the spatial construction of the painting is organized around a stable point of view. The pictorial vantage point—the "painter's eye"—is in fact mobile, however, though not in the sense generally understood in Chinese landscape painting. Early painters of monumental landscapes, such as Fan Kuan and Guo Xi (ca. 1000–ca. 1090), often used shifting points of view, angles of vision, and constructions of ground and depth to create noncontinuous yet visually coherent spatial compositions.[46] Leng Mei employs a variation of this strategy, utilizing distinct but related vantage points to fashion the mountains and valley separately.[47] The mountains are constructed from along a horizontal line that transects the image approximately a third of the way up the composition, roughly between the top of Ruyi Island and the northern shore of the lakes (fig. 4.13a). As such, the painter's eye looks down upon the foreground mountains, straight at those in the middle ground, and up the rising veins of those in the distance. Each mountainous form is depicted from a directly frontal point of view, meaning that the eye shifts from side-to-side along this horizontal line with the movement of the hills. By contrast, the valley is represented from a progressive vantage that moves upward along a central axis as the composition moves into the distance but is stable from left to right (fig. 4.13b). The painter's eye thus views the valley at a consistent angle of vision even as the composition moves into depth, rather than growing flatter and more oblique, as it would if the painter's eye were fixed or the viewer were situated at ground level.

This complex system of spatial construction functions in concert with the actual experience of looking at the painting. With the hanging scroll hung so its bottom roller sits at or just above the floor, a viewer of average height in the thick-soled boots common to court dress would have been looking directly at the upper half of Ruyi Island.[48] The heart of the composition, this level also corresponds with the approximate line along which the vantage point for the mountains moves. Standing in front of the work, the painting would have extended from roughly mid-thigh to well above the viewer's head. The viewer's physical position relative to the painting thereby reinforced Leng Mei's compositional construction: from eye level, one looks down, straight out, and up at the hills in the foreground, middle, and distance, while at the same time the vertically mobile vantage point allows the viewer to look up and into the valley as if floating above the landscape and following it into the distance.

While the construction of European perspective works to position the viewer relative to the composition physically, visually, and psychologically,

FIGURE 4.14
Anonymous, *Gentlewomen
in the Shade of a Paulownia
Tree*, Kangxi period (1661–
1722). Eight-panel screen,
oils on silk, 128.5 × 326 cm.
Provided by the Palace
Museum, Gu210740. Photo
by Zhao Shan.

the mobile vantage points conventionally employed in Chinese painting
meant that the link between image, viewer, and physically situated vision
was less determined. *View of Rehe*'s departure from this endogenous tra-
dition is exemplary of a fertile period of artistic experimentation in the
court beginning in the 1690s. During that time Leng Mei, Jiao Bingzhen,
and others associated with the studio of Italian Jesuit Giovanni Gherardini
(1655–1723?), who taught perspective in the court around the turn of the
century, worked creatively to integrate diverse perspectival techniques into
new modes of spatial representation and experience.[49]

In *Gentlewomen in the Shade of a Paulownia Tree* (Tongyin shinü tuping;
fig. 4.14), an undated eight-panel folding screen depicting a scene of ladies
in a lakeside garden, the slightly elevated posture of the screen, which stands
on short legs, is exploited by the painter, who offers a small set of stairs by
which the viewer may enter the painted pavilion around which the women
gather. The orthogonals of the painting converge at the top center of the
composition, creating a low vantage point. Thus the viewer is positioned
below the figures, looking up, which corresponds with how the actual
viewer—as in *View of Rehe*, first and foremost the emperor—would have
seen it, standing slightly below the level of the painting.[50] Other roughly
contemporary works, including the seated portrait of Kangxi reading (see
fig. 1.1) and scenes from *Images of Tilling and Weaving* (fig. 4.15), similarly
define the viewer's physical and visual relationship with the composition
through novel vantage points. In the former, the composition's perspective
focuses on the book in Kangxi's lap, heightening the sense that the already
substantial body of the emperor looms over the viewer, looking down from

above.[51] The more intimately scaled *Images of Tilling and Weaving* places the viewer just above the ground, looking into architectural spaces illustrated with roughly the same three-quarter vantage employed in Leng Mei's *View of Rehe* and Jiao Bingzhen's *Buildings in Landscapes*. Rather than being viewed from a distance, however, in *Images of Tilling and Weaving* the action crowds the picture plane, making it seem as though the viewer is just outside the scene looking in.

Like the *Gentlewomen* screen, *View of Rehe* relies on a form of accelerated perspective in which the perspectival illusion is predicated on an ideal viewing position (albeit without the precise degree of experiential specificity characteristic of such images in Europe, which would develop in Qing court painting by the later eighteenth century).[52] Yet quite distinct from *Gentlewomen* and the other Kangxi examples described here, in *View of Rehe* Leng Mei devised a system by which both depth and height—the y- and z-axes of the pictorial space—could be addressed, creating an image that incorporated features of ocular perspective into a system of mobile vantage points and multiple pictorial foci. The product was a painting that capitalized on new knowledge and techniques imported from Europe, while retaining the essential pictorial vocabulary and visual legibility of established genres and styles of painting in China.

## Measured Sight

Several aspects of Leng Mei's composition suggest not only an ideal position for the painting's viewer but that the work re-creates the view from a specific real-world location as well. Standing before the composition and following it from bottom to top—effectively, south to north—the painting's ground plane extends evenly before the viewer. From Pine Winds through Myriad Vales at its base to the bluish-silver lakes, the view proceeds through the forested plain of the Garden of Ten Thousand Trees to the low mountains in the distance. Though essentially even and continuous, a point of discontinuity in the terrain offers a subtle indication of recording the scene precisely as it appears in life. In the composition's foreground an area of pale green is bounded at its upper edge by a thin, black outline, most readily visible in the open space between architecture and low mountains in the lower left. In the lower right this same outline marks the boundary between ground and lakes just above a perimeter gate and small hall. This line denotes not simply transition but a sharp drop in elevation, as it defines the edge of the bluff upon which Pine Winds through Myriad Vales sits. In the painting, this ridge effectively obscures the lower portions of the lakes below, such that Clear Jade Pavilion (Qingbiting), the small lakeside kiosk located near the bridge to *Lingzhi* Path on an Embankment to the Clouds, is hidden from the viewer's gaze. Here, the painting appears to capture not

the omniscient bird's-eye view described earlier, but the scene as it would appear if seen from a low angle at some distance away. Mountains just south of the modern city of Chengde, roughly 3 kilometers from the entrance to the Mountain Estate (map 4.2), provide just such a vantage point.

On a number of occasions Kangxi made reference to the process of design and planning that preceded construction of the park-palace, including measurement of the valley's terrain. In "Record of the Mountain Estate," he recalled that, "survey[ing] the contrasts between the heights and the plains, the near and far, reveal[ing] the natural formations of the peaks and mountain mists," the plan for the garden emerged in harmony with the landscape.[53] Though the rhetorical quality of the emperor's language makes specific activities difficult to ascertain, the measurement of elevations and depressions, as well as of distance, echoes that of early Chinese mathematical and cartographic treatises.[54] As long histories of civil engineering, urban planning, and cartography attest, surveying—first of flat planes such as fields and then of heights—had existed as a progressively more sophisticated branch of practical geometry in China since the Zhou, reaching significant sophistication during the Song.[55]

During the Kangxi period this endogenous history was complemented by European methods introduced by Jesuits at the court. Trigonometric surveying, both small- and large-scale, was well established at the Qing court by 1703, part of the range of applied mathematics introduced by

Jesuit missionaries. Beginning with astronomy—in which the emperor had particular political interest as it related to the setting of the annual calendar—the court's engagement soon expanded to cartography through the efforts of Ferdinand Verbiest (1623–1688) and Jean-François Gerbillon (1654–1707). Verbiest charted topography and routes during the emperor's first seasonal tours north of the Great Wall in the early 1680s, and Gerbillon mapped the contested northern border with Russia, instrumental to its international settlement through the Treaty of Nerchinsk in 1689.[56]

MAP 4.2
The Rehe valley, with vectors illustrating the southern and southeastern vantage points reflected in Leng Mei's *View of Rehe*. Map by Daniel P. Huffman.

Following the conclusion of wars of conquest in the 1690s, the court sponsored a joint European-Qing surveying project to map the much expanded imperial territories that culminated with the creation of the *Map of a Complete Survey of Imperial Territories* (see fig. 2.1) between 1708 and 1718.[57] Leng Mei was not directly involved with any of these mapping projects or the translation and application of pure and applied mathematics that occupied much of the Jesuits' efforts in the court, but his teacher Jiao Bingzhen may have been. In the 1680s, Jiao held a supervisory role in the Astronomical Bureau, where he worked with Verbiest.[58] It has been suggested that Jiao may have learned perspective from the Flemish priest, who was one of several Europeans at the court to introduce the technique to the emperor.[59] Regardless, Jiao was surely expert in the mathematics that underpinned astronomy, a branch of knowledge understood by both Jesuits and Qing as linked to a range of other fields of applied mathematics, including surveying, cartography, and pictorial perspective.[60]

When the emperor and a cohort of senior officials visited Rehe Lower Camp in 1702, surveying and presumably some form of allied picture-making, perspectival or otherwise, were central to their preparations for construction. Among the group were several scholars close to the emperor who had long been engaged in his education in European sciences, most notably Li Guangdi (1642–1718), Zhang Ying (1637–1708), and Zhang Yushu.[61] Both the Board of Works and the Board of Rites were represented, as were the Jesuits: Claudio Filippo Grimaldi (1638–1712), who had assisted Verbiest at the Astronomical Bureau before succeeding him as Administrator of the Calendar (*zhili lifa*) in 1688, and Claude de Visdelou (1656–1737), one of the original "King's Mathematicians" sent by Louis XIV (r. 1643–1715) to the Qing in 1688, are both thought to have been part of the imperial retinue.[62]

Grimaldi, at least, was also a capable painter of perspective and anamorphosis—techniques that, in addition to their visual appeal for the emperor, were used by Jesuits to demonstrate mathematical problems.[63] Whether other painters were present is impossible to say, given that the comparatively low ranks of Jiao Bingzhen and Leng Mei, in particular, meant that they would not have been named in the court diaries. Nonetheless, an edict issued late that summer directed the Board of Works to

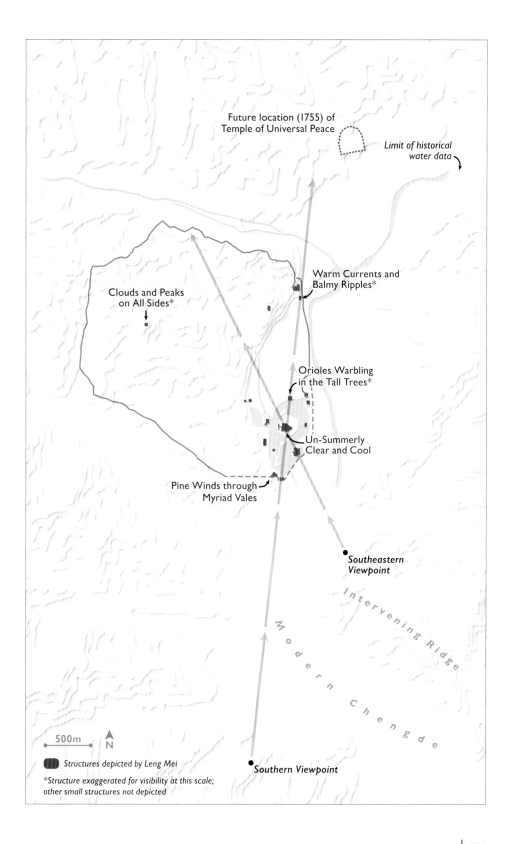

Future location (1755) of
Temple of Universal Peace

Limit of historical
water data

Clouds and Peaks
on All Sides*

Warm Currents and
Balmy Ripples*

Orioles Warbling
in the Tall Trees*

Un-Summerly
Clear and Cool

Pine Winds through
Myriad Vales

Southeastern
Viewpoint

Intervening Ridge

Modern Chengde

500m
N

Structures depicted by Leng Mei

*Structure exaggerated for visibility at this scale;
other small structures not depicted

Southern Viewpoint

survey and stake out the park in preparation for construction. Memorials shortly after the New Year of 1703 reported that surveying had commenced, as had the execution of paintings and designs by the Board of Works and the Imperial Household Department, which supervised court painters.[64]

Thus whether Leng Mei took part in the original planning and design of the site or not, the tools and methods for small-scale surveying, as well as the relationship between cartographic and pictorial techniques, were clearly established in the court by the first decade of the eighteenth century. Leng Mei's artistic background and the prevailing intellectual environment in court presses the question of whether the painting's apparent accuracy derives from real-world observation and measurement. Is the work merely a highly accurate impression of the valley, or do its particularities reflect a more or less precise record of a specific vantage point? Even though the conventional claim that premodern landscape painting in China was purely a product of the artist's imagination and studio has been discredited, the prospect that Leng Mei relied on surveying data in creating *View of Rehe* would be unprecedented.[65] No documentary evidence attesting to this proposition has come to light, and yet the painting, when compared with maps of the site, offers compelling evidence of its likelihood.

Referring again to a topographical map of the area around the park-palace (see map 4.2), it is apparent that although the Mountain Estate itself is oriented north-south, the valley, as defined by the mountains on either side and its opening to the north, angles to the northeast. Low mountains to the south, described earlier, offer a view up the valley. Between these mountains and the Mountain Estate, a low ridge extends from the east partway across the intervening space.

Broadly speaking, the vista obtained from the south is that of the painting: the valley stretches away from the viewer, framed by succeeding ridges of mountains on either side and culminating in low hills in the deep distance. In the painting, three buildings—Un-Summerly Clear and Cool, Orioles Warbling in the Tall Trees, and Warm Currents and Balmy Ripples—align precisely with one another on a trajectory that extends directly to the center of the mountain that serves as the valley's vanishing point (fig. 4.16). The structures are also aligned in the physical landscape: extended north, a line connecting them identifies the painting's vanishing point as a low foothill northwest of the future site of the Temple of Universal Peace (Puningsi, 1755; see map 4.2); extended south, this line perfectly intersects with the site of a pavilion in the southern foothills.[66] Although its original date of construction is not known, the pavilion is in an ideal location for gaining a clear vista of the park and likely occupies an established point for viewing the park at a distance.

Projecting a viewshed analysis from the site of the pavilion helps confirm the hypothesis of firsthand observation by explaining certain aspects

FIGURE 4.16
Trajectories of sight in Leng
Mei's *View of Rehe*: in red,
corresponding to a southern
viewpoint and connecting
Un-Summerly Clear and
Cool, Orioles Warbling
in the Tall Trees, and
Warm Currents and Balmy
Ripples, with the "vanishing
point mountain"; in blue,
corresponding with a
southeastern viewpoint and
the perspectival orthogonals
of the central architecture.

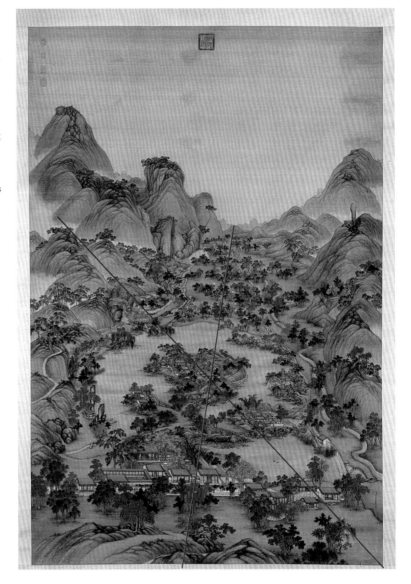

of the painting that depart from topographical reality (map 4.3).[67] The
pavilion stands roughly 90 meters above the park's central lakes (424 ver-
sus 336 meters above sea level), and between 3 and 5 kilometers from the
southernmost and northernmost structures that appear in the painting,
resulting in an extremely low angle of vision. As a consequence, the ridge
extending from the east across the space between the pavilion and the
park is high enough—at between 375 and 425 meters above sea level—to
obscure visibility of much of the half moon–shaped flood plain that forms
the eastern side of the valley. The result is a viewshed in which the valley
appears nearly straight along its eastern edge, just as Leng Mei renders it

in *View of Rehe*. The small northern portion of the flood plain that is still visible, roughly opposite the Garden of Ten Thousand Trees, also appears between the park wall and a vein of mountains slightly set back from the overall line of the valley floor.

The manner in which the mountains are rendered similarly reflects their appearance from the low vantage of the viewing pavilion (map 4.4). On the left of the viewshed analysis, four bands of mountains extend southeast to northwest inside the park. Moving north, each of the four bands is higher than the last, the nearest standing at approximately 370 meters while the most distant rises to roughly 430 meters. Thanks to the slight offset between an essentially northerly pictorial frame and a slightly northeasterly valley, only the very foothills of these ridges are detectable in the foreground of the Leng Mei's painting, while multiple peaks emerge further back. Essentially, the painting records this scene as it is in reality: a layered series of progressively taller veins moving into the distance. The same is true in the east, save for the fact that the southernmost reaches of these mountains are tall enough to occupy much of the viewshed, obscuring what lies behind until the eye reaches the higher peaks of the deep distance. While certainly outside the proper picture plane, the spire of Chime Hammer Peak is visible from the viewing pavilion, helping account for its inclusion in the painting.

The low angle of sight also explains the way in which the foreground ridge conceals the near shore of the lake, though not the extent to which it does so. The viewshed analysis indicates that the ridge ought to entirely obscure the lake south of Ruyi Island, yet a portion of this still appears quite distinctly in the painting. Similarly, while Leng Mei has correctly omitted a number of buildings that would have been concealed by various

MAP 4.3
Viewshed analysis from the southern vantage point (40.955311°, 117.933394°). Map by Daniel P. Huffman.

MAP 4.4
Three-dimensional pictorialization of the viewshed analysis from the southern vantage point (40.955311°, 117.933394°), reflecting the approximate frame of Leng Mei's *View of Rehe*. The red line indicates the location of the garden wall. Map by Daniel P. Huffman.

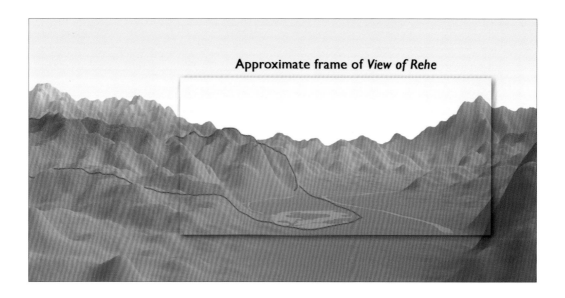

Approximate frame of *View of Rehe*

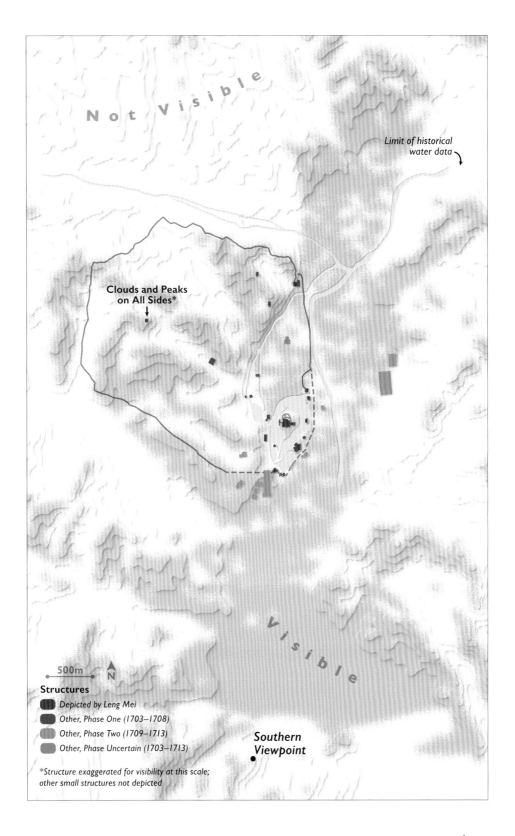

Not Visible

Limit of historical
water data

Clouds and Peaks
on All Sides*

Visible

500m

N

**Structures**

Depicted by Leng Mei

Other, Phase One (1703–1708)

Other, Phase Two (1709–1713)

Other, Phase Uncertain (1703–1713)

*Structure exaggerated for visibility at this scale;
other small structures not depicted

**Southern
Viewpoint**

topographical features (including Clear Jade Pavilion, the Temple of the Dragon King, and Pear Blossoms Accompanied by the Moon), several other buildings that should also be hidden appear nonetheless.

Their appearance in the painting may be accounted for by the use of a second viewpoint—a practical requirement for surveying by triangulation—which provided a location from which the lower lake could be seen.[68] Looking again at the architecture's perspective orthogonals, the vantage that corresponds with their approximate angle of vision is gained from points along the southern end of the low intervening ridge running between the viewing pavilion and the park-palace (see map 4.1). Looking north-northeast from that ridge, the compounds of Moonlight and the Sound of Rivers and Ruyi Islands are nearly aligned, the former just to the left of the latter, as they appear in the painting. Moreover, several structures that are hidden from sight when addressed from the south come into view, particularly Clouds and Peaks on All Sides and Northern Post Linking Paired Peaks (map 4.5).

Leng Mei's treatment of the mountains in the upper left of the composition also conform to this southeastern observation point. Looking closely at the painting, Verdant Isle of Green Maples sits in its saddle between two pavilion-topped peaks. Northern Post Linking Paired Peaks stands atop the taller of the two mountains on the right side of the saddle, with nothing behind it. Southern Mountains Piled with Snow is seen at the summit of the slightly lower peak to the left, at the foot of a vein that climbs to an unnamed peak, the highest point in the image. The painting's configuration of these elements differs from topographic reality, however (map 4.6). Within the actual site, the ridge that extends upward to the park's high point originates from Northern Post Linking Paired Peaks. Southern Mountains Piled with Snow, meanwhile, stands on a somewhat isolated summit. As in the other examples outlined earlier, the accuracy of Leng Mei's representation in *View of Rehe* is not simply to topographic reality but to the specific view of that reality gained from firsthand observation.

## Chorographic Rehe

The centrality of sight and measured observation in Leng Mei's representation of Rehe underlines the close connections that existed not only between branches of applied mathematics but also between topographical landscape painting and more technical approaches to representing space. In what ways is it useful to think about *View of Rehe* as maplike, and how do these aspects of the work complicate or expand its operation within the genre of landscape painting? At one level the early modern cartographic impulse, in China as in Europe, often arose from interests in accuracy or verisimilitude, and with the deeper forms of knowledge felt to be revealed

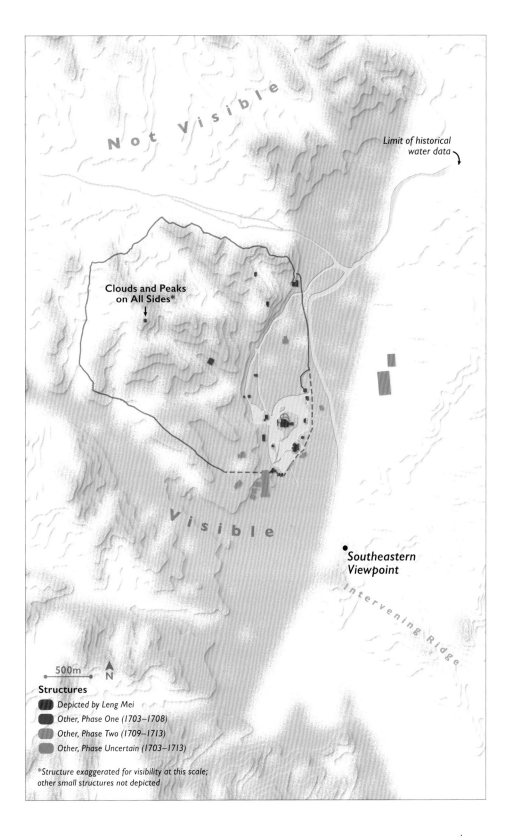

Not Visible

Limit of historical
water data

Clouds and Peaks
on All Sides*

Visible

Southeastern
Viewpoint

Intervening Ridge

500m

N

**Structures**

Depicted by Leng Mei

Other, Phase One (1703–1708)

Other, Phase Two (1709–1713)

Other, Phase Uncertain (1703–1713)

*Structure exaggerated for visibility at this scale;
other small structures not depicted

by such priorities. Such concerns were not exclusive to maps, of course, overlapping productively with smaller-scale genres of spatial representation, especially architectural plans. Yet the perception of accuracy, and particularly of the knowledge derived from firsthand observation and direct sight, also worked rhetorically, allowing images to make claims in support of other pictorial goals. Equally significant, cartographic qualities help suggest some final answers to how Leng Mei's unusual composition came into being, in both visual and technical terms.

If Leng Mei's painting is to be considered as a map, it is useful to think of it not as a work of geography—the recording and representation of large-scale fields of spatial knowledge, which was the Kangxi court's primary concern in this area—but as one of chorography. Chorography records the small-scale and the local: city views and water systems, villages and temples.[69] The chorographic traditions of both China and Europe combined descriptive and rhetorical qualities in depicting sites. This blending of manners underlines the communicative imperative of map-making—namely, that quantitative veracity is but one way in which a map may be thought of as accurate or truthful, and that maps, like all pictures, also communicate through visual, textual, and symbolic codes mutually intelligible to maker and viewer.[70]

Chorography and "city views" in particular return the discussion to the comparison made earlier with the work of Zhang Hong. As art historian James Cahill provocatively argued, Zhang Hong's unusual treatments of space in such works as *Wind in the Pines of Mount Gouqu* (see fig. 4.11) and "Complete View of the Garden to Rest In" (see fig. 6.9) show remarkable similarities to early modern European city views, such as those of *Civitates orbis terrarum*, produced in Cologne by the topogeographer Georg Braun (1541–1622) and the engraver Franz Hogenberg (1535–1590) between 1572 and 1617.[71] Unnaturally elevated or bird's-eye points of view, shifting ground planes, hints of ocular diminution, even the use of specific motifs all strongly indicate that European prints, including chorographies, were in circulation among select artists and intellectuals in late Ming China.[72]

Braun and Hogenberg's views, which were assembled from a wide variety of sources, followed a number of basic compositions; one in particular offers a compelling comparative model for *View of Rehe*. In "View of Besançon" (fig. 4.17), which depicts a city in Franche-Comté near the Swiss border, a small foreground promontory affords an expansive outlook on the city and the surrounding countryside to three observers, who may represent the chorographer or surveyor but in any case stand in for the viewer.[73] Designed by Pierre d'Argent and reproduced by Braun and Hogenberg, this woodcut is an early example of what urban historian Lucia Nuti terms a "perspective view."[74] The genre combines data drawn from surveying

MAP 4.6
Detail of the topography surrounding Verdant Isle of Green Maples, which sits between two pavilion-topped peaks, Northern Post Linking Paired Peaks and Southern Mountains Piled with Snow. Map by Daniel P. Huffman.

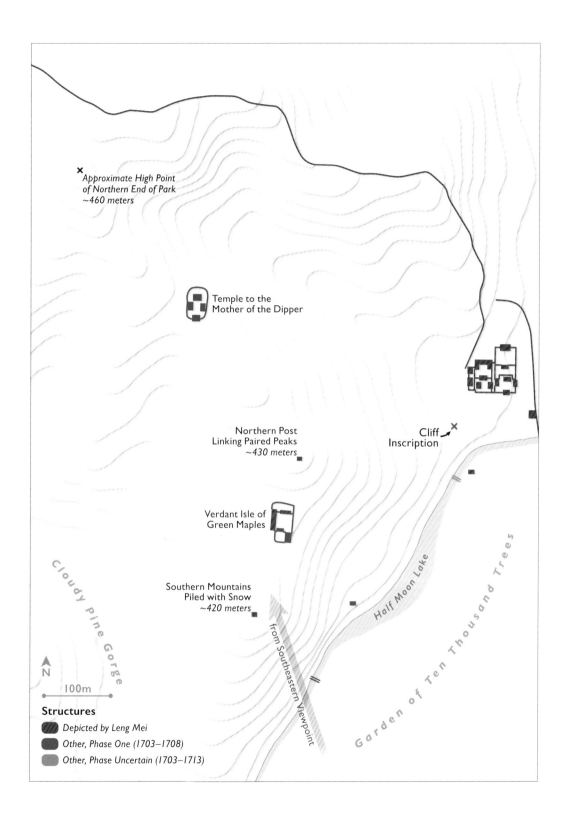

Approximate High Point
of Northern End of Park
~460 meters

Temple to the
Mother of the Dipper

Northern Post
Linking Paired Peaks
~430 meters

Cliff
Inscription

Verdant Isle of
Green Maples

Cloudy Pine Gorge

Half Moon Lake

Garden of Ten Thousand Trees

Southern Mountains
Piled with Snow
~420 meters

from Southeastern Viewpoint

N

100m

**Structures**

Depicted by Leng Mei

Other, Phase One (1703–1708)

Other, Phase Uncertain (1703–1713)

the city with pictorial strategies embedding the urban map within a surrounding landscape and a series of non-naturalistic elements asserting the authority of the image.[75] Like *View of Rehe*, "View of Besançon" does not follow a consistent perspectival method, nor even any one form of spatial construction within the image. Figures in the foreground notwithstanding, the viewpoint is unnaturally elevated above any available vantages, either in the image or reality. The city sits within a ring of surrounding hills, tilted subtly up from the predominant ground plane to make its plan more legible.[76] The mountains, by contrast, are essentially shown frontally, the viewer gazing into the deep distance. Roughly speaking, the lines of diminution converge at the summit of the central mountain against which Besançon sits, reinforced by the framing river that wraps around the city. The appearance of perspective serves to heighten a sense of eyewitness accountability, however. Within the city's walls individuated structures and the twisting particularities of streets likewise reinforce the viewer's trust in the image, central to its viability as a commercial product.

The perceived accuracy of images such as "View of Besançon" is as much a matter of pictorial rhetoric as anything else. As a genre that existed stylistically and technologically between cartography and landscape painting, city views were rooted in first-person observation and surveying data. From the late sixteenth century, seeking out elevated points from which to observe and measure the city became a popular pastime in Europe, and a familiarity with the methods and tools involved was widespread among the educated elite.[77] The refinement of instruments—including quadrants, sighting tubes, and surveyor's plane tables—evolved significantly during this period, easing use through portability and precision.[78] City views were very much products of the studio, however, both for practical reasons and because the application of surveying data was a mathematical process, not one done strictly by the eye.[79] Since Leon Battista Alberti's (1404–1472) work on mapping Rome in the mid-fifteenth century, the procedures for rendering abstracted surveying data as a map were well established, such that the surveyor and cartographer or painter could not only be different people but could easily be separated by both place and time.[80]

The compositional similarities between the two paintings are notable, especially when considered in light of Cahill's earlier discussions of Zhang Hong.[81] As mentioned earlier, neither the elevated viewpoint nor the integrated use of multiple vantages and perspectives were new to Chinese painting. Yet their particular combination in the manner seen here, together with an interest in a form of optical perspective, is strongly suggestive. So too are certain details, such as the shared use of a mountain as vanishing point in the distance and the foreground ridge. The latter is particularly unusual in the case of Leng Mei's painting: while Chinese landscape compositions frequently employ foreground landmasses of

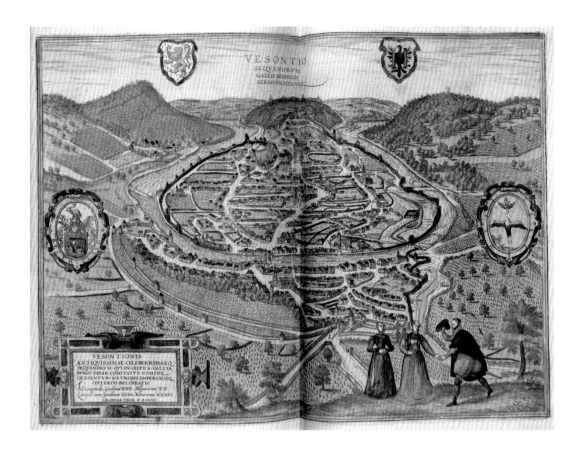

FIGURE 4.17
Pierre d'Argent, "View
of Besançon" (Vesontio
Sequanorum, Gallis
Besanson, Germanis
Byazant), in Georg Braun
and Frans Hogenberg,
*Civitates orbis terrarum*,
vol. 2 (Cologne, 1575).
Geography and Map
Division, Library of
Congress, g3200m.
gct00128a.180.

one form or another, they are generally set in from the picture plane and do not provide the viewer a literal point of entry into the pictorial space. Instead, they function as a kind of *repoussoir*, visually mediating between the two sides of the picture plane and facilitating the eye's movement into and through the represented space. In *View of Rehe*, by contrast, a narrow path leads the viewer directly into the image, much like the stairs at the center of *Gentlewomen in the Shade of a Paulownia Tree*. Finally, Leng Mei's central lakes are less dramatically tilted toward the viewer than the city of Besançon and other late sixteenth-century chorographs, a reflection perhaps of seventeenth-century developments in the genre that favored flatter, more naturalistic representations of the chorographic subject. The silver-blue disc of Leng Mei's lakes is nonetheless subtly raised, readable both as continuous with the valley's ground plane and, given its scale and color, shifted upward, highlighting the imperial "city" upon its islands.

The basic tools used for measured surveying in Europe were also present in the Qing court, well known even to the emperor through his mathematical education, as was at least one text in Chinese on their practical

application, *Practice of Instruments for Measuring Heights and Distances* (Celiang gaoyuan yiqi yongfa).[82] These and other devices for land measurement, such as timepieces and optical aids, were made in imperial workshops as well as imported from Europe by the Jesuits as gifts.[83] Kangxi is recorded by his teachers as being both familiar with the manufacture of surveying instruments—a number of extant examples from court workshops bear explicit reference to being "produced at imperial command"—and well-practiced in their use.[84] Given Leng Mei's close connections to the study of mathematics in the court through his relationship with Jiao Bingzhen and his integral role in the development of perspective in court painting, it is reasonable to imagine that he too might have been acquainted with the basics of surveying. This would not have been a necessity, however, as others in the court could (and most likely would) have performed the actual fieldwork. Using a later version of Alberti's techniques, Leng Mei could even have produced the more cartographic portions of the hanging scroll without ever having studied the site firsthand.

In whatever ways Leng Mei employed surveying data and direct study to construct his painting, *View of Rehe* was, like "View of Besançon," ultimately a product of the studio. The exact methods for this process of creation—the selection and translation of mathematical information and firsthand observation into a larger representational image of the site—is unclear in both European and Qing cases.[85] A partial explanation may be offered through the teaching and study of perspective in the court, however. The introduction of formal instruction in perspective at the Kangxi court in the 1690s coincided with new uses of perspective, particularly the illusionistic techniques of Andrea Pozzo (1642–1709), as core components of the global Jesuit mission's engagement of mathematics and art.[86] Pozzo was particularly known for *quadratura*, a technique that pictorially extends architectural space through complex illusions employed on the ceilings and walls of churches and private spaces, and for theater sets from the fifteenth century on. Giovanni Gherardini, the most significant among the Jesuit painters sent to the Kangxi court, was similarly trained in *quadratura*, and his painting on the ceiling of the Jesuit North Church (Beitang, completed 1703) in Beijing was one of the early monuments of illusionistic painting in the capital.[87] Forms of accelerated perspective related to *quadratura* ultimately became very important in Qianlong court painting.[88] Early evidence of the technique can be seen in the multiple ways in which both *Gentlewomen in the Shade of a Paulownia Tree* and *View of Rehe* blur the distinction between the viewer's space and that of the painting.

As with other branches of applied mathematics, the court eventually relied on a combination of imported, translated, and domestically produced texts on perspective. Pozzo's own text on the subject, *Perspectiva pictorum et architectorum*, first published in 1693, would enjoy great

significance in the late Kangxi and Yongzheng courts. It served as a key source for both Giuseppe Castiglione (1688–1766), the most famous of the eighteenth-century European painters at the Qing court, and *The Study of Vision* (Shixue), one of several related mathematical treatises published by the official Nian Xiyao (1671–1738) between 1718 and 1735.[89] Although Pozzo's text may not yet have been in Beijing when Leng Mei executed *View of Rehe*—the copy recorded in the catalogue of the North Church Library is a slightly later 1702–23 edition—a number of the seventeenth century's most important texts on perspective were.[90] Moreover, the core ideas that help explain the perspectival construction of *View of Rehe* had been well established in Europe for at least fifty years, such that tying Leng Mei's method to a specific text is unnecessary.

The construction of the valley floor and its architecture appear to involve three basic steps. In the first instance the primary line of sight was articulated through single-point convergent perspective, albeit at a "lateral aspect," off-set slightly to the right.[91] The secondary line of sight, by which the architecture is rendered, utilizes a technique known as *veduta per angolo*, or "angled view." This had its origins in theatrical scenery painting, where it extended the perspectival illusion to the wings and center of the audience alike.[92] While these two methods assured a sense of depth in space in the painting, a final step allowed the architecture of the central lakes to be properly arrayed. Looking down, the buildings are located in precise relation to one another, simultaneously receding along with the primary and secondary lines of sight. Such arrangements appeared commonly in European perspective manuals, often expressed through the depiction of complex flooring patterns. Nian Xiyao includes a number of examples of this technique in *The Study of Vision* (fig. 4.18), illustrations that he characterizes not as means for illustrating inlaid floors but—much to the point here—more broadly as a "method of creating things on a ground plane" (*diping shang qi wujian fa*).[93] Laid within a grid defined equally by simple geometry as by trigonometric surveying, the pavilions and halls of the Mountain Estate were arranged much like the individual tiles in an intricately patterned mosaic.

The comparison with "View of Besançon," and with city views more generally, suggests ways of accounting for aspects of *View of Rehe*'s unusual compositional strategies and the means of its creation. These comparisons should not be taken as comprehensive explanation for these concerns but instead understood in concert with other readings of the painting and the works that surrounded it in court. While it seems quite possible, even likely, that early European city scenes such as those from *Civitates orbis terrarum* were known in the Qing court, later examples of the genre offer more proximate and complex sources. Upon their return from Paris to Beijing in 1699, Louis XIV's "King's Mathematicians" carried with them

numerous monumental volumes of the *King's Cabinet* (Cabinet du roi), a collection of hundreds of engravings of the French court bound in red calfskin and embossed with gold.[94] Among them were a great number of landscapes, such as scenes of French cities and royal gardens. The volumes entered the Qing imperial library and later that of the North Church, where books in European languages were transferred under the Qianlong emperor.[95] Considered of exceptional quality even in Europe, the *Cabinet* prints' remarkable size and detail would surely have attracted the interest of an emperor attuned to how his contemporaries presented themselves. Given both their source and their material presence, it is difficult to imagine that these prints would not have made quite an impression in the Kangxi court.

Among the prints in Louis's *Cabinet* were a number of modern perspective and profile views that reflected up-to-date approaches to the types of chorographies included in *Civitates orbis terrarum*. Images such as "View of the Château of Fontainebleau from the Garden Side" (Veüe du Chasteau de Fontainebleau, du costé du Jardin; fig. 4.19), by Israël Silvestre (1621–1691), employed an expansive vista similar to that of "View of Besançon," but from a lower vantage point and a more naturalistic perspective of the print's primary subject.[96] The foreground figures are absent, replaced by a forking path that leads into a lively hunt scene. Although neither the scale nor the composition offer entry in the same *quadratura*-esque fashion as *Gentlewomen in the Shade of a Paulownia Tree* or *View of Rehe*, the oversized format and broad outlook draw the viewer in nonetheless. It is, like earlier city scenes, an image of order but with a changed emphasis: here, royal pleasure and imperial sovereignty replace the natural harmony and civic peace seen in "View of Besançon."

Though compositionally quite different, the depictions of Rehe and Fontainebleau share important similarities as images of imperial authority through landscape. Drawing upon the close identification of a ruler with a particular piece of land, the two scenes naturally reflect the ways in which imperial parks—ordered, controlled landscapes reserved for an individual's pleasure—serve synecdochically for empire. That this is so in both Qing and French cases is partially a function of the meanings read into gardens across a range of cultural contexts. Yet the transcultural exchange of garden images between Paris and Beijing also speaks to the ways in which landscape functioned as a medium for communication and expression in the context of early modern cosmopolitan emperorship. Part and parcel of that function was the literal and metaphoric relationship between technology, especially that of measurement, and the land. Like a painted bird's-eye view, cartography and chorography constitute forms of imperial vision: omniscient, possessing, and founded in the tension between claims to veracity and rhetorics of representation.

FIGURE 4.18
Nian Xiyao, "Illustrations
of a progressive method
for arranging things on a
ground plane with a lateral
aspect," *The Study of Vision*,
19r, 1735. Woodblock print.
The Bodleian Libraries,
University of Oxford,
Douce Chin., B.2, p. 37.

### Portrait, Plan, Map?

The tensions between visual rhetoric and measurable knowledge, between idealized and literal landscapes, ultimately return to the question with which this chapter opened, which has been the principal occupation of those writing on Leng Mei's *View of Rehe*: What, or possibly more accurately, *when* does the scroll depict, and when was it painted? If one accepts the premise employed by many—that the painting should be datable based on the architecture it depicts—then mapping the painting's buildings (see map 4.1) helps narrow a possible timeline. Working from the dating outlined in chapter 1—that, like the southeastern lakes and the Palace of Righteousness, the temple atop Gold Mountain postdates 1708 and Zhang Yushu's account of the park in that year—then *View of Rehe* can be dated generally to the period between Zhang Yushu's departure in late 1708 and the erection of Bishu Shanzhuang Gate in 1711, and quite specifically to the earliest phase of that period, before the dredging of the lakes and the construction of the palace: that is, 1709.

The key to this dating lies in a pavilion that, like Chime Hammer Peak, should not be visible in *View of Rehe*. Clouds and Peaks on All Sides, the second of the four pavilions that mark the peaks ascending the left side of the composition, is dated by a number of scholars to 1709. If this is correct, then not only does the painting date to that year but other post-1708 elements

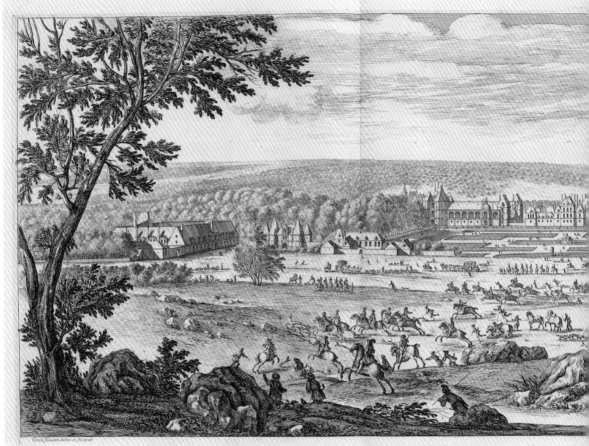

Veüe du Chasteau de Fontainebleau, du costé du Jardin

(including the southeastern lakes and the Palace of Righteousness) can be
more confidently dated to 1710–11. There is little in the painting to refute
this hypothesis given the current state of knowledge about the site under
Kangxi. No other obviously post-1708 features appear except for those
on Gold Mountain Island; likewise, little from the first phase that should
be visible is absent (the one exception, a small compound abutting the
perimeter wall east of Moonlight and the Sound of Rivers, was perhaps
omitted due to compositional crowding).

A second and perhaps more fertile approach is to consider the painting
stylistically and technically within the court's early experimentation with
strategies for the representation of complex space, in which Leng Mei was
intimately involved. While this does not lead to a narrower or more defin-
itive answer about dating, it positions *View of Rehe* by way of observable

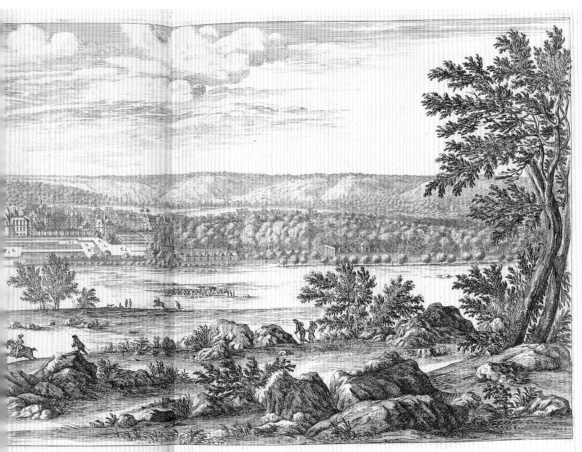

*Prospectus Regiæ Fontis-bellaquei, quà hortos spectat.*

comparisons between and across contemporary works, rather than relying on assumptions about accuracy as a pictorial value. Despite having relatively few comparable works from the period upon which to draw, the complexity of pictorial space and the refinement of formal expression—as well as the simple facts of the Mountain Estate's chronology—help situate *View of Rehe* after *Images of Tilling and Weaving* and *Gentlewomen in the Shade of a Paulownia Tree*, both thought to date to the last years of the seventeenth century. It may also be seen as an integral step in the development of spatial treatment between Wang Hui's *Southern Inspection Tour* scrolls and Wang Yuanqi's 1713 *Magnificent Record of Longevity* (Wanshou shengdian tu; see fig. 6.3), which depicted the emperor's sixtieth birthday celebrations.

In deemphasizing—even abandoning—the prospect that Leng Mei's painting will reveal something definitive about the chronology of

its creation, new possibilities about its specific temporality come to the fore.[97] Of a moment when the Qing court's engagement with new fields of knowledge intersected with established epistemological, political, and scientific understandings of space, *View of Rehe* offers particular insight into the processes by which these engagements, encounters, and intersections occurred. As others have observed with regards to applied mathematics, astronomy, and cartography in the court, this approach represents neither a hybrid nor a process of straightforward influence or accommodation.[98] Rather, the Qing court painting style reflected in *View of Rehe* is one of strategic and selective incorporation of new techniques into existing modes of picture-making, coinciding with, and no doubt contributing to, a period in which the court's perception of the ideological potential of images was rapidly changing. Ineluctably early modern in the sense of being dependent not only on the circulation of people, images, and ideas across Eurasia, but also on engagement with the networks of cosmopolitan empire and emperorship in a global context, Leng Mei's garden portrait is also essentially Qing, as it draws together endogenous and exogenous modes of pictorial communication and diverse ways of thinking about space into a single, coherent image.

# CHAPTER 5

# Paper Gardens

I N 1711 THE KANGXI EMPEROR formally initiated a project that sought to interweave the physical and sensory experiences of the Mountain Estate with his ideology of rulership and personal biography. *Imperial Poems on the Mountain Estate to Escape the Heat* presented the thirty-six scenes of the park-palace through a combination of imperially composed texts and images created by artists of the court (fig. 5.1). Produced almost simultaneously in three different mediums, the work was part of a coordinated, multifaceted effort to articulate a vision of Qing imperial rule through the links between landscape, technology, and the emperor himself. In addition to two woodblock-printed editions, in Chinese and Manchu, issued by the imperial printing house, *Imperial Poems* also existed in several painted versions, including an album, now lost, by the senior official and leading court painter Wang Yuanqi, and a set of copperplate engravings by the Italian missionary Matteo Ripa (Ma Guoxian; 1682–1746) and two Qing artists that marked the introduction of European copperplate intaglio techniques to China.

At one level *Imperial Poems* constituted a form of virtual tour, a reiteration of the Mountain Estate's design and organization via text and image. Through a complex series of formal, pictorial, and material means, this virtuality connected the volume and its viewing to the physical and perceptual experience of the park-palace—specifically, an experience shaped by, and reflective of, the emperor's own perceptions of the landscape. These formal and physical terms enmeshed the artistic and ideological intent of *Imperial Poems* within networks of meaning and signification operating between Chinese, Qing, and Eurasian cultures, thereby instantiating aspects of Kangxi's early modern cosmopolitan emperorship in pictorial form.

Understanding *Imperial Poems* as an integrated project brought to fruition across several iterations, rather than focusing solely on any one version of the work, allows for a more complex engagement with its use of landscape as a vehicle for ideological expression. The interplay across

mediums found here mirrors connections between forms of imperial space and representation more broadly, linked through the bodily, conceptual, and intellectual evocation of the emperor who created and animated them. Identifying the relationships between the painted, woodblock, and copperplate versions helps reconstruct the court's process of artistic production, the specific materiality of each iteration of the project, and their collective pictorial program. In turn, this conversation invites reconsideration of the stylistic and material stakes of the printed scenes and of the viewer's experience of this paper-borne landscape.

In discussing the broader visual and material discourses in which premodern print was enmeshed, art historian Jennifer Roberts suggests the concept of "reversal," by which she invokes the printing matrix—the original image, cut or engraved on a block or plate, from which a print is pulled.[1] Although technically referring to the oft-forgotten object standing behind the print, Roberts's notion of reversal extends beyond this physical antecedent to the human and cultural contexts of a work's creation. Exploring *Imperial Poems* through the lens of reversal—reconstructing the lost paintings that form the project's formal and material roots, engaging with the various versions as mutually entwined, and identifying the networks of individuals involved in their making—repositions the better-known woodblock prints as well as the entire *Imperial Poems* project in two important ways.

First, taking this course helps define an early Qing court visual manner that drew upon historic court styles, contemporary elite taste, and imported artistic technologies to form an innovative and cosmopolitan mode of picture-making. Together with such works as *View of Rehe, Images of Tilling and Weaving,* and the *Southern Inspection Tour* scrolls, the *Imperial Poems* project forms a Kangxi-era foundation for a court style that would be further developed by a second, and now better-known, generation of Qing and European artists in Yongzheng and Qianlong ateliers.[2] As such, this lineage is crucial for understanding the development and deployment of pictorial media as ideological vehicles not only in the Kangxi period but over the course of the dynasty. Extending what art historian Richard Neer has called "the stakes of style," the examination of *Imperial Poems* within the broader context of Kangxi court visual and textual production—including painting, printing, architecture, and monuments—invites seeing not only style but also composition, genre, format, and medium as formal tactics within a broader rhetorical strategy for ideological expression through cultural production generally and landscape specifically.[3]

Second, drawing the different iterations of *Imperial Poems* into dialogue with one another highlights the interrelation of painting and printing as pictorial media and, perhaps more significant, the ways in which the Kangxi court sought to capitalize on such connections as part of a coordinated regime of cultural production. Painting and print are often seen as

highly distinct mediums in histories of premodern art, Chinese as much as
European—the former intended for exclusive, private viewership; the latter
for mass consumption, with its distinct if not opposing values. By the Qing,
however, there was a long history of transmedial interconnection between
the two.[4] *Imperial Poems* marked the first time in the Kangxi court that
printed images documenting the emperor and imperial spaces were made, a
process of imperial identity formation and propagandistic expression likely
inspired by both domestic and foreign examples. The emergence of projects
linking painted and printed iterations in the late Kangxi period suggests
a nuanced and maturing engagement with the capacity of print to convey

pictorial information beyond the impressed image, as well as its potential to articulate complex imperial ideology to a broader, cultured audience.

## Imperial Orthodoxy

On July 6, 1711, a group of artists visited Rehe to "study the landscape for the thirty-six scenes."[5] Expanded from sixteen in the years since Zhang Yushu's tour of the park-palace, the scenes constituted the scenic focal points of the site, locales in which the sensory experience of the landscape combined with poetic prompts to encourage intellectual and emotional responses to the space. For Zhang Yushu and Kangxi's other guests, the scenes existed as physical spaces, ones defined and shaped by the specific experience of a given day. In their transformation into an album—one that paired distilled, idealized images of the landscape with the emperor's poetic reflections on it as well as on himself and the nature of emperorship—the scenes became at once fixed and infinite. In print, their interpretation and experience was more explicitly framed, with a reach that extended far beyond the walls of the Mountain Estate or any particular moment in time.

Among the assembled company was Matteo Ripa, whose journal tells of the visit. It is a key moment in Ripa's account of his development of copperplate engraving for the Qing court.[6] Unfortunately, the Italian neglected to transmit certain details of the trip crucial to an art historian, including names of the other artists, their specialties, or even specifics of the imperial commission. Shen Yu (b. 1649?), credited in the last of the woodblock-printed scenes with designing the prints, would certainly have been present.[7] So would Wang Yuanqi, one of the highest-ranking court officials at that time and painter of what was likely the emperor's personal album of the scenes.[8] Two other little-known Kangxi painters, Shen Yinghui and Dai Tianrui, are also recorded as executing versions of the scenes, though only the latter's survives.[9] Ripa's collaborators on the copperplate prints, Zhang Kui and another now forgotten artist, and the block-cutters responsible for producing the woodblock-printed editions, Zhu Gui and Mei Yufeng (both active ca. 1696–1713), may also have been present.[10] Finally, although Leng Mei is not now associated with *Imperial Poems*, he was of course intimately familiar with representing the Mountain Estate and during this same period was working with Wang Yuanqi and Shen Yu on a monumental handscroll depicting the emperor's sixtieth birthday celebrations.

At least one set of paintings was completed over the course of the next year, the designs from which the woodblocks were cut.[11] As an artist and the album's designer, Shen Yu remains an enigmatic figure. He was born to a Han Bannerman (Hanjun) family, members of the conquest elite who participated in the Manchu conquest of the Ming, most likely in or around the predynastic Manchu capital Shengjing.[12] At the time of his

involvement with *Imperial Poems*, Shen was a low-ranking official in the Imperial Household Department.[13] Specific details of Shen Yu's artistic career are scarce, and few works reliably attributable to him appear to survive.[14] Moreover, descriptions of Shen's painting style are largely generic: biographies record that he specialized in landscapes after Dong Yuan (d. ca. 962), Juran (active tenth century), and other early masters, and that he was also skilled in depicting architecture.[15] Highly conventionalized, these characterizations nonetheless suggest clear affinities to the Kangxi court manner found in Leng Mei's *View of Rehe* and related works, as well as with the contrast between architecture and landscape found in the printed scenes, which combine the layered forms of Orthodox landscapes with the precise delineation of *jiehua*.

Two of the court's most talented woodblock artisans, Zhu Gui and Mei Yufeng, directed the cutting of Shen Yu's designs. Zhu and Mei also cut the blocks for the imperial *Images of Tilling and Weaving* (see fig. 4.14), generically the closest precedent for *Imperial Poems* within Kangxi court art.[16] As with *Images of Tilling and Weaving*, which was executed after paintings originally by Jiao Bingzhen, in *Imperial Poems*, Zhu and Mei's dense, careful delineation of forms and voids seems intended to capture the style and feeling of the paintings that were used as models. This would have been in keeping not only with court precedent but also with printing trends of the sixteenth and seventeenth centuries, when the rise of popular printed painting manuals, the market for luxury editions, and the close involvement of certain painters with the printing industry demanded that woodblock artisans seek to communicate as much of an original painting or artist's style in a different medium as possible.[17]

Between 1712 and 1714 a second set of images was produced in the court, the copperplate engravings executed by Matteo Ripa and two Qing artists. Based closely on the woodblock versions of the scenes, these prints reflected the experimental elaboration of three printmakers possessing varying levels of technical experience in the medium and different artistic investments in its European models.[18] Ripa, a member of the Sacred Congregation for the Propagation of the Faith (Sacra Congregatio de Propaganda Fide), the Vatican's missionary branch, and by his own admission an inexperienced printmaker, altered the original woodblocks in a more European manner, with longer, modulated texture strokes, aerial perspective, and the insertion of environmental elements absent from the Chinese prints, such as animals, clouds, and even a radiating sun (fig. 5.2).[19] His tutees, however—Zhang Kui, who signed his prints, and another, unnamed artist—sought to transform their imported technique, rather than the images themselves, using the engraver's burin to create marks rooted in a woodblock aesthetic (fig. 5.3).[20] These different approaches speak to an interest in technological and cultural acquisition as much as to any consistent artistic inclination,

demonstrations of mastery that were elaborated and extended in the subsequent engraving of the *Complete Survey of Imperial Territories* (see fig. 2.1), to which Ripa, and perhaps his Qing partners, also contributed.

While existing scholarship has focused entirely on the two printed versions and, in passing, Shen Yu's designs, a third version, with paintings by Wang Yuanqi, expands the terms under which the prints and the project as a whole ought to be understood. Strong material evidence suggests that the three iterations—paintings, woodblocks, and copperplates—are directly related compositionally, each in some sense a version of the others. Moreover, both stylistic analysis and circumstance indicate that the Wang Yuanqi album is at least representative of the project's collective artistic intention and most likely the primary model followed by the others. Although no longer extant, the likely appearance of Wang's images can be reconstructed by triangulating known works, including the woodblock prints, Qianlong-era versions of the album, and Wang's own contemporary paintings.

In 1711, when the group of artists toured the Mountain Estate together, Wang Yuanqi was well established not only as one of the most important officials in the court but also its leading painter and painting theorist. First entering the imperial bureaucracy in 1683, Wang served in Beijing off and on until 1699—the year of Giovanni Gherardini's arrival at court—when he returned to the capital for good, remaining at court until his death in 1715. By the time of his return, Wang was renowned as one of the most famous painters in the empire and heir to the Orthodox mantle of Dong Qichang (1555–1636). The so-called Orthodox School was canonized by Wang Shimin (1592–1680), a student of Dong's and Wang Yuanqi's grandfather, and his followers in the Loudong school. With Wang Hui, Wang Yuanqi emerged as Orthodoxy's preeminent master in the last years of the seventeenth century. Inscriptions on Wang Yuanqi's paintings attest to this prominence, as he enjoyed extensive patronage networks both in the South and among Banner and Chinese elites in Beijing, including a number of influential officials at court.[21]

In 1700, Kangxi appointed Wang Yuanqi to the Hanlin Academy, where he succeeded Shen Quan (1624–1684) and Gao Shiqi (1645–1703) as the emperor's chief artistic adviser.[22] In the following years, Wang firmly established Orthodoxy as he defined it—that is, an elite, literati landscape painting lineage rooted in the models of the great Yuan masters, particularly Huang Gongwang—as the core theory of landscape painting in the court. It became a key component in a complex court style involving ruled-line painting, realistic portraiture, and forms of spatial perspective adapted from European as well as Chinese sources. Contrary to later reimaginations of early Orthodoxy as monochromatic, generic, and imitative, Wang's form of Orthodoxy, practiced both within and beyond the court, was compositionally and stylistically innovative.[23] It drew on past models but also engaged

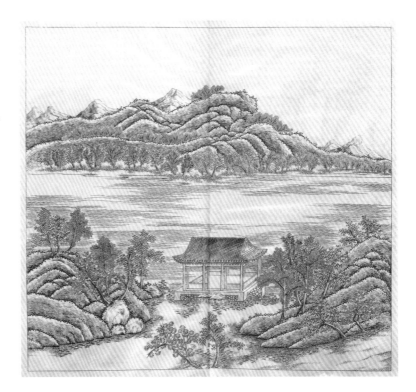

contemporary inputs and ideas, especially within the context of court production. The essential contradiction presented in this combination—the ostensibly antiprofessional, literati position of Orthodoxy and the court context in which it gained its greatest patronage—was inherent rather than external to Wang's artistic practice.

The practical mechanisms of imperial patronage were central to the canonization of Wang Yuanqi's ideas and practices in the court during the first decade of the eighteenth century. In the fifth month of 1705 the emperor invited thirteen officials, including Wang, to visit an imperial garden, where the guests enjoyed the lotuses, partook of a banquet, and received a gift of a porcelain flower vase.[24] During the visit the emperor commissioned several of the assembled scholars to undertake the compilation of *Peiwen Studio Catalogue of Painting and Calligraphy* (Peiwenzhai shuhuapu, 1708), a compendium of artists' biographies and historical texts on painting and calligraphy. Produced under Wang Yuanqi's direction, the text constructed the "authority of the historical canon of painting advocated by the Orthodox school," with significant emphasis on landscape painting, literati lineages, and the figure of Dong Qichang serving as theoretical foundation for the court's adoption and patronage of these styles.[25] Of the twelve compilers and collators who eventually worked on the project, ten were natives of the Suzhou region, from which Wang also hailed. Wang's recommendation of certain painters for official appointment populated the ranks of artists and officials with followers, helping ensure the spread of his ideas and styles within the court.[26] His role as master for the court's painters is said to have been made official during that same garden visit, as Kangxi instructed several painters to take Wang as their teacher and model, thus establishing a "school" of Qing court painting.[27]

Whether this narrative, drawn from a posthumously written biography, should be taken literally, the leading Chinese and Manchu painters of the Kangxi and subsequent courts included many of Wang Yuanqi's followers, while his style was adapted by those working in more naturalistic manners, such as Leng Mei in *View of Rehe*.[28] His continued formal and informal relationships with the emperor around art further reflected Wang's prestige. A member of the elite Southern Library (Nanshufang), a veteran court diarist, and an imperial tutor, Wang was part of Kangxi's intellectual and cultural inner circle. In addition to producing works for the emperor to give as gifts, the two frequently collaborated on fans, the emperor's calligraphy on the recto and a landscape by Wang on the reverse.[29] Wang was not alone in this privilege, but the artists who participated in such joint productions, such as Hanlin academicians Jiang Tingxi (1669–1732) and Song Junye (ca. 1662–1713), played similarly significant roles in major court scholarly and artistic efforts.[30] Jiang contributed to the annotation of *Imperial Poems* and would eventually be appointed chief compiler of *Imperially Endorsed*

*Complete Collection of Images and Writings from Antiquity to the Present.* The more senior Song, a student of Wang Hui's and director of the *Southern Inspection Tour* project (see figs 4.3 and 4.7), was also among the editors of *Peiwen Studio Catalogue of Painting and Calligraphy.*[31] Within this group, however, Wang Yuanqi held a particularly elevated position in the eyes of the emperor, who bestowed upon Wang a seal inscribed with words of transcendent esteem: "Paintings to be preserved for later generations to see" (*huatu liuyu renkan*).[32]

Activities such as "shared brush" (*hebi*) fan painting, in which the emperor and an official joined in an activity drawn from elite rituals of friendship, did not obviate the unbridgeable social chasm between the two participants. Yet at the least, they may be said to reflect a particular favor bestowed by the emperor, akin to, but even more intimate than the tour granted Zhang Yushu, a performance eliding customary differences to bind emperor and subject together. During the Kangxi period such activities often occurred within garden settings, making the relative informality of the garden one of its key attributes in the emperor's conduct of rulership. Inscriptions on a number of Wang Yuanqi's works from the last period of his life specifically mention being painted in the Garden of Perfect Brightness, where he and others close to the emperor had offices.[33] His ongoing participation in such rituals underlines the degree to which he held a special position, not only within court official and artistic hierarchies but also in Kangxi's personal favor.

In light of this history, the relationship between roughly contemporaneous versions of *Imperial Poems*—Wang Yuanqi's paintings, the woodblock-printed book, and the copperplate prints—takes on a different cast. Physical evidence indicates that these iterations were not simply coincident but most likely executed in a coordinated fashion. In particular, Wang's paintings and the two sets of prints are almost exactly the same size, approximately 27.5 × 30 centimeters.[34] That the copperplates would match the woodblock prints is not surprising; the close correlation between Wang Yuanqi's paintings and the woodblocks is more meaningful, however, as it ties Wang to the conception and composition of the project as a whole. Similarly, multiple versions share personnel: the calligraphy accompanying two surviving sets of copperplate prints was penned by, or after, Wang Cengqi (active early eighteenth century), who also supplied the calligraphy for Wang Yuanqi's album.[35]

These material connections suggest that *Imperial Poems* in all its different Kangxi-era forms was the result of a single endeavor undertaken by a small group of artists. Moreover, they indicate that the various iterations may be best understood as versions of one another, the specific materiality of each medium coloring how the other iterations should be viewed. As a practical matter, it also seems most likely that the various versions were

based on a common model. If that is the case, the overwhelming importance of Wang Yuanqi and his oeuvre, as compared to the near total absence of Shen Yu and his, argues strongly for viewing Wang's album as the prime object upon which the other painted and printed versions were based.

A project's production through multiple iterations, whether a draft of a final painting or linked painted and printed versions of a single composition, was common in the Kangxi court. For instance, Wang Yuanqi executed what seems to have been a draft of his *Ten Scenes of West Lake* (Xihu shijing) in ink and with plain black inscriptions, as opposed to the rich colors and gold ink of the composition's finished form (fig. 5.4).[36] Jiao Bingzhen produced a painted set of *Images of Tilling and Weaving* before the woodblock-printed volume based on his designs, while Leng Mei's paintings of the subject are so close to the prints that they would appear to be either the ultimate source for the woodblock designs or a repainting of the prints after their production.[37] Finally, *Magnificent Record of Longevity* (Wanshou shengdian tu; see fig. 6.3), which documented the six-mile-long festival through the streets of Beijing held to celebrate the Kangxi emperor's sixtieth birthday in 1713, began as a handscroll (now known only through a Qianlong-era copy) designed first by Song Junye and then, after Song's passing, Wang Yuanqi.[38] A draft of the composition was completed in 1714, at which time Wang conceived of producing a printed version for wider distribution, which would allow the emperor's subjects to "look up towards Heaven in admiration of His glory."[39] A new department was established for this purpose, the Bureau of the Pictorial Record of Longevity (Wanshou shuhua ju), again under Wang's leadership. At least sixteen artists are credited as contributing to the project, including both Leng Mei and Shen Yu, whose participation underlines their positions subordinate to Wang Yuanqi in the court artistic hierarchy.[40] Both scroll and book were completed in early 1716, less than a year after Wang's death. The two versions presumably followed each other fairly precisely, save that the painting was richly colored while the prints are monochrome.

*Magnificent Record of Longevity* thus represents a particularly well-documented case of an imperially significant landscape project under the direction of Wang Yuanqi that began as a painting before being reproduced and distributed as a book. While the same circumstances cannot necessarily be assumed to apply to the production of *Imperial Poems*, of the three major pictorial printing projects of the late Kangxi era, two—*Images of Tilling and Weaving* and *Magnificent Record of Longevity*—are known to have involved multiple individuals working across several versions in different mediums under directors who were both senior officials and prominent artists. These closely related examples suggest that Shen Yu's generally credited position as the artist responsible for the scenes of Rehe should be reevaluated. By shifting attention from an individual artist and binary production process

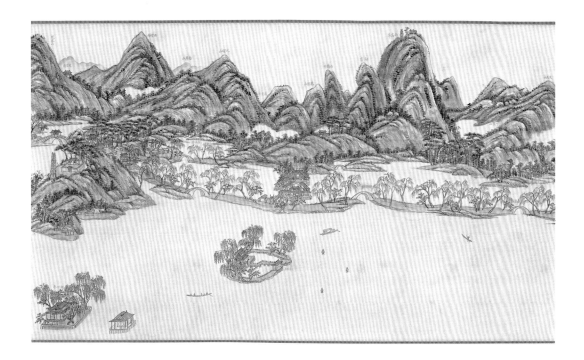

FIGURE 5.4
Wang Yuanqi, *Ten Scenes of West Lake*, 1708. Detail of a handscroll, ink and color on silk, 62.2 × 656.5 cm. Liaoning Provincial Museum.

to multiple artists working across intersecting mediums and formats, the pictoriality of the woodblock prints may be productively complicated, both as interpretations of an Orthodox album by Wang Yuanqi and as mass-produced expressions of a unique original.

## The Painted Matrix

The entry for Wang Yuanqi's *Imperial Poems* in *Precious Records of the Stone Moat* describes the album in precise, material terms: "Thirty-six scenes of the Mountain Estate to Escape the Heat painted by Wang Yuanqi, one album. White writing paper, painted in colors. Altogether thirty-six folios. On the left of each folio is inscribed one of the Benevolent Emperor Sheng-zu's [Kangxi's] poems in small characters."[41] The entry also records the text of each poem, the seals and signatures of Wang and the calligrapher, Wang Cengqi, and the paintings' dimensions. Although the album does not survive, this description, coupled with contemporary works by Wang Yuanqi, compositional similarities across extant, Qianlong versions of *Imperial Poems*, and the consistent size of the three Kangxi versions noted above, suggest that Wang's paintings can be productively characterized, if not precisely re-created, in ways that expand understanding of how a Qing viewer might have read the neutral, monochrome woodblock prints.[42] Viewed within the broader context of imperial art production, this reconstruction

illustrates ways in which court visual culture drew upon historical models, engaged novel contemporary inputs, and capitalized on the potential of both style and genre as meaning-bearing aspects of a work to convey a multivalent expression of cosmopolitan emperorship under Kangxi.

Three roughly contemporaneous topographical landscapes by Wang Yuanqi provide the most immediate context for *Imperial Poems*. Painted for a private patron, the otherwise anonymous Master Jiweng (Jiweng xiansheng), *Ten Records of a Thatched Hut* (Caotang shizhi), dated 1708, and *Wheel River Villa* (Wangchuantu), datable to 1711, offer close generic and likely stylistic models for *Imperial Poems*. The third, *Ten Scenes of West Lake*, a court work datable to 1708, represents Wang Yuanqi's first major contribution to the pictorialization of an explicitly Qing territory.[43] Each captures a historical or semihistorical landscape organized around a series of scenes, borrowing from or adapting existing compositional traditions in depicting established pictorial cycles. The works represent prime examples not only of Wang's style in the last phase of his life but also his understanding of the fertile overlaps that might exist between the idealized landscapes normally associated with Orthodox painting and the topographical records in which both his patrons were interested.

Created only a year or so before *Imperial Poems*, *Wheel River Villa* (fig. 5.5) is the closest, most productive comparison for understanding the court album's subject and style. *Wheel River Villa* depicts the country estate of poet and painter Wang Wei (699–759) outside the Tang capital of Chang'an. Combining poetry and scenes from the property, Wang Wei's original composition, long known only through copies, served as a progenitor of the garden portrait tradition, and Wang Wei himself as a model for cultured garden owners.[44] Building on a long series of linked versions of the Wheel River landscape, Wang Yuanqi based his scroll on a Ming rubbing of a Song stone engraving that was thought to follow Wang Wei's original composition—a Qing painting in "inspired imitation" (*fang*) of a transmitted copy of a reliably early image after a now lost original.[45]

Beginning at the edge of the estate, Wang Yuanqi's handscroll works its way through the "twenty scenes" of Wang Wei's property. The names and accompanying poems, composed by Wang Wei in five-character regulated verse, appear following the painting. The educated viewer would likely have known the texts by heart, able to recall them as they journeyed through

FIGURE 5.5
Wang Yuanqi, *Wheel River Villa*, 1711. Detail of a handscroll, ink and color on paper, 35.6 × 545.5 cm. Metropolitan Museum of Art, Ex coll.: C. C. Wang Family, Purchase, Douglas Dillon Gift, 1977, 1977.80.

the pictorial landscape. Encountering the verses following the painting thus allowed a second trip through the estate, a literary recursion that not only evoked established images of the landscape but also the composition by Wang Yuanqi just concluded. Wang Yuanqi's landscape forms are built from small, sketchily outlined masses assembled at uncertain angles to create the hills and open fields of the villa. The outlines do little of the work, however. Rather, Wang assembles volumes from dry, twisting texture strokes and pale washes of blue, green, and peach. Color is not simply a descriptive presence: it complements, if not substantially displaces, black ink as the essential medium from which the landscape emerges piece by piece. Forms are vertiginously juxtaposed against voids, destabilizing the composition's capacity as a solid, inhabitable space. Close up, the style teeters on the edge of abstraction, its individual elements resisting their delicate dissolution to cohere as a composition.[46]

In later historiography Orthodox painting has often been characterized as strictly monochrome, imagined as befitting the restrained expression of literati, while the use of color has been denigrated as a decorative effect suitable to professional painters and court artists interested only in literal descriptiveness. Yet during the early Qing, color played an important role in the manners of many so-called Orthodox artists as well as those imitating their styles. This was particularly true for Wang Yuanqi, who developed a progressively more complex color technique over the last twenty-five years of his life. The brushwork and color employed in *Wheel River Villa* can be seen as a pictorial manifesto for his late style, the culmination of his life's work on canonizing an Orthodox approach to landscape. In a colophon following the painting, Wang Yuanqi described the passing of the "lamp-flame" (*yideng xiangxu*) of Orthodoxy along a lineage that originated with Wang Wei and continued via the canonical masters of the Song and Yuan: Jing Hao, Guan Tong, Dong Yuan, Juran, Li Cheng (919–967), Mi Fu (1052–1107) and Mi Youren (1074–1151), Fan Kuan, Gao Kegong (1248–1310), Zhao Mengfu (1254–1322), and the Four Masters of the Yuan, Huang Gongwang (1269–1354), Wu Zhen (1280–1354), Ni Zan (1301–1374), and Wang Meng (ca. 1308–1385). In the Ming "only Dong [Qichang] succeeded in sweeping away the web of illusion," while Wang Yuanqi's grandfather, Shimin, "personally inherited the mantle [from Dong]." The inscription goes on to imply that the mantle then passed particularly to him, Wang

Yuanqi: "As I used to attend [my grandfather] in my youth, I have learned a few things [about painting]."[47]

Wang Yuanqi then recounts the process of commissioning and painting *Wheel River Villa*. While in the past he had no reliable model to work from, the recent acquisition of a stone rubbing of the composition, together with Wang Wei's own poetic descriptions of the site, gave him confidence to proceed. Yet it was not, like so many earlier versions of *Wheel River Villa*, a mere rote copy, a task appropriate to "a professional painter." Rather, Wang Yuanqi "made this scroll with my own ideas. . . . By adding poetry to the ink engraving, I have been able to see the wonders of Youcheng's [Wang Wei's] designs of *yang* and *yin*, their ever changing forms and steps. Though some may think my work clumsy and inferior, I believe that it has captured some of [Wang Wei's] idea of 'painting in poetry and poetry in painting.'"[48] For Wang Yuanqi, *Wheel River Villa* was thus a process of reiteration, a painting through which he retraced the long artistic thread that connected him to the first of the Orthodox masters. It was also an assertion of his mastery, his position as the culmination of that lineage. Having learned from the past, he pursued Wang Wei's underlying intention—"painting in poetry and poetry in painting"—through his own distinctive style.

Based on a comparison with Wang Yuanqi's *Ten Scenes of West Lake* (see fig. 5.4), the latest reliably datable, extant court work available for contrast, *Wheel River Villa* likely takes these formal pressures on representation further than Wang would have in paintings for the emperor. In *Ten Scenes of West Lake*, his palette is less diverse, relying heavily on greens and browns. The forms are also more balanced, not only as individual elements but in their construction of the larger landscape: mountains ring the lake in stable, vertical assemblages, while the islands and shore have a solidity separate from the water that supports the extensive and detailed architecture. Although compositionally still relatively flat, as though concerned more with the painterly qualities of the ink washes than with the naturalistic representation of volume, the ground plane is consistent, avoiding the shifting and pitching of *Wheel River*'s landforms. Yet the underlying technique, integrally employing color in gradated washes to assemble forms, is essentially the same as in *Wheel River Villa*. The relative technical conservatism is a matter of degree appropriate to the work's context of production and is comparable to Wang Yuanqi's other imperial paintings, rather than constituting a radical departure that would argue for distinct courtly and private manners.

Returning to *Imperial Poems* with these formal models in mind, it is not difficult to understand the landscape forms seen in the prints as a stylized translation of Wang Yuanqi's dynamic brushstrokes into the cuts of a woodblock knife. Taking the ninth scene, "Clouds and Peaks on All Sides" (fig. 5.6), as illustration, the roiling mountains are built through an assem-

FIGURE 5.6
Shen Yu et al., "Clouds and
Peaks on All Sides," 1713,
from Kangxi et al., *Imperial
Poems*, scene 9. Woodblock
print. Chinese Collection,
Harvard-Yenching Library,
© President and Fellows of
Harvard College.

blage of smaller forms in a manner directly evocative of Wang's own. While the block-cutter has favored small, discrete texture marks, their density and pattern, arranged tip to tail in a staccato series of staggered lines, creates the appearance of long, albeit broken brushstrokes. They impart a similar effect to Wang's "hemp-fiber" strokes but without the visual muddiness that an accumulation of continuous lines would bring to a printed page. They also suggest ink washes without actually employing such an effect, signaling the way in which Wang Yuanqi used wash as well as line to create volume and texture. The outlines of the forms, though present, are visually elided. Delineated in thin, wiry tracery, they are covered by foliage dots or otherwise fade into the texture patterns, echoing and reinforcing, sotto voce, the more evident curvatures and volumes of the texture.

Previous efforts to capture the manners of Orthodox masters in print, such as those reproduced in the famous *Mustard Seed Garden Manual of Painting* (Jieziyuan huazhuan, 1679), tended to focus on outline and composition. This strategy is in keeping with the manuals' likely use not as practical texts for learning to paint but as primers for recognizing and speaking about an art form with which one was unfamiliar.[49] Similar to the woodblock-printed *Imperial Poems*, texture is signaled through accumulated, overlapping internal lines, albeit far less densely and without the staccato quality of the Qing court production. Thus Huang Gongwang is evoked through the accreted, progressive forms of his mountains and an indicative selection of long strokes (fig. 5.7); absent is the careful layering of

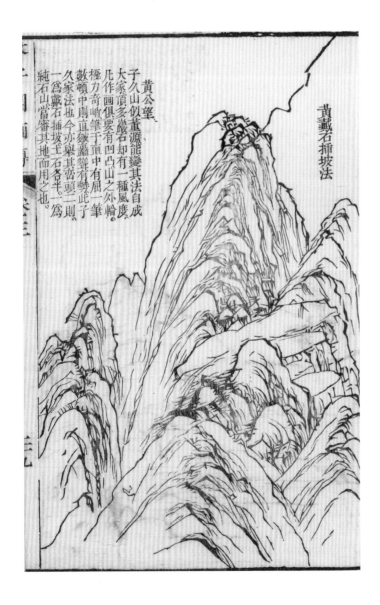

FIGURE 5.7
Wang Gai et al., "Huang Gongwang," *Mustard Seed Garden Painting Manual*, j. 3, Kangxi period (1661–1722). Chinese Collection, Harvard-Yenching Library, © President and Fellows of Harvard College.

wash and texture, dark over light, that is characteristic of his actual manner. While the Kangxi woodblocks certainly cannot be said to imitate precisely Wang Yuanqi's painting style, the way in which the surface of the print is densely and deliberately worked recalls that same quality seen in *Wheel River Villa*. The seemingly unprecedented manner in which Shen Yu, Zhu Gui, and Mei Yufeng depicted the mountains suggests an interest in capturing something new and unique—perhaps a mature and distinctively Qing style such as Wang Yuanqi's—rather than a generic printed landscape, Orthodox or otherwise.

This sense of specificity is furthered by comparison with the second of Wang Yuanqi's paintings for Master Jiweng, *Ten Records of a Thatched Hut*. The album follows a thematic series originating with the eighth-century recluse painter Lu Hong (active 713–742) that depicts Lu's retreat on Mount Song, built by the Tang emperor Xuanzong (r. 713–756) for Lu after he declined an invitation to serve at court in favor of his life as a hermit. Transmitted over time through copies and attributed versions, including one believed by Qianlong to be the original (fig. 5.8), *Ten Records* was also an occasional subject for well-established artists painting under their own names, such as the mid-Ming Suzhou master Xie Shichen (1487–ca. 1567; fig. 5.9).[50] As with *Wheel River Villa*, the consistency of compositions across versions—here illustrated by the opening scene, showing Lu Hong sitting in the eponymous Thatched Hut staring placidly out at the viewer—

attests to the ways in which the iconography of certain themes became firmly established over centuries of repeated creation. This essential composition came to have a life beyond *Ten Records*, carrying associations of Lu Hong's remembered or imagined estate to other similar garden portraits. Wen Zhengming (1470–1559) borrows the frontal view of a simple, grass-roofed structure for the opening leaf of his 1551 album of the *Garden of the Artless Official* (Zhuozhengyuan tushice; see fig. 6.5), for instance, which depicts the garden's main structure, Almost-a-Villa Hall (Ruoshutang). While owner Wang Xianchen (active ca. 1500–1535) is physically absent from that building, perhaps in acknowledgment of his likely recent death, the composition is enough to evoke its missing occupant and commemorate an identity intertwined with the garden.[51]

Like *Wheel River Villa*, *Ten Records of a Thatched Hut* can be seen as a form of "mnemonic topography." The paintings are topographical in that they record a specific, known site according to a stable iconography of place that renders the subject recognizable and familiar to an informed viewer. Yet the topography is defined principally through memory and tradition rather than through extant, verifiable landmarks, drawing on collective interpretations of certain structures or features of the land that relate not to firsthand observation but to textual mediation, topos-specific iconographies, and accreted pictorial conventions. This need not make such landscapes any less "real" in the sense of depicting an actual place. Although

FIGURE 5.9
Xie Shichen, *Ten Records of a Thatched Hut*, sixteenth century, leaf 1. Album leaf, ink on paper. Shenyang Palace Museum.

FIGURE 5.10
Wang Yuanqi, *Ten Records of a Thatched Hut*, 1708, leaf 1, after Wang Wei. Album leaf, ink and color on paper, 29 × 29 cm. Provided by the Palace Museum, Xin16669-1/10. Photo by Sun Zhiyuan.

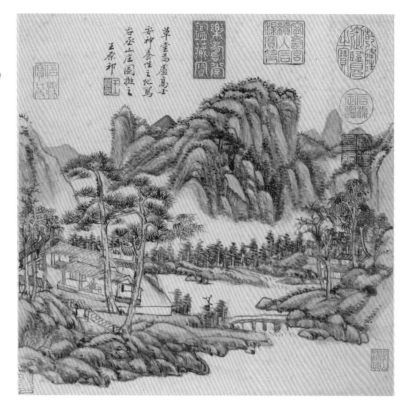

the garden itself was no longer available to measure the picture against, tradition and memory served as robust and, for all intents and purposes, equivalent substitutes. As with Wen Zhengming's album depicting the Garden of the Artless Official, Wang Yuanqi's paintings for Master Jiweng provided a rich pictorial vocabulary upon which other garden representations could build and a context within which they would be understood.

Wang Yuanqi's *Thatched Hut* album is a work that simultaneously engaged with the past and actively reinterpreted the ostensible terms of Orthodoxy. While it followed the number and sequence of scenes established for the theme, it departed in important ways from the Lu Hong tradition. Consisting of six color and four monochrome leafs, each measuring 29 × 29 centimeters—interestingly close to the various *Imperial Poems*—Wang's paintings set aside the theme's canonical style and palette in exchange for his own distinctive manner.[52] In the album's opening leaf of the site's eponymous hall (fig. 5.10), Wang's characteristic use of wash and line describes a small valley ringed by mountains that surround the garden. The palette is more reliant on rich greens and light browns, like *Ten Scenes of West Lake* of the same year, than the paler peaches, blues, and greens of *Wheel River Villa* three years later. The composition has also changed from its iconic models. Although someone—Lu Hong, Master Jiweng, or,

in some sense, both—still sits within the Thatched Hut, leaning on a low table beside him, the point of view has risen and the hall has shifted to the edge of the image. As with the other leaves in the album, Wang's conception of the theme tempers an emphasis on architecture with an interest in the broader contextual landscape.

In Wang Yuanqi's inscription on this first leaf, he explicitly connects the image, and perhaps the album as a whole, to Wang Wei's representation of his "mountain estate."[53] The composition, particularly the way in which Wang Yuanqi has enclosed the thatched hut within a low wall, relates to the central halls of *Wheel River Villa* as they appeared in the Song stone engraving and subsequently Wang's 1711 scroll. The import of Wang Yuanqi's reliance on Wang Wei is not simply or even primarily formal, however. Rather, as in *Wheel River Villa*, which Wang Yuanqi "made with [his] own ideas," the more significant connection is the linking together of two related but independent topos, two models of cultured behavior, and two culturally redolent gardens by means of Wang's contemporary manner. Through these albums, Wang Yuanqi connected himself and his patron to his artistic models, Wang Wei and Lu Hong, while also relating them to one another as paradigms of common values by means of the landscapes through which those values were mnemonically encoded.[54]

Just as Wang Yuanqi's style may be understood as a tension between abstraction and representation, so too may at least some of his paintings—*Wheel River Villa* and *Ten Records of a Thatched Hut*, especially, but also *Ten Scenes of West Lake* and *Imperial Poems*—be seen as existing between idealized and topographical landscapes. Orthodox painting is conventionally understood as atopographical, concerned only with the representation of idealized landscapes and through those with the exploration of a formal pictorial language.[55] Like many other elements of both Orthodox theory and its later reception, however, this notion does not reflect historical reality, either among the artists who most interested Dong Qichang or for his leading Kangxi-era followers, Wang Yuanqi and Wang Hui. Nonetheless, like other so-called Orthodox painters, Wang Yuanqi painted landscapes that ostensibly looked to the established canon of Song and Yuan masters upon whom Dong Qichang and Wang Shimin rested the foundations of their artistic theory. As with many other painters of the late Ming and early Qing, Wang Yuanqi frequently produced works in "inspired imitation" of these paragons, paintings that in turn became vehicles for transmitting Orthodoxy and its artistic associations. Rather than imitating their models wholesale, however, Wang Yuanqi and others captured the essence of these iconic artists through standard compositional forms or intentional stylistic mannerisms, such as Mi-style ink dots after the Song painters Mi Fu and Mi Youren, or turgid brushwork and leaning peaks meant to evoke Wang Meng (fig. 5.11).

For patrons, an album comprised of these "Old Masters" works represented an assemblage of classic styles and compositions done à la mode, executed by a contemporary artist engaged in current discourses. For the artists, such albums served as affirmation of lineal connections and even as literal primers.[56] Wang Yuanqi himself painted Old Masters albums in a great number of variations. Consisting of six to twelve leaves, Wang worked in a variety of formats and a mixture of monochrome and color palettes. He made the albums for both private patrons and the emperor, often closely repeating elements across multiple iterations, and drew on a largely set group of artists for inspiration.[57] Song painters Dong Yuan, Juran, Jing Hao, and Guan Tong, either individually or paired in different combinations, represent the monumental landscape tradition. Among other Song artists, Zhao Lingrang (active ca. 1070–1100), Li Cheng, and the Mi Family (Mijia, i.e., Mi Fu and Mi Youren) each had specific compositions and styles associated with them. Huang Gongwang, Ni Zan, Wu Zhen, Wang Meng, and Zhao Mengfu represented the Yuan period, together with the now less well-known Gao Kegong. Drawing on such a canonical repertoire naturally disinclined aspects of Orthodox painting from individualized, specifically descriptive compositions, but as is clear, did not preclude the representation of topographical subjects.

FIGURE 5.11
Wang Yuanqi, *Ten Records of a Thatched Hut*, 1708, leaf 2, after Wang Meng. Album leaf, ink on paper, 29 × 29 cm. Provided by the Palace Museum, Xin16669-2/10. Photo by Sun Zhiyuan.

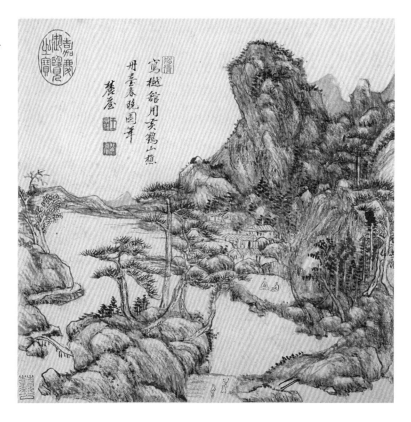

Wang Yuanqi's reinterpretation of *Ten Records of a Thatched Hut* through the framework of an Old Masters album led to a departure from the traditional compositions and style associated with Lu Hong's retreat and an innovative new marriage of the ideal and the specific. After the opening leaf, which makes reference to Wang Wei and *Wheel River Villa*, the remaining leaves of the album are in the manners of Huangheshan (Wang Meng); Beiyuan (Dong Yuan); Dachi (Huang Gongwang); the Mi family; Jing Hao and Guan Tong, or Jing Guan; Jiang Shen (ca. 1090–1138), a relatively obscure reference for early Qing Orthodox painters; Zhao Danian (Zhao Lingrang); Mei Daoren (Wu Zhen); and Zhao Cheng (Zhao Mengfu).[58] The individual images rely on Wang's established formal associations for each artist, while inserting specific iconographic elements identifiable with the Lu Hong tradition. For instance, leaf 6 (fig. 5.12) shows a small pavilion, in which two gentlemen sit, situated in a clearing surrounded by mountains. The intricately textured hills, assembled from a great number of small forms and surmounted by a leaning bluff, are painted after Jing Hao and Guan Tong, and clearly resemble another such painting (fig. 5.13) from an undated but likely slightly earlier album of twelve leaves now in the Shanghai Museum.[59] Yet the architecture standing prominently at the

FIGURE 5.13
Wang Yuanqi, "Landscape after Jing [Hao] and Guan [Tong]," ca. 1670–1715, from *Landscapes in Inspired Imitation of the Ancients*. Album leaf, ink and color on paper, 35 × 26 cm. Shanghai Museum of Art.

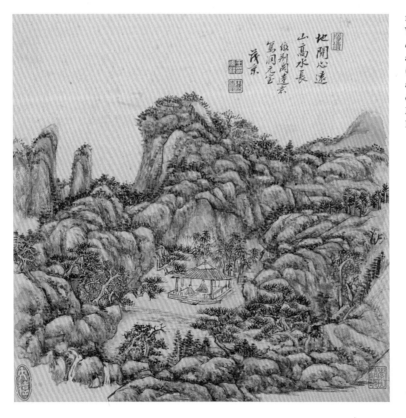

FIGURE 5.12
Wang Yuanqi, *Ten Records of a Thatched Hut*, 1708, leaf 6, after Jing (Hao) and Guan (Tong). Album leaf, ink and color on paper, 29 × 29 cm. Provided by the Palace Museum, Xin16669-6/10. Photo by Sun Zhiyuan.

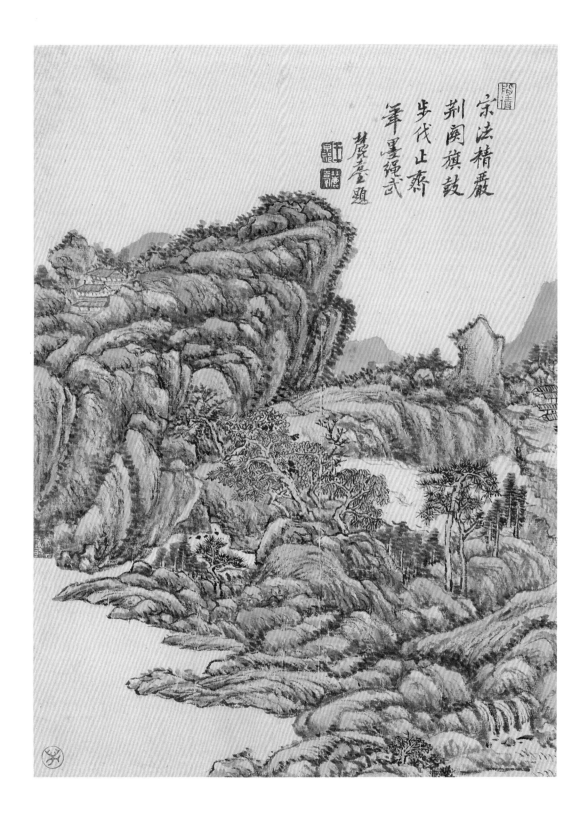

宗法精嚴
荆關旗鼓
步伐止齊
筆墨繩武

center of the scene is otherwise out of place in a Wang Yuanqi painting after a Song master. The Distant Grotto Kiosk (Dongyuanwu), named in the inscription but also recognizable to a cultured viewer, firmly places the scene within the established mnemonic topography of Lu Hong's estate.

Compositional comparison indicates that the original *Imperial Poems* may, like *Ten Records of a Thatched Hut*, have been intended as an Old Masters album. Unlike the Rehe album's style, which is signaled, however briefly, in *Precious Records of the Stone Moat*, no account of Wang's compositional approach remains. In the absence of the original paintings, comparison between the woodblock prints and extant Qianlong-era versions, including albums by Zhang Zongcang (1686–1756) and Qian Weicheng (1720–1772), among others, suggests a relatively stable compositional program across different iterations of the thirty-six scenes.[60] Though not Wang Yuanqi's direct students, Zhang Zongcang and Qian Weicheng were among those in the Qianlong court most strongly associated with the Orthodox legacy through their teachers, Huang Ding (1660–1730) and Dong Bangda (1699–1769), respectively.[61] Given Wang Yuanqi's influence in Kangxi and Qianlong court ateliers, together with the fact that Wang's album was most probably in the imperial collection at the time the later albums were produced in the early to mid-1750s, it is highly likely that these shared compositions extended to Wang Yuanqi's original as well.[62]

While the topographic impulse in *Imperial Poems* was necessarily very strong given the subject, patron, and audience, it was clearly coupled with certain compositional models. The variety of inspirational sources employed is not as diverse as those found in other of Wang Yuanqi's Old Masters albums, in which a given artist would rarely appear more than once. Certain key exemplars emerge nonetheless. Chief among these is Ni Zan's iconic composition of a foreground kiosk divided from a central mountain by intervening water. Wang Yuanqi's Ni Zan landscapes employ this same formula, with only slight variations—sometimes the foreground architecture is to the side rather than in the center, other times it is set on a small island instead of the shore.[63] This basic formula appears several times in the *Imperial Poems*: "Orioles Warbling in the Tall Trees" (see fig. 3.4), "Untrammeled Thoughts by the Hao and Pu Rivers" (see fig. 3.5), "Clear Ripples with Layers of Greenery" (fig. 5.14), and perhaps even "Sounds of a Spring Near and Far" (see fig. 1.9) would have called to mind Ni Zan.

Equally telling is "Southern Mountains Piled with Snow" (fig. 5.15). While the woodblock-printed image is naturally devoid of color and shading, Qianlong-era albums, including those by Zhang Zongcang (fig. 5.16) and Qian Weicheng, reveal that this composition was consistently illustrated as a winter scene, with gray-washed sky and a different treatment of texture strokes to create the appearance of a snowy landscape. Though relatively rare, winter scenes in Wang Yuanqi's oeuvre were always associated

with Song painters, primarily Li Cheng and Juran (fig. 5.17).[64] Importantly, within the context of early Qing Orthodox painting, such scenes do not exist outside references to these or similar artists. Rendering "Southern Mountains Piled with Snow" as a winter landscape is apt given the scene's title, but it also necessarily evokes Orthodox treatments of certain Song masters.

Other comparisons are less specific in terms of model, but nonetheless clearly relate to compositions found repeatedly in Wang Yuanqi's oeuvre. For instance, "Verdant Isle of Green Maples" (fig. 5.18) depicts a small garden compound perched on the edge of a cliff overlooking the valley below. While the composition, which highlights the peak above the compound, finds analogues in paintings by Wang Yuanqi following Wang Meng, a combination of Dong Yuan and Juran, and Zhao Mengfu, among others, the closest comparisons are to four album leaves after Wu Zhen, most especially the seventh leaf of *Ten Records of a Thatched Hut* (fig. 5.19).[65] "Pine Winds through Myriad Vales" (fig. 5.20) presents a similar case. The image offers a view from roughly Encircling Jade Island, looking south. In the foreground a small bridge connects *Lingzhi* Path on an Embankment to the Clouds to the southern shore of the lakes. A cluster of buildings sits within a low range of hills. Very similar compositions by Wang Yuanqi can be seen in paintings nominally following the Song masters Fan Kuan and Juran as well as Yuan painters Wang Meng and Wu Zhen.[66] Comparing Zhang Zongcang's version of this scene (fig. 5.21) and Qian Weicheng's almost identical leaf in the Bishu Shanzhuang Museum to another album

FIGURE 5.17
Wang Yuanqi, "Landscape after Juran," ca. 1670–1715, from *Landscapes in Inspired Imitation of the Ancients*. Album leaf, ink on paper. Provided by the Palace Museum, Gu4870-2/10. Photo by Zhao Shan.

FIGURE 5.16
Zhang Zongcang, "Southern Mountains Piled with Snow," 1752, from *Thirty-Six Scenes of the Mountain Estate to Escape the Heat*, scene 13. Album leaf, ink on paper, 31.5 × 30.2 cm. The Collection of the National Palace Museum, Guhua3373-13.

leaf by Wang Yuanqi (fig. 5.22) again suggests Wu Zhen is the most likely source.[67]

In many cases, however, Wang Yuanqi's compositions appear relatively similar across imitative models, with exact identification possible only through the artist's inscription—a level of specificity not available in the case of *Imperial Poems*. Indeed, within Wang's known body of work, *Imperial Poems* is rare, if not unique, in not being explicitly identified as an Old Masters album. This degree of relative uncertainty highlights a tension between the ostensible characteristics of particular traditional styles as interpreted through the filter of Wang's brush and the reality that these compositional types are ultimately Wang's own, and therefore unsurprisingly found throughout his oeuvre. Put differently, the association of Wang's compositions with the legacy of Song and Yuan masters transcends specific, leaf-by-leaf identification and was instead intrinsic to the artistic theory upon which his work was founded. Although not expressly framed as an Old Masters album, given the roots of *Imperial Poems* in Wang Yuanqi's oeuvre and artistic theory, its visual connections to Orthodox painting within the court, and Wang's own prominence as the emperor's leading artist, visually literate viewers would have almost certainly appreciated it in this way.

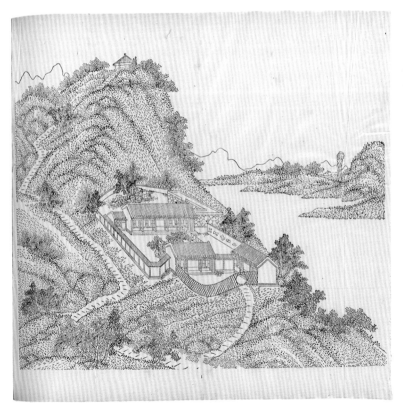

FIGURE 5.18
Shen Yu et al., "Verdant Isle of Green Maples," 1713, from Kangxi et al., *Imperial Poems*, scene 21. Woodblock print. Chinese Collection, Harvard-Yenching Library, © President and Fellows of Harvard College.

FIGURE 5.19
Wang Yuanqi, *Ten Records of a Thatched Hut*, 1708, leaf 7, after Wu Zhen. Album leaf, ink and color on paper, 29 × 29 cm. Provided by the Palace Museum, Xin16669-7/10. Photo by Sun Zhiyuan.

## (Inter)materiality and (Re)iteration

The comparisons to garden paintings, topographic works, and Old Masters albums outlined in this chapter put pressure on both sides of the ostensible imperial/Orthodox or imperial/literati divide in ways that have important implications for the nature of *Imperial Poems* as a series of landscape pictures and for the meanings borne by such pictures in the Qing court. Topographic painting inherently reflects an interest in the specific and in documentation. For an imperial court, especially one focused on establishing legitimate claim to territory, this is a valuable impulse. Topographic representation can be seen as complementing paintings documenting significant events by situating these occasions in identifiable spaces. Although hardly literal maps of the empire, Wang Hui's *Southern Inspection Tour* scrolls, Leng Mei's *View of Rehe,* and pictorial maps of imperial tombs all depended on the stylistic and compositional appearance of veracity to accomplish their rhetorical aims.[68] Orthodoxy, at least in its traditional construction, ostensibly occupies the opposite pole. Stylistically and compositionally, Orthodox theory presented its adherents as rooted in, and inspired by, the great masters of the past, focused solely on a formal engagement with canonical models. Abstract, generic, theorized, its compositions

are simultaneously the sum of their individual marks and as invested in the marks themselves as in the pictorial whole.

Contrary to conventional expectations, Wang Yuanqi's late career demonstrates a sustained interest in using the formal vocabulary of Orthodoxy to depict topographical spaces, both private and imperial. This innovation was not unique to Wang Yuanqi's practice: Wang Hui, for instance, not only directed the *Southern Inspection Tour* project but also painted a number of garden portraits for private patrons. The tension between the topographical and ideal takes on new dimensions in *Imperial Poems* and related paintings, particularly his albums for Master Jiweng and *Ten Scenes of West Lake*. In *Ten Records of a Thatched Hut* and *Wheel River Villa*, Wang Yuanqi created versions of classical compositions for his patron in his own distinctive hand; they were in some sense both contemporary paintings

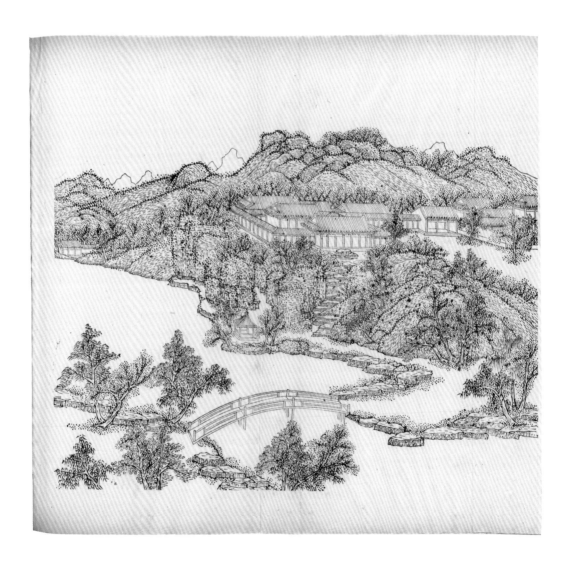

and antiques. The works rested in a space that encompassed the past, the present, and all that was in between. Whether explicitly, in the form of *Ten Records* as an Old Masters album, or implicitly, in the accretive culmination of painting history in Wang's brush recorded on *Wheel River Villa*, both paintings embodied a certain artistic and cultural history—its individual moments and its totality—in their depictions of particular gardens.

While Wang Hui and Leng Mei incorporated aspects of an Orthodox vocabulary into a stylistically diverse amalgam that became the foundation of Qing court style, *Ten Scenes of West Lake* seems to be the first instance of an Orthodox painter in the Qing court working essentially in his own style to depict a topographic landscape. In comparison with the contemporary *Ten Records of a Thatched Hut*, the more muted palette of *Ten Scenes of West Lake* relies, as in the work of Wang Hui and Leng Mei, on greens and blues. Wang's composition highlighted the gardenlike qualities of the site, which, in addition to being a highly planned and managed landscape, shared formal modes of organization through naming and literary commemoration with gardens, as did all "famous places" (*mingsheng*). Similarly, just as *Wheel River Villa* and *Ten Records of a Thatched Hut* reflect aspects of what art

FIGURE 5.21
Zhang Zongcang, "Pine Winds through Myriad Vales," 1752, from *Thirty-Six Scenes of the Mountain Estate to Escape the Heat*, scene 6. Album leaf, ink on paper, 31.5 × 30.2 cm. The Collection of the National Palace Museum, Guhua3373-6.

historian Richard Vinograd calls "landscapes of property," depictions of places associated through ownership and history with the persons and values of their owners, Wang Yuanqi's *Ten Scenes of West Lake* ties the famous site to his imperial patron.[69] In it we see a landscape of personal preference or attachment, one whose organization and history was literally fixed in stone by the emperor, who had grown attached to it over repeated visits, through the erection of imperial stelae at points marking the ten scenes.[70] Its formal connections to Wang Yuanqi and literati production in general, including other "landscapes of property," heighten the sense of the emperor's connection to, if not outright ownership of, West Lake and its history.

*Imperial Poems* attracts many of these same readings. The album itself is invested with values associated with the genre of private garden painting, connotations beginning with Wang Wei and Lu Hong that through *Imperial Poems* then accreted to the Mountain Estate itself. Yet the album was also of its moment, a product of the period's most famous artist, embodying that individual's theories at the height of his creative and intellectual powers, and of a Qing court enmeshed, artistically and otherwise, in the early modern world. The Mountain Estate that was imagined through its images was therefore one of both classical greatness *and* the contemporary environment, its owner constructed as one of a succession of men whose personal ethics were reflected in their appreciation of nature.

The relationship between painted and printed albums is not merely one of style, however, but also of format, a matrix equally profound in its effects on how *Imperial Poems* as a theme expressed across different media and iterations may be understood. Whether derived from, or simply correlated to, the unique album, the woodblock-printed book functions as a surrogate for the paintings. It imitates the album's arrangement and mode of engagement with the landscape, pairing image and text in an intimately scaled format. The style of the images evokes Wang Yuanqi but also, and more significant, the emperor's most important artist, thereby marking the book as a work of the court's highest echelon of cultural production and an object clearly commissioned and owned by the emperor. This connection is reinforced by the book's calligraphic manner, which, although not specifically imitative of the emperor's own hand, had through repeated use in elite court publications become associated with the throne.

The printed *Imperial Poems*'s material reiteration of the painted album is furthered through its production and consumption, particularly the manual and intellectual activity linking the two. Kangxi was intimately involved in the minutiae of the book's production, from the selection of a specific type of high-quality paper, to reviewing and editing the printing proofs, to inspecting samples of the finished work.[71] He was kept closely informed about the progress of the project, including difficulties in curing the datewood blocks Zhu Gui and Mei Yufeng used as well as the need for

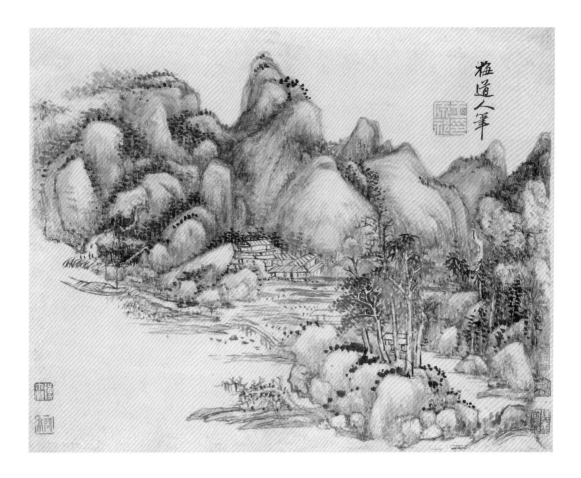

FIGURE 5.22
Wang Yuanqi, "Landscape
after Wu Zhen," 1696, from
*Landscapes in Inspired
Imitation of the Ancients*.
Album leaf, ink on paper,
29.5 × 35.9 cm. Nanjing
Museum.

more artisans given the scale and intricacy of the work.[72] The order for
four hundred copies (two hundred in Chinese and another two hundred
in Manchu) came directly from the throne.[73] In comparison to other con-
temporary projects with print runs of one thousand or more, this number
suggests that the emperor had a clear sense of the exclusive audience he
intended to reach.[74]

There is no record of the deadline against which the block-cutters, print-
ers, and binders all labored. Given the timing of the project and the flurry
of reports around printing and binding that appear from the intercalary
fifth through the seventh months of 1713, however, it seems most likely
that the volumes were meant as gifts for the emperor's sixtieth birthday
celebrations that year.[75] The scale and lavishness of production accords
with this hypothesis, as four hundred copies indicates intended distribution
among a relatively small circle of imperial clansmen, steppe elites, senior
officials, and others close to the throne.[76]

Beyond involvement in the production of the material book itself,
Kangxi also contributed (or is credited with contributing) artistically to

the project. As the author of "Record of the Mountain Estate to Escape the Heat," which circulated independently in addition to serving as the preface for *Imperial Poems*, and of the textual portions of each scene, the emperor participated in a manner similar to the making of a jointly brushed fan like those described above.[77] Although both painted and printed *Imperial Poems* involved the efforts of a sort of "substitute brush" (*daibi*) in the form of Wang Cengqi's calligraphy and the block-cutters' tools, *Imperial Poems* must be thought of as in part *by* the emperor, not simply because he commissioned it but because he helped create it. Together, these various forms of imperial investment tie the album and book to the emperor in a way that transcends simple ownership, while linking the two iterations, painted and printed, by means of the emperor's labor.[78]

The second printed version of *Imperial Poems*, the set of copperplates made under the supervision of Matteo Ripa, is equally tied to a matrix of labor and imperial possession, albeit on a more global and transcultural scale. Produced in response to the emperor's commission of a set of images "in the European style," the prints are the work of not one but three hands: Ripa, who developed the materials and techniques necessary for engraving in the Qing court, and the two Qing artists who received his instruction, one unknown and the other, Zhang Kui, who signed nine of the prints.[79] Each of the three arrived at distinct solutions to what constituted "the European style," solutions related to culturally conditioned pictorial vocabularies and expectations of pictoriality, as well as to the ways in which those ideas were expressed technically.[80] As art historian Jennifer Roberts notes, the printmaking process undertaken in transforming woodblock into copperplate was quite literally one of reversal, the intaglio effectively removing what relief printing left behind.[81] Yet from their prints, such as "Clear Ripples with Layers of Greenery" (see fig. 5.3; compare with fig. 5.14, above), it seems that both Qing artists sought essentially to recreate the marks of the original woodblocks in copperplate. This might suggest that "the European style" was as much about reconciling a new technology with existing approaches to picture-making as it was about stylistic attributes.

The prints likely attributable to Ripa, however, reflect almost the opposite impulse (see fig. 5.2). Essentially untrained in intaglio techniques, the Italian claimed in his memoirs to have seen the process demonstrated only once, in preparation for his travels overseas.[82] Ripa employed the techniques and motifs of European printmaking, including modulation of lines to reflect light, aerial perspective to heighten the sense of spatial recession, and a variety of motifs drawn from his own visual vocabulary. Yet these elements appear to be entirely superficial in their Europeanness, at least from the perspective of their audience, and stripped of their original meaning. There is no evidence, for instance, that perspective or an image

of the sun emerging from a storm was understood, let alone accepted by Qing viewers as connoting God's omniscience or grace. Instead, such motifs serve primarily as signifiers of foreignness and, through their incorporation into Qing imagery, of the court's cosmopolitan reach. Like the novel technology with which they were associated, these pictorial elements were symbolic of the mastery of signs—symbols, labor, and ideas encountered, processed, and possessed by the Qing.

As with Leng Mei's painting *View of Rehe*, these cosmopolitan encounters help account for the existence and appearance of *Imperial Poems*. Numerous endogenous models contributed to *Imperial Poems* generically and formally, series of famous scenes and private garden paintings chief among them. Fueled by the printing boom of the sixteenth and seventeenth centuries, these genres were well established among popular and elite audiences in China. Yet the depiction of imperial gardens—and indeed of *the imperial*—in the manner of *Imperial Poems* was unprecedented. While the scenes fit within a broader imperial strategy of engaging with, and even presenting the emperor as conversant with, elite culture, they may also reflect an awareness of Kangxi's peers, including his immediate contemporaries Louis XIV, Peter the Great, and Aurangzeb—all of whom were themselves great garden builders.

Louis XIV's *King's Cabinet*, in particular, introduced the Kangxi court to the designs, structures, gardens, and activities of the French royal palaces in lavish detail. The image of the monarch on display in the prints was of course important, but so too was the manner in which it was presented. *Imperial Poems* does not imitate the variety of subjects found in the *King's Cabinet*—there is no analogue in either text or image to the images of Louis's *fêtes de Versailles*, for instance, which captured grand performances from the vantage of the king.[83] It is possible, however, that the unique manner of binding used in *Imperial Poems*, in which the images fold out to provide an unobstructed panorama, rather than being broken in the middle by the book's gutter, was inspired by unfolding the *Cabinet*'s oversized prints.[84] Compelling similarities also appear in some of the compositions. Views of the chateaus at Fontainebleau (see fig. 4.19) and St. Germain en Laye (fig. 5.23), though compositionally quite different, share a focus on the architectural setting, which is depicted with a frontality and immediacy that draw the eye and mind imaginatively into the space. The *Cabinet*'s many palace scenes employ a range of approaches in terms of position of the imagined viewer, distance from the picture plane, orientation of architecture, and degree of activity shown, some more closely resembling the *Imperial Poems* than others. Yet both articulate an understanding of rulership through imperial landscapes, and in particular the powerful vantage of the ruler himself, surveying, experiencing, and possessing his territories. For Kangxi the novelty of intaglio printing, so impressively

presented in the *King's Cabinet* and executed for the first time in China by Ripa and his Qing collaborators, was part and parcel of that ideological expression.

## Primes and Echoes

The exclusivity of the printed *Imperial Poems*, both in rarity and production, advances the interwoven nature of the painted album, the printed book, and the individual lived experience of the garden that each was meant to evoke. Kangxi was evidently interested in print's particular capacity for communicating aspects of imperial ideology to a broader audience—Wang Yuanqi's memorial initiating a woodblock version of *Magnificent Record* came only two years later, and *Images of Tilling and Weaving* was already in circulation. The particular significance of this transmedial mutability to *Imperial Poems* is apparent from several other rare or unique examples in which the borders between versions are further blurred. In one case a set of paintings on silk by Dai Tianrui (fig. 5.24), a court artist known principally for finger-painting (*zhihua*), was interleafed with the woodblock-printed

FIGURE 5.23
Israël Silvestre, "Château neuf de St Germain en Laye from the River Side," in *Views of the Royal Palaces and Conquered Cities of Louis XIV, Cabinet of the King*, 1666–1682. The Getty Research Institute, Los Angeles (94-B18666).

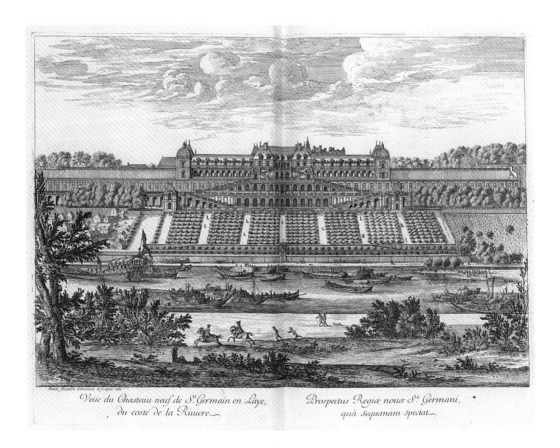

Veüe du Chasteau neuf de St Germain en Laye, du costé de la Riuiere

Prospectus Regiæ nouæ Sti Germani, quà Sequanam spectat

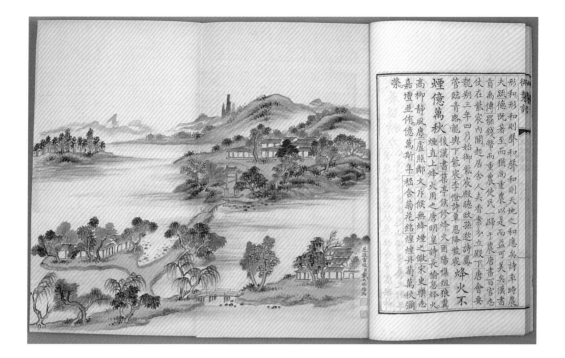

FIGURE 5.24
Dai Tianrui, "*Lingzhi* Path
on an Embankment to
the Clouds," ca. 1711, from
Kangxi et al., *Imperial
Poems*, scene 2. Provided by
the Palace Museum. Photo
by Liu Zhigang.

texts, mixing media and suggesting the fungibility of painted and printed versions. The same was done with sets of the copperplate prints.[85] Collating engraving and woodblock, these may represent the manner in which the intaglio edition was bound for Qing recipients, a demonstration and literal binding together of the emperor's equal mastery of two forms of print technology and artistic labor.

A final pair of albums completes these processes of exchange. The two combined the copperplate prints with handwritten poems inscribed by or after Wang Cengqi, whose calligraphy accompanied Wang Yuanqi's original compositions, bound in facing folios just as the original paintings and texts had been. One set, covered in imperial silk, is now in a private collection in Hong Kong, while the other resides in the Bibliothèque nationale de France, having migrated there from the Bibliothèque du roi.[86] It is unknown whether the two albums were unique among original preparations of the prints, though given the exclusivity of the hand-inscribed calligraphy, it seems likely that, like Dai Tianrui's paintings, they were. Nor is it certain when the Parisian album entered the French royal library, as its collection stamp indicates only that the volume was incorporated into the Bibliothèque nationale following the establishment of the First Republic. It is tempting to see the two as linked: one the Kangxi emperor's own copy of the copperplates, a direct analogue to the album by Wang Yuanqi in mounting and inscription, the other a duplicate for Louis XV, son of the

monarch who first sent images of Versailles to Beijing, and a mirror both of the emperor's copy and of the prime object from which all other versions derived.

For each of these different iterations the echo of prime objects and prime landscapes reverberates: a precious series of paintings that was the personal possession of the emperor, a garden in and through which the emperor conveyed a vision of ideal rulership. These landscapes, in turn, refer to embodied acts of viewing, of networks of sociability and of labor, and of the individuals whose contributions brought the landscapes to life. Jennifer Roberts refers to these echoes as "a ghost archive of reversals," an archive accessed first through the forest of marks, undulating monochrome hills, and empty halls of the woodblock-printed *Imperial Poems*.[87] At one level, the effect is to place all the versions in a web of mutual implication, each invoking or referring to the materiality of the others. Simultaneously, each leads back, like branch to tree, to Wang Yuanqi's landscapes, to the park-palace itself, and to their owner, Kangxi. These two modes of relation coexist, and the idea of the Mountain Estate that is constructed through *Imperial Poems* is one that emerges from the iterative line and the connected web. At the root of line and web stands the emperor, whose possession of and engagement with the landscape, however defined, is expressed in *Imperial Poems* through both content and materiality. His ghostlike presence, the most significant of the reversals, runs throughout the ultimate acts of reception, the virtual tours of the Mountain Estate that *Imperial Poems* provide.

PART IV   The Metonymic Landscape

# Touring the Rear Park

W‌HEN ZHANG YUSHU traveled to Rehe in the summer of 1708, he did so as part of a cohort of officials accompanying Kangxi on his annual summer tour, which for the first time included an extended stay at the emperor's new traveling palace. Zhang's detailed account of his time in Rehe offers a particular perspective on the construction of imperial identity under Kangxi and its bearing on bonds the emperor sought to create with important figures around him. Arriving at Rehe on July 19, Zhang and his fellow officials, both Manchu and Chinese, waited nine days before being offered a personal tour of the "rear park" (*houyuan*), personal both in the intimate environs to which it offered access and because of its host. Entering through the main gate, the emperor led his guests over a small mountain, descending to the lakes that sat at the center of the traveling palace (see map 1.3). The group crossed a small bridge onto *Lingzhi* Path on an Embankment to the Clouds (see figs. 1.1 and 5.24), where the emperor ascended into a small pavilion and introduced his assembled guests to the design of his newly constructed garden, invoking auspicious imagery and poetic landscapes of the past. Continuing on to the central island, they visited the emperor's private quarters (see figs. 3.2 and 6.19) before being led on a lengthy progress through the park-palace. From Ruyi Island they crossed the lake by boat, lingered along the shore shaded by trees preserved by the emperor's command (see figs. 3.4 and 3.5), and visited the hot springs that may have first attracted Kangxi to the Rehe valley. The visit to the park-palace involved entertainments as well, including a theater performance and a banquet, where the guests were granted dishes from the imperial table. Nine days later, the officials toured once more, this time hiking through the foothills of the park's western mountains. With the emperor at its head, the group experienced many of the site's most scenic spots, already identified in a series of sixteen scenes that shaped the visitor's experience within, and memory of, the traveling palace.

Although much about the circumstances of Zhang Yushu's time in the emperor's retinue occurred within the broad historical norms of imperial audiences, the tour Zhang describes was substantively different in setting, activity, and subtext from other, far more ritualized forms of interaction between emperor and subject. His account conveys a sense of intimacy between host and guest, as the emperor shared a personal landscape marked by favored itineraries, pleasurable activities, even a view of the inner palace. The group visited the hall in which the throne sat, but the emperor did not ascend it. When the emperor addressed his guests, it was not from a site of authority but from a simple garden pavilion, and he spoke directly not of rulership and power but of garden design and an auspicious landscape. In essence, in Zhang Yushu's experience and description of the traveling palace, the symbolic landscape of political majesty was subsumed by one of elite sociability, of dwelling in and passing through the garden in the company of likeminded peers.[1]

Underlying this creation of a sense of intimacy with the emperor is the idea of access, whether physical, visual, or emotional. In varying forms and contexts, many historic imperial gardens were open to the public. Under the Tang an abandoned imperial hunting park was available for public use. During the Northern Song the public was given access to the Reservoir of Metal's Luster (Jinmingchi) during certain seasonal festivals to observe imperial war games and enjoy the garden.[2] During the Ming, levels of access varied but was generally available to those of sufficient social standing.[3] While such privilege offered a form of connection with the imperial, it did not necessarily include direct exchange with the emperor, either because his absence was precisely what made the visitor's presence possible or, in the case of festival days, because one purpose of the event was to present the ruler to his subjects at a remote, elevated remove.

Under Kangxi, admittance to imperial gardens for those not directly in service to the emperor or involved in the sites' maintenance appears to have been by invitation only. While not "public," such access was not as limited as it might seem. Official visits to the Mountain Estate involving formal ritual were very common, yet archival records and the architecture of the site itself both suggest that less formal interactions such as those described by Zhang Yushu played an equally important part in Kangxi imperial statecraft in Rehe.[4] For Mongol leaders, high officials, imperial kinsmen, and other elites, travel to Rehe was certainly a possibility, if not a likelihood. Such an invitation would have been prized as an exclusive mark of imperial favor, a mark made tangible by the personal attention the emperor accorded his guests.[5]

In its most literal sense the printed *Imperial Poems* extended the limited scope in which Kangxi offered access to the site. Through its visual and textual descriptions of scenic spaces, the book permitted its readers to

enjoy the imperial park at will, possessors of a perpetual invitation from the emperor. *Imperial Poems* does not simply depict the park or re-create the experience of an imperially guided tour of Rehe, however. It is a distinct landscape in its own right, through which the court constructed a complex vision of imperial identity that it sought to convey to recipients of the book.[6] Engaging a combination of generic convention and innovative form, *Imperial Poems* conveyed visual, sensory, emotional, behavioral, intellectual, and cultural elements of each view from the emperor's perspective. Together, text and image created a sense of intimacy through the evocation of the host–guest relationship that was so central to Zhang Yushu's experience of the park-palace but, even more significantly, deepened that intimacy by allowing the viewer into the emperor's embodied and perceptual landscape.

## Writing the Owner through the Garden

Depictions and descriptions of imperial gardens in China are relatively rare; a view as detailed as that offered by *Imperial Poems* was unprecedented, as was the publication of such a view for a broader (albeit still quite limited) audience. In earlier works imperial gardens served as stages for literal or implied representations of the emperor, perhaps intended as pictorial supplements or substitutes for occasions on which the emperor appeared before the public. In *Capturing the Flag at the Reservoir of Metal's Luster* (Jinmingchi zhengbiao tu; fig. 6.1), for instance, Zhang Zeduan depicts the Song court's annual war games. Though the emperor is not explicitly depicted, his presence is repeatedly signaled, whether by his dragon boat and the pavilion in which he sat, or the garden and its festivities as a whole.[7] Several handscrolls depicting celebrations of the Lantern Festival in the Ming court convey a seemingly more intimate portrait of the Xuande emperor (r. 1426–1435), as he and his attendants play games and enjoy the season within elaborate gardens and palaces (fig. 6.2).[8]

While both works show guests enjoying the imperial garden in the emperor's presence, the hierarchical relationship between ruler and subject is foregrounded in each and indeed is intrinsic to the construction of emperorship they sought to convey. In Zhang Zeduan's detailed depiction of space and architecture, commoners move freely around the periphery while imperial activity occupies both geographic and pictorial center stage. His composition underlines the ritualized nature of the Song emperor's "sharing pleasure with the people" (*yumin tongle*), in which the garden, as manifestation of imperial bounty, traditionally played an important role.[9] The Ming scrolls, by contrast, are important early examples of *xingletu*, or portraits of the emperor at leisure. Although providing court artists with an alternative to formal portraits, *xingletu*, such as *Kangxi Reading* (see

FIGURE 6.1
Zhang Zeduan, *Capturing the Flag at the Reservoir of Metal's Luster*, first half of the twelfth century. Album leaf, ink and color on silk, 28.6 × 28.5. Tianjin Museum of Art.

FIGURE 6.2
Anonymous Ming court
artist(s), *Amusements in the
Xuande Emperor's Palace*,
ca. 1426–1487. Detail of a
handscroll, ink and color
on silk, 36.6 × 687 cm.
Provided by the Palace
Museum, Gu6247. Photo by
Liu Mingjie.

fig. 1.1), remained centered on the depiction of the imperial body, and
through it, imperial identity.

Under Kangxi the Qing court began to exploit both genres, producing
elaborate documentary works purporting to record the emperor's activities
and environs during significant ritual and state events, and exploring the
rhetorical potential of *xingletu* in constructing multifaceted images of the
imperial for different audiences.[10] In two primary examples of documen-
tary painting from the Kangxi era, the *Southern Inspection Tour* scrolls (see
figs. 4.3, 4.7) and *Magnificent Record of Longevity* (fig. 6.3), Kangxi appears
both literally, one among hundreds of figures shown thronging the imperial
route, and figuratively, reflected in the depicted events' elaborate demon-
strations of imperial prosperity. As in *Amusements in the Xuande Emperor's
Palace* and *Capturing the Flag at the Reservoir of Metal's Luster*, these works
clearly associate the auspicious display of imperial spaces—in the Qing
cases the capital and the territory, rather than the more discrete gardens
and parks of the earlier examples—with the emperor's person and reign.

Such works provide one context for understanding *Imperial Poems*, yet the exceptional nature of Kangxi's garden album suggests looking beyond historic habits of imperial picturing or contemporary court documentary practices to popular and elite genres of landscape representation. Reading *Imperial Poems* within the context of Han literati culture, social networks and gardening practices, particularly in relation to garden albums of the sixteenth and seventeenth centuries, highlights the generic conventions upon which Kangxi was drawing and, in turn, the identity he sought to construct through this work. The central project of the garden album, perhaps better termed a "garden portrait," was the identification of a person with his garden, a site that reflected not only his wealth and property-owning status but his position within elite social networks that took gardens as a principal stage for their activities. As embodied records of sociability and cultural performance, gardens not only reflected their owners, but also reflected *back upon* their owners.

Although all the elements of the album contributed to this equation, the "record" (*ji*) with which many albums opened often played a particularly important role. It was generally both the album's longest sustained textual narrative and, by nature of its generic conventions, the piece most suitable for directly conveying a sense of the garden owner in social, intellectual, and emotional terms. Records were a genre with a long history in relation to landscape that enjoyed particular popularity in the Ming, when literati sought to describe not only their experiences within the landscape as travelers, pilgrims, garden owners, and the like, but also to express the spiritual, philosophical, or existential insights prompted by their environment.[11] The content and even form of garden records varies, but as a genre they generally describe the circumstances of the site's construction and the nature of its landscape, while also explaining the owner's relationship to the site. The record was then generally followed by the album itself, which formed a sort of tour of the garden, whether through texts, images, or, as in the case of *Imperial Poems* and many other examples, a combination of the two. These pairings, known as "pictured verses" (*tuyong*), joined text and image to create, in two-dimensional form, the "scene," expressing visually and poetically the holistic multisensory and imaginative experience of the physical space.

Handscrolls and, later, albums were particularly conducive to presenting the cycles of established scenes around which culturally significant landscapes had been organized since at least the Tang.[12] Portable formats allowed artists to present a series of vistas that could be experienced progressively by an individual or small group of viewers in a manner evocative of visiting the site itself. The court's evocation of the album format through *Imperial Poems* thus allowed both book and landscape to engage with broader generic conventions in significant ways. First, it communi-

FIGURE 6.3
Wang Yuanqi et al.,
*Magnificent Record of
Longevity*, j. 42, f. 59,
1717. Woodblock print.
Chinese Collection,
Harvard-Yenching Library,
© President and Fellows of
Harvard College.

cated with the emperor's audience through a familiar genre that combined affective and sensory experience with cultural and mnemonic associations of the landscape. Second, it constituted a cultural mediation of the Rehe landscape as both garden and famous site that contributed to its structural association with other, historically established landscapes, particularly in China proper.[13] Finally, by connecting the emperor and his garden to elite, rather than imperial, traditions of defining and experiencing the landscape, the album format tied *Imperial Poems* and the imperially led tours of the park-palace that the book effectively virtualized to more intimate, less hierarchical modes of interaction.

Canonical topoi range from the gardens and estates of Lu Hong and Wang Wei, to such famous sites and regions as Hangzhou's West Lake and the Ming capital of Beijing, among many others.[14] Three Ming albums offer especially productive points of comparison for understanding *Imperial Poems* as an example of the genre: a 1551 album by Wen Zhengming depicting the famed Garden of the Artless Official in Suzhou; Zhang Hong's (1577–ca. 1652) *Garden to Rest In* (Zhiyuan) album of 1627, painted for the otherwise anonymous Huishan Cizong; and *Footnotes to Allegory Mountain* (Yushanzhu), a private publication by the literatus Qi Biaojia (1602–1645)

depicting his garden in Shanyin (modern Shaoxing), Zhejiang. Each of the three Ming albums employs images and, in two cases, texts to record the property and identity of the garden owner. Understanding the variations in these elements—such as how each artist invests static representations with qualities of lived experience and the physical landscape; how the garden owner is constructed as occupant or host; and the ways in which an imagined viewer is invited to occupy the pictured space and, through that, relate to the garden's owner—helps illuminate the complex narrative and spatial strategies of *Imperial Poems*.[15]

Like Kangxi, Qi Biaojia sought to introduce his garden—and himself—to a select audience through a printed tour. An example of the small but significant vanity publishing movement of the late Ming, *Footnotes to Allegory Mountain* opens with a lengthy record composed by Qi.[16] A garden owner who, more than most, may be said to have been owned *by* his garden, Qi recounts the circumstances under which he came to build Allegory Mountain, its general layout, and constituent parts. Having resigned from an imperial post in the capital, Qi returned to his hometown, a place he describes in the record as a landscape of memories: the pines he planted as a child have now grown tall and the people he recalls have moved or passed away. Barely settled, the idea of building a garden came to him and although he started small, his visitors' suggestions for expansion, perhaps taken as subtle criticisms, soon fanned his interest into an obsession—one that, in the course of two years, "emptied [his] purse."[17]

Through this confession to garden mania, however, Qi reveals a site totally of his own conception and design—one inextricably linked to him, and he to it. To look upon Allegory Mountain was to look upon Qi himself, and although his album as a whole included only two images (fig. 6.4), looking or, more accurately, experiencing, was exactly Qi's intention. As he wrote in conclusion: "The vistas of all four seasons are here to be enjoyed, as one drifts in a boat beneath the clouds and in a gentle breeze. Within these 'Three Paths' [the residence of a refined man in retreat], one can summon the clouds and become drunk in the snow. Here, the refined man may feast his eyes, while the recluse, for his part, may find a haven for his soul."[18] While Qi's description of its construction consisted primarily of an inventory of the garden's elements and the circumstances of their creation, his conclusion brings his audience—the "refined man" and the "recluse"—into the garden and sets them in motion, experiencing a landscape completely amenable to their elevated natures. That Qi's was the mind behind all this is something in which he feigns sudden disinterest; nonetheless the garden reflects not only his ostensible strengths but also his admitted weaknesses: elegance and obsession.

Although no record survives in connection with Wen Zhengming's 1551 album of the Garden of the Artless Official, he composed one as preface to

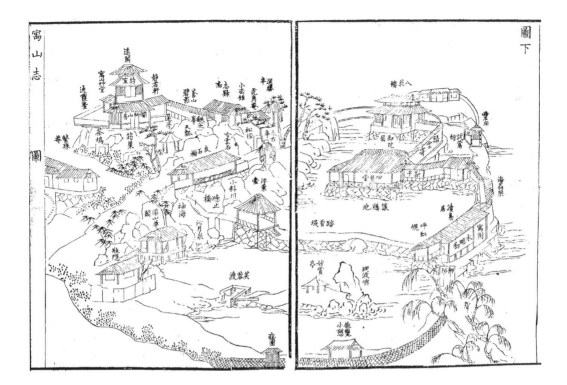

FIGURE 6.4
Qi Biaojia, "View of
Allegory Mountain," ca.
1637, second of two views
from *Footnotes to Allegory
Mountain*. Woodblock print.
National Central Library,
Taiwan (03864).

an earlier 1533 album of thirty-one leaves painted for the garden's owner,
Wang Xianchen.[19] In it, Wen creates a similar link between the biographies
of garden and owner, describing the Garden of the Artless Official as a
place of retreat for Wang, who had recently retired from life in Beijing
after a career spent in the Imperial Censorate. The biographical structure
of both album and garden is reinforced by the opening scene, "Many Fra-
grances Bank" (Fanxiangwu; fig. 6.5), in which the viewer faces a small,
open-sided building, Almost-a-Villa Hall (Ruoshutang).[20] According to
Wen Zhengming's record, Almost-a-Villa Hall was preeminent within the
garden: first to be built as Wang Xianchen laid out the landscape, it was
the site's main structure despite its modest proportions. In the opening
leaf of Wen's 1533 album, which depicts the same scene, Wang Xianchen
appears at the center of the composition with a servant boy, affirming the
relationship between owner, garden, and hall.[21] In the 1551 album, by con-
trast, the hall stands empty, perhaps a reference to Wang Xianchen's death.
Wang's remembered presence is evoked by the painting's highly descriptive
frontal composition, which immediately recalls the opening image of Lu
Hong's *Ten Records of a Thatched Hut* (see figs. 5.8 and 5.9). Almost-a-Villa
Hall and Many Fragrances Bank may be read therefore not just as the first
feature encountered upon entering both physical and virtual garden, but
as its spatial and biographical focal point. The image's composition affirms

this position and signals the scene as the natural point of departure for the tour presented through the album.

Engaging many of these same tropes, Kangxi's "Record of the Mountain Estate to Escape the Heat" frames the emperor as a garden builder whose private landscape reflects his virtue while simultaneously making him more virtuous. In his opening, the emperor loosely evokes the model of the retired scholar, for whom the identification of the perfect plot of land serves as metaphor for reaching the point in life when one may dedicate oneself to garden building, rather than to one's career. For Kangxi this place was not his hometown, as it was for Qi Biaojia or Wang Xianchen, nor did his prior connections with the region figure into his framing of it. Instead, the fitness of Rehe as an imperial site analogous to "returning home" lay in its auspicious features: the mountain veins, cloud-enshrouded pools, fertile fields, and clear winds that reflected its being "nourished by Heaven and Earth" and allowed the emperor to maintain his strength for renewed service (rather than retirement) in his old age.

As with Qi Biaojia and Wang Xianchen, the metaphoric life journey that culminated in Kangxi's garden was substantially a physical journey as well. Both Qi and Wang built gardens after retiring from often tumultuous official careers in the capital. For Kangxi the consolidation of core

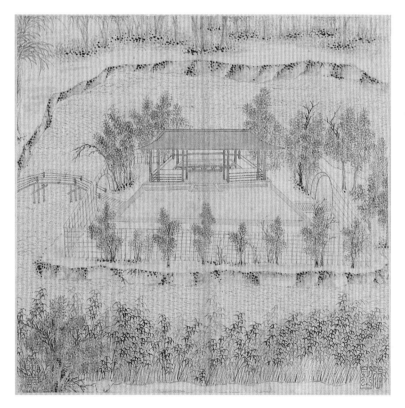

FIGURE 6.5
Wen Zhengming, "Many Fragrances Bank," 1551, from *Garden of the Artless Official*, leaf 1. Album leaf, ink on paper, 26.4 × 27.3 cm. Metropolitan Museum of Art, Gift of Douglas Dillon, 1979.358.1a.

Qing territories in 1697 marked the end of decades of war and freed him to focus on political and cultural issues. In his "Record," the emperor elides the military nature of many of these campaigns, framing them instead as tours of benevolent inspection providing the insight necessary for sage rule. Nevertheless, the underlying message of having reached a journey's end in Rehe remains the same: having finally arrived in Rehe, "how can embracing this [place] in [my] heart harm affairs of state?" Simultaneously, "Record of the Mountain Estate" describes a landscape that reflected the character of its owner. For Kangxi this meant one embodying the imperial virtues of humane and attentive rule. Recounting the construction of the site, the emperor emphasized the sense of humility and frugality with which the process was undertaken, and linked the landscape to moral qualities intended to reflect back upon the emperor. Through "Record of the Mountain Estate," Kangxi thus engaged a recognizable literary genre to convey elements of imperial identity and ideology in terms familiar to his readers, many of whom would also have written personal records. In so doing, he presented aspects of his life that would otherwise have been private or highly ritualized in a manner that suggested congruency between the lives and experiences of his constituents and his own.

## Structuring Narrative Space

Having framed owner and site along familiar rhetorical lines, *Imperial Poems* turns to presenting a tour of the Mountain Estate through the emperor's thirty-six scenes. The manner in which it does so is not readily evident—the book does not follow a strictly topographical sequence, nor is there an explicit narrative arc that progresses through the volume. The structure of *Imperial Poems*, which emphasizes memory, the senses, and embodied knowledge of the site, is fundamental to appreciating its function as a communicative medium between emperor and subject, however, and may be better appreciated through comparison with earlier examples.

Although each of the albums described earlier presents its garden in distinctive ways, broadly speaking, organization may be broken into two categories, the "sequential" and the "episodic." Simply put, sequential series follow a logical progression through the garden that reflects the spatial organization of the primary site, such that viewing the album directly imitates the experience of touring the garden. In contrast, episodic series include isolated images that bear no obvious signs of spatial succession. This is not to say that episodic albums are random in their selection and ordering of scenes, but rather that the scenes are selected and ordered based upon some other narrative logic besides touring. Such albums may instead emphasize experiential, environmental, intellectual, or emotional narratives, often structured chronologically rather than topographically.

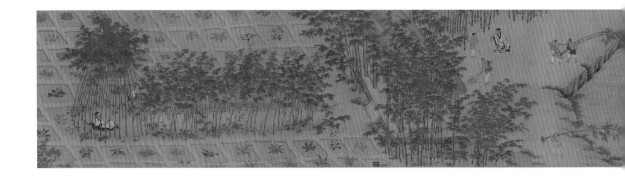

FIGURE 6.6
Qiu Ying, *Garden of Solitary
Enjoyment*, 1515–52. Detail
of a handscroll, ink and
color on silk, 28 × 519.8 cm.
Cleveland Museum of Art,
John L. Severance Fund
1978.67.

In general, episodic albums convey occasional experiences rather than
the seemingly filmic movement of sequential albums. As art historian Craig
Clunas notes, albums as a series of images are inherently asyndetic—that is,
the images lack visual links between scenes of the sort that simultaneously
divide and join the scenes of handscrolls.[22] This is not to say that the leaves
of albums do not convey a sense of connection from one scene to the next,
however.[23] Although handscrolls offer the suggestion of contiguous space,
in reality the scene-cell divider does not impose spatial sequence any more
than it does regular temporal progression. This is true whether the divider
appears impenetrable, as in Qiao Zhongchang's *Illustration to the Second
Prose Poem on the Red Cliffs* (see fig. 4.5), or seemingly more porous, as in
Qiu Ying's *Garden of Solitary Enjoyment* (fig. 6.6).

Similarly, the scenes of an album need not be logically disconnected
simply because their relationship is not explicitly continuous. Indeed, the
concept of asyndeton applies here precisely *because* the narrative of the
album is intelligible (at least in principle) despite the absence of explicit
connections between leaves. Nor does the isolation of individual album
leaves from the progressive conceit of a handscroll necessarily render them
a succession of static "places" as opposed to the supposed narrativized
"spaces" of handscrolls. The integral combination of text and image in
the *tuyong* format creates what philosopher Michel de Certeau terms "a
practiced place," one enlivened or set in motion through narrativity.[24]
Through the viewer's imaginative intervention, a lived environment is real-
ized through the act of reading and looking, image and text contributing
to this sense of spatiality individually or in combination.[25] The presence or
suggestion of figures within the garden may also enliven the pictorial space,
serving as actors in the spatializing stories that give the album meaning.
These figures need not be explicitly or specifically depicted, as the text,
context, or the viewer themselves supplements what the painter omits.[26]

Among the three Ming garden portraits, *Garden of the Artless Official*
is the most clearly episodic, at least within the eight-leaf version dated
1551.[27] The first and second leaves, "Many Fragrances Bank" (see fig. 6.5)

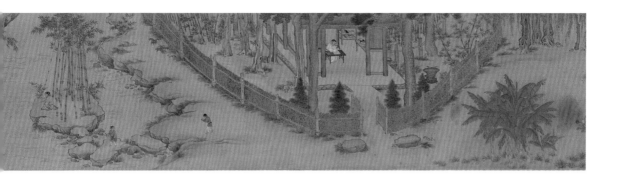

and "Little Azure Waves" (fig. 6.7) are the only two that clearly depict their spatial relationship, the latter being a view from the left side of the former. Several of Wen's prose descriptions add further information, such as the relationship between the Xiang Bamboo Bank ("north of the Pavilion for Resting in Rain") and the Banana Enclosure ("to the left of the Pavilion for Resting in Rain"), or the site of the Garden to Attract Birds (Laiqinyou), an orchard "of several hundred apple trees planted on both sides of the Azure Waves pond."[28]

Although not explicitly chronological, Wen's album is instead organized as a sort of biography-by-garden. In addition to his metonymic representation in the opening scene, Wang Xianchen figures prominently throughout, appearing directly in five of eight leaves. The images depict what one imagines were some of his favorite garden pastimes: coming or going from viewing bronzes in Little Azure Waves, or watching a crane preen with its mate near the Xiang Bamboo Bank (Xiangyunwu; fig. 6.8). A subtle link ties the experiential quality between these two scenes, as the bronzes, a tripod *ding* and a beaker holding a flower, appear in each, although the buildings are different. This indication of possession, preference, and the passage of time adds depth to the retelling of Wang Xianchen's life through the garden portrait. Whether Wang himself was the audience for the 1551 album, as he was for the 1533 original, or it was intended for those who remembered him, the album's organization depends on a familiarity with both garden and owner that presumes an intimate audience.

In contrast, Qi Biaojia's *Footnotes to Allegory Mountain* is the most plainly sequential of the three Ming comparators. Despite containing only two views of the garden, a pair of maps that open the text (see fig. 6.4), the text clearly follows an order of sites that the map confirms to be contiguous. As might be expected for a published work, Qi signals from the start that the tour is intended for his reader-guest, not for his own private consumption. Referring to Allegory Mountain as "my garden," Qi describes the experience of the garden as though he and his reader stand side-by-side. Upon disembarking from the boat that has brought Qi's reader-guest to

the garden, they pass through the main gate and immediately enter Water Bright Gallery (Shuiminglang), a pavilion overlooking the garden's central water feature, Asymmetric Pond (Rang'ouchi). Looking out upon the deep, reflective waters, "both Master and guest look as if they have travelled here from the Kingdom of Aquamarine; their beards and eyebrows drip and their clothes are drenched."[29] Host and guest then proceed, one site to the next, through the forty-nine named scenes in the garden. The lengthy prose descriptions of each spot combine spatializing descriptions that elaborate on the introductory map and give a sense of the experience of movement in the garden, with narrative that winds its way through personal and historical anecdote, references to myth, poetry and philosophy, and further details of the construction of the garden and life within its walls.

Sociability is one of several essentially autobiographical themes through which Qi writes himself directly onto the architecture and landscape. Despite frequently evoking a desire for reclusion, Qi admits that "my garden is long on open vistas, but short of secluded spots," while the "sandals of visitors form a constant pile" near the most scenic areas.[30] Curiously, where one would expect to see depictions of the garden's scenes, there are none. Instead, Qi includes poems by famous friends describing the scene at hand.[31] The verses themselves are not exceptional in that they are standard poetic responses to the view, the environment, and personal emotion. Their significance comes from the relationships and activities to which they attest, friendship and status manifested through the sociability of the garden.

The landscape of Allegory Mountain also memorializes elements of Qi's familial past, often in personal ways that reflect a sense of loss. The Adytum for the Study of the *Book of Changes* (Duyiju) prompts Qi to tell of a familial interest in the text across generations, although Qi himself "is incapable of fully understanding its principles."[32] Elsewhere, Qi regrets that despite following his father in a love of gardens, Qi has failed to achieve the latter's natural humility by being "content simply with having enough room to hug my knees"; instead, he has permitted himself "to become possessed by material things," such that "the garden has become a token of the extent to which I have proven incapable of manifesting restraint."[33] Although it is often difficult to separate the sincere and ironic in Qi's garden writings, a terse memorial to his late brother Yuanru reveals genuine emotion. Heaven's Calabash (Tianpiao), a rock near the garden's summit, was named for a favorite scenic spot of his brother's. Qi writes: "He [Yuanru] wrote a poem to record the excellence of the sight. I, for my part, cannot bear to allow this name to disappear, so I have retained it."[34]

Qi's texts, the testaments from friends, and the publication of his garden portrait together present a distinct construction of himself intended to draw

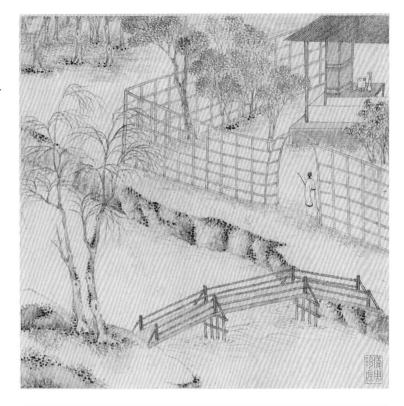

FIGURE 6.7
Wen Zhengming, "Little
Azure Waves," 1551, from
*Garden of the Artless
Official*, leaf 2. Album leaf,
ink on paper, 26.4 × 27.3 cm.
Metropolitan Museum of
Art, Gift of Douglas Dillon,
1979.358.1b.

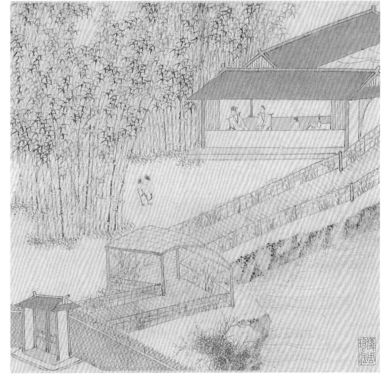

FIGURE 6.8
Wen Zhengming, "Xiang
Bamboo Bank," 1551,
from *Garden of the Artless
Official*, leaf 3. Album leaf,
ink on paper, 26.4 × 27.3 cm.
Metropolitan Museum of
Art, Gift of Douglas Dillon,
1979.358.1c.

in the reader and create a sense of intimate connection as though with a guest. While the frequent references to visitors, particularly famous ones, might in other contexts serve to exclude the reader, imposing a voyeuristic position by dint of not being among the named, Qi's frequent use of inclusive language removes such barriers to entry. This attitude is expressed clearly in his description of the Pavilion for the Appreciation of Excellence (Miaoshangting), in which he describes the metaphysical release offered by the garden as though he and the reader were of one mind, intellectual and, by implication, social peers, concluding: "To assemble here together all that is excellent, how could this fail to move refined men to appreciation?"[35] Unlike depictions of Wang Xianchen in *Garden of the Artless Official*, in *Footnotes to Allegory Mountain*, Qi simultaneously occupies his garden and creates space for the reader as guest.

*Garden to Rest In*, finally, radically deemphasizes the owner in favor of opening the garden to the viewer-guest. Without the extensive texts detailing the garden's history or the owner's emotions that are such a significant part of *Garden of the Artless Official* and *Footnotes to Allegory Mountain*, Zhang Hong's paintings carry the weight of meaning.[36] Nevertheless, Zhang's compositional and narrative strategies build on those seen in Qi's and Wen's albums. The album opens with "Complete View of the Garden to Rest In" (Zhiyuan quantu; fig. 6.9), a bird's-eye map of the precincts that the viewer-guest will soon enter.[37] Lacking more than a title, the image does not speak directly to the identity of the garden owner as Qi Biaojia's and Wen Zhengming's accounts do, yet the all-encompassing perspective underlines the relationship between the synthetic, even omniscient, gaze and ownership, as it does in Leng Mei's *View of Rehe* (see fig. 4.1) and other panoramic representations of property.[38]

In Zhang Hong's construction of pictorial and imaginative space, the "Complete View" both replaces the "Record" structurally and answers the need for information describing spatial relationships between views that in other examples was provided through text.[39] Using the opening leaf as key, the viewer may proceed through the album, situating each scene within the whole and relative to the ones before and after. Although the original order of the album is now uncertain, working from "Complete View," the nineteen remaining leaves appear to follow a logical, geographically based sequence beginning and ending at the garden's entrance, a conceit found in *Footnotes to Allegory Mountain* and many other garden descriptions.[40] The visit begins as the viewer-guest, arriving by boat, nears a gate at the river's edge. Entering the garden, the tour opens with a view across a lake to a small pavilion (leaf 2). From there the visitor walks along a bamboo-lined path (3) and through an elaborate rockery (4), ascending a hall to take in the scene that unfolds below (5). On through the garden the viewer proceeds leaf by leaf, until a last walk along a quiet path through a bamboo

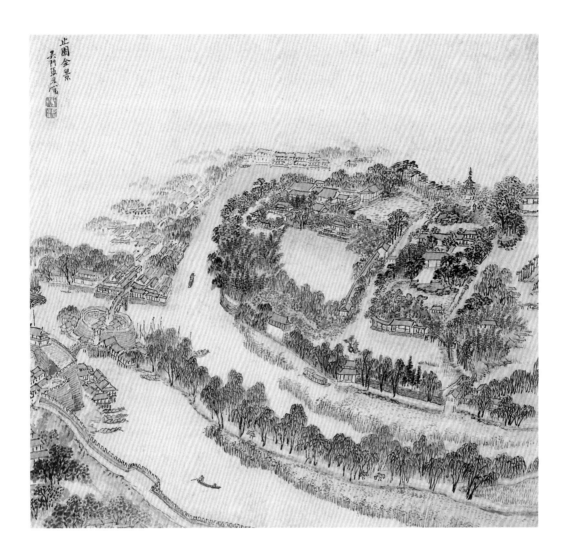

forest (18) leads back to the main gate (19) and then, in the final scene, out
onto the river again (20), where the album began.

The manner in which the views are composed and presented is essential
to this pictorial tour. Each scene is depicted from a somewhat elevated point
of view in which the focal point of the composition, whether architectural
or landscape, is pushed back from the picture plane. The viewer is provided
with a wide and unobstructed field of vision that permits greater freedom
of imagination and therefore action. Similarly, the figures that appear in
most of the scenes are depicted almost incidentally, as if to enliven the scene
through a suggestion of activity rather than its explicit depiction. They
do not prevent entry by the viewer into the pictorial space as larger, less
anonymous figures might; were they to do so, the viewer would be forced
to remain imaginatively outside the image. As a result, the viewer is drawn

into the pictured garden in such a way that the tour not only "spatializes" the album in an abstract, structural sense, but spatializes it *for the viewer*, who thereby comes to occupy the space. Alternatively, one might say that unlike the spatialization of *Footnotes to Allegory Mountain* and *Garden of the Artless Official*, which each reflect their owner's identity, *Garden to Rest In* is able to be spatialized in part by the viewer's own narrative.

Although an autobiographical narrative is not foregrounded in *Garden to Rest In* as it is in others discussed, the viewer-guest's tour appears to follow not only the garden path but also the seasons of the year in a progression that is analogous to the seasons of life.[41] The tour reaches its seasonal apex in an expansive view from a broad platform across the garden's largest lake, on the far side of which can be seen brightly flowering trees of summer (fig. 6.10). Several leaves later, blossoming chrysanthemums mark the garden owner's first explicit appearance in the album as an autumn scene (fig. 6.11); in the following leaf, he is clearly marked by his red robe, larger size, and the use of trees as a screening element to momentarily distance the viewer-guest.[42] Zhang Hong's depiction of the garden's owner through the album accords in two ways with the previous portraits discussed: first, in its representation of the garden as site and evidence of its owner's social position and social relations, and second, in its use of the garden as both progressive record and symbolic endpoint in describing literal and figurative journeys through life.[43] To a degree greater than that seen in either *Garden of the Artless Official* or *Footnotes to Allegory Mountain*, however, Zhang Hong's compositions may be understood as visually and imaginatively accessible to the viewer-guest, even while maintaining the biographical structure familiar to the genre.

## Access and Intimacy

According to these terms, *Imperial Poems* is both episodic and sequential in turns. There is no consistent topographical order to the images as is found in *Garden to Rest In* or, later, in Qianlong's *Forty Scenes of the Garden of Perfect Brightness* (Yuzhi Yuanmingyuan Sishijing Shi), which, like Zhang Hong's album, proceed counterclockwise around the garden.[44] Different groupings in *Imperial Poems* suggest a variety of approaches. Some may have been intended to recreate the actual experience of tours, such as the one Zhang Yushu enjoyed. Others follow very different organizational logics, including highlighting sensory or temporal affects, the topography and physical layout of the garden, and a strong autobiographical narrative that echoes themes in the emperor's "Record."[45]

As *Imperial Poems* opens, the viewer-guest has already entered the park-palace; the first scene (see fig. 3.1) offers a view of Misty Ripples Bringing Brisk Air, a hall in the rear courtyards of the Palace of Righteousness, which

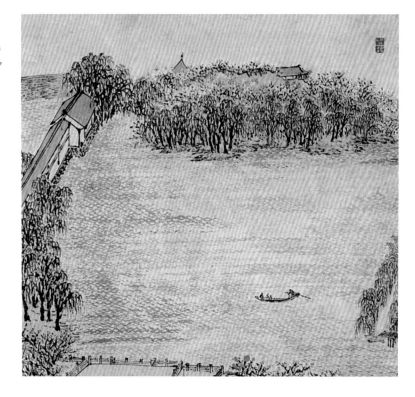

FIGURE 6.10
Zhang Hong, *Garden to Rest In*, 1627, leaf 9?. Album leaf, ink and color on paper, 32.39 × 34.29 cm. Los Angeles County Museum of Art, Far Eastern Art Council Acquisition Fund, AC1995.166.1.

FIGURE 6.11
Zhang Hong, *Garden to Rest In*, 1627, leaf 15?. Album leaf, ink and color on paper, 32.4 × 34.5 cm. Museum für Asiatische Kunst, SMB, 1988.463e © bpk-Bildagentur.

by 1713 functioned as Kangxi's inner court.[46] The composition—frontal, emphasizing a building closely associated with the person of the emperor—immediately recalls the opening scenes of both *Ten Records of a Thatched Hut* and *Garden of the Artless Official*, while initially adopting the organizational structure of *Footnotes to Allegory Mountain* and *Garden to Rest In* by opening at, or near, the park-palace's entrance. From there the album follows Zhang Yushu's route for four more leaves, naming or depicting many of the structures that Zhang mentioned seeing as he walked across *Lingzhi* Path on an Embankment to the Clouds (scene 2; see fig. 1.1) to the halls of Ruyi Island (scenes 3–5). Scene 6 (see fig. 5.20) then imagines the viewer-guest turning to look back at the path they have just traversed, gazing south at "Pine Winds through Myriad Vales," which stands atop a small hill overlooking the lakes.

In this opening sequence, *Imperial Poems* employs a representational strategy echoing Zhang Hong's in *Garden to Rest In*—first-person movement along a topographically ordered route that replicates the experience of touring. The imperial album exploits the relationship between point of view and the experience of vision to further the viewer-guest's sense of occupying another's eyes, replicating the specific focus of the guest's gaze and balancing objective and subjective experiences of the park. The images of Ruyi Island deemphasize or eliminate structures that are not the primary, titular focus of the scene, a distortion of architecture and topography that ensures the viewer-guest is drawn imaginatively into the intended space.

This subtle reinforcement of actual sight (as opposed simply to the artist's disembodied "eye") is particularly evident in scene 6. Here, as in this entire first sequence, the standard compositional conceit of *Imperial Poems*—a window into and from the space rather than a view *of* it from any particular point in the real world through the combination of textual

description and expansive, almost omniscient perspective—is played with. By progressing from compounds *on* Ruyi Island to one that could be seen *from* the island's banks, the sequence employs a variation of the "progressing towards, looking out, looking back" seriation also used by Zhang Hong. In three leaves of *Garden to Rest In*, the viewer first approaches a giant rockery from behind, then ascends and looks out from a multistory hall built in its midst, and, having moved again to the opposite side of the pond, finally looks back at the fake mountain from which they came.[47] "Pine Winds through Myriad Vales" reminds the viewer that multiple forms of vision, both literal and imagined, are at play in *Imperial Poems*. This visual duality echoes the nature of experience, in which the perceived, the remembered, and the imagined coexist, and in this way the book transcends a straightforward pictorial record of the Mountain Estate, becoming instead a record of knowing and dwelling in, of being *familiar with* the park-palace.

Following scene 6, the order of the images in *Imperial Poems* is no longer topographically clear.[48] An alternative method of viewing the album reveals patterns of organization and grouping that instead build upon the play between vision, experience, and knowledge or imagination. Piecing the thirty-six images together into a single composition as though they formed a handscroll, certain groupings become immediately apparent based wholly on compositional continuities. Although there is no primary evidence that *Imperial Poems* ever existed in this format, when reconstructed in this manner, the resulting composition bears a number of distinctive similarities to Wang Yuanqi's handscrolls, including the division of scenes by diagonal bodies of water and scene-to-scene transitions from deeper distance to mountains that suddenly crowd the picture plane (fig. 6.12; compare with fig. 5.5).[49] Among Wang Yuanqi's major topographical landscapes of this period, the majority—*Ten Scenes of West Lake*, *Wheel River Villa*, and *Magnificent Record of Longevity*—are handscrolls. In its printed form,

the latter recreated its original scroll format across the folded pages of a book; at least one other similar example is known, Wang Tingna's (ca. 1569–after 1628) early seventeenth-century *Garden Views of Encircling Jade Hall* (Huancuitang yuanjingtu), a vanity publication along the lines of Qi Biaojia's *Footnotes to Allegory Mountain* that consisted primarily of a long, continuous progression through the garden.[50] Finally, there is clear precedent in the Qing court for pairs of album leaves depicting discontinuous spaces employing roughly continuous compositions. The technique appears in *Images of Tilling and Weaving*, for which many of the scenes, mounted in facing pairs, are linked compositionally even as they show distinct activities in the production of rice and silk (fig. 6.13).

The compositional and thematic links in particular sections of *Imperial Poems* argue strongly for their relevance to understanding the ordering of the series. These groupings highlight narrative and sensory themes embedded in the park-palace's plan, rather than the touristic sequence with which the series opens. These themes reflect a deeper familiarity with the spatial, poetic, and imaginative organization of the Mountain Estate that would not necessarily have been self-evident if viewed individually. Like the opening six scenes, some of these narratives relate to comparative examples found in earlier garden portraits, while others more specifically reflect the context

FIGURE 6.13
Leng Mei, *Images of Tilling and Weaving*, after 1696, leaves 9 and 10. Two facing album leaves, ink and color on silk and paper, each leaf 31.2 × 24 cm. The Collection of the National Palace Museum, Guhua3383-9, 10.

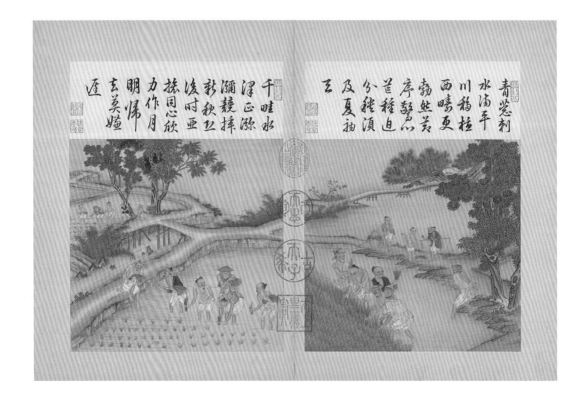

of production of *Imperial Poems*. Patterns emerge relating to the site's over-all plan, its sensory environments, and habits of seeing in the landscape. Together the groupings suggest an "itinerary of experience" that seeks to recreate a sense of the physical, sensory, and intellectual dimensions of dwelling in, and moving through, the imperial park.

At the most literal level, in a number of instances, two or more scenes join to form a single composition that more or less precisely reflects topo-graphic reality beyond what could be accommodated in a single view. This is the case in scenes 26 and 27 (fig. 6.14): on the far left a small pavilion near the northwest corner of Ruyi Lake, Fragrant Islet by Flowing Waters, offers a commanding view of the park's central areas. Moon Boat with Cloud Sails, to the right, is situated roughly opposite, on the western bank of Ruyi Island. Though the juxtaposition is not perfectly accurate—Fragrant Islet by Flowing Waters is in reality somewhat northwest of Moon Boat with Cloud Sails, rather than due west, and thus ought to be visible in the distance behind the boat-shaped hall—the two scenes clearly form a sin-gle landscape in image as in reality. "Shapes of Clouds and Figures in the Water" (Yunrong Shuitai) and "Clear Spring Circling the Rocks," scenes 28 and 29, operate similarly (fig. 6.15). Each depicts a portion of two streams that descend adjoining ravines in the mountains northwest of the central lakes. These streams ultimately meet (though well downstream from the points in their respective courses depicted in the scenes) before emptying together into Half Moon Lake, which in turn feeds Ruyi Lake. The sites are not physically or visually adjacent, as is the case with Fragrant Islet by Flowing Waters and Moon Boat with Cloud Sails; rather, their linking via

waterway conveys deeper topographical knowledge about the park that would otherwise be unavailable to the viewer-guest.

Other groupings depend on artificial connections to create a more impressionistic sense of the landscape. For instance, scenes 6 through 10 present a series of views of sites along the lakeshore and atop the highest peaks within the park (fig. 6.16). Depicted as though seen from *Lingzhi Path on an Embankment to the Clouds*, they are joined by a backdrop of mountains. Although portions of the compositions do not match particularly well and are linked only in spots, such as the path and bridge that meet between "Scenes of Clouds and Mountains" and "Clouds and Peaks on All Sides," the continuous, undulating ridge offers the visual effect of standing at the heart of the park-palace and looking at the mountains ringing the

FIGURE 6.15
Merged view (right to left) of Shen Yu et al., "Shapes of Clouds and Figures in the Water" and "Clear Spring Circling the Rocks," 1713, from Kangxi et al., *Imperial Poems*, scenes 28 and 29. Woodblock prints. Chinese Collection, Harvard-Yenching Library, © President and Fellows of Harvard College.

lake on three sides. The fact that the scenes are neither contiguous in space nor even presented in circular order serves only to reinforce the individual nature of visual experience and the asyndetic qualities of narrative logic in both handscrolls and albums.

Pairings presenting views that are in effect looking at one another offer yet another play on the experience of sight. For instance, scenes 33 and 34 show vistas from opposite ends of the same bridge, as though the viewer-guest turned at the far side to look back from whence they came (fig. 6.17). Despite reflecting opposing points of view, the first facing north, the second, south, the compositions are loosely linked by a central hill, similar shorelines, and the presence of water lilies in each.[51] In departing from the physical realities of the site, the illusion of topographic reality created here expands upon the device of mirrored views described earlier to deepen the sense of a kaleidoscopic imaginative landscape.

Likewise, there are pairings mimicking the sense of moving forward in space, in a manner comparable to Zhang Hong's successive scenes depicting the master of the Garden to Rest In (see fig. 6.11). The guest's initial progress through the palace and out to Ruyi Island is composed in this fashion, for instance (figs. 6.18 and 6.19), as are two scenes showing the area where the Wulie River is diverted through the northeastern sluice gate and into the park (fig. 6.20). In the latter case the two images are not only joined in a handscroll-like fashion but also move forward as though magnified through a lens, the second a fairly literal detail of the first.[52]

Beyond recreating space visually and cognitively, some groupings draw attention to experiences of the senses, which play a central part in Kangxi's personal landscape. "Morning Mist by the Western Ridge" (Xiling Chenxia) and "Sunset at Hammer Peak," for instance, describe the morning

FIGURE 6.16
Merged view (right to left) of Shen Yu et al., "Pine Winds through Myriad Vales," "Sonorous Pines and Cranes," "Scenes of Clouds and Mountains," "Clouds and Peaks on All Sides" and "Northern Post Linking Paired Peaks," 1713, from Kangxi et al., *Imperial Poems*, scenes 6–10. Woodblock prints. Chinese Collection, Harvard-Yenching Library, © President and Fellows of Harvard College.

and evening light reflected off the mountains, together forming a highly atmospheric pair (fig. 6.21).[53] Although when joined, the two pavilions appear to sit on opposite shores facing each other, there actually is no immediate topographic relationship between them. Rather, the landscape stretching between Sunset at Hammer Peak, on the left, and the eponymous object of its view, the towerlike rock formation Chime Hammer Peak, has been vastly simplified in the interest of compositional unity. Along the same lines, "Golden Lotuses Reflecting the Sun" ( Jinlian Yingri) and "Sounds of a Spring Near and Far" depict two sites that are in very different areas of the park but for which the enjoyment of flowers plays a central role (fig. 6.22). On the right a two-story hall stands at the head of a courtyard filled with lotus-like flowers; the hall's name expresses the emperor's delight in the reflection of the sun off the golden blossoms. The scene on the left is named for part of the four-courtyard compound in the foreground from which the emperor enjoyed the sound of nearby springs.[54] The juxtaposition of these two scenes draws out an element of the sensory environment that might otherwise have gone unnoticed, adding to the depth and breadth of the viewer-guest's experience. Together these pairings underline the album's creation of a landscape depicting not only vision and movement in the first person but of the senses and the passage of time.

FIGURE 6.17
Merged view (right to left) of Shen Yu et al., "Pair of Lakes Like Flanking Mirrors" and "Long Rainbow Sipping White Silk," 1713, from Kangxi et al., *Imperial Poems*, scenes 33 and 34. Woodblock prints. Chinese Collection, Harvard-Yenching Library, © President and Fellows of Harvard College.

FIGURE 6.18
Merged view (right to left) of Shen Yu et al., "Misty Ripples Bringing Brisk Air," "*Lingzhi* Path on an Embankment to the Clouds," and "Un-Summerly Clear and Cool," 1713, from Kangxi et al., *Imperial Poems*, scenes 1–3. Woodblock prints. Chinese Collection, Harvard-Yenching Library, © President and Fellows of Harvard College.

A final pairing extends the temporal dimensions of the landscape beyond the guest's limited time within the park through the convention of garden portraits as representations of their owners' journeys through life. Throughout the album the emperor's poetry emphasizes the burdens of rule, describing the Mountain Estate as both a comfort and a reminder of his responsibilities. The final two scenes, "Immense Field with Shady Groves" (Futian Congyue) and "Clouds Remain as Water Flows On" (Shuiliu Yunzai), draw these themes together, merging structures on opposite ends of the north shore of Ruyi Lake into a single landscape that excludes the area in between (fig. 6.23). In "Immense Field with Shady Groves," on the right, Kangxi describes his hope for respite in his later years by evoking common rituals of autumn: the conclusion of the harvest and the seasonal hunts.[55] The vista complements these themes, as a bridge leads from the foreground to the front gate of a small garden plot, the emperor's "melon patch." Beyond it stretches the steppe-like expanse of the Garden of Ten Thousand Trees, where the emperor and his guests hunted within the park walls. On the left, the album's final scene, "Clouds Remain as Water Flows On," presents another bridge, this time leading to a boathouse—an echo of the guest's departure in Zhang Hong's *Garden to Rest In* and perhaps a metaphor for the emperor's own eventual passing. The emperor's tone becomes more somber here, as he expresses his feelings about old age and death.[56]

The final pair thus offers a reflective conclusion to an album that was, as much as anything else, an autobiographical landscape.[57] As with the three Ming garden portraits, the viewer-guest's passage through the multifaceted landscape of *Imperial Poems* echoes the arch of the emperor's life. The emperor's presentation of himself through *Imperial Poems* extended far beyond a straightforward autobiographical narrative, however, offering insight into his emotions, his intellectual inclinations, and his sensory experience of the landscape, most particularly through vision. The highly personal nature of the emperor's textual landscape, reinforced by the non-topographical logics underlying the compositional groupings, furthered the album's creation of a sense of intimacy between reader and ruler.

Seen in another light, the atmospheric, cognitive, and behavioral aspects of the textual and visual landscapes also operated as highly normative framing elements through which the emperor dictated the terms by which the viewer experienced the scenes. As is true for many other albums of famous and scenic sites, *Imperial Poems* is fundamentally prescriptive in its encapsulation of the emperor's vision and experience of the site for consumption by the viewer. This normative posture also characterizes the tradition around the Ten Scenes of West Lake, for instance, one of the most famous examples of the genre and the model adopted by Wang Yuanqi when recording the famous landscape for Kangxi. Originating in the Southern Song period, the

FIGURE 6.19
Merged view (right to left) of Shen Yu et al., "Inviting the Breeze Lodge" and "Fragrant Waters and Beautiful Cliffs," 1713, from Kangxi et al., *Imperial Poems*, scenes 4 and 5. Woodblock prints. Chinese Collection, Harvard-Yenching Library, © President and Fellows of Harvard College.

FIGURE 6.20
Merged view (right to left) of Shen Yu et al., "Warm Currents and Balmy Ripples" and "Fountainhead in a Cliff," 1713, from Kangxi et al., *Imperial Poems*, scenes 19 and 20. Woodblock prints. Chinese Collection, Harvard-Yenching Library, © President and Fellows of Harvard College.

FIGURE 6.21
Merged view (right to left) of Shen Yu et al., "Morning Mist by the Western Ridge" and "Sunset at Hammer Peak," 1713, from Kangxi et al., *Imperial Poems*, scenes 11 and 12. Woodblock prints. Chinese Collection, Harvard-Yenching Library, © President and Fellows of Harvard College.

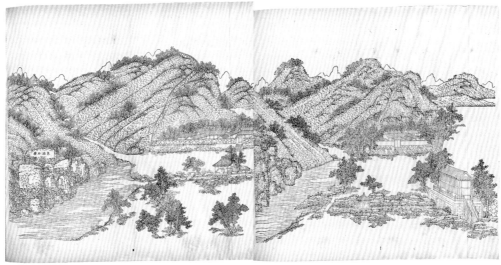

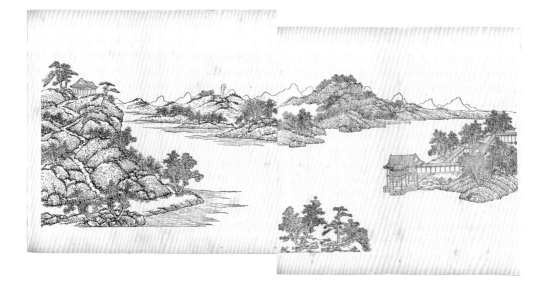

Ten Scenes of West Lake celebrated the seasonal beauty of Hangzhou while canonizing an itinerary of cultural practice that strengthened contemporary connections to the new Song capital.[58] By the Ming period numerous painted and woodblock versions of the album existed, as the Ten Scenes evolved into an itinerary canonized through collective memory.[59] They served as a guide to contemporary cultured behaviors as well, organized and presented as a series of normative experiences that specified weather, activity, company, even dress. A famous essay on viewing the midsummer moon at West Lake by the Ming literatus Zhang Dai (1597–ca. 1684) illustrates just this point: extolling the pleasures of "watching people watch the moon," Zhang describes both the degree to which proper behavior was socially defined and aspired to as well as the centrality of voyeurism in the popular experience of famous places in the late Ming.[60]

A late Ming version of the Ten Scenes illustrates one approach to constructing this voyeuristic position pictorially. In "Autumn Moon Over a Calm Lake" (Pinghu qiuyue; fig. 6.24), the viewer looks out from behind a screen of reeds to observe two gentlemen enjoying an evening on the lake. Near the boatman is a dinner basket; on the bow sits a servant, jug of wine close at hand. The scene is immediately identifiable because of the background, in which Su Dyke, named for the famous scholar-official Su Shi, can be seen. The lake, its pleasure seekers, the autumn moonlit night—image and title together present a description of an ideal practice of cultured appreciation.

Through a series of pictorial elements, the image's composition positions the viewer in a voyeuristic rather than participatory aspect. First, the

FIGURE 6.22
Merged view (right to left) of Shen Yu et al., "Golden Lotuses Reflecting the Sun" and "Sounds of a Spring Near and Far," 1713, from Kangxi et al., *Imperial Poems*, scenes 24 and 25. Woodblock prints. Chinese Collection, Harvard-Yenching Library, © President and Fellows of Harvard College.

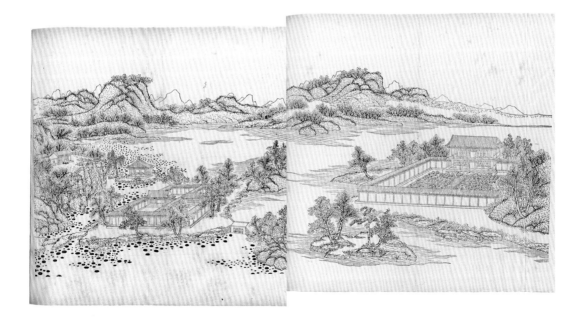

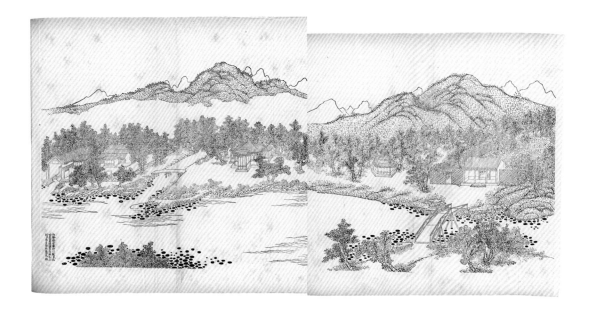

FIGURE 6.23
Merged view (right to
left) of Shen Yu et al.,
"Immense Field with Shady
Groves" and "Clouds
Remain as Water Flows
On," 1713, from Kangxi et
al., *Imperial Poems*, scenes
35 and 36. Woodblock
prints. Chinese Collection,
Harvard-Yenching Library,
© President and Fellows of
Harvard College.

cluster of reeds that serves as a screening element psychologically hides the viewer from the actors within the scene, while simultaneously preventing participation.[61] The viewer's field of vision is further limited by the use of level distance, which places the viewer and actors on roughly the same plane, and the actors' position close to the picture plane. This vantage furthers the voyeuristic gaze suggested by the reed screen by placing the viewer in a passive position, just as an elevated, panoramic perspective communicates ownership and power through knowledge. As such, the compositional focus on actors and action reinforces the identity of the viewer *as viewer*, as in Wen Zhengming's *Garden of the Artless Official*, rather than inviting their performative engagement with the scene, as in Zhang Hong's *Garden to Rest In*.

To understand the significance of the screening element and the presence of identifiable figures within the scene, another concept related to Michel de Certeau's "spatial stories" may be useful. Adopting de Certeau's terms, depicting specific landscapes through albums constitutes an example of "marking out boundaries" of a narrative, in that the picture bears the "function of founding and articulating spaces" by "creating a theater of actions."[62] The pictured space, which is defined by the narrative being depicted by the artist, is naturally different from the space occupied by the viewer, which is founded by a distinct narrative of its own—that of an individual in the real world. These two spaces, being bounded, are separated by a "frontier," represented by the picture plane. The presence of screening elements in "Autumn Moon Over a Calm Lake" accentuates the barrier of the picture plane by doubling it, serving as a visual reiteration of the artist's

"fourth wall" and reinforcing the viewer's voyeuristic positionality. By the same token, a compositional emphasis on performative figures necessarily displaces the viewer by reiterating their situation in an adjoining space, other than the pictorial one.

In *Imperial Poems*, the expansive perspective and absence of figures may be seen as momentarily reverting a space to a place, a neutral site that the viewer-guest may then spatialize with their own narrative.[63] Emphasizing wide fields of vision, detailed depiction of the landscape, and a complete absence of screening elements and figures, the compositional strategy found in *Imperial Poems* allows the viewer to bridge the pictorial frontier and imaginatively enter the imperial park in a way that would not be possible if the body of the emperor were present. At the same time, the emperor's emotions and thinking, his experience of the space and its relationship to his life, are presented through his annotated poetry and prose, which form a prescriptive context through which the viewer understands the landscape unfolding as the book progresses. *Imperial Poems* thus combines elements of the more normative modes deployed in "Autumn Moon Over a Calm Lake" and *Garden of the Artless Official* with the freer, more accessible nature of *Garden to Rest In* to offer a complex form of access combining the physical and the psychological.

Given the permeability of the spatial boundaries between viewer and imperial landscape, it remains to understand the positionality not only of emperor's guest but of the emperor himself. The term *jing*, "scene," is key to understanding the operation of *Imperial Poems* in this regard. Historically, a pictorial scene has often been understood as a single, framed composition, a reconstruction of the ostensible act of seeing from a particular vantage point. Scenes may also work serially to construct an itinerary, guiding movement through the landscape. Whether operating singly or in groups, the subject of the scene is typically the object of the gaze, as is the case, for instance, in both "Xiang Bamboo Bank" and the grand summer lake seen from the viewing platform in *Garden to Rest In* (see figs. 6.8, 6.10).

In *Imperial Poems*, although the object of the viewer's gaze may have scenic qualities, the aesthetic quality of that view, of the thing directly depicted, is not the principal focus of the scene. Rather, the object of the viewer's gaze is a site of activity, a functional structure within the emperor's garden. It is a place from which to experience the *jing*—the true subject of the scene. The notion that the *object* of the scene, the place depicted, is not in and of itself the *purpose* of the scene is reinforced by the accompanying text. While the image provides a sense of the physical site—the nature of the architecture, the lay of the land, the scenery beyond—the text offers the experiential details that stirred emotional and sensory responses in the viewer. The sound of the brook, the smell of the lotuses, the elegant detail of the rockery, all described by the emperor, join together with the image

FIGURE 6.24
"Autumn Moon Over a Calm Lake," 1609, from *Ten Scenes of West Lake*, in *Extraordinary Views within the Seas*. Woodblock print. Chinese Collection, Harvard-Yenching Library, © President and Fellows of Harvard College.

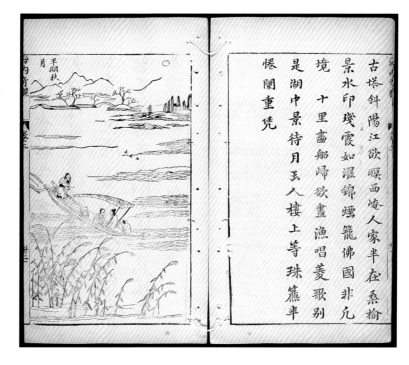

to create a holistic environment in which the viewer-guest may imagine themselves.

The absence of figures, most particularly the emperor, is key to this imaginative leap. Just as in images that use figures to tell stories or define behaviors, if Kangxi were depicted, he would necessarily be the principal object of the view, filling and defining the space and displacing all other narratives besides his own. His absence, however, reiterates that the scenes depict the emperor's point of view, thus allowing the viewer to share the emperor's gaze and join him in looking out upon the landscape. This experience of shared sight serves as the primary framing device for *Imperial Poems*, operating on both sensory and imaginative levels. By providing access to a landscape framed by the emperor's normative texts but devoid of actors, the thirty-six scenes are free to be spatialized by the viewer-guest. The power of this functional performance lies in the role being played. Despite the emperor's absence, like all garden portraits, *Imperial Poems* ultimately reflects and embodies its owner. In projecting themselves into the pictorial landscape, the viewer is invited to occupy the emperor's point of view, in essence becoming the ruler's intimate, if not the emperor himself, a transposition reinforced by the scene's construction of shared vision and thought.

Kangxi's absence from the images has a second semiotic function, raised by the question of the emperor's real or implied position relative to the physical images themselves. The reading of *Imperial Poems* presented in

this chapter began with a twofold understanding of sociability encoded throughout the imperially printed book. This sociability depends on the printed landscape's conceptual and material connections to other iterations of the album, particularly Wang Yuanqi's paintings. Albums are, by their very nature, a painting format that dictate an intimate viewing experience enjoyed by two or perhaps three people, side by side. The album's small compositions draw viewers in; they share an intimate social experience together as they progress, leaf by leaf, through the series. The materiality of the printed *Imperial Poems*—its physical form as well as its history of production—clearly evokes that of the paintings upon which the book was based and, by extension, the habits of viewing that attended the unique original album. Similarly, in *Imperial Poems* the emperor not only shared intimate views of his garden but also re-created the experience of touring it, a social ritual that was central to elite consumption of garden spaces. Like the implied act of viewing paintings, Zhang Yushu's accounts of his visits to the Mountain Estate evoked rituals of, if not friendship, then a greater intimacy than would have characterized the highly hierarchical interactions that were the norm between emperor and subject. The emperor's absence from the scenes enables and reinforces these transmedial evocations of shared experience, as it suggests that he is looking with the viewer, guiding them through the garden along a scenic itinerary.

Viewer and emperor are thus joined in a dual performance through *Imperial Poems*, each aspect of which is founded upon the suggestion of a shared experience of the Mountain Estate facilitated by the emperor's presentation of his private landscape and his absence from the landscape image. Placing the emperor beside the viewer, the first performance is a social one, external to the book. In this case, the emperor shares his album of garden views with the viewer, offering visual access to the garden through a series of discrete pictures. Although word and image are obviously operative on this level, the primary evocation is that of the social act of communal viewing, which in turn grounds the viewer's passage through the landscape of *Imperial Poems* in imperially hosted tours of the park itself. The second performance is one of shared position within the album and, by extension, shared vision and experience of the landscape. By assuming the emperor's perspective and then his position within the visually and textually constructed landscape of *Imperial Poems*, the viewer's relationship with the emperor advanced past one of collective social experience to one engaged with introspective, individual experience—a relationship of true intimacy that, it was hoped, would generate a particular bond of loyalty between the emperor and those he favored with this rare gift.

# The Landscape of the Emperor

*Now, there is no differentiation between the center and the periphery.*

THE KANGXI EMPEROR

So WROTE KANGXI on the imperial stele commemorating the comple-
tion of the Temple of Universal Benevolence in 1713. Construction of the
temple at the behest of the court's Inner Mongolian allies was itself evidence
of the unification of people and territories under the Qing, ideals also rep-
resented through the construction of the Mountain Estate to Escape the
Heat. In this text, however, it was not the landscape or architecture that
reflected the unification of the empire, but the virtuousness and efficacy of
Qing rule, which had succeeded in a historic geographic and ethnic joining
of inner and outer. The emperor identified himself as the direct embod-
iment of this equally political and ideological transformation, describ-
ing himself as a ruler with "a deep well of benevolence and generosity
extending to [his] very marrow" through whose virtue "a peaceful age has
taken form."[1]

The degree to which landscape served as a medium for expressing this
virtue, standing in for the emperor conceptually, and at times almost cor-
porally, is a recurrent theme in the court's articulation of the Mountain
Estate. Imperial morality was encoded into the written, visual, and physical
landscapes of Rehe; in turn, the emperor's virtue precipitated the produc-
tivity, order, and peace of the land. In the last portion of "Record of the
Mountain Estate to Escape the Heat," Kangxi employed a series of analogies
to connect features of the Mountain Estate's natural landscape with virtues
he sought to embody.[2] The irises and orchids, pines and bamboo, and clear
currents and creeping vines with which Kangxi concludes the text represent
perhaps the most basic construction of landscape from moral materials.
The landscape itself prompts in the emperor thoughts that reflect his inner
character to the reader while simultaneously creating a link between the
landscape of Rehe and the throne's virtuous nature.

The emperor borrowed this series of metaphors directly from a text by
Zhang Tianxi (346–406), the last ruler of the Former Liang (Qian Liang,
320–376), one of the so-called Sixteen Kingdoms during the Jin dynasty

(265–420). Before ascending the Liang throne, Zhang struggled to establish himself socially and militarily. In the late 360s, however, the Jin named him successor to several largely ceremonial titles, including Duke of Xiping (Xipinggong), the title associated with his family line of Liang rulers. Early in his reign, Zhang was known for neglecting his rule, banqueting frequently in his gardens, behavior against which his senior officials strongly remonstrated. In response, Zhang is recorded as saying,

> I have not acted well, and actions have consequences. Watching honorable members of the court, I respect wonderfully talented gentlemen; enjoying irises and orchids, I love servants who act virtuously; gazing upon pines and bamboo leads me to ponder morally upright worthies; looking down into clear currents leads me to prize incorruptible ambassadors; I inspect the thick, creeping vines and despise corrupt and immoral officials; encountering a great storm, I hate ruthless and deceitful followers. If one takes [something] as a guide and stretches its meaning, touches upon categories and extends them, nothing will be left out.[3]

Zhang's final sentence comes from the "The Great Treatise" (Xici), a section of the *Book of Changes* that explores the capacity for trigrams to account for and interpret the world's multitude of phenomena.[4] In his parallel phrase Kangxi departs from his primary source yet retains its essential meaning: "[All] this is in keeping with the ancients, [who] relied upon things in order to [express ideas through] comparison [with natural principles, *bi*] or give rise to [hidden emotional responses, *xing*]; [through these means,] there is nothing that may not be known." Here, Kangxi references two techniques for creating poetic imagery, *bi* and *xing*, long-standing rhetorical means for expressing philosophical, political, and social ideas through analogy.[5] Literary scholar Stephen Owen explains the basic distinctions that Liu Xie (ca. 465–522), who first defined the terms' rhetorical functions, makes between the two: "Comparison [*bi*] is to be understood by reflection; *xing* is to be understood immediately. . . . *Bi* uses one word to 'refer' to something else; *xing* uses words to stir a certain response. The grounds of comparison in a *bi* are based on common 'principle' [*li*] and shared category [*lei*] . . . *Xing*, on the other hand, is based on association, which occurs within the mind rather than in the world, and thus is covert."[6]

Taking the section "When it comes to enjoying irises and orchids, then I love virtuous acts" as illustration, in each line Kangxi engages in both *bi* and *xing*. Through *bi*, "irises and orchids" are connected to "virtuous acts." Through *xing*, "irises and orchids" automatically stimulate feelings of virtue and friendship. By employing *bi* and *xing* together, the emperor creates a poetic landscape that operates on both physical and metaphoric levels.

In poetry scholar Pauline Yu's terms, the *bi* here signals "that the poetry originates in a stimulus-response relationship between the poet and his/her world, and it answers a pressing need to locate a specific empirical source for a poem."[7] In this example the emperor is essentially saying, "When it comes to enjoying the irises and orchids *that are actually here in front of me*, then I love virtuous acts." Simultaneously, in their usage as *xing*, the "irises and orchids," while still physically there, stand for something emotional and nonspecific, understanding human feelings through natural imagery.[8] Thus the landscape of the Mountain Estate that the emperor describes is simultaneously a literal one to which he may be safely entrusted by his officials, as it guides him toward, rather than distracts him from, conscientious rule, and a philosophic one, a "landscape of virtue" in which the streams, flowers, trees, and grasses are in fact loyalty, modesty, righteousness, humaneness, and purity of spirit—all essential traits of a worthy ruler. This landscape, the landscape of virtue, is not simply an embodiment of the ideal emperor—it *is* the ideal emperor.

The portrait of the emperor with which this book began (see fig. 1.1) offers a pictorial analog to irises and orchids that is suggestive of how connections between ruler and landscape contributed to the formation of Qing imperial identity. An anonymous work associated with the studio of the Italian Jesuit Giovanni Gherardini, the scroll depicts the Kangxi emperor seated in informal dress, an open book on his lap; undated, the portrait was most likely executed in the years around the commencement of construction in Rehe. The image portrays the emperor as a cosmopolitan early modern monarch defined by the breadth of knowledge under his control, represented equally by the string-bound volumes that frame him and the unusual convergent perspective used to construct the composition. Like Leng Mei's painting *View of Rehe*, Kangxi's *Imperial Poems*, and the reflection of the empire in the park itself, the portrait is an image of the Qing and Qing emperorship defined by all that it encountered and controlled.

Seated in a low-ceilinged study, rising above the viewer from his mat, the emperor's body may be read as a powerful and generative landscape similar to that of the Mountain Estate itself.[9] The emperor is clothed for summer in an informal, unlined robe and fringed traveling hat that pictorially locates him outside formal ritual, and most likely outside the capital as well. His garments are unusual, if not unique.[10] Rather than being made from plain unfigured satin or bearing embroidered roundels, as was generally the case for informal court robes in the Qing, here the emperor's surcoat and robe are adorned with the central coiled dragon and auspicious landscape elements of more formal robes. He sits erect, his body taking the triangular form of a mountain, the ridges and valleys of his robes resembling the densely folded terrain of the Northeast or the openings and closings of an Orthodox landscape. His arms and hands emphasize the structure

of his mountain-body, its auspicious veins flowing toward and into his lap and the book lying there, reinforcing the converging orthogonals of the painting's perspective.

It is a composition strongly reminiscent of the roughly contemporary views of Rehe and Fuling (see figs. 4.1 and 4.8), the open book taking the place of palace or tomb. The book, in turn, is conspicuously blank, its unprinted pages nearly the same color as the emperor's skin, creating a unity between the compositional focus of the portrait-landscape and the body-as-territory within which it is set. History, geography, and culture converge in the landscape of Kangxi's robed form, individually and totem-ically identified as the essence of the Qing. And, indeed, in one sense he literally was: of Manchu, Mongol, and Banner Chinese descent, center and periphery were resolved in the emperor's own body. The capacity of landscape to reflect the physical, social, and conceptual transformation of geography inherent to empire made parks, gardens, and famous sites rich resources for articulating the nature of Qing rule.[11] Kangxi's great interest in and development of diverse landscapes offers a window into key issues in his reign, the progression of Qing history, and the state in early modern society. Unlike Qianlong, Kangxi did not seek to define himself as a universal ruler but rather as a polyglot one. Rather than segregating his intended audiences as he did in other contexts, courting a Chinese constituency while on tours to the south and Mongol khans while hunting in the north, the landscape of the Mountain Estate—or, more precisely, the landscape-as-medium out of which the emperor constructed himself through the Mountain Estate—was one that spoke to multiple audiences in varied and overlapping terms.

A second portrait of the emperor reading underlines the complexity of this discourse under Kangxi (fig. c.1).[12] Painted with oils on paper, it appears almost a perfect partner to the first portrait. The emperor sits with his body slightly turned to the picture plane, looking directly out at the viewer. He is clothed in what appears to be the same summer dress—a blue surcoat over a plain blue robe, a red fringed hat upon his head. The two faces are almost precisely identical, save for the oil portrait's slight turn of the head: light whiskers at the corners of each jaw, faint wrinkles at the corners of his eyes, the gentle bulges of his slightly heavy brow. So, too, are his right hands, fingers hanging loosely down, his pinky bent in a slight curve as though broken in the past. In the oil portrait, however, Kangxi's left hand cradles the book in his lap instead of letting it rest in front of him, a different method of reading necessitated by a different mode of sitting. Here again the book is blank, suggesting perhaps that the portrait's sitter is the source of knowledge, rather than the other way around.

Executed in the style of a European seated portrait, the emperor's body framed in an oval, it is mounted in a Chinese manner, set within a standing

FIGURE C.1
Anonymous, *Kangxi
Reading*, ca. 1699–1704.
Screen, oils on paper,
126 × 95 cm. Palace
Museum. Beijing. Provided
by the Palace Museum,
Gu6414. Photo by Tian
Mingjie.

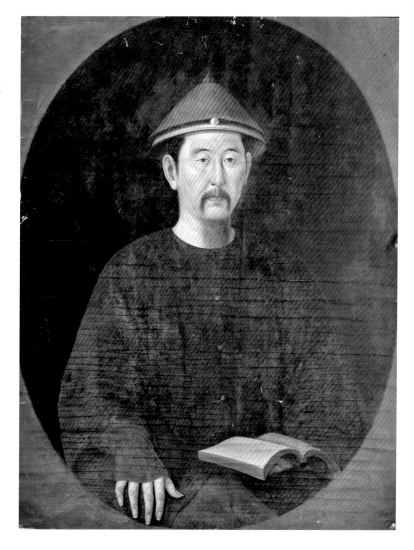

screen. At 126 × 95 centimeters it is much larger than most of its ostensible
European models but not quite as large as its ink and silk analogue. Though
it is apparently unsigned and undated, its remarkably close resemblance
to the other work, both in composition and in the emperor's appearance,
suggests that the two portraits were made at roughly the same time, most
likely in the same studio. Were they intended as a pair, and if so, what
did this pairing seek to convey? Taken together, these portraits may rep-
resent two modes of being that seem, at first blush, parallel but distinct.
Each draws upon a separate generic tradition for representing cultured
leisure—one Chinese, the other European. Yet upon further consideration,
this division becomes entirely superficial as, in their context and creation,
the portraits undermine the stability of the very categories they seem to

represent. Made in the Qing court using an admixture of techniques circulating back and forth across Eurasia, by anonymous hands that could have been Qing, European, or both, the portraits represent a ruler and a court deeply enmeshed in cultural networks within and beyond the empire's boundaries. As the emperor himself wrote of Rehe, these two works can be recognized as points of interchange, places in which inner and outer become one.[13]

Like his contemporaries across Asia and Europe, the Kangxi emperor oversaw a metamorphosis in the nature of state power and its expression in the seventeenth and eighteenth centuries that was both a vehicle for, and a result of, changes in collective imagination of the geographic, political, and cultural body. Thinking through the transcultural encounters that fundamentally contributed to the Qing court's construction and deployment of landscape highlights the Qing's active engagement in multiple and diverse discourses of imperial ideological expression, both within its own territories and across the early modern world. These were not necessarily discourses of admiration or, for that matter, of competition, aggression, or misapprehension, although such values and imperatives did appear in eighteenth-century artistic engagement, just as they did in domestic and international relations of the period.[14]

Rather, they were above all exercises in utility and utilization, of tactics and tools, art and architecture serving, like astronomy, surveying, court ritual, and the exchange of gifts, as particular solutions to the challenges and opportunities of Kangxi's specific moment.[15] One purpose of this narrative has been an effort to define that moment in part through the cultural formations that were produced in response to it. Yet in trying to come to terms with the ways in which the Kangxi court constructed and deployed landscape, and how it understood itself through landscape, we have few if any explicit words upon which to rely. Instead, we seek to extract discernible meaning from buildings, pictures, and scattered texts, recovering ideas and actions refracted through rhetorical images, poetic language, and the changing land itself. These sources test the limits of historical knowledge, accreting context from the activities around them and from the way in which they were received by subsequent rulers and artists, coming to us now only as a series of repetitions and signals to be reconstructed into a portrait of the past.[16]

# Glossary

Aihu 愛滹
Anyuanmiao 安遠廟
Aohan 敖漢

Bagua 八卦
Banyuehu 半月湖
Baotuquan 趵突泉
Beijing 北京
*Beijing bajingtu* 北京八景圖
Beitang 北堂
beiwen 碑文
Beiyuan 北苑
Beizhen Shuangfeng 北枕雙峰
bi 比
Bianliang 汴梁
Bifengsi 碧峰寺
Bishu Shanzhuang 避暑山莊
"Bishu Shanzhuang ji"
    避暑山莊記
Bishu Shanzhuang
    men 避暑山莊門
*Bishu Shanzhuang tu*
    避暑山莊圖

*Caotang shizhi* 草堂十志
caoyandi 草掩地
*Celiang gaoyuan yiqi yongfa*
    測量高遠儀器用法
Chang'an 長安
Changbaishan 長白山
Changchunyuan 暢春園
Changhong Yinlian 長虹飲練
chaojin 朝覲
Chen Ruyan 陳汝言

"Chen Wendi aice wen"
    陳文帝哀策文
Chengbo Diecui 澄波疊翠
Chengde 承德
*Chengde fuzhi* 承德府志
Chenghu 澄湖
Chengquan Raoshi 澄泉遶石
Chuifeng Luozhao 錘峰落照
Chunhaoxuan 春好軒
cun 寸

*Da Ming yitongzhi* 大明一統志
Da Qing shengshi 大清盛世
Dacheng 大成
Dachi 大癡
daguan 大觀
Dai Tianrui 戴天瑞
daibi 代筆
Danbo Jingcheng 淡泊敬誠
Dantu 丹徒
dao 道
"Dazongshi" 大宗師
Dehuimen 德匯門
*Dilishuo* 地理說
ding 鼎
dipian shang qi wujian fa
    地平上起物件法
Dong Bangda 董邦達
Dong Qichang 董其昌
Dong Yuan 董源
dongbei/xibei yilu shenggai
    東北／西北一路勝概
Donggong 東宮
Dongyuanwu 洞遠屋

Doumuge 斗姥閣
Du Qiong 杜瓊
Duyiju 讀易居

en 恩

Falinsi 法林寺
Fan Kuan 范寬
fang 仿
*Fang Qiu Ying Hangong
    chunshao tu* 仿仇英漢宮春曉圖
Fangshengting 放生亭
Fangzhang 方丈
Fangzhu Linliu 芳渚臨流
fei 廢
fen 分
feng 峰
Fengquan Qingting 風泉清聽
fengshansi 封禪祀
Fengzeyuan 豐澤園
Fuling 福陵
*Fulingtu* 福陵圖
Futian Congyue 甫田叢樾

ganshi xiaoyi 旰食宵衣
Gao Kegong 高克恭
Gao Shiqi 高士奇
*Gengzhi tu* 耕織圖
Gongbu 工部
*Gouqu songfeng tu* 句曲松風圖
Guan Huai 關槐
Guan Tong 關仝
guannei 關內
Guanputing 觀瀑亭

guanwai 關外
guapu 瓜圃
guimen 鬼門
Guo Xi 郭熙
Guo Zhongshu 郭忠恕

Hainei qiguan 海內奇觀
Haixi 海西
Han Wudi 漢武帝
Hanjun 漢軍
Hanlinyuan 翰林院
Hanrunting 含潤亭
Hao Pu Jianxiang 濠濮間想
hebi 合筆
Heishan 黑山
"Hou Chibifu" 後赤壁賦
Hou Chibifu tu 後赤壁賦圖
houyuan 後苑
hua 畫
Huanbi 環碧
Huanbizhou 環碧洲
Huancuitang yuanjing tu
　　還翠堂園景圖
huang 荒
Huang Ding 黃鼎
Huang Gongwang 黃公望
Huang Xiangjian 黃向堅
Huangheshan 黃鶴山
huangye 荒野
Huangyu quanlan tu 皇輿全覽圖
Huashan 華山
huatu liuyu renkan 畫圖留與人看
Huayugou 化魚溝
"Hucong ciyou ji"
　　扈從賜遊記扈
Huidiji men 惠迪吉門
Huifa 輝發
Huilanshi 洄瀾石
Huishan Cizong 徽山詞宗
Huntong 混同
huogan huoxiao 或旰或宵

ji 記
Jiang Shen 江參
Jiang Tingxi 蔣廷錫
Jianzhanggong 建章宮
Jianzhou 建州
jiao 郊
Jiao Bingzhen 焦秉貞

jiaowai 郊外
Jiaqing 嘉慶
Jiededao 戒德島
jiehua 界畫
jiejing 借景
Jieziyuan huazhuan 芥子園畫傳
Jin 晉
"Jin yi zhongwai wubie yi"
　　今已中外無別矣
jing 景
Jing Guan 荊關
Jing Hao 荊浩
Jinghu 鏡湖
Jingkou Sanshan 京口三山
Jingshui Yuncen 鏡水雲岑
Jingzong 景宗
Jinlian Yingri 金蓮映日
Jinmingchi 金明池
Jinmingchi zhengbiao tu
　　金明池爭標圖
Jinshan 金山
Jinshandao 金山島
Jinshi 金史
Jinshu 晉書
Jinzhou 金州
Jiuchenggong 九成宮
"Jiuchenggong liquan ming"
　　九成宮醴泉銘
Jiurutu 九如圖
Jiweng xiansheng 寄翁先生
jun 君
Juran 巨然

kaihe 開合
Kaiyuan 開原
Kaiyunshan 開運山
Kalahetun 喀喇河屯
kan 坎
Kangxi 康熙
Kangxi Nanxuntu 康熙南巡圖
Kangxi zidian 康熙字典
kejue danying 刻楠丹楹
kuangju 筐筥
kuangyuan zhi chu 曠遠之處

laichao 來朝
Laiqinyou 來禽囿
lei 類
Leng Mei 冷枚

li 理
Li Bo 李白
Li Cheng 李成
Li Guangdi 李光地
Li Song 李嵩
"Liangsi" 良耜
Libu 禮部
Lihua Banyue 梨花伴月
Liji 禮記
Linfangye dao 臨芳墅島
Lingze Longwangmiao 靈澤龍王廟
lingzhi 靈芝
Lishuyu 梨樹峪
Liu Xiaowei 劉孝威
Liu Xie 劉勰
Liu Zongyuan 柳宗元
liubeiting 流杯亭
Liubeiting men 流杯亭門
Lizhengmen 麗正門
Long 隴
longmai 龍脈
Longyeshan 隆業山
Lou Shou 樓璹
Loudong 婁東
Lu Hong 盧鴻
Lushan 廬山
Lüshun 旅順

Ma Guoxian 馬國賢
Manzhou shilu 滿洲實錄
Mei Daoren 梅道人
Mei Yufeng 梅裕鳳
Mi Fu 米芾
Mi Youren 米友仁
Miaoshangting 妙賞亭
Mijia 米家
Minghuang bishugong
　　tu 明黃避暑宮圖
mingsheng 名勝
Mulan Weichang 木蘭圍場

"Naliang" 納涼
Naluwoji 納祿窩集
nanmu 南畞/畮
　　("Southern Acres")
nanmu 楠木 (any of several
　　species of Phoebe)
Nanshan 南山
Nanshan Jixue 南山積雪

Nanshufang 南書房
neidi 內地
Neihu 內湖
Neiwufu 內務府
Neiwufu siku 內務府司庫
"Neiwufu siku jiayi chen Shen Yu gonghua" 內務府司庫加一臣沈喻恭畫
neiyuan 內苑
Ni Zan 倪贊
nian Rehe zhi di wei zhongwai zhi jiao 念熱河之地為中外之交
Nian Xiyao 年希堯
Nuanliu Xuanbo 暖溜暄波
Nüzhen 女真

*Peiwenzhai shuhuapu* 佩文齋書畫譜
Penglai 蓬萊
pimacun 披麻皴
Pinghu Qiuyue 平湖秋月
Pulesi 普樂寺
Puningsi 普寧寺
Purensi 溥仁寺
Pushansi 溥善寺
Puyuanting 瀑源亭

Qi Biaojia 祁彪佳
qian 乾
*Qian Han ji* 前漢紀
Qian Liang 前涼
Qian Weicheng 錢維城
Qianling 乾陵
Qianlong 乾隆
Qiao Zhongchang 喬仲常
qifu 起伏
Qin 秦
*Qinding Gujin tushu jicheng* 欽定古今圖書集成
*Qinding Rehezhi* 欽定熱河志
*Qinding Shengjing tongzhi* 欽定盛景通志
Qing 清
Qingbiting 晴碧亭
Qingchuifeng 磬錘峰
qin'geng 親耕
Qingfeng Lüyu 青楓綠嶼
Qingliandao 清蓮島
qinglü 青綠

*Qingming shanghe tu* 清明上河圖
Qingshu Shanguan dao 清舒山館島
Qingyiyuan 清漪園
"Qiongdao Chunyun" 瓊島春雲
"Qiuguan sikou" 秋官司寇
"Qiwulun" 齊物論
Quanyuan Shibi 泉源石壁
Qufu 曲阜
Qushu Hexiang 曲水荷香

Rang'ouchi 讓鷗池
Rehe 熱河
Rehe Shangying 熱河上營
Rehe Xiaying 熱河下營
Ruoshutang 若墅堂
*ruyi* 如意
Ruyihu 如意湖
Ruyizhou 如意洲

Sanfan zhi luan 三藩之亂
Santun 三屯
Shangdige 上帝閣
Shanghu 上湖
*Shanshui louge tuce* 山水樓閣圖冊
Shanyin 山陰
"Shanzhong wenda" 山中問答
Shen Nong 神農
Shen Quan 沈荃
Shen Yinghui 沈映輝, also 沈映暉
Shen Yu 沈崳, also 沈喻
sheng 生
Shengjing 盛京
Shengzu renhuangdi 聖祖仁皇帝
*Shengzu renhuangdi shilu* 聖祖仁皇帝實錄
Shenyang 瀋陽
Shiji Guanyu 石磯觀魚
*Shijing* 詩經
*Shiqu baoji* 石渠寶笈
*Shixieshan tu* 石屑山圖
*Shixue* 視學
Shizong 世宗
shu 熟
Shuanghu Jiajing 雙湖夾鏡
Shuifang Yanxiu 水芳巖秀
Shuiliu Yunzai 水流雲在
Shunzhi 順治
si Wang 四王

silai 賜賚
Simian Yunshan 四面雲山
Song Junye 宋駿業
Songhe Qingyue 松鶴清越
Songhezhai 松鶴齋
Songhua 松花
Songlinyu 松林峪
Songyunxia 松雲峽
Su Shi 蘇軾
Sudi 蘇堤

Taishan 泰山
"Taishan shanmai zi Changbaishan lai" 泰山山脈自長白山來
"Taiye Qingbo" 太液晴波
Taiyechi 太液池
Taizong 太宗
Tang Dai 唐岱
"Tangong shang" 檀弓上
Tangquan 湯泉
Tantan Dangdang men 坦坦蕩蕩門
Tao Yuanming 陶淵明
tianchou huangwu 田疇荒蕪
Tianming 天命
Tianpiao 天瓢
Tianxia 天下
tianye 田野
Tianyu Xianchang 天宇咸暢
Tianzhushan 天柱山
Tingputing 聽瀑亭
Tongjia 通加
*Tongyin shinü tuping* 桐蔭仕女圖屏
Tumenhe 土門河
Tumenjiang 土門江
tuyong 圖詠

Waibamiao 外八廟
Wanhe Songfeng 萬壑松風
Wang Cengqi 王曾期
Wang Hui 王翬
Wang Jian 王鑒
Wang Lü 王履
Wang Meng 王蒙
Wang Shimin 王時敏
Wang Tingna 汪廷訥
Wang Wei 王維
Wang Xianchen 王獻臣

Wang Yuanqi　王原祁
*Wangchuantu*　輞川圖
Wangluting　望鹿亭
*Wanshou shengdian tu*
　　萬壽盛典圖
Wanshou shuhua ju　萬壽書畫局
Wanshuyuan　萬樹園
wei　衛
Wei Zheng　魏徵
Wen Zhengming　文徵明
Wenjindao　文津島
Wenyuandao　文園島
Wu Zhen　吳鎮
Wulashan　烏喇山
Wuliehe　武烈河
Wushu Qingliang　無暑清涼
wuwei　無為
Wuyingdian　武英殿
Wuyue　五嶽

Xiahu　下湖
Xianfeng　咸豐
Xiangyuan Yiqing　香遠益清
Xiangyunwu　湘筠塢
Xianling　顯陵
Xiao Canglang　小滄浪
Xiao Gang　蕭綱
"Xiaowen huangdi ji, shang"
　　孝文皇帝紀上
*Xiaozhong xianda*　小中現大
Xibeimen　西北門
"Xici"　繫辭
Xie Huan　謝環
Xie Shichen　謝時臣
"Xie Youcheng shanzhuangtu ni
　　zhi"　寫右丞山莊圖擬之
*Xihu shijing*　西湖十景
Xiling Chenxia　西嶺晨霞
xing　興
xinggong　行宮
Xingjing　興京
xingletu　行樂圖
"Xingxing Ganquangong ge"
　　行幸甘泉宮歌
*Xingyuan yaji tu*　杏園雅集圖
Xipinggong　西平公
Xiyu　西峪

Xu Ling　徐陵
Xuanzong　玄宗

Yalu　鴨綠
Yanbo Zhishuang　烟波致爽
yang　陽
Yang Rong　楊榮
Yangxindian　養心殿
*Yangzheng tuce*　養正圖冊
Yanxun Shanguang　延薰山館
yao　遙
ye　野
yesi　野司
yeyu　野虞
yi　邑
yideng xiangxu　一燈相續
yihai sanshan　一海三山
Yiheyuan　頤和園
*Yijing*　易經
yin　陰
Yingzhou　瀛洲
Yingzhuan Qiaomu　鶯囀喬木
Yinhu　銀湖
Yipianyun　一片雲
Yiwulushan　醫巫閭山
Yongcuiyan　涌翠巖
Yongle　永樂
Yongling　永陵
Yongzheng　雍正
*Yongzheng shieryue xingletu*
　　雍正十二月行樂圖
*Yousong tu*　友松圖
yuanfei yuyue　鳶飛魚躍
Yuanjin Quansheng　遠近泉聲
Yuanmingyuan　圓明園
Yuese Jiangsheng　月色江聲
Yuese Jiangsheng dao
　　月色江聲島
Yunfan Yuefang　雲帆月舫
Yunhe　雲壑
Yunpu　雲瀑
Yunrong Shuitai　雲容水態
Yunshan Shengdi　雲山勝地
*Yushanzhu*　寓山注
*Yuxuan Tangshi*　御選唐詩
*Yuzhi Bishu Shanzhuang shi*
　　御製避暑山莊詩

*Yuzhi Yuamingyuan sishi jing shi*
　　御制圓明園四十景詩

Zhang Hong　張宏
Zhang Kui　張奎
Zhang Ruoai　張若藹
Zhang Tianxi　張天錫
Zhang Ying　張英
Zhang Yushu　張玉書
Zhang Zeduan　張擇端
Zhang Zongcang　張宗蒼
zhangbang zhi ye　掌邦之野
zhangye　掌野
zhanshifu zhanshi　詹事府詹事
Zhao Boju　趙伯駒
Zhao Cheng　趙承
Zhao Danian　趙大年
Zhao Lingrang　趙令穰
Zhao Mengfu　趙孟頫
Zhaoling　昭陵
zhen　枕 (pillow, hitching post)
zhen　鎮 (talisman)
Zhenggong　正宮
zhengpai　正派
Zhenziyu　榛子峪
zhihua　指畫
Zhijing Yundi　芝逕雲隄
"Zhijing yundi xiyu guichuan"
　　芝徑雲隄細雨歸舟
zhili lifa　治理曆法
Zhiyuan　止園
"Zhiyuan quantu"　止園全圖
Zhongjing　中京
"Zhongshu Guo tuotuo zhuan"
　　種樹郭橐駝傳
*Zhouli*　周禮
*Zhouyi*　周易
Zhu Gui　朱圭
*Zhu Zhanji xingletu*
　　朱瞻基行樂圖
*Zhuozhengyuan tushice*
　　拙政園圖詩冊
Zuoyinyuan　座陰園
Zuoyinyuan jingshi　座陰園景詩
*Zuoyinyuan yibaiershi yong*
　　座陰園一百二十咏

# Notes

## Note to Readers

1. H. Zou, "*Jing*" and "*Jing* of a Perspective Garden."
2. Harrist, "Site Names and Their Meanings"; and Makeham, "Confucian Role of Names."

## INTRODUCTION

### Historicizing the Early Qing Landscape

1. Hevia, "World Heritage." Visitorship is said to be over ten million annually; Zhang Binchong, personal communication with the author, June 2013.
2. For a related narrative, see Haiyan Lee, "Ruins of Yuanmingyuan."
3. Hevia, *Cherishing Men from Afar*.
4. On geobodies, see Winichakul, *Siam Mapped*.
5. Whiteman, "From Upper Camp," 250–57.
6. The literature on early modern imperial gardens is extensive; studies influential for this research include Mukerji, *Territorial Ambitions*; Schönle, *Ruler in the Garden*; and Wescoat and Wolschke-Bulmahn, *Mughal Gardens*.
7. Elias, *Court Society*. This interpretation has been challenged by studies arguing for the court system as a form of collaboration; see, e.g., Beik, "Absolutism of Louis XIV"; and Burke, *Fabrication of Louis XIV*. Cf. Babaie, *Isfahan and Its Palaces*.
8. Mitchell, "Imperial Landscape," 14–15.
9. Hall and Ames, "Cosmological Setting."
10. Cooper and Gregory, "Mapping the English Lake District."
11. Paraphrasing Marin, *Portrait of the King*, especially, "Third Entrance: 'A Portrait of Caesar is Caesar,' or the King in His Frame."
12. Regarding "things-in-motion," see Appadurai, "Introduction," 5.
13. Regarding the notion of a "space" as a "practiced place," see de Certeau, "Spatial Stories," 117.
14. Examples of scholarship relying on Qianlong and nineteenth-century materials include, e.g., *CBS* and Forêt, *Mapping Chengde*. Principal post-Kangxi sources

include, e.g., *Veritable Records of the Kangxi era* (Shengzu renhuangdi shilu, comp. Yongzheng era); *Imperial Gazetteer of Rehe* (Qinding Rehezhi, 1781); and *Gazetteer of Chengde Prefecture* (Chengde fuzhi, 1887).
15. Clunas, *Elegant Debts*, 14.
16. Ibid.
17. Pinney, *Photos of the Gods*, 202. In this I am motivated by Christopher Pinney's suggestion that we may write "not a history of art . . . , [but] a study of how pictures [or in this case, landscapes] were an integral element of history in the making"; see ibid., 8.
18. As Joanna Waley-Cohen, "New Qing History," 200, notes, this mode of imperial communication has been particularly well studied in the context of court ritual.

## CHAPTER 1

### Reconstructing Kangxi

1. Kangxi may have explored the idea of a simple palace for "escaping the heat" as early as 1677; see Liu Yuwen, "Kangxi huangdi," 116.
2. KX41/閏6/14–KX41/7/2, or August 7–24, 1702; see *TQJZ*, 17:T09445–T09475.
3. Kangxi imperial rescripts collected in the "Gongbu laiwen" and the collection of Qinghua University Library, Beijing, cited in Liu Yuwen, "Bishu shanzhuang," 87, 91n26.
4. *TQJZ*, T10107, T10109; *BQJZ*, B013237–B013238, B013319; *Daqing Shengzu renhuangdi shilu*, j. 224, 225; Heshen and Liang Guozhi, *Qinding Rehezhi*, 3:141a–142a; Hai Zhong, Ting Jie, and Li Shiyin, *Chengde fuzhi*, 243–46; and Zhang Yushu, "Hucong ciyou ji." For more on naming, see Whiteman, "From Upper Camp," 275n38.
5. Chen Congzhou, *Zhongguo yuanlin*, 287; and *CBS*, 13–14. For a table listing the architecture of Bishu Shanzhuang and related information, including proposed dates of construction, usage, and current condition, see *CBS*, 116–25. Chen Baosen's work has been used here as a starting point for dating and modified based on additional research; he does not provide sources for the dates and

other information he lists, however, which must therefore be taken as provisional.

6. For the year 1703: seven days over two visits; for 1704: no more than eighteen days; for 1705: no more than nineteen days; for 1706: eleven days over two visits; for 1707: no more than fifteen days. For 1703, see *TQJZ*, 18:T10106–10122; for 1706, *BQJZ*, 26:B013319–B013341, and 27:B013655; for 1704, 1705, 1707, and 1708, as well as confirmation of the dates for 1703 and 1706, see Heshen and Liang Guozhi, *Qinding Rehe zhi*, 3:141a–142b; and Hai Zhong, Ting Jie, and Li Shiyin, *Chengde fuzhi*, 243–46. For further discussion of travel during this period, see Whiteman, "From Upper Camp," 275n38.

7. *CBS*, 116–25, table 3.

8. *YZBSSZS*, "Nuanliu xuanbo" and "Quanyuan shibi," n.p.

9. *CBS*, 121. Chen Baosen dates the compound, cliff carving, and pavilion to before 1708, although this is unconfirmed; the sluice gate would by necessity have been built before then.

10. *YZBSSZS*, "Nuanliu xuanbo," n.p. Some confusion about this name persists in the *Imperial Poems*, as Kangxi's preface to "Nuanliu xuanbo" locates it over a hill south of "the winding waters" (*qushui*). If this refers to the floating cups pavilion, "Qushui Hexiang," then although the image in the *Imperial Poems* clearly depicts the northeastern sluice gate, it would seem that the emperor's poem is still describing the area near Rehe Spring. *YZBSSZS*, "Nuanliu xuanbo," n.p.

11. Other examples of shifting names between 1708 and 1711 include Clear Ripples with Layers of Greenery and Untrammelled Thoughts by the Hao and Pu Rivers (Hao Pu Jianxiang). This practice continued under the Qianlong emperor. For the latter, see Whiteman, "From Upper Camp," 268–69.

12. For the southern Jinshan, see *GJTSJC*, 19:972; *Mingshan tu* (1633), in *Zhongguo gudai banhua congkan erbian*, 13:195; and Wang Qi and Wang Siyi, *Sancai tuhui*, 270.

13. *Thirty-Six Views*, 30. Richard Strassberg identifies this as the climax of the series. For another interpretation of Jinshan's significance in the Mountain Estate's design, see Forêt, *Mapping Chengde*, 2, 51–52, and Forêt, "Manchu Landscape Enterprise," 325–34.

14. Hummel, *Eminent Chinese*, 65.

15. On the inscription and experience of overlapping yet distinct circuits within a landscape, cf. Upton, "Black and White Landscapes."

16. *CBS*, 14n2; and Liu Yuwen, "Kangxi huangdi yu Bishu shanzhuang," 115.

17. Matteo Ripa indicates that by the time of his visits, Ruyi Island was primarily a residence for palace women and a place for the emperor to visit; Biblotheca Nazionale di Napoli, ms 1.g.75.

18. Audiences with small cohorts of named officials and Inner Asian allies are the most common imperial activities recorded at Rehe in *Diaries of Activity and Repose*.

19. Dating at least to the Han; see Wang Juyuan, *Zhongguo gudai yuanlin shi*, 1:58, fig. 3-17.

20. The massive *nanmu* pillars for which the hall is now known

are a product of Qianlong's rebuilding and expansion of the structure in 1754; see *CBS*, 26.

21. *YZBSSZS*, "Bishu shanzhuang ji," n.p.

22. Zhang Lihuan and Wang Xingfeng, "Jianzhu de yuezhang," 237–38.

23. *YZBSSZS*, "Yunshan shengdi," n.p.; see Strassberg trans. in *Thirty-Six Views*, 154f.

24. These lakes were filled in by the Japanese in the 1930s and remained at least partially dry in the post-UNESCO era, ca. 1992; see *CBS*, 39–40. In recent years they have been partially restored.

25. With the possible exception of Clear Lake, these names do not appear in Kangxi-era documents; see *YZBSSZS*, "Wushu qingliang," n.p.

26. Zhang Yushu, "Hucong ciyou ji"; Leng Mei, *View of Rehe* (see fig. 4.1); and *YZBSSZS*, scenes 33 and 36 (see figs. 6.17, right, and 6.23, left).

27. *CBS*, 120, asserts a date of 1703, but the structure does not appear in Leng Mei's painting or in Kangxi's *Imperial Poems*.

28. Based on site inspection; see also *YZBSSZS*, "Chengbo diecui," n.p.

29. See *YZBSSZS*, scenes 2–4, 6, 8, 10, 11, 15, 17–20, 22, 24–26, 30–33, 35, and 36.

30. *YZBSSZS*, "Yunfan Yuefang," n.p.

31. For text examples, see Hargett, *Riding the River Home*; for images, see Zhang Hong's *Garden to Rest In* album, discussed in chapter 6 of this book, which is bookended by the viewer-guest's arrival and departure by boat; reproduced in Li, Cahill, and Zhang Hong, *Paintings of Zhi Garden*.

32. Inscriptions by Matteo Ripa, in Bibliotheca Nazionale di Napoli, ms 1.g.75; *Thirty-Six Views*, 151, 187; and *CBS*, 77–8, 122.

33. For example, *YZBSSZS*, "Fengquan qingting," "Yuanjin quansheng," "Chengquan raoshi," "Shuifang yanxiu," and "Nuanliu xuanbo."

34. The "near" spring of the structure's name refers to the waterfall. The "far" spring is described by the emperor in his preface as "Leaping Spring" (Baotuquan), a reference to a famous spring in modern Shandong. It is unclear to which spring the emperor is referring. *YZBSSZS*, "Yuanjin quansheng," n.p.

35. *MWZPPZ*, 1282–1285, no. 3171.

36. KX57/3/27; see *MWZPPZ*, 1282–1285, no. 3171.

37. *YZBSSZS*, "Yuanjin quansheng," n.p.; see Strassberg, trans., in *Thirty-Six Views*, 222, n84.

38. *YZBSSZS*, "Fengquan qingting," n.p.; see Strassberg, trans., in *Thirty-Six Views*, 186.

39. *YZBSSZS*, "Fengquan qingting," n.p.; see Strassberg, trans., in *Thirty-Six Views*, 186.

40. *Thirty-Six Views*, 187n53.

41. Cf. Venturi, Brown, and Izenour, *Learning from Las Vegas*, figs. 19–30.

42. For Buddhist monastic architecture at Chengde, see Chayet, *Les temples de Jehol*.

43. Forêt, *Mapping Chengde*, chapter 4; Forêt, "Intended Perception," 353–59; and Forêt, "Manchu Landscape Enterprise," 329–32.

44. Forêt, *Mapping Chengde*, 2.

45. Chayet, "Architectural Wonderland."

46. Ibid., 36. For an argument that Qianlong's construction of links with Kangxi through the Mountain Estate landscape may relate as much to *realpolitik* as to filial piety, cf. Whiteman, "From Upper Camp."

47. Cf. Berger, *Empire of Emptiness*; Wen-Shing Chou, "Imperial Apparitions"; Farquhar, "Emperor as Bodhisattva"; Köhle, "Why Did the Kangxi Emperor Go To Wutai shan?"; and Tuttle, "Tibetan Buddhism at Wutai shan."

48. Brokaw, *Ledgers of Merit and Demerit*, 82n57; Despeaux and Kohn, *Women in Daoism*, 67; and Pregado, *Encyclopedia of Taoism*, 1207.

49. For a list of temples within the park, see *CBS*, 183, table 5.

50. On the Daoist "idol," see, e.g., Bibliotheca Nazionale di Napoli, ms 1.g.75; *Thirty-Six Views*, 194–95, 250–51; and *YZBSSZS*, "Tianyu Xianchang," "Jinshui Yuncen," n.p.

51. The emperor's schedule during 1711 through 1717 is from the following accounts: for 1711: *TQJZ*, T10665–T10927, T11115–11128; for 1712: *TQJZ*, T11390–T11591, T11809–T11825; for 1713: *TQJZ*, T12145–T12372; for 1714: *BQJZ*, B013917–B014092, B014189; for 1715: *BQJZ*, B014419–B014636; for 1716: *BQJZ*, B015079–B015258, B015443; and for 1717: *BQJZ*, B015749–B016059.

52. See, e.g., *TQJZ*, T10665–T10853.

53. For an exception, see KX51/6/11, *TQJZ*, T11463–T11468.

54. See, e.g., accounts for 1711–1712, *TQJZ*, T10853–T10901 and T11539–T11577, especially T11557–T11569.

55. See especially Rossabi, *China and Inner Asia*, chapter 3; and Chia, "Lifanyuan," 70–86.

56. See, e.g., KX51/8/11–13, *TQJZ*, T11545–11549.

57. See, e.g., KX56/8/15, *BQJZ*, B015961f.

58. See, e.g., KX51/6/22, *TQJZ*, T11479f; KX51/7/26, *TQJZ*, T11531; KX52/5/25, *TQJZ*, T12149–T12151; KX52/闰5/6, *TQJZ*, T12170f; etc.

59. Chia, "Lifanyuan," 64–70; cf. Bartlett, "Imperial Notations," part 1.

60. See Coaldrake, *Architecture and Authority*, especially chapters 1, 6.

61. Whiteman, "From Upper Camp," 265–68; Wu Hung, *Double Screen*, 223–31; and Kleutghen, *Imperial Illusions*, chapter 3.

62. Venturi, Brown, and Izenour, *Learning from Las Vegas*, especially 3–72.

CHAPTER 2
Mountain Veins

1. Cams, *Companions in Geography*; Fuchs, *Jesuiten-Atlas*; Wang Qianjin and Liu Ruofang, *Qingting sanda shice quantuji*; and Yee, "Traditional Chinese Cartography," 180–85.

2. Cams, "Converging Interests," 61–70.

3. Kessler, *K'ang-Hsi and the Consolidation of Ch'ing Rule*; Perdue, *China Marches West*, chapters 4–5; Rawski, *Last Emperors*, 19–20; Shepherd, *Statecraft and Political Economy*, 103–108; Spence, "K'ang-hsi Reign," 136–46; and Wakeman, *Great Enterprise*, 1099–1127.

4. Cf. Hostetler, *Qing Colonial Enterprise*.

5. Waldron, *Great Wall*, introduction.

6. Waldron, *Great Wall*, 10.

7. See Köhle, "Why Did the Kangxi Emperor Go to Wutai Shan?"

8. Rawski, *Last Emperors*, 35, 313n53.

9. Perdue, *China Marches West*, 422; and M. Chang, *Court on Horseback*, 27.

10. M. Chang, *Court on Horseback*, 29, chapter 2.

11. Ibid., chapter 2.

12. Rawski, *Last Emperors*, 35. On smallpox in the early Qing, see Perdue, *China Marches West*, 45–49.

13. Spence, "K'ang-hsi Reign," 127–28.

14. Elliott, "Limits of Tartary," 608–609.

15. M. Chang, *Court on Horseback*, 74; and Dott, *Identity Reflections*, 151.

16. See Kleeman, "Mountain Deities in China"; and Szonyi, "Illusion of Standardizing the Gods."

17. M. Chang, *Court on Horseback*, 49.

18. Dott, *Identity Reflections*, 164.

19. Ibid., 164–65.

20. Ibid., 40–52.

21. Ibid., 176 and chapter 2.

22. On the rejection of "superstitious practices," see ibid., 179.

23. Elliott, "Limits of Tartary," 612.

24. Territorial integration as it relates to the conceptualization of Qing geography is distinct from the realities of the state's demographic and economic administration of the region; see Isett, *State, Peasant, and Merchant*; and Bello, *Across Forest, Steppe, and Mountain*.

25. Elliott, "Limits of Tartary," 614; also Crossley, "Introduction to the Qing Foundation Myth" and "Manzhou yuanliu kao."

26. Crossley, *The Manchus*, 103.

27. Ibid., 6.

28. Elliott, "Limits of Tartary," 608.

29. On the significance of mapping to the Qing imperial project, see Cams, *Companions in Geography*; Elliott, "Limits of Tartary"; Millward, "'Coming onto the Map'"; Hostetler, *Qing Colonial Enterprise*; and Teng, *Taiwan's Imagined Geography*.

30. Yee, "Traditional Chinese Cartography," 177–78; and Wakeman, *Great Enterprise*, 464n1.

31. Yee, "Traditional Chinese Cartography," 183–84.

32. Fuchs, *Jesuiten-Atlas*.

33. This order became less clear over time as the atlas went through multiple editions, including two woodblock versions, a manuscript, and a copperplate printing between 1717 and 1721, before finally being rendered in a single sheet. Yee, "Traditional Chinese Cartography," 181–83.

34. M. Chang, *Court on Horseback*, 73–76.

35. *Daqing Shizu zhanghuangdi shilu*, 37:23a, 38:3a; cited in Elliott, "Limits of Tartary," 609.

36. Elliott, "Limits of Tartary," 608–609.

37. Crossley, "Introduction to the Qing Foundation Myth," 20–21, especially 20n26.

38. Tuotuo, *Jinshi*, 3:819–20.

39. The Songhua, also known as the Sungari, was referred to

in various texts as the Huntong; a variant name for the Aihu is the Tumen. Sungari and Tumen are generally used here.

40. *Manzhou shilu*, 1–2; translated in Matsumura, "On the Founding Legend of the Ch'ing Dynasty," 12. On the court's various statements of Manchu origins and related historiographic issues, see also Matsumura, "Founding Legend of the Qing Dynasty Reconsidered"; Crossley, "Introduction to the Qing Foundation Myth" and "Manzhou yuanliu kao"; and Elliott, "Limits of Tartary."

41. Crossley, "Introduction to the Qing Foundation Myth," 19.

42. Ibid., 13–14; and Crossley, "Manzhou yuanliu kao."

43. Elliott, "Limits of Tartary," 612–13; and Rawski, *Last Emperors*, 85.

44. Chang Jiang and Li Li, *Qinggong shiwei*, 193–98; translated in Rawski, *Last Emperors*, 85.

45. *Daqing Shizu zhanghuangdi shilu*, 69:3a–b, 70:8a, 71:10b; cited in Elliott, "Limits of Tartary," 613.

46. Gao Shiqi, *Hucong dongxun rilu*; translated in Elliott, "Limits of Tartary," 612.

47. Li Shutian, *Ula shilue*, 181; translated in Elliott, "Limits of Tartary," 612.

48. Guoli gugong bowuyuan, ed., *Qinding Siku quanshu*, 1299:577. A partial translation is in Dott, *Identity Reflections*, 161–62. Although undated, the basic geographic information and much of the language used had been worked out by 1684; see Dott, *Identity Reflections*, 308n44.

49. Kangxi, "Taishan shanmai," translation after Dott, *Identity Reflections*, 161.

50. Kangxi, "Taishan shanmai"; for Naluwoji, see *GJTSJC*, 8:1665; for Hetu Ala, see *GJTSJC*, 8:1573–74; and for Kaiyunshan, see *GJTSJC*, 8:1573.

51. Kangxi, "Taishan shanmai."

52. Ibid. For Tianzhushan, Longyeshan, and Yiwulushan, see Zang Lihe, *Zhongguo gujin diming*, 135, 963, and 1325, respectively.

53. *GJTSJC*, 8:1575.

54. Ibid., 7:1351. For more, see Twitchett and Tietze, "The Liao," 118–19, map 7 inset; and Steinhardt, *Liao Architecture*, 5, 56, and chapter 10.

55. *GJTSJC*, 7:1371.

56. Elliott, "Limits of Tartary," 612–13.

57. *GJTSJC*, 8:1665, 18:84–85 and 8:166.

58. Ibid., 8:1665–66.

59. Yang Bin, *Liubian jilue*; translated in Elliott, "Limits of Tartary," 612.

60. Li Shutian, *Ula shilüe*, 181; translated in Elliott, "Limits of Tartary," 612.

61. *GJTSJC*, 18:84; and *Dongbei shizhi*, 4–5. The image from the *Veritable Records* is reproduced in Elliott, "Limits of Tartary," fig. 2.

62. E.g., *GJTSJC*, 8:1574, 1670.

63. The Tumen*he*, as opposed to the Tumen*jiang*, the major eastward-flowing river originating in Mount Changbai; see *GJTSJC*, 18:84.

64. Kangxi, "Taishan shanmai," translation after Dott, *Identity Reflections*, 162.

65. Kangxi, "Bishu shanzhuang ji."

66. Jinshan is a very common toponym and temple name across Chinese history; see Zang Lihe, *Zhongguo gujin diming*, 358–59. For a detailed look at Northeastern Jinshans discussed by Forêt, see *Mapping Chengde*, 71, and "Manchu Landscape Enterprise," 331, 334n13–14; see also Whiteman, "Creating the Kangxi Landscape," 68–69n80 and fig. 2.11.

67. *GJTSJC*, 8:1676.

68. Forêt, *Mapping Chengde*, 73, and "Manchu Landscape Enterprise," 331.

69. Serruys, "Mongol Altan 'Gold' = 'Imperial.'"

70. *YZBSSZS*, "Beizhen shuangfeng," n.p.

71. Related meanings refer to the stabilizing cross bar on a chariot and a bone in the brain of a fish. *KXZD*, "Zhen," http://ctext.org/dictionary.pl?if=en&id=330205, accessed January 11, 2019.

72. *YZBSSZS*, "Beizhen shuangfeng," n.p.

73. The line's interlinear commentary emphasizes its divinatory associations; see *YZBSSZS*, "Beizhen Shuangfeng," n.p.

74. *KXZD*, "Qian," https://ctext.org/dictionary.pl?if=en&id=317643, accessed January 11, 2019.

75. *KXZD*, "Kan," https://ctext.org/dictionary.pl?if=en&id=321814, accessed January 11, 2019.

CHAPTER 3
Only Here in Rehe

1. Ca. KX51/6/21–29, or August 5–13, 1711; see *TQJZ*, T10794–T10805.

2. Spence, "K'ang-hsi Reign," 147–99; B. Wang, "Boxue Hongci"; and Williams, "Heroes within Bowshot."

3. Lowe, "Preface to the 'Thirty-Six Views of Bishu Shanzhuang,'" 168. Cf. Zou, "*Jing* of Line-Method," 313, "wild and uncultivated."

4. *KXZD*, "Huang," Chinese Text Project, https://ctext.org/dictionary.pl?if=en&id=345187, accessed January 12, 2019.

5. *KXZD*, "Ye," Chinese Text Project, https://ctext.org/dictionary.pl?if=en&id=353540, accessed July 6, 2018; and *Zhouli*, "Qiuguan sikou," Chinese Text Project, http://ctext.org/rites-of-zhou/qiu-guan-si-kou, accessed January 12, 2019.

6. John Dardess describes a tripartite division of "urban," "suburban," and "nemoral." "Nemoral pursuits" include "grazing, hunting, gathering, mining, industry, and the like." See Dardess, "Ming Landscape," 325–26, 335.

7. *KXZD*, "Ye," Chinese Text Project, https://ctext.org/dictionary.pl?if=en&id=353540, accessed January 12, 2019.

8. See, e.g., *Liji*, "Tangong shang," Chinese Text Project, http://ctext.org/liji/tan-gong-i, accessed January 12, 2019.

9. Liu Yuwen, "Kangxi huangdi," 117.

10. Barfield, *Perilous Frontier*, especially 16–19, 186.

11. On the Great Wall, see Waldron, *Great Wall*, especially chapters 1 and 11; and Rojas, *Great Wall*, especially chapter 1. On border zones, see Lattimore, *Inner Asian Frontiers*, 3; and Barfield, *Perilous Frontier*, 12.

12. Wakeman, *Great Enterprise*, 30.

13. *YZBSSZS*, "Yanbo zhishuang," n.p.; translation after Strassberg, in *Thirty-Six Views*, 124.

14. *YZBSSZS*, "Zhijing yundi," n.p.; translation after Strassberg, in *Thirty-Six Views*, 130.

15. Kangxi, "Bishu shanzhuang ji." Cf. *ganshi xiaoyi* or close variations; see e.g., Xu Ling (507–ca. 582), "Eulogy for Emperor Wen of Chen" ("Chen Wendi aice wen"), "Chen Wendi," Chinese Text Project, https://ctext.org/dictionary.pl?if=gb&id=541933, accessed January 12, 2019.

16. See Kangxi and Spence, *Emperor of China*, esp. chap. 1.

17. *YZBSSZS*, "Zhijing yundi," n.p.; translation after Strassberg, in *Thirty-Six Views*, 128.

18. *YZBSSZS*, "Wushu qingliang," n.p.; translation after Strassberg, in *Thirty-Six Views*, 134–35.

19. *YZBSSZS*, "Shuifang yanxiu," n.p.; Strassberg, trans., in *Thirty-Six Views*, 142–43.

20. Kangxi, "Bishu shanzhuang ji"; cf. *Qian Han ji*, "Xiaowen huangdi ji, shang," Chinese Text Project, http://ctext.org/qian-han-ji/xiao-wen-huang-di-ji-shang, accessed July 6, 2018.

21. *YZBSSZS*, "Yanxun Shanguan," n.p.

22. Transcribed in Liu Yuwen, "Bishu shanzhuang," 86, 91n19.

23. *YZBSSZS*, "Zhijing yundi," n.p.; translation after Strassberg, in *Thirty-Six Views*, 128–31.

24. *Thirty-Six Views*, 129.

25. Kangxi, "Purensi beiwen." For a rubbing and transcription, see Feng Chunjiang, *Kangxi yuzhi Bishu shanzhuang beiwen*, 81–109.

26. Elvin, *Retreat of the Elephants*, 36, 52.

27. Kangxi, "Purensi beiwen."

28. *YZBSSZS*, "Zhijing yundi," n.p.; translation after Strassberg, in *Thirty-Six Views*, 130.

29. M. Chang, *Court on Horseback*, 35n4.

30. Especially *Shijing*, e.g., "southern acres" (*nanmu*), a reference to fertile land, and "harvest baskets" (*kuangju*); "Liangsi," Chinese Text Project, http://ctext.org/book-of-poetry/liang-si, accessed July 6, 2018.

31. Chia, "Lifanyuan," 69–70.

32. See Hammers, *Pictures of Tilling and Weaving*; and Lo, "Political Advancement," chapter 2.

33. Kangxi, "Changchunyuan ji"; Zou, trans., in "*Jing* of Line-Method," 307–8.

34. Lo, "Political Advancement," 88–89, 89n43.

35. *YZBSSZS*, "Futian congyue," n.p.

36. *MWZPZZ*, no. 3002.

37. Ibid., no. 3002.

38. Ibid., nos. 3171, 1284.

39. Ibid., nos. 2389, 2479, 2798, 3113; and *BQJZ*, B015064–66.

40. *MWZPZZ*, no. 3002.

41. Clunas, *Fruitful Sites*, chapter 1.

42. *MWZPZZ*, nos. 4149–52.

43. Ibid., no. 4153.

44. Ibid., no. 3142.

45. Kangxi, "Returning by Boat from *Lingzhi* Path on an Embankment to the Clouds in a Light Rain" ("Zhijing yundi xiyu guichuan"), in *Yuzhi wenji*, 4:2455.

46. Transcribed in Liu Yuwen, "Bishu shanzhuang," 87, 91n26.

47. Kangxi, "Purensi beiwen."

48. Chia, "Lifanyuan," 65.

49. Chayet, *Temples de Jehol*, 26–27.

50. *BQJZ*, B013233–B013439.

51. E.g., KX52/5/25, *TBQJZ*, T12149–51; and KX52/9/5, *TBQJZ*, T12348.

52. E.g., KX52/8/25, *TBQJZ*, T13243–45.

53. E.g., *CBS*, chap. 3.2; Forêt, *Mapping Chengde*, 43–49.

54. C. Liu, "Archive of Power," 43–66.

55. Transcribed in Liu Yuwen, "Bishu shanzhuang," 87, 91n26.

56. Zhang Yushu, "Hucong ciyou ji."

57. For the Fangsheng Pavilion and Huilan Rock, see Zang Lihe, *Zhongguo gujin diming*, 469 and 637, respectively.

58. Harrist, *Landscape of Words*.

59. *Thirty-Six Views*, 82–90.

60. Zang Lihe, *Zhongguo gujin diming*, 808. E.g, KX50/6/17, *TQJZ*, T10782–T10792; KX51/6/12, 8/18, *TQJZ*, T11468f, T11552f; KX52/6/11, *TQJZ*, T12219f; KX53/6/8, *BQJZ*, B013960; KX54/5/6, 5/10, *BQJZ*, B014420, B014422; KX55/5/14, 6/9, *BQJZ*, B015116f, B015144f; and KX56/5/6, 6/27, 7/22–23, 9/16, *BQJZ*, B015754f, B015863f, B015920f, B015989f.

61. *YZBSSZS*, "Changhong yinglian," n.p. Zhang Yushu does not specify the Aohan lotuses' color; a hanging scroll by Jiang Tingxi dated 1722 suggests that they were light red. See National Palace Museum, Taipei, Guhua002998.

62. *YZBSSZS*, "Futian congyue," n.p.; translation after Strassberg, in *Thirty-Six Views*, 262.

63. Cf. Rawski, *Last Emperors*, 18.

64. Ibid., 19.

65. Steinhardt, *Chinese Imperial City Planning*, 122–23; Rawski, *Last Emperors*, 295. *Contra* Forêt, *Mapping Chengde*, 21, 325, and chapter 2; and Waley-Cohen, "Commemorating War," 874.

66. Rawski, *Last Emperors*, 21.

67. Stary et al., *On the Tracks*, 1–10.

68. Earlier iterations of the park's wall were more modest. See Shi Lifeng, "Bishu shanzhuang gongqiang," 258.

69. Cf. Hall and Ames, "Cosmological Setting," 175–78.

70. Rojas, *Great Wall*, chapter 1, refers to the Wall as "a unity of gaps."

71. C.-F. Chang, "Disease and Its Impact," 185.

72. Dai Yi, "Bishu shanzhuang he Kang Qian shengshi," 13.

73. Teng, *Taiwan's Imagined Geography*, chapter 5; and Hostetler, *Qing Colonial Enterprise*, 102n4, 138. For background, see Fiskesjö, "On the 'Raw' and 'Cooked' Barbarians." Meserve, "Smallpox among the Tungus People," 93n43, stresses the distinction between the cultural and immunological uses of these terms.

74. Kangxi, "Purensi beiwen."

75. See Beardsley, *Gardens of Revelation*, chapter 3.

CHAPTER 4

## Painting and the Surveyed Site

1. *SQBJ*, 1:222, 453, 507, 628, 676, 761–63, 766; *SQBJXB*, 7:4105–26; Rosenzweig, "Court Painters," especially

chapter 5.2; Sirén, *Chinese Painting: Leading Masters*, 7:372; and Yu Jianhua, *Zhongguo meishujia*, 267.

2. *SQBJ*, 1:676. Seals include three from the Qianlong era, and one each from Jiaqing and Xuantong.

3. Yang Boda, "Leng Mei."

4. E.g., Peng, "Guanyu Bishu shanzhuang." Because of ambiguity around naming at the site, I have opted for the title *View of Rehe*.

5. Jackson, "Word Itself"; and Cosgrove, introduction to *Social Formation*.

6. On transcultural pictorial engagement as a process of experimentation, see Screech, "Meaning of Western Perspective," 59.

7. During the Qianlong period the painting was stored in the Hall of Mental Cultivation (Yangxindian), the emperor's private residence; *SQBJ*, 1:676. Its location and display under Kangxi are not known.

8. Vinograd, *Boundaries*, especially chapter 3.

9. See Zhang Hongxing, *Masterpieces*, 224.

10. For the Palace of Nine Perfections as a remembered landscape, see, e.g., Yuan Jiang (active ca. 1680–ca. 1730), *The Palace of the Nine Perfections*, 1691, Metropolitan Museum of Art, New York, 1982.125a–l. For Kangxi's invocation of it, see *YZBSSZS*, "Yanbo zhishuang" and "Zhijing yundi," n.p., which cite Wei Zheng (580–643), "Jiuchenggong liquan ming," Liu Xiaowei (496–549), "Xingxing Ganquangong ge," and Xiao Gang (503–551), "Naliang."

11. Guo Xi, "The Significance of Landscape," in Bush and Shih, *Early Chinese Texts*, 153.

12. Kangxi, "Bishu shanzhuang ji."

13. Maeda, "*Chieh-hua*," 123–24.

14. H. Liu, "Water Mill."

15. Tsao, "Unraveling the Mystery," especially 166–67.

16. E.g., Hearn, "Art Creates History," 138, 150–51, 173; and Ma, "Picturing Suzhou," especially chapter 2.

17. Hearn, "Document and Portrait," 119–28.

18. *Yongzheng shieryue xingletu juan*, a series of twelve hanging scrolls in the collection of the Palace Museum, Beijing.

19. Chen Yunru, "Shijian de xingzhuang," 115; and Tong Peng, "Jiao Bingzhen shinü tuhui yanjiu," 43.

20. On "Orthodox," see Cahill, "Orthodox Movement," 169–81; and Powers, "Questioning Orthodoxy," 73–74.

21. Hearn, "Art Creates History," 136–39.

22. C. Chang, "Wang Hui," 93–96.

23. Chung, *Drawing Boundaries*, 67; Little et al., *Taoism*, 377; and Vinograd, "Some Landscapes."

24. Chung, *Drawing Boundaries*, 117–19 and chapter 6, notes that immortal realms enjoyed great popularity in eighteenth-century commercial painting but were not a common subject in the court.

25. Hsü, "Imitation and Originality," 306.

26. Spring, "Celebrated Cranes," 8.

27. Also, e.g., Chen Ruyan (active ca. 1340–1380), *Mountains of the Immortals*, Cleveland Museum of Art, 1997.95; and Zhao Boju (ca. 1123–ca. 1162), attr., *Eight Immortals*, Chinese Rare Book Collection, Asian Division, Library of Congress.

28. Beer, *Encyclopedia of Tibetan Symbols*, 55, 82, 96.

29. Based on calligraphy by Zhang Ruoai (1713–1746); Yu Jianhua, *Zhongguo meishujia*, 839; Rosenzweig, "Court Painters," 237; and cf. Yang Boda, "Leng Mei," 113–14.

30. Lin Li-chiang, "Mingdai banhua 'Yangzheng tujie'"; and Murray, "Squaring Connoisseurship." For a variant theme, see Leng Mei's *Spring Dawn at the Han Palace, after Qiu Ying* (Fang Qiu Ying Hangong chunshao tu), dated 1703, National Palace Museum, Taipei, Guhua001717; and Chung, *Drawing Boundaries*, 102–107, on related Qianlong-era compositions.

31. Wang Yuanqi, *Yuchuang manbi*; and Bush, "Long-mo."

32. Cahill, *Compelling Image*, 196.

33. Cf. a similar image of Yongling, the tomb of Nurhaci's ancestors, in the First Historical Archives, Beijing; and Guan Huai (active late eighteenth century), *Daoist Temples at Dragon Tiger Mountain*, in the collection of the Los Angeles County Museum of Art, M.87.269, reproduced in Little et al., *Taoism*, cat. no. 151.

34. Forêt, "Manchu Landscape Enterprise," 328. Forêt does not address Leng Mei in his discussion of geomancy.

35. Ibid., 328.

36. Liu Yuwen, "Kangxi huangdi," 118.

37. Kangxi, "Bishu shanzhuang ji."

38. *YZBSSZS*, "Zhijing yundi," n.p.; translation after Strassberg, in *Thirty-Six Views*, 128.

39. Ledderose, "Earthly Paradise," 165–72; and Rawson, "Eternal Palaces," 18–19, 23–24.

40. Not all such garden ponds included three islands. See Fu and Steinhardt, *Chinese Architecture*, 100–104, 205–207; Steinhardt, *Chinese Imperial City Planning*, 155, 172; and McMullen, "Recollection."

41. Liscomb, "Eight Views," 140–41.

42. Ibid., 130.

43. Later Qing imperial gardens also followed this model. On immortal's palaces in the Garden of Perfect Brightness, see Chung, *Drawing Boundaries*, 117–19 and plate 6; for Kunming Lake in Pure Ripple Garden, see Fu and Steinhardt, *Chinese Architecture*, 283–88.

44. Nelson, "On Through to the Beyond," 26–28.

45. Also *Mount Shixie* (Shixieshan tu; 1663), National Palace Museum, Taipei, Guhua000639. See also Cahill, *Compelling Image*, chapter 1; and Aoki and Kobayashi, "*Chūgoku no yōfūga ten*," chapter 2.

46. See Fong and Watt, *Possessing the Past*, 124–30; and Silbergeld, *Chinese Painting Style*, 37–38 and figs. 19, 21.

47. *Contra* Chung, *Drawing Boundaries*, 87.

48. For measurements of the painting, see Yang Boda, "Leng Mei ji qi 'Bishu shanzhuang tu,'" 115, who measures the current silk mounting of the painting—which, if not original, can be assumed to be roughly equal to whatever mounting it replaced—at approximately 68.1 centimeters above and below the painting. Average adult male height estimated to be 165 to 177 cm. Setting the bottom of the painting 68.1 centimeters above the floor, 165 centimeters marks a point near the top of Ruyi Island, while 177 centimeters is just below the northern shore of the lakes. A number of sources (e.g., Bell, *Travels from St. Petersburg*, 214) state that Kangxi was somewhat taller than many in court.

49. Corsi, "Late Baroque Painting," 103–22; and Kleutghen, *Imperial Illusions*, 47–52, 68–69.

50. Tong Peng, "Jiao Bingzhen shinü," 115–16 and fig. 3-60.

51. Ibid., 21 and fig. 1-7-2; and Corsi, "Late Baroque Painting," 119.

52. Regarding images in Europe, see, e.g., ceilings by Andrea Pozzo, S. J., in the Church of Saint Ignatius of Loyola at Campus Martius, Rome, and the Jesuit Church, Vienna, both of which mark the specific location of the ideal viewing point on the floor. On the use of accelerated perspective under Qianlong, see Musillo, *Shining Inheritance*, 109–10; and Kleutghen, *Imperial Illusions*, 228–41.

53. Kangxi, "Bishu shanzhuang ji."

54. Hsu, "Qin Maps," 96–97; and Needham and Wang, *Mathematics and the Sciences*, 538–40.

55. Needham and Wang, *Mathematics and the Sciences*, 25, 30–31, 97.

56. Golvers, "Unnoticed Letter"; and Cams, "Not Just a Jesuit Atlas," 191–92.

57. Cams, *Companions in Geography*.

58. Hu Jing, *Guochao yuanhua lu*, 1797; and Jami, *Emperor's New Mathematics*, 242.

59. Golvers, *Astronomia Europaea*, 298; Kleutghen, *Imperial Illusions*, 44; and Musillo, *Shining Inheritance*, 110, 112.

60. Hu Jing, *Guochao yuanhua lu*, 1797, ascribes this view to the Kangxi emperor. Golvers, *Astronomia Europaea*, 21, 101; and Jami, *Emperor's New Mathematics*, 5, 71–2, 245–53.

61. Hummel, *Eminent Chinese*, 64–66, 473–75.

62. Liu Yuwen, "Bishu shanzhuang chujian shijian," 86; and Jami, *Emperor's New Mathematics*, 107, 116.

63. Jami, *Emperor's New Mathematics*, 72; and Musillo, *Shining Inheritance*, 110.

64. Liu Yuwen, "Bishu shanzhuang chujian shijian," 87.

65. Artists whose practice explicitly reflected real-world observation include, e.g., Wang Lü (1332–1391) and Huang Xiangjian (1609–1673); see Liscomb, *Learning from Mount Hua*; and Kindall, *Geo-Narratives of a Filial Son*.

66. The viewing pavilion is located at 40.955311°, 117.933394°, which are the coordinates used for viewshed projection in the discussion that follows.

67. Employing a digital elevation model (DEM), which models the earth's topography, a viewshed analysis shows what is and is not visible from a specified vantage point. Note that DEMs, and therefore viewshed analyses, do not capture foliage and are only as precise as their resolution. In the model used here, each pixel is 10 × 10 meters square. A pixel registers as visible if the center point of the pixel can be seen from the designated viewpoint.

68. Lindgren, "Land Surveys," 482–89.

69. Nuti, "Mapping Places," 90.

70. Ballon and Friedman, "Portraying the City," 687–96; see also Harley, "Maps, Knowledge, and Power"; and Turnbull, *Maps Are Territories*.

71. Cahill, *Compelling Image*, 16–22; and Cahill, "Late Ming Landscape Albums."

72. E.g., *Ten Scenes of Yue*, Collection of the Yamato Bunkakan, Nara; see Cahill, *Compelling Image*, 18; and Mungello, *Great Encounter*, 75.

73. Ballon and Friedman, "Portraying the City," 690; Nuti, "Perspective Plan," 114; and Nuti, "Mapping Places," 95.

74. Originally published in Munster, *Cosmographia*; see McLean, *Cosmographia*, 177.

75. Nuti, "Perspective Plan," 105–28; and Ballon and Friedman, "Portraying the City," 690–96.

76. A variation sees the city more markedly tilted and with less perspectival diminution; see, e.g, *View of Damascus*, in Braun and Hogenberg, *Civitates Orbis Terrarum*, vol. 2, f. 55 (1575), which also strongly resembles *View of Rehe*.

77. Nuti, "Mapping Places," 95; and Nuti, "Perspective Plan," 121.

78. Lindgren, "Land Surveys," 495–500.

79. Ballon and Friedman, "Portraying the City," 690; and Nuti, "Perspective Plan," 120–21.

80. Ballon and Friedman, "Portraying the City," 682; and Grafton, *Leon Battista Alberti*, 241–48.

81. Aoki Shigeru and Kobayashi Hiromitsu, *"Chūgoku no yōfūga ten,"* 128–29, have also noted this comparison, though without discussion.

82. Jami, *Emperor's New Mathematics*, 194.

83. Cams, "Converging Interests," 60–61; and Golvers, *Astronomia Europaea*, 115–16.

84. On being "produced at imperial command," see, e.g., Liu Lu, *Qinggong xiyang yiqi*, nos. 15, 46, 47, 97–99. On education in the use of these instruments, see Cams, "Converging Interests," 58–60; and Jami, *Emperor's New Mathematics*, 194.

85. Nuti, "Perspective Plan," 120.

86. Kleutghen, *Imperial Illusions*, 47.

87. Ibid., 47–49.

88. Ibid., chapter 6.

89. Musillo, *Shining Inheritance*, 100; Corsi, "Envisioning Perspective"; and Kleutghen, *Imperial Illusions*, chapter 2.

90. Regarding the 1702–23 edition, see Lazarist Mission, *Catalogue of the Pei-t'ang Library*, nos. 2511–2512. *Catalogue of the Pei-t'ang Library* records at least nineteen such treatises published before 1700; although it is not possible to date the precise arrival of these volumes, most, if not all, would have come with missionaries in the mid- to late Kangxi period. For a list and further discussion, see H. Chen, "Chinese Perception," 111–14. Also see Golvers, *Astronomia Europaea*, 115.

91. E.g., Cerceau, *Leçons de perspective positive*, illustration for lesson 3.

92. Musillo, *Shining Inheritance*, 92.

93. Nian Xiyao, *Shixue*, 20r; and Kleutghen, *Imperial Illusions*, 73–74.

94. February 19, 1699, "Registre des livres de figures et estampes qui ont esté distribuées suivant les orders de Monseigr le Marquis de Louvois, depuis l'inventaire fait avec Mr l'abbe Varés au mois d'aoust 1684," Bibliothèque Nationale de France, Paris, Est. Res. Ye 144. My gratitude to Robert Wellington for sharing this inventory with me.

95. Lazarist Mission, *Catalogue of the Pei-t'ang Library*, nos. 284, 667, 705, and 706.

96. In the volume *Veües de maison royales et de villes conquises*

par Louis XIV; and Lazarist Mission, *Catalogue of the Pei-t'ang Library*, no. 705.

97. See also Juneja, "Circulation and Beyond," 68.

98. Cams, "Not Just a Jesuit Atlas," 198; and Jami, *Emperor's New Mathematics*, 3–4.

CHAPTER 5

## Paper Gardens

1. Roberts, "Reversing American Art."

2. Hearn, ed., *Landscapes Clear and Radiant*; Berger, *Empire of Emptiness*; Kleutghen, *Imperial Illusions*; Musillo, *Shining Inheritance*; and others tend to address Kangxi pictoriality as precursor to, rather than foundation for, Qianlong art, the primary focus of their studies.

3. Neer, "Connoisseurship."

4. E.g., Bentley, "Authenticity and the Expanding Market"; Wright, "'Luoxuan biangu jianpu'"; and Murray, "Didactic Picturebooks." For an interesting comparative case from Europe, see Wellington, "Cartographic Origins."

5. Ripa, *Giornale*, 2:41.

6. E.g., Ripa, *Storia* and *Memoirs of Father Ripa*.

7. "Neiwufu siku jiayi chen Shen Yu gonghua," reading *hua*, generally, "to paint," instead as "to delineate," "to plan," or "to represent." YZBSSZS, "Shuiliu yunzai," lower left corner; KXZD, "Hua," http://ctext.org/dictionary.pl?if=en&id=336782, accessed January 19, 2019.

8. Supervisor of the Household of the Heir Apparent (*zhanshifu zhanshi*), a post associated with appointment to the Hanlin Academy. Huang Weiling, "Huatu liuyu renkan," 21; and Hucker, *Dictionary*, nos. 79–80.

9. For Shen Yinghui, see Hu Jing, *Guochao yuanhua lu*, 1846; Pelliot, "Les 'Conquêtes,'" 239–40; and Finlay, "'40 Views,'" 131–32. On Dai Tianrui, see Bussotti, "'Dessins' et 'Desseins,'" 259–60; Gugong bowuyuan, *Shengshi wenzhi*, 254–55; Gugong bowuyuan, *Tianlu zhencang*, 112; and Yu Jianhua, *Zhongguo meishujia*, 1448.

10. On Zhang Kui and the second, unknown Qing artist, see *Thirty-Six Views*, 104–16. For Zhu Gui and Mei Yufeng, see YZBSSZS, "Shuiliu yunzai."

11. MWZPZZ, no. 1993, dated KX51/7/22 (August 23, 1712), is the first extant memorial on the subject of the printing of *Imperial Poems*. One version of Shen Yu's designs would have been destroyed during the block cutting, begging the question of whether Shen ever produced a set that stood as paintings in their own right. In a letter now in the New York Public Library (MEXE+) that accompanied two sets of the copperplate prints sent to Italy, Ripa states that he is enclosing one of the original paintings upon which the prints were based. Often assumed to refer to Shen Yu's paintings, Ripa does not name the artist and no evidence of such a painting is known. Monnet, *Chine, l'Empire du trait*, cat. 119, mistakenly suggests that Shen Yu's paintings may be in the collection of the National Palace Museum, Taipei; also see Finlay, "'40 Views,'" 131n318.

12. Hummel, *Eminent Chinese*, 330; Lu Fusheng, *Zhongguo shuhua quanshu*, 10:435, and 11:333, 749; Rosenzweig,

"Court Painters," 290–91; Sirén, *Chinese Painting*, 7:396; and Yu Jianhua, *Zhongguo meishujia*, 432.

13. Specifically, Warehouseman in the Imperial Storehouse (*neiwufu siku*; Hucker, *Dictionary*, no. 5674). Zhang Geng, *Guochao huazheng lu*, 58; and Hu Jing, *Guochao yuanhua lu*, 1821.

14. For recorded works by Shen Yu, see SQBJ 1:454, 2:761; Lu Fusheng, *Zhongguo shuhua quanshu*, 11:749; and Ferguson, *Lidai zhulu huamu*, 162a. The album described at SQBJ 2:761 survives in the collection of the National Palace Museum, Taipei, Guhua001279. For additional attributions, see Zhu Chengru, *Qingshi tudian*, 4:306–307; and *Nanju meiga-en*, vol. 23 (also Sirén, *Chinese Painting*, 7:396). See also Whiteman, "Creating the Kangxi Landscape," 142–62.

15. Yu Jianhua, *Zhongguo meishujia*, 432.

16. On *Images of Tilling and Weaving* in the Kangxi court, see P. Hu, "Idealized Labor"; and Lo, "Political Advancement," chapter 2.

17. For instance, Wang Gai's *Mustard Seed Garden Painting Manual* included pictorial descriptions of various painters' styles, ranging from individual motifs (e.g., rock or tree) to assemblage, and finally whole compositions after known paintings; see, e.g., fig. 5.7.

18. For a more substantial discussion of the copperplate engravings, see *Thirty-Six Views*, 73–119.

19. On Ripa's printmaking experience, see Ripa, *Giornale*, 2:29, 2:38.

20. For more, see *Thirty-Six Views*, 104–16.

21. Zheng Wei, "Wang Yuanqi nianbiao"; and S. Wang, "Wang Yuanqi," 90–91.

22. Fong, "Wang Hui, Wang Yüan-ch'i, and Wu Li," 181; Hay, "Kangxi Emperor's Brush-Traces," 315; Yang Boda, "Tung Ch'i-ch'ang," 15–3; for Gao Shiqi, see Hummel, *Eminent Chinese*, 413–15.

23. For the modern origins of the "Four Wangs" (si Wang; Wang Shimin, Wang Jian [1598–1677], Wang Hui, and Wang Yuanqi) as moribund and representative of the decline of late imperial culture, see Chen Duxiu, "Meishu geming"; for more on the formation of modern criticism of Qing Orthodoxy, see J. Chou, "In Defense of Qing Orthodoxy."

24. Cheng Muheng, *Loudong qijiu zhuan*, j. 5; and Zheng Wei, "Wang Yuanqi nianbiao," 107. Referred to only as the "inner garden" (*neiyuan*), it was most likely the private portion of the Garden of Joyful Spring.

25. S. Wang, "Wang Yuanqi," 219, 226–27.

26. Ibid., 243–48; and Yang Boda, "Tung Ch'i-ch'ang," 15–6.

27. Cheng Muheng, *Loudong qijiu zhuan*, j. 5; Zheng Wei, "Wang Yuanqi nianbiao," 107; and Huang Weiling, "Huatu liuyu renkan," 88.

28. For direct students of Wang Yuanqi among court painters, see Hu Jing, *Guochao yuanhua lu*, 1800, "Tang Dai."

29. Regarding gifts, see MWZPZZ, nos. 1133, 1135, 1146, pp. 517–18, 523; e.g., Palace Museum, Beijing, "Wang Yuanqi, 'Landscape,' fan," www.dpm.org.cn/collection/paint/234118.html, accessed January 19, 2019. For jointly produced fans, see Zheng Wei, "Wang Yuanqi nianbiao," 115–16; e.g., Palace Museum, Beijing, Gu7020.

30. E.g., Jiang Tingxi, Palace Museum, Beijing, Gu7810, Gu7811, and Song Junye, Gu7164.
31. For Jiang Tingxi, see *YZBSSZS*, back matter, n.p.; and Hummel, *Eminent Chinese*, 142–43. For Song Junye, see Hummel, *Eminent Chinese*, 844; and Hearn, ed., *Landscapes Clear and Radiant*, 118–19, 133.
32. The seal appears to have been granted between late 1699 and late 1701. Zhang Geng, *Guochao huazheng lu*, 84; and Hearn, *Cultivated Landscapes*, 107, 159n109.
33. E.g., Zheng Wei, "Wang Yuanqi nianbiao," 91, 96, 102, 106–7, 112–13.
34. The *SQBJ* lists Wang's paintings as 8 *cun* 3 *fen* × 9 *cun* 3 *fen*, where 10 *fen* = 1 *cun*. A conversion rate of 3.2 *cun* = 1 centimeter is calculated by averaging the known measurements of eight extant works by Wang against their listed measurements in the *SQBJ*. The size of the image field for the copperplates is based on the inscribed frame (the plates themselves were substantially larger). Although the woodblocks' vertical dimensions are unknown because the compositions lack clear upper and lower boundaries, the side edges are clearly discernible and correspond in width to the other versions.
35. Now in the Bibliothèque nationale de France, Hd 90, and the Collection of Raymond Yip, Hong Kong, reproduced as Kangxi emperor, Shen Yu, and Wang Cengqi, *Tongban Bishu shanzhuang sanshiliu jing shitu*.
36. *SQBJ*, 2:786. Cf. Giuseppe Castiglione, *One Hundred Horses*, 1723–25, Metropolitan Museum of Art, 1991.134, which is a draft of a handscroll in color on silk, dated 1728, now in the National Palace Museum, Taipei, Guhua000916N.
37. Although the emperor commissioned paintings by Jiao Bingzhen in 1696, Wang Bomin, *Zhongguo banhua shi*, 144, has argued that the prints may not have been produced until 1712. This hypothesis is not widely accepted, but comparison with contemporary images suggests the question merits further research.
38. Hummel, *Eminent Chinese*, 845. The Qianlong copy is now in the Palace Museum, Beijing.
39. Memorial dated KX54/闰5/3, in Wang Yuanqi et al., *Wanshou shengdian chuji*, 40:6, quoted in part in S. Wang, "Wang Yuanqi," 242–43.
40. Rosenzweig, "Court Painters," 290.
41. *SQBJ*, 2:745.
42. Cf. Baxandall, "Period Eye."
43. Based on the combination of titles recorded in Wang Yuanqi's signature on the painting, which he held together only briefly in 1708.
44. Harrist, *Painting and Private Life*, 68–78.
45. On the course of transmission, see Wang Yuanqi's inscription on the painting, translated by Marilyn and Shen Fu in Whitfield and Fong, *In Pursuit of Antiquity*, 204.
46. Cf. Liu Yuzhen, "Wang Yuanqi," 118; and Fong, "Wang Hui, Wang Yüan-ch'i, and Wu Li," 183–84, who compares the style to that of Paul Cézanne (1839–1906).
47. Translated by Marilyn and Shen Fu, in Whitfield and Fong, *In Pursuit of Antiquity*, 203–204.
48. Ibid.
49. Park, *Art by the Book*.
50. On the copies and attributed versions, see Harrist, *Painting and Private Life*, 79–81. Regarding the one believed by Qianlong to be the original, see *SQBJXB*, 2:1493–96.
51. An earlier version of the album, now lost, pictures Wang seated in Almost-a-Villa Hall but with a different composition; preserved in Wen and Kerby, *Old Chinese Garden*.
52. Liu Yuzhen, "Wang Yuanqi," 131, suggests Wang may have also looked to Dong Qichang's treatment of the subject.
53. "Xie Youcheng shanzhuangtu ni zhi"; see Wang Yuanqi, "Caotang" colophon.
54. Liu Yuzhen, "Wang Yuanqi," 119–20.
55. Cahill, "Wang Yüan-ch'i and Tao-chi," especially 190–96.
56. E.g., *To See the Great within the Small* (*Xiaozhong xianda*, after 1627), National Palace Musuem, Taipei, an album purportedly commissioned by Wang Shimin; see Fong, "Wang Hui and Repossessing the Past," 13–21.
57. Imperial albums include a twelve-leaf album now in the Palace Museum, Beijing, reproduced in Zhongguo gudai shuhua jiandingzu, ed., *Zhongguo huihua quanji*, 27:42–47; and an eight-leaf album in Taipei, reproduced in Guoli gugong bowuyuan, *Gugong shuhua tulu*, 24:181–82.
58. On artistic references for early Qing Orthodox painters, see Liu Yuzhen, "Wang Yuanqi," 124.
59. Chen Lüsheng and Li Laoshi, *Wang Yuanqi huaji*, 2:385; and Yang Jianfeng, *Wang Yuanqi*, 2:351.
60. For known Qianlong-era paintings of *Imperial Poems*, see *Thirty-Six Views*, 95n34. An additional album by Qian Weicheng in the Bishu Shanzhuang Museum is partially reproduced in Chengdeshi wenwuju, *Zisai zhencui*, 100–103.
61. Zhang Geng, *Guochao huazheng lu*, 155–56; and Hu Jing, *Guochao yuanhua lu*, 1800.
62. Given that *Precious Records of the Stone Moat* was published in 1745.
63. E.g., Yang Jianfeng, *Wang Yuanqi*, 1:24–25, 2:192, 211, 222, 227, 281, 298, 303, 361; Chen Lüsheng and Li Laoshi, *Wang Yuanqi huaji*, 1:64–65, 148–49; 2:300, 305.
64. Also Yang Jianfeng, *Wang Yuanqi*, 2:302, 345.
65. Yang Jianfeng, *Wang Yuanqi*, 1:32 (Zhao Mengfu), 2:336 (Jing Guan); *Wang Yuanqi huaji*, 1:142–43 (Wang Meng). Also *Jiurutu* (1696), a handscroll in the Liaoning Provincial Museum, nominally after Huang Gongwang. Yang Jianfeng, *Wang Yuanqi*, 1:20–21, 36–37. Also a hanging scroll, dated 1699; see Yang Jianfeng, *Wang Yuanqi*, 1:107.
66. Yang Jianfeng, *Wang Yuanqi*, 1:16–17 (Wang Meng), 28 (Fan Kuan), 64–65 (Wu Zhen); and Chen Lüsheng and Li Laoshi, *Wang Yuanqi huaji*, 1:144–45 (Juran).
67. Permission difficulties prevented the publication of the Qian Weicheng leaf.
68. Hearn, "'Kangxi Southern Inspection Tour,'" 72–174; and Hearn, "Pictorial Maps."
69. Vinograd, "Family Properties."
70. E. Wang, "Perceptions of Change," 83.
71. E.g., *MWZPZZ*, nos. 1998, 2161, 2200, 2228.
72. *MWZPZZ*, no. 2011.
73. *MWZPZZ*, nos. 2001, 2218.
74. *MWZPZZ*, no. 2001; in this memorial the print run of

*Imperially Selected Tang Poems* (Yuxuan Tangshi, 1712)—one thousand copies—is expressly cited in contrast to just two hundred sets of the Chinese *Imperial Poems*.

75. Late June to mid-September; *MWZPZZ*, nos. 2154, 2157, 2161, 2165, 2186, 2200, 2204, 2206, 2211, 2217, 2218, 2228, 2229, 2230, 2231, 2235, 2245.

76. Weng Lianxi, *Qingdai neifu keshu tulu*, 15–17.

77. On circulation and gifting of hand-calligraphed copies of "Record of the Mountain Estate to Escape the Heat," see *BQJZ*, B103813–14; and Zhongguo diyi lishi dang'an guan, *Kangxi chao Hanwen zhupi zhouzhe*, 1264–65.

78. Suggesting essentially the inverse of the estrangement of labor described in Lukács, "Reification."

79. The nine scenes are 1, 12, 15, 18, 20, 27, 29, 30, and 36. See, e.g., *Maison de plaisance de l'empereur de la Chine*, Dresden Kupferstich-Kabinett Ca 139.

80. *Thirty-Six Views*, 104–19.

81. Roberts, "Reversing American Art."

82. Ripa, *Giornale*, 2:29, 2:38.

83. Wellington, "Lines of Sight."

84. My thanks to Chen Yunru for this observation.

85. E.g., National Palace Museum, Taipei Gudian029529; Inner Mongolia Library, described in Weng Lianxi, "Xin faxian."

86. On the imperial silk covering the set in the Collection of Raymond Yip, see Hsu Yuan-ting, pers. comm., January 25, 2018. For the Paris set, see chap. 5, note 35, above.

87. Roberts, "Reversing American Art."

CHAPTER 6

Touring the Rear Park

1. A key function of nonimperial gardens in both China and Europe; cf. Clunas, *Fruitful Sites*, and Cosgrove, *Social Formation and Symbolic Landscape*.

2. West, "Spectacle, Ritual," 291.

3. Clunas, *Fruitful Sites*, 95.

4. E.g., *chaojin*; see Chia, "Lifanyuan," 64–66, and chapter 3 in this book.

5. Song emperors also used their gardens to host banquets for senior officials and imperial kinsmen; see Chen Yunru, "At the Emperor's Invitation," 60.

6. See Hall and Ames's "rhetorical landscape," defined in part as "a world of its own, in the most profound sense of the term, owning the same ontological status as the 'natural' environs." Hall and Ames, "Cosmological Setting," 179.

7. West, "Spectacle, Ritual," 304–309.

8. C. Wang, "Material Culture," chapter 4; and Li and Knight, *Power and Glory*, cat. no. 115.

9. West, "Spectacle, Ritual," 304.

10. For examples of documentary painting, see Nie Chongzhen, *Qingdai gonging huihua*, cat. nos. 43–44, 54, 57, 82–83. On *xingletu*, see Lo, "Political Advancement."

11. P. Wu, *Confucian's Progress*, 117; and Clunas, *Fruitful Sites*, 139, 220n8. For a brief history of the "garden record," see Clunas, *Fruitful Sites*, 137–39.

12. H. Zou, "Jing: A Phenomenological Perspective."

13. For more, see *Thirty-Six Views*, 78–85.

14. H. Lee, *Exquisite Moments*; E. Wang, "Rhetorics of Book Illustrations"; and Liscomb, "Eight Views."

15. On the investment of static representations with qualities of lived experience and the physical landscape, or in Certeauan terms, the transformation of "place" to "space," see de Certeau, "Spatial Stories." Cf. Clunas, *Fruitful Sites*, 140–41.

16. For a related example of late Ming vanity publishing, see Wang Tingna (ca. 1569–after 1609), *Garden Views of Encircling Jade Hall* (Huancui tang yuanjingtu), reproduced in Li Cheng, Huang Yingzu, and Qian Gong, *Huancuitang yuanjingtu*; on Wang Tingna, see Lin Li-chiang, "Huizhou banhua," and "Making of Images." For a translation of Qi Biaojia's preface to *Footnotes to Allegory Mountain*, see Campbell, "Qi Biaojia's 'Footnotes.'"

17. On Qi's obsession with garden building, see Handlin-Smith, "Gardens."

18. Qi Biaojia, *Yushanzhu*, 1:4b; and Campbell, "Qi Biaojia's 'Footnotes,'" 247.

19. The 1533 album, now lost, is reproduced in Wen and Kerby, *Old Chinese Garden*. Also see Clunas, *Fruitful Sites*, especially 23–59, and Lu, "Deciphering."

20. Whitfield and Fong, *In Pursuit of Antiquity*, 66.

21. Reproduced in *Thirty-Six Views*, 92.

22. Clunas, *Fruitful Sites*, 148.

23. *Contra* ibid., 148–50.

24. De Certeau, "Spatial Stories," 117; *contra* Clunas, *Fruitful Sites*, 148.

25. Cf. "rhetorical landscapes," in Hall and Ames, "Cosmological Setting."

26. De Certeau, "Spatial Stories," 117–18. "Spatializing" here refers to the Certeauan transformation of "place" to "space."

27. Lu, "Deciphering," argues that together text and image in the 1533 album provide sufficient spatial information to allow a reconstruction of the garden.

28. Whitfield, in Whitfield and Fong, *In Pursuit of Antiquity*, 67–68.

29. Campbell, "Qi Biaojia's 'Footnotes,'" 247.

30. Ibid., 252–53.

31. Qi Biaojia, *Yushanzhu*, 1:4b–14a.

32. Campbell, "Qi Biaojia's 'Footnotes,'" 248.

33. Ibid., 257.

34. Ibid., 256.

35. Ibid., 255.

36. A "Record of the Garden to Rest In" has recently been discovered, but questions of its relationship to Zhang Hong's album remain open and are beyond the scope of this project; see Gao Juhan [James Cahill], Huang Xiao, and Liu Shanshan, *Buxiu de linquan*, 48–51. The album is considered here as it has long been understood, as a pictorial work without accompanying texts. Garden portraits without text are not unprecedented, and related texts often circulated separately. For instance, *Garden Views of Encircling Jade Hall*, which depicted Wang Tingna's Shaded Seat Garden (Zuoyinyuan), did not include any text. Independent associated texts include *Poems on the Views in*

*Shaded Seat Garden* (Zuoyinyuan jingshi) and *One Hundred Twenty Songs on Shaded Seat Garden* (Zuoyinyuan yibaiershi yong); see Li Cheng, Huang Yingzu, and Qian Gong, "Guanyu 'Huancuitang yuanjing tu,'" n.p.

37. For further discussion of Zhang Hong and this album, see Cahill, *Distant Mountains*, 39–59; Gao Juhan [Cahill], Huang Xiao, and Liu Shanshan, *Buxiu de linquan*, 15–47; and Li, Cahill, and Zhang, *Paintings of Zhi Garden*.

38. Barrell, "Public Prospect," cited in Clunas, *Fruitful Sites*, 221n27. For discussion of a related view of West Lake by the Southern Song court painter Li Song (ca. 1190–1260), see H. Lee, *Exquisite Moments*, 20–29, fig. 3.

39. "Complete View of the Garden to Rest In" thus serves as a Certeauean "map" for the entire album in that it describes a "place" through "*seeing* (the knowledge of an order of places) . . . , [by] present[ing] a *tableau*." The subsequent leaves constitute a "tour," a presentation of "space" predicated on "*going* (spatializing actions) . . . organiz[ing] *movements*" (emphasis in original). De Certeau, "Spatial Stories," 119.

40. Regarding uncertainty around the original order of the album, it was divided in the 1950s and until recently was held in four separate collections; Cahill, "Exploring the Zhi Garden." See Gao Juhan [James Cahill], Huang Xiao, and Liu Shanshan, *Buxiu de linquan*, 16–17; and Li, Cahill, and Zhang, *Paintings of Zhi Garden*, 8, for slightly variant orders of the leaves. Regarding the use of the entrance as start and end point for accounts of gardens, see Duncan Campbell and Alison Hardie, eds., *Dumbarton Oaks Anthology of Chinese Garden Literature*, forthcoming.

41. Li, Cahill, and Zhang, *Paintings of Zhi Garden*, also posits a seasonal order.

42. A small red-robed figure, presumably the owner, appears in several other leaves, although he is not the focus as in the leaf that follows fig. 6.11. Red robes often designated the owner or host in garden portraits; see, e.g., Du Qiong (ca. 1396–1474), *Befriending the Pines* (Yousong tu), Palace Museum, Beijing, and versions of *Elegant Gathering in the Apricot Garden* (Xingyuan yaji tu) by and after Xie Huan (1377–1452), now in the Zhenjiang Municipal Museum and the Metropolitan Museum of Art (1989.141.3), respectively.

43. Corresponding to Certeauan definitions of "tour" and "map," respectively; see de Certeau, "Spatial Stories," 118–22.

44. For a map of the *Forty Scenes*, see Zou, "*Jing* of Line-Method," fig. 4a.

45. *Thirty-Six Views*, chapter 1; and Strassberg, "Transmitting."

46. *CBS*, 29–31, 116–25.

47. Leaves 5, 6 and 7 in Li, Cahill, and Zhang, *Paintings of Zhi Garden*. Gao Juhan [James Cahill], Huang Xiao, and Liu Shanshan, *Buxiu de linquan*, orders the three leaves differently.

48. Strassberg, "Imperial Duet," argues that some scenes may constitute pairs alternating between the park's core and periphery.

49. Also see an undated handscroll reproduced in Yang Jian-feng, *Wang Yuanqi*, 2:346–47, and the transitions in *Nine As-You-Likes* (Jiurutu), reproduced in ibid., 1:88–95.

50. See note 16, in these chapter notes.

51. Also see "Untrammeled Thoughts by the Hao and Pu River" and "The Entire Sky Is Exuberant" (scenes 17, 18).

52. Cf. "Scent of Lotuses by a Winding Stream" and "Fragrance Grows Purer in the Distance" (scenes 15, 23).

53. *YZBSSZS*, "Xiling chenxia," "Chuifeng luozhao," n.p.

54. *YZBSSZS*, "Jinlian yingri," "Yuanjin quansheng," n.p.

55. *YZBSSZS*, "Futian congyue," n.p.

56. *YZBSSZS*, "Shuiliu yunzai," n.p.

57. For more, see *Thirty-Six Views*, chapter 1.

58. H. Lee, *Exquisite Moments*, especially 31–33 and 57n50; and *Thirty-Six Views*, 83–88.

59. For the itinerary as cultural mnemonic and touchstone, see Halbwachs, "Legendary Topography."

60. Zhang Dai, "West Lake at the Midsummer Festival," translated in Strassberg, *Inscribed Landscapes*, 342–45.

61. Cf. Mitchell, *Landscape and Power*, 4, who argues that foreground screening elements reinforce the pictoriality of the picture, which by extension affirms the spectatorial position of the viewer.

62. Ibid., 122–23.

63. Reading the scene as a Certeauean "space," one may imagine the prenarrative site as a "place." Following de Certeau, "Spatial Stories," 117, "the law of the 'proper' rules in the place: the elements taken into consideration are *beside* one another, each situated in its own 'proper' and distinct location, a location it defines. *A place is thus an instantaneous configuration of positions*" (emphasis added).

CONCLUSION

## The Landscape of the Emperor

*Epigraph:* "Jin yi zhongwai wubie yi," in Kangxi, "Purensi beiwen."

1. Kangxi, "Purensi beiwen."

2. Kangxi, "Bishu shanzhuang ji."

3. *Jinshu*, j. 86, "Jiang Tianxi zhuan"; see *Chinese Text Project*, "Quan Jinwen, j. 154," https://ctext.org/wiki.pl?if=gb&chapter=181079, accessed January 21, 2019. This text also appears twice in *GJTSJC*, once in the *Book of Jin* (Jinshu) and a second time in a group of quotations connecting sage rule and virtuous behavior to gardens and nature.

4. *Zhouyi*, "Xici" shang, 9.2, *Chinese Text Project*, http://ctext.org/dictionary.pl?if=en&id=46929, accessed May 28, 2017.

5. Owen, *Readings*, 256.

6. Ibid., 257. For reception of Liu Xie's interpretation of these terms, see P. Yu, *Reading of Imagery*, chapter 2.

7. P. Yu, *Reading of Imagery*, 61.

8. Ibid., 62.

9. My thanks to Maria Evangelatou, who first proposed this reading.

10. Yan Yong, personal communication, December 2012.

11. Mitchell, "Imperial Landscape," 17, describes landscapes as "tailor-made for the discourse of imperialism, which

conceives itself precisely (and simultaneously) as an expansion of landscape understood as an inevitable, progressive development in history, an expansion of 'culture' and 'civilization' into a 'natural' space in a progress that is itself narrated as 'natural.'"

12. Brief discussions of this work can be found in Tong Peng, "Jiao Bingzhen," 19–21; and Wang Qi, "Kangxi huangdi xiaoxianghua," 50–51.

13. Kangxi, "Purensi beiwen."

14. See Clunas, "Qing Encounters."

15. On the work of art as a solution to a technical or conceptual problem, see Kubler, *Shape of Time*, chapter 2.

16. Ibid., 16–30.

# Bibliography

ABBREVIATIONS

| | |
|---|---|
| *BQJZ* | Zou Ailian, ed., *Qingdai qijuzhu ce, Kangxi chao* |
| *CBS* | Chen Baosen, *Chengde Bishu shanzhuang Waibamiao* |
| *GJTSJC* | Chen Menglei, Jiang Tingxi, et al., eds., *Qinding gujin tushu jicheng* |
| *KXZD* | Zhang Yushu, Chen Tingjing, et al., eds., *Kangxi zidian* |
| *MWZPZZ* | Zhongguo diyi lishi dang'an guan, ed., *Kangxi chao Manwen zhupi zouzhe quanyi* |
| *SQBJ* | Guoli gugong bowuyuan, eds., *Midian zhulin Shiqu baoji* |
| *SQBJXB* | Guoli gugong bowuyuan, eds., *Midian zhulin Shiqu baoji xubian* |
| *Thirty-Six Views* | Strassberg and Whiteman, *Thirty-Six Views: The Kangxi Emperor's Mountain Estate in Poetry and Prints* |
| *TQJZ* | Guoli gugong bowuyuan, eds., *Qingdai qijuzhu ce, Kangxi chao* |
| *YZBSSZS* | Kangxi et al., *Yuzhi Bishu shanzhuang shi* |

SOURCES

Aoki Shigeru and Kobayashi Hiromitsu. *"Chūgoku no yōfūga" ten: Minmatsu kara Shin jidai no kaiga, hanga, sashiebon.* Machida-shi: Machida Shiritsu Kokusai Hanga Bijitsukan, 1995.

Appadurai, Arjun. "Introduction: Commodities and the Politics of Value." In *The Social Life of Things: Commodities in Cultural Perspective*, edited by Arjun Appadurai, 3–63. Cambridge, UK: Cambridge University Press, 1997.

Babaie, Sussan. *Isfahan and Its Palaces: Statecraft, Shi'ism and the Architecture of Conviviality in Early Modern Iran*. Edinburgh: University of Edinburgh Press, 2008.

Ballon, Hilary, and David Friedman. "Portraying the City in Early Modern Europe: Measurement, Representation, and Planning." In *Cartography in the European Renaissance*, edited by David Woodward, 680–704. Vol. 3, part 1 of *History of Cartography*. Chicago: University of Chicago Press, 1998.

Barfield, Thomas J. *The Perilous Frontier: Nomadic Empires and China*. Cambridge, MA: Basil Blackwell, 1989.

Barmé, Geremie. *The Forbidden City*. Cambridge, MA: Harvard University Press, 2008.

Barnhart, Richard M. *Peach Blossom Spring: Gardens and Flowers in Chinese Paintings*. New York: Metropolitan Museum of Art, 1983.

Barrell, John. "The Public Prospect and the Private View: The Politics of Taste in Eighteenth-Century Britain." In *Landscape, Natural Beauty and the Arts*, edited by Salim Kemal and Ivan Gaskell, 81–102. Cambridge, UK: Cambridge University Press, 1993.

Bartholomew, Terese Tse. "Botanical Puns in Chinese Art from the Collection of the Asian Art Museum of San Francisco." *Orientations* 16:9 (1985): 18–34.

Bartlett, Beatrice S. "Imperial Notations on Ch'ing Official Documents in the Ch'ien-lung (1736–1795) and Chia-ch'ing (1796–1820) Reigns." *National Palace Museum Bulletin* 7:2 (1972): 1–13, and 7:3 (1972): 1–13.

Baxandall, Michael. "The Period Eye." In *Painting and Experience in Fifteenth-Century Italy*, 29–57. 2nd edition. Oxford: Oxford University Press, 1988.

Beardsley, John. *Gardens of Revelation: Environments by Visionary Artists*. New York: Abbeville Press, 2003.

Beer, Robert. *The Encyclopedia of Tibetan Symbols and Motifs*. Boston: Shambala, 1999.

Beik, William. "The Absolutism of Louis XIV as Social Collaboration." *Past and Present* 188:1 (2005): 195–224.

Bell, John. *Travels from St. Petersburg in Russia to Diverse Parts of Asia*. 2 volumes. Reprint, Cambridge, UK: Cambridge University Press, 2014.

Bello, David A. *Across Forest, Steppe, and Mountain: Environment, Identity and Empire in Qing China's Borderlands.* Cambridge, UK: Cambridge University Press, 2016.

Bentley, Tamara. "Authenticity and the Expanding Market in Chen Hongshou's Seventeenth-Century Printed Playing Cards." *Artibus Asiae* 69:1 (2009): 147–88.

Berger, Patricia Ann. *Empire of Emptiness: Buddhist Art and Political Authority in Qing China.* Honolulu: University of Hawai'i Press, 2003.

Berliner, Nancy. "Gardens, Water and Calligraphy: The Development and References of the Curving Waterway Garden Element." Artful Retreat: Garden Culture of the Qing Dynasty, symposium, Harvard University, November 12, 2010.

Bickford, Maggie. "Three Rams and Three Friends: The Working Lives of Chinese Auspicious Motifs." *Asia Major* 12, part 1 (1999): 127–58.

Bishu shanzhuang yanjiuhui, ed. *Bishu shanzhuang luncong.* Beijing: Zijincheng Chubanshe, 1986.

Braun, Georg, and Franz Hogenberg. *Civitates Orbis Terrarum.* Cologne, Germany: Gottfried von Kempen, 1572–1575.

Brokaw, Cynthia J., and Kai-wing Chow. *Printing and Book Culture in Late Imperial China.* Berkeley: University of California Press, 2005.

Burke, Peter. *The Frabrication of Louis XIV.* New Haven, CT: Yale University Press, 1992.

Bush, Susan. "Lung-mo, K'ai-ho, and Ch'i-fu: Some Implications of Wang Yüan-ch'i's Three Compositional Terms." *Oriental Art* 8:3 (1962): 120–27.

Bush, Susan, and Christian F. Murck, eds. *Theories of the Arts in China.* Princeton, NJ: Princeton University Press, 1983.

Bush, Susan, and Hsio-yen Shih. *Early Chinese Texts on Painting.* Cambridge, MA: Harvard University Press, 1985.

Bussotti, Michela. "'Dessins' et 'Desseins': Techniques d'Impression chez Matteo Ripa et Édition Impériale en Chine (XVIIIᵉ Siècle)." In *Empires en marche: Rencontres entre la Chine et l'Occident à l'âge moderne (XVIᵉ—XIXᵉ siècles)*, edited by Dejanirah Couto and François Lachaud, 247–73. Paris: École Française d'Extrême-Orient, 2017.

Cahill, James. *The Compelling Image: Nature and Style in Seventeenth-Century Chinese Painting.* Cambridge, MA: Harvard University Press, 1982.

———. *The Distant Mountains: Chinese Painting of the Late Ming Dynasty, 1570–1644.* New York: Weatherhill, 1982.

———. "Exploring the Zhi Garden in Zhang Hong's Album." http://jamescahill.info/the-writings-of-james-cahill/ca hill-lectures-and-papers/37-clp-22-1995-exploring-the-zhi -garden-in-zhang-hongs-album-lecture-lacma. Accessed July 8, 2018.

———. "The Orthodox Movement in Early Ch'ing Painting." In *Artists and Traditions: Uses of the Past in Chinese Culture*, edited by Christian F. Murck, 169–84. Princeton, NJ: Princeton University Art Museum, 1976.

———. "Wang Yüan-ch'i and Tao-chi." In *The Compelling Image: Nature and Style in Seventeenth-Century Chinese Painting*, 184–227, 237–38. Cambridge, MA: Harvard University Press, 1982.

Cams, Mario. *Companions in Geography: East–West Collaboration in the Mapping of Qing China (c. 1685–1735).* Leiden, Netherlands: Brill, 2017.

———. "Converging Interests and Scientific Circulation between Paris and Beijing (1685–1735): The Path towards a New Qing Cartographic Practice." *Revue d'histoire des sciences* 70:1 (2017): 47–78.

———. "Not Just a Jesuit Atlas of China: Qing Imperial Cartography and Its European Connections." *Imago Mundi* 69:2 (2017): 188–201.

Campbell, Duncan. "Qi Biaojia's 'Footnotes to Allegory Mountain': Introduction and Translation." *Studies in the History of Gardens & Designed Landscapes* 19:3–4 (1999): 243–71.

Cerceau, Jacques Androuet du. *Leçons de perspective positive.* Paris: Patisson, 1576.

Chang, Chia-Feng, "Disease and Its Impact on Policy, Diplomacy, and the Military: The Case of Smallpox and the Manchus (1613–1795)." *Journal of the History of Medicine and Allied Sciences* 57:2 (2002): 177–97.

Chang, Chin-Sung. "Wang Hui: The Evolution of a Master Landscapist." In *Landscapes Clear and Radiant: The Art of Wang Hui (1632–1717)*, edited by Maxwell K. Hearn, 49–127. New York: Metropolitan Museum of Art, 2008.

Chang, Michael G. *A Court on Horseback: Imperial Touring and the Construction of Qing Rule, 1680–1785.* Cambridge, MA: Harvard University Asia Center, 2007.

Chang Jiang and Li Li. *Qinggong shiwei.* Shenyang: Liaoning Daxue Chubanshe, 1994.

Chang Te-ch'ang. "The Economic Role of the Imperial Household in the Ch'ing Dynasty." *Journal of Asian Studies* 31:2 (1972): 243–73.

Chayet, Anne. "Architectural Wonderland: An Empire of Fictions." In *New Qing Imperial History: The Making of Inner Asian Empire at Qing Chengde*, edited by James A. Millward, Ruth W. Dunnell, Mark C. Elliott, and Philippe Forêt, 33–52. London: Routledge, 2004.

———. *Les temples de Jehol et leurs modèles tibétains.* Paris: Editions Recherche sur les civilisations, 1985.

Chen, Hui-hung. "Chinese Perception of European Perspective: A Jesuit Case in the Seventeenth Century." *The Seventeenth Century* 24:1 (2009): 97–128.

Chen Baosen. *Chengde Bishu shanzhuang Waibamiao.* Beijing: Zhongguo Jianzhu Gongye Chubanshe, 1995.

Chen Congzhou. *Zhongguo yuanlin jianshang cidian.* Shanghai: Huadong Shifan Daxue Chubanshe, 2001.

Chen Duxiu. "Meishu geming." *Xinqingnian* 6:1 (1918): 85–86.

Chen Keyin and An Lili. *Chengde fengguang.* Shijiazhuang: Hebei Meishu Chubanshe, 1987.

Chen Lüsheng and Li Laoshi, eds. *Wang Yuanqi huaji.* 2 volumes. Beijing: Renmin Meishu Chubanshe, 1995.

Chen Menglei, Jiang Tingxi, et al., eds. *Qinding Gujin tushu jicheng.* Taipei: Dingwen Shuju, 1977.

———. *Qinding Gujin tushu jicheng.* Beijing: s.n., 1728.

Chen Yunru. "At the Emperor's Invitation: Literary Gathering and the Emergence of Imperial Garden Space in Northern Song Painting." *Orientations* 38:1 (2007): 56–61.

———. "Shijian de xingzhuang—Qing yuanhua shier yueling tu yanjiu." *Gugong xueshu jikan* 22:4 (2005): 103–39.

Cheng Muheng, *Loudong qijiu zhuan, 5 juan*. China: s.n., n.d.

Cheng Te-k'un. "The Travels of Emperor Mu." *Journal of the North China Branch of the Royal Asiatic Society* 64 (1933): 124–42 and 65 (1934): 128–49.

Chengde Bishu shanzhuang guanlichu. *Bishu shanzhuang yu Waibamiao*. Beijing: Wenwu Chubanshe, 1976.

———. *Qinggong micang: Chengde Bishu shanzhuang zangchuan fojiao wenwu tezhan*. Taipei: Guanxiang Wenwu Yishu Youxian Gongsi, 1999.

Chengdeshi wenwuju. *Chengde Bishu shanzhuang*. Beijing: Wenwu Chubanshe, 1980.

———. *Qingdi yu Bishu shanzhuang*. Beijing: Zhongguo Lüyou Chubanshe, 2003.

———. *Zhongguo Chengde: Bishu shanzhuang 300 nian tezhan tulu, 1703–2003*. Beijing: Zhongguo Lüyou Chubanshe, 2003.

———. *Zisai zhencui—Chengde guancang wenwu jingpin tulu*. Bejing: Wenwu Chubanshe, 2012.

Chengde shi wenwuju and Zhongguo diyi lishi dang'anguan, eds. *Qinggong Rehe dang'an*. 18 volumes. Beijing: Zhongguo Dang'an Chubanshe, 2003.

Chia, Ning. "The Lifanyuan and the Inner Asian Rituals in the Early Qing (1644–1795)." *Late Imperial China* 14:1 (1993): 60–92.

Chou, Ju-hsi. "In Defense of Qing Orthodoxy." In *The Jade Studio: Masterpieces of Ming and Qing Painting and Calligraphy from the Wong Nan-P'ing Collection*, edited by Richard M. Barnhart, 35–42. New Haven, CT: Yale University Press, 1994.

Chou, Ju-hsi, and Claudia Brown. *The Elegant Brush: Chinese Painting under the Qianlong Emperor, 1735–1795*. Phoenix, AZ: Phoenix Art Museum, 1985.

Chou, Wen-shing. "Imperial Apparitions: Manchu Buddhism and the Cult of Mañjuśrī." *Archives of Asian Art* 65:1–2 (2015): 139–79.

Chow, Kai-wing. *Publishing, Culture, and Power in Early Modern China*. Stanford, CA: Stanford University Press, 2004.

Chu, Petra Ten-Doesschate, and Ning Ding, eds. *Qing Encounters: Artistic Exchanges between China and the West*. Los Angeles: Getty Research Insitute, 2015.

Chung, Anita. *Drawing Boundaries: Architectural Images in Qing China*. Honolulu: University of Hawai'i Press, 2004.

Clunas, Craig. *Elegant Debts: The Social Art of Wen Zhengming, 1470–1559*. London: Reaktion, 2004.

———. *Fruitful Sites: Garden Culture in Ming Dynasty China*. Durham, NC: Duke University Press, 1996.

———. "The Gift and the Garden." *Orientations* 26:2 (1995): 38–45.

———. "Qing Encounters," *Journal18* (2016). www.journal18. org/277. Accessed August 8, 2017.

Coaldrake, William Howard. *Architecture and Authority in Japan*. Nissan Institute/Routledge Japanese Studies Series. London: Routledge, 1996.

Cooper, David, and Ian N. Gregory. "Mapping the English Lake District: A Literary GIS." *Transactions of the Institute of British Geographers* 36:1 (2011): 89–108.

Corsi, Elisabetta. "Envisioning Perspective: Nian Xiyao's (1671–1738) Rendering of Western Perspective in the Prologues to 'The Science of Vision.'" In *A Life Journey to the East: Sinological Studies in Memory of Giuliano Betuccioli (1923–2001)*, edited by Antonino Forte and Federico Masini, 201–43. Kyoto, Japan: Scuola Italian di Studi sull'Asia Orientale, 2002.

———. "Late Baroque Painting in China Prior to the Arrival of Matteo Ripa, Giovanni Gherardini and the Perspective Painting Called Xianfa." In *La missione cattolica in Cila tra i secoli XVIII–XIX, Matteo Ripa e il Collegio dei Cinesi*, edited by Michele Fatica and Francesco D'Arelli, 103–23. Naples, Italy: Instituto Universitario Orientale, 1999.

Cosgrove, Denis E. *Social Formation and Symbolic Landscape*. Madison: University of Wisconsin Press, 1998.

Cronon, William. *Uncommon Ground: Rethinking the Human Place in Nature*. New York: W.W. Norton & Co., 1996.

Crossley, Pamela Kyle. "The Conquest Elite of the Ch'ing Empire." In *The Ch'ing Dynasty to 1800*, edited by Willard J. Peterson, 310–59. Vol. 9, part 1 of *The Cambridge History of China*. Cambridge, UK: Cambridge University Press, 2002.

———. "An Introduction to the Qing Foundation Myth." *Late Imperial China* 6:2 (1985): 13–23.

———. "Early Modern Cosmopolitanism and the Kangxi Emperor." In *The Reign of the Kangxi Emperor*, edited by Shuyi Kan, 11–19. Singapore: Asian Civilisations Museum, 2010.

———. *The Manchus*. Cambridge, MA: Blackwell Publishers, 1997.

———. "Manzhou yuanliu kao and the Formalization of the Manchu Heritage." *Journal of Asian Studies* 46:4 (1987): 761–90.

———. "The Rulerships of China." *American Historical Review* 97:5 (1992): 1468–83.

———. "Thinking about Ethnicity in Early Modern China." *Late Imperial China* 11:1 (1990): 1–35.

———. *A Translucent Mirror: History and Identity in Qing Imperial Ideology*. Berkeley: University of California Press, 1999.

Crossley, Pamela Kyle, and Evelyn S. Rawski. "A Profile of the Manchu Language in Ch'ing History." *Harvard Journal of Asiatic Studies* 53:1 (1993): 63–102.

Dai Yi. "Bishu shanzhuang he Kang Qian shengshi." In *Shanzhuang yanjiu: Jinian Chengde Bishu shanzhuang jianyuan 290 zhounian lunwenji*, edited by Dai Yi, 7–13. Beijing: Zijincheng Chubanshe, 1994.

———. *Qingshi yanjiu yu Bishu shanzhuang*. Shenyang: Liaoning Minzu Chubanshe, 2005.

———, ed. *Shanzhuang yanjiu: Jinian Chengde Bishu shanzhuang jianyuan 290 zhounian lunwenji*. Beijing: Zijincheng Chubanshe, 1994.

*Daqing Shengzu renhuangdi shilu*. Taipei: Xinwenfeng Chuban Gongsi, 1978.

*Daqing Shizu zhanghuangdi shilu*. Taipei: Xinwenfeng Chuban Gongsi, 1978.

Dardess, John W. "A Ming Landscape: Settlement, Land Use, Labor, and Estheticism in T'ai-ho County, Kiangsi." *Harvard Journal of Asiatic Studies* 49:2 (1989): 295–364.

de Certeau, Michel. "Spatial Stories." In *The Practice of Everyday Life* by Michel de Certeau, 115–30. Berkeley: University of California Press, 1984.

Dennerline, Jerry. "The Shun-chih Reign." In *The Ch'ing Dynasty to 1800*, edited by Willard J. Peterson, 73–119. Vol. 9, part 1 of *The Cambridge History of China*. Cambridge, UK: Cambridge University Press, 2002.

Despeaux, Catherine, and Livia Kohn. *Women in Daoism.* Cambridge, MA: Three Pines Press, 2003.

Dickinson, Gary, and Linda Wrigglesworth. *Imperial Wardrobe.* Revised edition. Berkeley, CA: Ten Speed Press, 2000.

Dong Liming, Xie Ninggao, and Li Guoliang. "Chengde shi yu Bishu shanzhuang." *Dili zhishi* 10 (1978): 8–10.

Dott, Brian Russell. *Identity Reflections: Pilgrimages to Mount Tai in Late Imperial China.* Cambridge, MA: Harvard University Asia Center, 2004.

Du Jiang. *Qingdi Chengde ligong.* Beijing: Zijincheng chubanshe, 1998.

———. "Qingdai ligong—Bishu shanzhuang." *Zijincheng* 3 (1981): 32–34.

Duan Huijie. *Bishu shanzhuang mingjing elian manhua.* Beijing: Zhongguo Wenlian Chuban Gongsi, 1993.

Duan Zhongrong. *Bishu shanzhuang qishier ding jingshi dianping.* Hohhot: Yuanfang Chubanshe, 2003.

Edgren, Sören. *Chinese Rare Books in American Collections.* New York: China House Gallery, China Institute in America, 1984.

Elias, Norbert. *The Court Society.* Revised edition. Dublin: University College Dublin Press, 2006.

Elliott, Mark C. "The Limits of Tartary: Manchuria in Imperial and National Geographies." *Journal of Asian Studies* 59:3 (2000): 603–46.

———. "The Manchu-Language Archives of the Qing Dynasty and the Origins of the Palace Memorial System." *Late Imperial China* 22:1 (2001): 1–70.

———. *The Manchu Way: The Eight Banners and Ethnic Identity in Late Imperial China.* Stanford, CA: Stanford University Press, 2001.

Elliott, Mark C., and Ning Chia. "The Qing Hunt at Mulan." In *New Qing Imperial History: The Making of Inner Asian Empire at Qing Chengde*, edited by James A. Millward, Ruth W. Dunnell, Mark C. Elliott, and Philippe Forêt, 66–83. London: Routledge, 2004.

Elman, Benjamin A. *From Philosophy to Philology: Intellectual and Social Aspects of Change in Late Imperial China.* Cambridge, MA: Council on East Asian Studies, Harvard University, 1984.

Elvin, Mark. *The Retreat of the Elephants: An Environmental History of China.* New Haven, CT: Yale University Press, 2004.

Erickson, Susan N. "Boshanlu Mountain Censers of the Western Han Period: A Typological and Iconological Analysis." *Archives of Asian Art* 45 (1992): 6–28.

Fan Shuyuan and Duan Zhongrong. *Bishu shanzhuang yuzhi fengjing shi jianshang.* Hailaer, Inner Mongolia: Neimenggu Wenhua Chubanshe, 2000.

Farquhar, David M. "The Ch'ing Administration of Mongolia up to the Nineteenth Century." PhD diss., Harvard University, 1960.

———. "Emperor as Bodhisattva in the Governance of the Ch'ing Empire." *Harvard Journal of Asiatic Studies* 38:1 (1978): 5–34.

———. "Mongolian vs. Chinese Elements in the Early Manchu State." *Ch'ing shih wen-t'i* 2:6 (1971): 11–23.

———. "The Origins of the Manchu's Mongolian Policy." In *The Chinese World Order: Traditional China's Foreign Relations*, edited by John King Fairbank and Ch'en Ta-tuan, 198–205. Cambridge, MA: Harvard University Press, 1968.

Feng Chunjiang. *Kangxi yuzhi Bishu shanzhuang beiwen.* Beijing: Zhongguo Xiju Chubanshe, 2003.

Feng Erkang. "'Yuzhi gonghe Bishu shanzhuang tuyong' de shiliao jiazhi." In *Shanzhuang yanjiu: Jinian Chengde Bishu shanzhuang jianyuan 290 zhounian lunwenji*, edited by Dai Yi, 14–19. Beijing: Zijincheng Chubanshe, 1994.

Ferguson, John C. *Lidai zhulu huamu.* Beijing: Renmin Meishu Chubanshe, 1993.

Finlay, John. "'40 Views of the Yuanming yuan': Image and Ideology in a Qianlong Imperial Album of Poetry and Paintings." PhD diss., Yale University, 2011.

Fiskesjö, Magnus. "On the 'Raw' and the 'Cooked' Barbarians of Imperial China." *Inner Asia* 1 (1999): 139–68.

Fong, Wen C. *Beyond Representation: Chinese Painting and Calligraphy, 8th–14th Century.* New York: Metropolitan Museum of Art, 1992.

———. "Wang Hui and Repossessing the Past." In *Landscapes Clear and Radiant: The Art of Wang Hui (1632–1717)*, edited by Maxwell K. Hearn, 3–48. New York: Metropolitan Museum of Art, 2008.

———. "Wang Hui, Wang Yüan-ch'i, and Wu Li." In *In Pursuit of Antiquity: Chinese Paintings of the Ming and Ch'ing Dynasties from the Collection of Mr. and Mrs. Earl Morse*, edited by Roderick Whitfield and Wen C. Fong, 175–94. Princeton, NJ: Princeton University Art Museum, 1969.

Fong, Wen C., and James C. Y. Watt. *Possessing the Past: Treasures from the National Palace Museum, Taipei.* New York: Metropolitan Museum of Art, 1996.

Forêt, Philippe. "The Intended Perception of the Imperial Gardens of Chengde in 1780." *Studies in the History of Gardens & Designed Landscapes, Chinese Gardens II* 19:3–4 (1999): 343–63.

———. "The Manchu Landscape Enterprise: Political, Geomantic and Cosmological Readings of the Gardens of the Bishu Shanzhuang Imperial Residence at Chengde." *Cultural Geographies* 2:3 (1995): 325–34.

———. *Mapping Chengde: The Qing Landscape Enterprise.* Honolulu: University of Hawai'i Press, 2000.

Franke, Herbert. "The Chin Dynasty." In *Alien Regimes and Border States, 907–1368*, edited by Herbert Franke and Denis C. Twitchett, 215–320. Vol. 6 of *The Cambridge History of China.* Cambridge, UK: Cambridge University Press, 1994.

Franke, Herbert, and Denis C. Twitchett, eds. *Alien Regimes and Border States, 907–1368.* Vol. 6 of *The Cambridge History of China.* Cambridge, UK: Cambridge University Press, 1994.

Fu Xinian and Nancy Shatzman Steinhardt. *Chinese Architecture*. New Haven, CT: Yale University Press, 2002.

Fuchs, Walter. *Der Jesuiten-Atlas der Kanghsi-Zeit: Seine Entstehungsgeschichte Nebst Namensindices für die Karten der Mandjurei, Mongolei, Ostturkestan und Tibet, mit Wiedergabe der Jesuiten-Karten in Original Grösse*. Monumenta Serica Monograph, series 4. Peking: Fu-Jen Universität, 1943.

Gao Juhan [James Cahill], Huang Xiao, and Liu Shanshan. *Buxiu de linquan: Zhongguo gudai yuanlin huihua*. Beijing: Sanlian Shudian, 2012.

Gibert, Lucien. *Dictionnaire Historique et Géographique de la Mandchourie*. Hong Kong: Imprimerie de la Société des missions-étrangères, 1934.

Golvers, Nöel. *The Astronomia Europaea of Ferdinand Verbiest, S. J. (Dillingen, 1687): Text, Translation, Notes and Commentaries*. Nettetal, Germany: Steyler Verlag, 1993.

———. "An Unnoticed Letter of F. Verbiest, S.J., On His Geodesic Operations in Tartary (1683/1684)." *Archives internationales d'histoire des sciences* 50 (2000): 86–102.

Grafton, Anthony. *Leon Battista Alberti: Master Builder of the Italian Renaissance*. New York: Hill and Wang, 2000.

Gray, Basil. "Lord Burlington and Father Ripa's Chinese Engravings." *British Museum Quarterly* 22:1–2 (1960): 40–43.

Gugong bowuyuan, ed. *Gugong bowuyuan cang Qingdai gongting huihua*. Beijing: Wenwu Chubanshe, 1992.

———. *Gugong cangshu mulu huibian*. Beijing: Xianzhuang Shuju, 2004.

———. *Qingdai dang'an shiliao congbian*. Beijing: Zhonghua Shuju, 1978.

———. *Qingdai gongting banhua*. Beijing: Zijincheng Chubanshe, 2006.

———. *Shengshi wenzhi—Qinggong dianji wenhua*. Beijing: Zijincheng Chubanshe, 2005.

———. *Tianlu zhencang: Qinggong neifuben sanbainian*. Beijing: Zijincheng Chubanshe, 2007.

Gugong bowuyuan tushuguan, ed. *Gugong fangzhi mu*. Beijing: Gugong Bowuyuan Tushuguan, 1931.

———. *Gugong putong shumu*. Beijing: Gugong Bowuyuan, 1934.

———. *Gugong suocang dianban shumu*. Beijing: Gugong Bowuyuan Tushuguan, 1933.

Gugong bowuyuan tushuguan and Liaoning sheng tushuguan, eds. *Qingdai neifu keshu mulu jieti*. Beijing: Zijincheng Chubanshe, 1995.

Guo Chenghe and Feng Shudong. *Bishu shanzhuang Waibamiao jianjie*. Beijing: Zhongguo Xiju Chubanshe, 2007.

Guoli gugong bowuyuan, ed. *Gongzhong dang Kangxi chao zouzhe*. Taipei: Guoli Gugong Bowuyuan, 1976.

———. *Gugong shuhua tulu*. 27 volumes. Taipei: Guoli Gugong Bowuyuan, 1989–2010.

———. *Gugong shuhualu*. Zhonghua congshu. Taipei: Zhonghua Congshu Weiyuanhui, 1956.

———. *Gugong shuhualu: zengdingben*. Taipei: Guoli Gugong Bowuyuan, 1965.

———. *Midian zhulin Shiqu baoji*. Taipei: Guoli Gugong Bowuyuan, 1971.

———. *Midian zhulin Shiqu baoji xubian*. Taipei: Guoli Gugong Bowuyuan, 1971.

———. *Qingdai qijuzhu ce, Kangxi chao*. Taipei: Lianjing Chuban Shiye Gongsi, 2009.

———. *Qinding Siku quanshu*. Taipei: Taiwan Yinshuguan, 1995.

———. *Yongzheng: Qing Shizong wenwu dazhan*. Taipei: Guoli Gugong Bowuyuan, 2009.

Guwu chenliesuo, ed. *Neiwubu guwu chenliesuo shuhua mulu*. Beijing: Zhongguo Dabaike Quanshu Chubanshe, 1997.

Guy, R. Kent. "Who Were the Manchus? A Review Essay." *Journal of Asian Studies* 61:1 (2002): 151–64.

Hai Zhong, Ting Jie, and Li Shiyin. *Chengde fuzhi*. Beijing: s.n., 1887.

Halbwachs, Maurice. "The Legendary Topography of the Gospels of the Holy Land." In *On Collective Memory*, translated by Lewis A. Coser, 193–235. Chicago: University of Chicago Press, 1992.

Hall, David L., and Roger T. Ames. "The Cosmological Setting of Chinese Gardens." *Studies in the History of Gardens & Designed Landscapes* 18:3 (1998): 175–86.

Hammers, Roslyn Lee. *Pictures of Tilling and Weaving: Art, Labor, and Technology in Song and Yuan China*. Hong Kong: Hong Kong University Press, 2011.

Hammond, Kenneth J. "Wang Shizhen's Yan Shan Garden Essays: Narrating a Literati Landscape." *Studies in the History of Gardens & Designed Landscapes* 19:3–4 (1999): 276–87.

Handlin-Smith, Joanna F. "Gardens in Ch'i Piao-chia's Social World: Wealth and Values in Late-Ming Kiangnan." *Journal of Asian Studies* 51:1 (1992): 55–81.

Hardie, Alison, and Duncan Campbell, eds. *Dumbarton Oaks Anthology of Chinese Garden Literature*. Washington, DC: Dumbarton Oaks Research Library and Collection, 2020.

Hargett, James M. "Huizong's Magic Marchmount: The Genyue Pleasure Park of Kaifeng." *Monumenta Serica* 38 (1988): 1–48.

———. "The Pleasure Parks of Kaifeng and Lin'an During the Sung (960–1279)." *Chinese Culture* 30:1 (1989): 61–78.

———, trans. *Riding the River Home: A Complete and Annotated Translation of Fan Chengda's (1126–1193) Travel Diary Record of a Boat Trip to Wu (Wuchuan lu)*. New York: Columbia University Press, 2008.

Harley, J. Brian. "Maps, Knowledge, and Power." In *The New Nature of Maps: Essays in the History of Cartography*, edited by Paul Laxton, 51–83. Baltimore, MD: Johns Hopkins University Press, 2001.

Harrist, Robert E. *The Landscape of Words: Stone Inscriptions from Early and Medieval China*. Seattle: University of Washington Press, 2008.

———. *Painting and Private Life in Eleventh-century China: Mountain Villa by Li Gonglin*. Princeton, NJ: Princeton University Press, 1998.

———. "Site Names and Their Meanings in the Garden of Solitary Enjoyment." *Journal of Garden History* 13:4 (1993): 199–212.

Hay, Jonathan. "The Kangxi Emperor's Brush-Traces: Calligraphy, Writing and the Art of Imperial Authority." In *Body*

and Face in Chinese Visual Culture, edited by Wu Hung and Katherine Tsiang Mino, 311–34, 417–23. Cambridge, MA: Harvard University Press, 2005.

He Yan. Qingdai huangdi beixun yudao yu xinggong. Urumqi: Xinjiang Renmin Chubanshe, 2001.

Hearn, Maxwell K. "Art Creates History: Wang Hui and The Kangxi Emperor's Southern Inspection Tour." In Landscapes Clear and Radiant: The Art of Wang Hui (1632–1717), edited by Maxwell K. Hearn, 128–83. New York: Metropolitan Museum of Art, 2008.

———. Cultivated Landscapes: Chinese Paintings from the Collection of Marie-Hélène and Guy Weill. New York: Metropolitan Museum of Art, 2002.

———. "Document and Portrait: The Sothern Inspection Tour Paintings of Kangxi and Qianlong." In Chinese Painting Under the Qianlong Emperor, edited by Ju-hsi Chou and Claudia Brown, eds., Phoebus 6:1 (1988): 91–131.

———. "The 'Kangxi Southern Inspection Tour': A Narrative Program by Wang Hui." PhD diss., Princeton University, 1990.

———. "Pictorial Maps, Panoramic Landscapes, and Topographic Paintings: Three Models of Depicting Space during the Early Qing Dynasty." In Bridges to Heaven: Essays on East Asian Art in Honor of Professor Wen C. Fong, edited by Jerome Silbergeld, Dora C. Y. Ching, Judith G. Smith, and Alfreda Murck, 93–114. Princeton, NJ: P. Y. and Kinmay W. Tang Center for East Asian Art, Department of Art and Archaeology, Princeton University, 2011.

———, ed. Landscapes Clear and Radiant: The Art of Wang Hui (1632–1717). New York: Metropolitan Museum of Art, 2008.

Heshen, and Liang Guozhi. Qinding Rehezhi. Tianjin: Tianjin Guji Chubanshe, 2003.

Hevia, James L. Cherishing Men from Afar: Qing Guest Ritual and the Macartney Embassy of 1793. Durham, NC: Duke University Press, 1995.

———. "World Heritage, National Culture, and the Restoration of Chengde." positions: east asia cultures critique 9:1 (2001): 291–43.

Ho, Wai-kam, ed. Eight Dynasties of Chinese Painting: The Collections of the Nelson Gallery-Atkins Museum, Kansas City, and the Cleveland Museum of Art. Cleveland, OH: Cleveland Museum of Art, 1980.

Hostetler, Laura. "Contending Cartographic Claims? The Qing Empire in Manchu, Chinese, and European Maps." In The Imperial Map: Cartography and the Mastery of Empire, edited by James R. Akerman, 93–132, 321–26. Chicago: University of Chicago Press, 2009.

———. Qing Colonial Enterprise: Ethnography and Cartography in Early Modern China. Chicago: University of Chicago Press, 2001.

———. "Qing Connections to the Early Modern World: Ethnography and Cartography in Eighteenth-Century China." Modern Asian Studies 34:3 (2000): 623–62.

Hou Renzhi, ed. Beijing lishi dituji. Beijing: Beijing Chubanshe, 1988.

Hsu, Mei-ling. "The Qin Maps: A Clue to Later Chinese Cartographic Development." Imago Mundi 45 (1993): 90–100.

Hsü, Ginger Cheng-chi. "Imitation and Originality, Theory and Practice." In A Companion to Chinese Art, edited by Martin J. Powers and Katherine R. Tsiang, 293–311. Chichester, UK: John Wiley & Sons, 2016.

Hu, Philip K. "Idealized Labor: Material and Social Manifestations of Riziculture and Sericulture in Imperial China." Unpublished conference paper. Columbia University, 2002.

———. Visible Traces: Rare Books and Special Collections from the National Library of China. New York: Queens Borough Public Library, 2000.

Hu Jing. Guochao yuanhua lu. In Huashi congshu, vol. 3, edited by Yu Haiyan. Taipei: Wenshizhe Chubanshe, 1974.

Huang, Pei. "New Light on the Origins of the Manchus." Harvard Journal of Asiatic Studies 50:1 (1990): 239–82.

Huang Weiling. "Huatu liuyu renkan: You Wang Yuanqi de shitu yu huaye kan Qing chu gongting shanshui huafeng de dianli." MA thesis, National Taiwan University, 2005.

Huang Ximing. "Zijincheng nei Wuyingdian." Zijincheng 1 (2005): 22–27.

Huang Yingzu and Qian Gong. Huancui tang yuanjing tu. Edited by Li Pingfan. Beijing: Renmin Meishu Chubanshe, 1981.

Hucker, Charles O. A Dictionary of Official Titles in Imperial China. Stanford, CA: Stanford University Press, 1985.

Hummel, Arthur W., ed. Eminent Chinese of the Ch'ing Period (1644–1912). Washington, DC: Government Printing Office, 1943.

Isett, Christopher Mills. State, Peasant, and Merchant in Qing Manchuria, 1644–1862. Stanford, CA: Stanford University Press, 2007.

Jackson, John Brinkerhoff. "The Word Itself." In John Brinkerhoff Jackson, Discovering the Vernacular Landsacpe, 1–8. New Haven, CT: Yale University Press, 1984.

Jami, Catherine. The Emperor's New Mathematics: Western Learning and Imperial Authority during the Kangxi Reign (1662–1722). Oxford, UK: Oxford University Press, 2011.

———. "Imperial Control and Western Learning: The Kangxi Emperor's Performance." Late Imperial China 23:1 (2002): 28–49.

Ji Ruo. "Rehe gongting wenwu qianyun zaoji." Gugong bowuyuan yuankan 2 (1997): 37–46.

Jiao Bingzhen. Moyin caihui Gengzhi tu. Beijing: Beijing Tushuguan Chubanshe, 1999.

Jin, Feng. "Jing, The Concept of Scenery in Texts on the Traditional Chinese Garden: An Initial Exploration." Studies in the History of Gardens & Designed Landscapes 18:4 (1998): 339–65.

Jin Quan. Xishuo Rehe: Bishu shanzhuang de xingshuai shi. Hong Kong: Heping Tushu Youxian Gongsi, 2004.

Jin Ruihua. Bishu shanzhuang yuanzhongyuan jianzhu yishu. Beijing: Zhongguo Xiju Chubanshe, 2003.

Johnson, Linda Cooke. "The Place of 'Qingming shanghe tu' in the Historical Geography of Song Dynasty Dongjing." Journal of Song-Yuan Studies 26 (1996): 145–82.

Juneja, Monica. "Circulation and Beyond—The Trajectories of Vision in Early Modern Eurasia." In Circulations in the Global History of Art, edited by Thomas DaCosta Kaufmann, Catherine Dossin, and Béatrice Joyeux-Prunel, 59–77. Farmham, UK: Ashgate, 2015.

Kangxi emperor. "Bishu shanzhuang ji." In *Yuzhi Bishu shan-zhuang shi*. Beijing: Wuyingdian, 1712.

———. *Kangxi di yuzhi wenji, Qing Shengzu zhuan*. Zhongguo shixue congshu, 41. Taipei: Taiwan Xuesheng Shuju, 1966.

———. "Preface to the 'Thirty-six Views of Bishu shan-zhuang': Record of the Mountain Villa to Escape the Heat." Translated by Mark C. Elliott and Scott Lowe. In *New Qing Imperial History: The Making of Inner Asian Empire at Qing Chengde*, edited by James A. Millward, Ruth W. Dunnell, Mark C. Elliott, and Philippe Forêt, 167–70. London: Rout-ledge, 2004.

———. "Purensi beiwen." In Feng Chunjiang, *Kangxi yuzhi Bishu shanzhuang beiwen*, 81–109. Beijing: Zhongguo Xiju Chubanshe, 2003.

———. "Taishan shanmai zi Changbaishan lai." In *Qinding Siku quanshu*, edited by Guoli gugong bowuyuan, 1299:577. Taipei: Taiwan Yinshuguan, 1995.

———. *Yuzhi Bishu shanzhuang shi*. Beijing: s.n., ca. 1713. Gudian029529. National Palace Museum, Taipei.

———. *Yuzhi (Shengzu) wenji*. Beijing: Wuyingdian, 1711–34.

Kangxi emperor and Chen Tingjing. *Yuxuan Tang shi*. 32 vol-umes. Beijing: Wuyingdian, 1713.

Kangxi emperor and Jiao Bingzhen. *Yuzhi Gengzhi tu*. Beijing: Wuyingdian, 1696.

Kangxi emperor, Kuixu, and Shen Yu. *Han-i araha alin-i tokso de halhûn be jailaha gi bithe*. Beijing: Wuyingdian, 1712.

———. *Yuzhi Bishu shanzhuang shi*. Beijing: Wuyingdian, 1712.

Kangxi emperor, Shen Yu, and Wang Cengqi. *Tongban Bishu shanzhuang sanshiliu jing shitu*. Beijing: Xueyuan Chuban-she, 2002.

Kangxi emperor and Jonathan Spence. *Emperor of China: Self Portrait of K'ang Hsi*. New York: Knopf, 1974.

Kelsall, Malcolm. "The Iconography of Stourhead." *Journal of the Warburg and Courtauld Institutes* 46 (1983): 133–43.

Kessler, Lawrence D. *K'ang-Hsi and the Consolidation of Ch'ing Rule, 1661–1684*. Chicago: University of Chicago Press, 1976.

Keswick, Maggie. *The Chinese Garden: History, Art, and Architecture*. Revised by Alison Hardie. Cambridge, MA: Harvard University Press, 2003.

Kindall, Elizabeth. *Geo-Narratives of a Filial Son: The Paint-ings and Travel Diaries of Huang Xiangjian (1609–1673)*. Cambridge, MA: Harvard University Asia Center, 2016.

Kleeman, Terry F. "Mountain Deities in China: The Domes-tication of the Mountain God and the Subjugation of the Margins." *Journal of the American Oriental Society* 114:2 (1994): 226–38.

Kleutghen, Kristina Renée. *Imperial Illusions: Crossing Pic-torial Boundaries in the Qing Palaces*. Seattle: University of Washington Press, 2015.

———. "From Science to Art: The Evolution of Linear Per-spective in Eighteenth-Century Chinese Art." In *Qing Encounters: Artistic Exchanges between China and the West*, edited by Petra Ten-Doesschate Chu and Ning Ding, 127–89. Los Angeles: Getty Research Insitute, 2015.

Köhle, Natalie. "Why Did the Kangxi Emperor Go to Wutai shan? Patronage, Pilgrimage, and the Place of Tibetan Bud-dhism at the Early Qing Court." *Late Imperial China* 29:1 (2008): 73–119.

Kubler, George. *The Shape of Time: Remarks on the History of Things*. New Haven, CT: Yale University Press, 1962.

Laing, Ellen Johnston. "Ch'ing Dynasty Pictorial Jades and Painting." *Ars Orientalis* 16 (1986): 59–91.

Lattimore, Owen. *Inner Asian Frontiers of China*. Hong Kong: Oxford University Press, 1988.

Lazarist Mission. *Catalogue of the Pei-t'ang Library*. Reprint, Beijing: Beijing Guojia Tushuguan Chubanshe, 2009.

Ledderose, Lothar. "The Earthly Paradise: Religious Ele-ments in Chinese Landscape Art." In *Theories of the Arts in China*, edited by Susan Bush and Christian F. Murck, 165–83. Princeton, NJ: Princeton University Press, 1983.

Lee, Haiyan. "The Ruins of Yuanmingyuan: Or, How to Enjoy a National Wound." *Modern China* 35:2 (2009): 155–90.

Lee, Hui-shu. *Exquisite Moments: West Lake and Southern Song Art*. New York: China Institute Gallery, 2001.

Li, Chu-tsing. *A Thousand Peaks and Myriad Ravines: Chinese Paintings in the Charles A. Drenowatz Collection*. Artibus Asiae Supplementum 30. Ascona, Switzerland: Artibus Asiae, 1974.

Li, Gertraude Roth. "State Building before 1644." In *The Ch'ing Dynasty to 1800*, edited by Willard J. Peterson, 9–72. Vol. 9, part 1 of *The Cambridge History of China*. Cambridge, UK: Cambridge University Press, 2002.

Li, He, and Michael Knight. *Power and Glory: Court Arts of China's Ming Dynasty*. San Francisco: Asian Art Museum of San Francisco, 2008.

Li, June, James Cahill, and Zhang Hong. *Paintings of Zhi Garden by Zhang Hong: Revisiting a Seventeenth-Century Chinese Garden*. Los Angeles: Los Angeles County Museum of Art, 1996.

Li Cheng, Huang Yingzu, and Qian Gong. *Huancuitang yuanjingtu*. Reprint, Beijing: Renmin Meishu Chubanshe, 2014.

Li Guorong. "Qinggong Bishu shanzhuang dang'an shouci xitong gongbu." *Zijincheng* 2 (2004): 75–80.

Li Lin-ts'an. "A Study of the Masterpiece 'T'ang Ming-huang's Journey to Shu.'" *Ars Orientalis* 4 (1961): 315–21.

Li Shutian. *Ula shilüe*. Changchun: Jilin Wenshi Chubanshe, 1993.

Li Xian and Wan An. *Da Ming yitongzhi*. Beijing: Beijing Tushuguan Chubanshe, 2009.

Li Yimei. "Leng Mei 'Fang Qiu Ying Han'gong chunshao tu' yanjiu." *Yiyi fenzi* 11 (2008): 39–66.

Li Yueming. "Bishu shanzhuang de sange diyi jing." *Chengde minzu shizhuan xuebao* 20:3 (2000): 18–21.

Li Zhizhong, ann. *Moyin caihui Gengzhi tu*. Beijing: Beijing Tushuguan Chubanshe, 1999.

Lin Boting. *Daguan: Beisong shuhua tezhan*. Taipei: Guoli Gugong Bowuyuan, 2006.

Lin Li-chiang. "Huizhou banhua 'Huancuitang yuanjingtu' de yanjiu." In *Quyu yu wangluo—Jin qiannian lai Zhongguo meishushi yanjiu guoji xueshu yantaohui lunwenji*, edited by Chen Baozhen, 299–328. Taipei: National Taiwan Uni-versity, 2001.

———. "The Making of Images—Reading Wang Tingna's

'Everyday Life' through His *Huancui tang yuanjing tu*." *Meishu shixue* 25 (2011): 401–49.

———. "Mingdai banhua 'Yangzheng tujie' zhi yanjiu." *Meishu yanjiu jikan* 33 (2012): 163–224.

Lindgren, Uta. "Land Surveys, Instruments, and Practitioners in the Renaissance." *Cartography in the European Renaissance*, edited by David Woodward, 477–508. Vol. 3, part 1 of *History of Cartography*. Chicago: University of Chicago Press, 1998.

Liscomb, Kathlyn Maurean. "'The Eight Views of Beijing': Politics in Literati Art." *Artibus Asiae* 49:1–2 (1988): 127–52.

———. *Learning from Mount Hua: A Chinese Physician's Illustrated Travel Record and Painting Theory*. Cambridge, MA: Cambridge University Press, 1993.

Little, Stephen, Shawn Eichman, Patricia Ebrey, et al. *Taoism and the Arts of China*. Chicago: Art Institute of Chicago, 2000.

Liu, Cary Y. "Archive of Power: The Qing Dynasty Imperial Garden-Palace at Rehe." *Meishushi yanjiu jikan* 28 (2010): 43–66.

———. "The Ch'ing Dynasty Wen-yüan-ko Imperial Library: Architecture and the Ordering of Knowledge." PhD diss., Princeton University, 1997.

Liu, Heping. "'The Water Mill' and Northern Song Imperial Patronage of Art, Commerce and Science." *The Art Bulletin* 84:4 (2002): 566–95.

Liu Lu. *Qinggong xiyang yiqi*. Gugong bowuyuancang wenwu zhenpin quanji 58. Shanghai: Shanghai Kexue Jishu Chubanshe, 1999.

Liu Shaohui. "Bishu shanzhuang huqu yuanqiao chutan." In *Jinian Bishu shanzhuang jianyuan sanbai zhounian lunwenji*, edited by Zhao Ling, 286–91. Shenyang: Liaoning Minzu Chubanshe, 2005.

Liu Yuwen. "Bishu shanzhuang chujian shijian ji xiangguan shishi kao." In *Qingshi yanjiu yu Bishu shanzhuang*, edited by Dai Yi, 85–91. Shenyang: Liaoning Minzu Chubanshe, 2005.

———. "Kangxi huangdi yu Bishu shanzhuang—du Qing Shengzu 'Yuzhi Bishu shanzhuang ji' zhaji." *Qingdai yanjiu* 2 (1998): 115–19.

Liu Yuzhen. "Wang Yuanqi (1642–1715) 'Ni Lu Hong Caotang shizhi tuce' ji qi huadao zhuiqiu." *Gugong xueshu jikan* 21:3 (2004): 117–52.

Lo, Hui-chi. "Political Advancement and Religious Transcendence: The Yongzheng Emperor's (1678–1735) Deployment of Portraiture." PhD diss., Stanford University, 2009.

Lowe, Scott, trans. "Preface to the 'Thirty-Six Views of Bishu shanzhuang': Record of the Mountain Villa to Escape the Heat." In *New Qing Imperial History: The Making of Inner Asian Empire at Qing Chengde*, edited by James A. Millward, Ruth W. Dunnell, Mark C. Elliott, and Philippe Forêt, 168. London: Routledge, 2004.

Lu, Andong. "Deciphering the Reclusive Landscape: A Study of Wen Zheng-Ming's 1533 Album of the Garden of the Unsuccessful Politician." *Studies in the History of Gardens & Designed Landscapes* 31:1 (2011): 40–59.

Lu Fusheng. *Zhongguo shuhua quanshu*. 14 volumes. Shanghai: Shanghai Shuhua Chubanshe, 1992.

Lukács, György. "Reification and the Consciousness of the Proletariat." In *History and Class Consciousness: Studies in Marxist Dialectics*, translated by Rodney Livingstone, 83–222. Cambridge, MA: MIT Press, 1972.

Luo Yunzhi. *Qingdai Mulan weichang de tantao*. Taipei: Wenshizhe Chubanshe, 1989.

Ma, Ya-chen. "Picturing Suzhou: Visual Politics in the Making of Cityscapes in Eighteenth-century China." PhD diss., Stanford University, 2006.

Maeda, Robert. "*Chieh-hua*: Ruled-Line Painting in China." *Ars Orientalis* 10 (1975): 123–41.

Makeham, John. "The Confucian Role of Names in Traditional Chinese Gardens." *Studies in the History of Gardens & Designed Landscapes* 18:3 (1998): 187–210.

Mancall, Mark. *Russia and China: Their Diplomatic Relations to 1728*. Cambridge, MA: Harvard University Press, 1971.

*Manzhou shilu*. Qingshi ziliao, di 2 ji, Kaiguo shiliao (2), 1–3. Taipei: Tailian Guofeng Chubanshe, 1968.

Marin, Louis. *Portrait of the King*. Translated by Martha Houle. Minneapolis: University of Minnesota Press, 1988.

Matsumura Jun. "The Founding Legend of the Qing Dynasty Reconsidered." *Memoirs of the Research Department of the Tōyō Bunko* 55 (1997): 41–60.

———. "On the Founding Legend of the Ch'ing Dynasty." *Acta Asiatica* 53 (1988): 1–23.

McLean, Matthew. *The Cosmographia of Sebastian Münster: Describing the World in the Reformation*. London: Routledge, 2007.

McMullen, David L. "Recollection without Tranquility: Du Fu, the Imperial Gardens and the State." *Asia Major*, 3rd ser. 14:2 (2001): 189–252.

Meng, Zhaozhen. "Bishu shanzhuang yuanlin yishu gong zai qianqiu." In *Qingshi yanjiu yu Bishu shanzhuang*, edited by Dai Yi, 243–45. Shenyang: Liaoning Minzu Chubanshe, 2005.

———. *Bishu shanzhuang yuanlin yishu*. Beijing: Zijincheng Chubanshe, 1985.

Meng Zhaoxin. "Kangxi huangdi yu Bishu shanzhuang." In *Shanzhuang yanjiu: Jinian Chengde Bishu shanzhuang jianyuan 290 zhounian lunwenji*, edited by Dai Yi, 20–29. Beijing: Zijincheng Chubanshe, 1994.

Meserve, Ruth I. "Smallpox among the Tungus People: The Language of Disease." *Central Asiatic Journal* 50.1 (2006): 75–100.

Millward, James A. *Beyond the Pass: Economy, Ethnicity, and Empire in Qing Central Asia, 1759–1864*. Stanford, CA: Stanford University Press, 1998.

———. "'Coming onto the Map': 'Western Regions' Geography and Cartographic Nomenclature in the Making of Chinese Empire in Xinjiang." *Late Imperial China* 20:2 (1999): 61–98.

———. "Qing Inner Asian Empire and the Return of the Torghuts." In *New Qing Imperial History: The Making of Inner Asian Empire at Qing Chengde*, edited by James A. Millward, Ruth W. Dunnell, Mark C. Elliott, and Philippe Forêt, 91–106. London: Routledge, 2004.

Millward, James A., Ruth W. Dunnell, Mark C. Elliott, and Philippe Forêt, eds. *New Qing Imperial History: The Making*

*of Inner Asian Empire at Qing Chengde*. London: Routledge, 2004.

Mitchell, W. J. T. "Imperial Landscape." In *Landscape and Power*, edited by W. J. T. Mitchell, 5–34. 2nd edition. Chicago: University of Chicago Press, 2002.

———, ed. *Landscape and Power*. 2nd edition. Chicago: University of Chicago Press, 2002.

Monnet, Nathalie. *Chine, l'Empire du trait: Calligraphies et dessins du Ve au XIXe siècle*. Paris: Bibliothèque nationale de France, 2004.

Mukerji, Chandra. *Territorial Ambitions and the Gardens of Versailles*. Cambridge, UK: Cambridge University Press, 1997.

Munakata, Kiyohiko. *Sacred Mountains in Chinese Art: An Exhibition Organized by the Krannert Art Museum and Curated by Kiyohiko Munakata; Krannert Art Museum, November 9–December 16, 1990, the Metropolitan Museum of Art, January 25–March 31, 1991*. Champaign: Krannert Art Museum, University of Illinois–Urbana-Champaign, 1991.

Mungello, David E. *The Great Encounter of China and the West, 1500–1800*. 2nd edition. Lanham, MD: Rowman & Littlefield Publishers, 2005.

Munster, Sebastian. *Cosmographia*. Basel: Adam Petri, 1572.

Murray, Julia K. "Changing the Frame: Prefaces and Colophons in the Chinese Illustrated Book, *Dijian tushuo* (The Emperor's Mirror, Illustrated and Discussed)." *East Asian Library Journal* 12:1 (2003): 20–67.

———. "Didactic Picturebooks for Late Ming Emperors and Princes." In *Culture, Courtiers, and Competition: The Ming Court (1368–1644)*, edited by David M. Robinson, 231–68. Cambridge, MA: Harvard University Asia Center, 2008.

———. "From Textbook to Testimonial: The Emperor's Mirror, an Illustrated Discussion (*Di jian tu shuo/Teikan zusetsu*) in China and Japan." *Ars Orientalis* 31 (2001): 65–101.

———. "Squaring Connoisseurship with History: Jiao Hong's Yangzheng tujie." In *The Art of the Book in China*, edited by Ming Wilson and Stacey Pierson, 139–57. London: Percival David Foundation, 2006.

———. "What Is 'Chinese Narrative Illustration'?" *The Art Bulletin* 80:4 (1998): 602–15.

Musillo, Marco. *Shining Inheritance: Italian Painters at the Qing Court, 1699–1812*. Los Angeles: Getty Publications, 2016.

*Nanju Meiga-en*. 25 volumes. Tokyo: Shimbi Shoin, 1904–1910.

Needham, Joseph, and Wang Ling. *Mathematics and the Sciences of the Heavens and Earth*. Vol. 3 in *Science and Civilisation in China*. Cambridge, UK: Cambridge University Press, 1959.

Neer, Richard. "Connoisseurship and the Stakes of Style." *Critical Inquiry* 32:1 (2005): 1–26.

Nelson, Susan E. "On Through to the Beyond: The Peach Blossom Spring as Paradise." *Archives of Asian Art* 39 (1986): 23–47.

Nian Xiyao. *Shixue*. Beijing: s.n., 1735.

Nie Chongzheng. "Qingdai gongting huihua gaoben shukao." *Gugong bowuyuan yuankan* 113:3 (2004): 75–91.

———, ed. *Qingdai gongting huihua*. Hong Kong: Shangwu Yinshuguan Gufen Youxian Gongsi, 1996.

Nuti, Lucia. "Mapping Places: Chorography and Vision in the Renaissance." In *Mappings*, edited by Denis Cosgrove, 90–108. London: Reaktion Books, 1999.

———. "The Perspective Plan in the Sixteenth Century: The Invention of a Representational Language." *Art Bulletin* 76:1 (1994): 105–28.

Oertai, and Zhang Tingyu. *Guochao gongshi*. Beijing: Beijing Guji Chubanshe, 2001.

Owen, Stephen, trans. and ed. *Readings in Chinese Literary Thought*. Harvard-Yenching Institute Monograph Series 30. Cambridge, MA: Council on East Asian Studies, Harvard University, 1992.

Oxnam, Robert B. *Ruling from Horseback: Manchu Politics in the Oboi Regency, 1661–1669*. Chicago: University of Chicago Press, 1975.

Pan Tianzhen. "Kangxi Wuyingdian keshu de shilu." *Beijing tushuguan guankan* 1 (1999): 77–79, 89.

Park, J. P. *Art by the Book: Painting Manuals and the Leisure Life in Late Ming China*. Seattle: University of Washington Press, 2012.

Pelliot, Paul. "Les 'Conquêtes de l'empereur de Chine.'" *T'oung-pao* 20 (1921): 183–274.

Peng Junbo. "Guanyu Bishu shanzhuang fazhan shi." N.d.

Perdue, Peter C. "Boundaries, Maps, and Movement: Chinese, Russian, and Mongolin Empires in Early Modern Central Eurasia." *International History Review* 20:2 (1998): 263–86.

———. *China Marches West: The Qing Conquest of Central Eurasia*. Cambridge, MA: Belknap Press of Harvard University Press, 2005.

———. "Military Mobilization in Seventeenth and Eighteenth-century China, Russia, and Mongolia." *Modern Asian Studies* 30:4 (1996): 757–93.

Peterson, Willard J., ed. *The Ch'ing Dynasty to 1800*. Vol. 9, part 1 in *The Cambridge History of China*. Cambridge, UK: Cambridge University Press, 2008.

Pinney, Christopher. *Photos of the Gods: The Printed Image and Political Struggle in India*. London: Reaktion, 2004.

Poppe, N. N., Leon Hurvitz, and Okada Hidehiro. *Catalogue of the Manchu-Mongol Section of the Tōyō Bunko*. Tokyo: Tōyō Bunko, 1964.

Powers, Martin J. "Questioning Orthodoxy." *Orientations* 28:10 (1997): 73–74.

———. "When Is Landscape Like a Body?" In *Landscape, Culture, and Power in Chinese Society*, edited by Wen-Hsin Yeh, 1–22. Berkeley: Institute of East Asian Studies, University of California–Berkeley, Center for Chinese Studies, 1998.

Pregado, Fabrizio, ed. *The Encyclopedia of Taoism*. London: Routledge, 2013.

Qi Biaojia. *Yushanzhu*. 2 volumes. China: s.n., 1628.

Qianlong emperor, Kangxi emperor, Oertai, Kuixu, and Shen Yu. *Bishu shanzhuang sanshiliu jing*. Zhongguo gudai fengjing banhua congkan. Beijing: Renmin Meishu Chubanshe, 1984.

———. *Bishu shanzhuang sanshiliu jing shitu (gongting ban)*. Beijing: Zhongguo Jianzhu Gongye Chubanshe, 2009.

———. *Yuzhi Bishu shanzhuang tuyong*. Nanjing: Jiangsu Guji Chubanshe, 2003.

Qu Yanjun, ed. *Zhongguo Qingdai gonggting banhua*. Hefei: Anhui Meishu Chubanshe, 2002.

Rawski, Evelyn S. "Presidential Address: Reenvisioning the Qing: The Significance of the Qing Period in Chinese History." *Journal of Asian Studies* 55:4 (1996): 829–50.

———. *The Last Emperors: A Social History of Qing Imperial Institutions*. Berkeley: University of California Press, 1998.

Rawski, Evelyn S., and Jessica Rawson, eds. *China: The Three Emperors, 1662–1795*. London: Royal Academy of Arts, 2005.

Rawson, Jessica. "The Eternal Palaces of the Western Han: A New View of the Universe." *Artibus Asiae* 59:1–2 (1999): 5–58.

Rinaldi, Bianca Maria. *The "Chinese Garden in Good Taste": Jesuits and Europe's Knowledge of Chinese Flora and Art of the Garden in the 17th and 18th Centuries*. Munich, Germany: Meidenbauer, 2006.

Ripa, Matteo. *Descrizione della villa Imperiale de Gehol in 35 rami*. Ms 1.g.75. China: s.n., ca. 1713. Bibliotheca Nazionale di Napoli.

———. *Giornale (1705–1724)*. 2 volumes. Edited by Michele Fatica. Naples, Italy: Instituto Universitario Orientale, 1991 and 1996.

———. *Maison de plaisance de l'empereur de la Chine*. Ca 139. China: s.n., ca. 1713. Dresden Kupferstich-Kabinett.

———. *Memoirs of Father Ripa, during thirteen years' residence at the court of Peking in the service of the emperor of China; with an account of the foundation of the college for the education of young Chinese at Naples*. Translated by Fortunato Prandi. New York: Wiley & Putnam, 1846.

———. *Paysage chinois (Yuzhi Bishu shanzhuang sanshiliu jing shi)*. Hd 90. China: s.n., ca. 1713. Bibliothèque nationale de France.

———. *Storia della Fondazione della Congregazione e del Collegio de'Cinesi sotto il titolo della famiglia sagra di G. C.* Naples, Italy: Manfredi, 1832.

———. *Thirty-Six Views of Jehol*. MEXE+, 611030B. China: s.n., ca. 1713. Miriam and Ira D. Wallach Division of Arts, Prints and Photographs, New York Public Library.

———. *Views of Jehol, the Seat of the Summer Palace of the Emperors of China*. RBR L-2-6 RIP. China: s.n., ca. 1713. Dumbarton Oaks Research Library and Collection.

Roberts, Jennifer. "Reversing American Art." www.nga.gov/content/ngaweb/audio-video/video/wyeth-roberts.html. Accessed August 5, 2017.

Rojas, Carlos. *The Great Wall: A Cultural History*. Cambridge, MA: Harvard University Press, 2010.

Rosenzweig, Daphne Lange. "Court Painters of the K'ang-Hsi Period." PhD diss., Columbia University, 1978.

———. "Court Painting and the K'ang-hsi Emperor." *Ch'ing shih wen-t'i* 3 (1975): 60–81.

———. "Official Signatures on Qing Court Painting." *Oriental Art* n.s. 27:2 (1981): 183–89.

———. "Painters at the Early Ch'ing Court: The Socioeconomic Background." *Monumenta Serica* 31 (1974–1975): 475–87.

Rossabi, Morris. *China and Inner Asia: From 1368 to the Present Day*. New York: Pica Press, 1975.

Schama, Simon. *Landscape and Memory*. New York: A.A. Knopf, 1995.

Schönle, Andreas. *The Ruler in the Garden: Politics and Landscape Design in Imperial Russia*. Bern, Switzerland: Peter Lang, 2007.

Screech, Timon. "The Meaning of Western Perspective in Edo Popular Culture." *Archives of Asian Art* 47 (1994): 58–69.

Serruys, Henry. "Mongol Altan 'Gold' = 'Imperial.'" *Monumenta Serica* 21 (1962): 357–78.

———. "Place Names along China's Northern Frontier." *Bulletin of the School of Oriental and African Studies, University of London* 45:2 (1982): 271–83.

Shen Jin. *Zhongguo zhenxi guji shanben shulu*. Guilin: Guangxi Shifan Daxue Chubanshe, 2006.

Shepherd, John Robert. *Statecraft and Political Economy on the Taiwan Frontier, 1600–1800*. Stanford, CA: Stanford University Press, 1993.

Shi Lifeng, "Bishu shanzhuang gongqiang de lishi yange." In *Jinian Bishu shanzhuang jianyuan sanbai zhounian lunwenji*, edited by Zhao Ling, 286–91. Shenyang: Liaoning Renmin Chubanshe, 2005.

Shi Liwu, ed. *Bishu shanzhuang yanjiu 2007*. Shenyang: Liaoning Minzu Chubanshe, 2007.

Silbergeld, Jerome. *Chinese Painting Style: Media, Methods, and Principles of Form*. Seattle: University of Washington Press, 1982.

Sima Qian. *Records of the Grand Historian of China*. Translated by Burton Watson. New York: Columbia University Press, 1971.

Sirén, Osvald. *Chinese Painting: Leading Masters and Principles*. 9 volumes. New York: Ronald Press, 1956.

Smith, Richard J. *The Qing Dynasty and Traditional Chinese Culture*. Lanham, MD: Rowman and Littlefield, 2015.

Sommer, Deborah. "The Art and Politics of Painting Qianlong at Chengde." In *New Qing Imperial History: The Making of Inner Asian Empire at Qing Chengde*, edited by James A. Millward, Ruth W. Dunnell, Mark C. Elliott, and Philippe Forêt, 136–45. London: Routledge, 2004.

Song Luo, ed. *Yupi zizhi tongjian gangmu*. Beijing: Wuyingdian, 1708.

Spence, Jonathan D. "The K'ang-hsi Reign." In *The Ch'ing Dynasty to 1800*, edited by Willard J. Peterson, 120–82. Vol. 9, part 1 of *The Cambridge History of China*. Cambridge, UK: Cambridge University Press, 2002.

———. "The Seven Ages of K'ang-hsi (1654–1722)." *Journal of Asian Studies* 26:2 (1967): 205–11.

———. *Ts'ao Yin and the K'ang-Hsi Emperor: Bondservant and Master*. New Haven, CT: Yale University Press, 1966.

Spring, Madeline K. "The Celebrated Cranes of Po Chü-i." *Journal of the American Oriental Society* 111:1 (1991): 8–18.

Stary, Giovanni, Nicola di Cosmo, Tatiana A. Pang, and Alessandra Pozzi. *On the Tracks of Manchu Culture, 1644–1994: 350 Years after the Conquest of Peking*. Wiesbaden, Germany: Harrassowitz, 1995.

Stein, Rolf Alfred. *The World in Miniature: Container Gardens*

*and Dwellings in Far Eastern Religious Thought*. Stanford, CA: Stanford University Press, 1990.

Steinhardt, Nancy Shatzman. *Chinese Imperial City Planning*. Honolulu: University of Hawai'i Press, 1990.

———. *Liao Architecture*. Honolulu: University of Hawai'i Press, 1997.

Strassberg, Richard E. *Inscribed Landscapes: Travel Writing from Imperial China*. Berkeley: University of California Press, 1994.

———. "Transmitting a Qing Imperial Garden: Kangxi's Thirty-six Views of Bishu shanzhuang and Their Journey to the West." Translated by Wang Jintao. *Fengjing yuanlin* 6 (2009): 80–91.

———. "War and Peace: Four Intercultural Landscapes." In *China on Paper: European and Chinese Works from the Late Sixteenth to the Early Nineteenth Centuries*, edited by Marcia Reed and Paola Demattè, 89–137. Los Angeles: Getty Research Institute, 2007.

Strassberg, Richard E., and Stephen H. Whiteman. *Thirty-Six Views: The Kangxi Emperor's Mountain Estate in Poetry and Prints*. Washington, DC: Dumbarton Oaks Research Library and Collection, 2016.

Stuart, Jan. "Imperial Pastimes: Dilettantism as Statecraft in the Eighteenth Century." In *Life in the Imperial Court of Qing Dynasty China*, edited by Chuimei Ho and Cheri A. Jones, 55–66. Proceedings (Denver Museum of Natural History), ser. 3, no. 15. Denver, CO: Denver Museum of Natural History, 1998.

Szonyi, Michael. "The Illusion of Standardizing the Gods: The Cult of the Five Emperors in Late Imperial China." *Journal of Asian Studies* 56:1 (1997): 113–35.

Tan Qixiang. *Zhongguo lishi ditu ji*. 8 volumes. Shanghai: Ditu Chubanshe, 1982.

Tao Xiang, ed. *Gugong dianben shuku xiancun mu san juan*. Beijing: Gugong Bowuyuan, 1933.

Teng, Emma. *Taiwan's Imagined Geography: Chinese Colonial Travel Writing and Pictures, 1683–1895*. Cambridge, MA: Harvard University Asia Center, 2004.

Tianjin daxue jianzhuxi and Chengdeshi wenwuju. *Chengde gu jianzhu: Bishu shanzhuang he Waibamiao*. Beijing: Zhongguo Jianzhu Gongye Chubanshe, 1982.

Tong Peng. "Jiao Bingzhen shinü tuhui yanjiu." Master's thesis, National Taiwan Normal University, 2013.

Torbert, Preston M. *The Ch'ing Imperial Household Department: A Study of Its Organization and Principal Functions, 1662–1796*. Cambridge, MA: Council on East Asian Studies, Harvard University, 1977.

Tripodes, Lucia. "Painting and Diplomacy at the Qianlong Court: A Commemorative Picture by Wang Zhicheng (Jean-Denis Attiret)." *RES: Anthropology and Aesthetics* 35 (1999): 185–200.

Tsao Hsingyuan. "Unraveling the Mystery of the Handscroll 'Qingming shanghe tu.'" *Journal of Song-Yuan Studies* 33 (2003): 155–79.

Tsien Tsuen-hsin. *Chemistry and Chemical Technology: Paper and Printing*. Vol. 5, part 1 in *Science and Civilisation in China*, edited by Joseph Needham. Cambridge, UK: Cambridge University Press, 1985.

Tuotuo. *Jinshi*. Beijing: Zhonghua Shuju, 1975.

Tuttle, Gray. "Tibetan Buddhism at Wutai shan in the Qing: The Chinese Language Register." *Journal of the International Association of Tibetan Studies* 6 (2011): 163–214. www.thlib.org?tid=T5721. Accessed August 19, 2017.

Turnbull, David. *Maps Are Territories: Science Is an Atlas. A Portfolio of Exhibits*. Chicago: University of Chicago Press, 1989.

Twitchett, Denis, and Klaus-Peter Tietze. "The Liao." In *Alien Regimes and Border States, 907–1368*, edited by Herbert Franke and Denis Twitchett, 43–153. Vol. 6 in *The Cambridge History of China*. Cambridge, UK: Cambridge University Press, 1994.

Upton, Dell. "Black and White Landscapes in Eighteenth-Century Virginia." In *Material Life in America, 1600–1860*, edited by Robert Blair St. George, 357–69. Boston: Northeastern Univeristy Press, 1987.

Vanderstappen, Harrie. "Painters at the Early Ming Court (1368–1435) and the Problem of a Ming Painting Academy." *Monumenta Serica* 15 (1956): 259–302.

Venturi, Robert, Denise Scott Brown, and Steve Izenour. *Learning from Las Vegas: The Forgotten Symbolism of Architectural Form*. Cambridge, MA: MIT Press, 1977.

Vinograd, Richard Ellis. *Boundaries of the Self: Chinese Portraits, 1600–1900*. Cambridge, UK: Cambridge University Press, 1992.

———. "Family Properties: Personal Context and Cultural Pattern in Wang Meng's 'Pien Mountains' of 1366." *Ars Orientalis* 13 (1982): 1–29.

———. "Fan Ch'i (1616–after 1694): Place Making and the Semiotics of Sight in Seventeenth-Century Nanching." *Meishushi yanjiu jikan* 14 (2003): 129–57, 244.

———. "Some Landscapes Related to the Blue-and-Green Manner from the Early Yüan Period." *Artibus Asiae* 41:2–3 (1979): 101–31.

Wakeman, Frederic E. *The Great Enterprise: The Manchu Reconstruction of the Imperial Order in Seventeenth-century China*. 2 volumes. Berkeley: University of California Press, 1985.

———, ed. *Ming and Qing Historical Studies in the People's Republic of China*. Berkeley: Institute of East Asian Studies, University of California–Berkeley, Center for Chinese Studies, 1980.

Waldron, Arthur. *The Great Wall of China: From History to Myth*. Cambridge, UK: Cambridge University Press, 1990.

Waley-Cohen, Joanna. "Commemorating War in Eighteenth-Century China." *Modern Asia Studies* 30:4 (1996): 869–99.

———. "The New Qing History." *Radical History Review* 88 (2004): 193–206.

Wallis, Helen. "Chinese Maps and Globes in the British Library and the Phillips Collection." In *Chinese Studies: Papers Presented at a Colloquium at the School of Oriental and African Studies, University of London, 24–26 August 1987*, edited by Frances Wood, 88–95. London: British Library, 1988.

Walton, Linda A. "Southern Song Academies and the Construction of Sacred Space." In *Landscape, Culture, and Power in Chinese Society*, edited by Wen-Hsin Yeh, 23–51. Berkeley:

Institute of East Asian Studies, University of California–Berkeley, Center for Chinese Studies, 1998.

Wang, Bing. "The Boxue Hongci 博學宏詞 Examinations, Literary Anthologies by Emperors and the Literary Circles during the Kangxi and Qianlong Periods." *Ming Qing Yanjiu* 20 (2017): 94–108.

Wang, Cheng-hua. "Material Culture and Emperorship: The Shaping of Imperial Roles at the Court of Xuanzong (r. 1426–35)." PhD diss., Yale University, 1998.

Wang, Eugene Y. "Perceptions of Change, Changes in Perception—West Lake as Contested Site/Sight in the Wake of the 1911 Revolution." *Modern Chinese Language and Culture* 12:2 (2000): 73–122.

———. "The Rhetorics of Book Illustrations." In *Treasures of the Yenching: Seventy-Fifth Anniversary of the Harvard-Yenching Library*, edited by Patrick Hanan, 190–205. Cambridge, MA: Harvard-Yenching Library, 2003.

———. "Tope and Topos: The Leifeng Pagoda and the Discourse of the Demonic." In *Writing and Materiality in China: Essays in Honor of Patrick Hanan*, edited by Judith T. Zeitlin and Lydia H. Liu, 488–552. Cambridge, MA: Harvard University Asia Center, 2003.

Wang, Shen. "Wang Yuanqi and the Orthodoxy of Self-Reflection in Early Qing Landscape Painting." PhD diss., University of Pennsylvania, 2010.

Wang, Yaoting. "Shiba shiji gongting huihua." *Gugong wenwu yuekan* 1:11 (1984): 85–93.

Wang Bomin. *Zhongguo banhua shi*. Shanghai: Shanghai Renmin Meishu Chubanshe, 1961.

Wang Chaosheng. "Jizhong xianjiande 'Gengzhi tu.'" *Gujin nongye* 1 (2003): 64–80.

Wang Juyuan. *Zhongguo gudai yuanlin shi*. Beijing: Zhongguo Jianzhu Gongye Chubanshe, 2006.

Wang Liping and Li Long. *Chengde Bishu shanzhuang ji zhouwei simiao*. Beijing: Zhongguo Shuili Shuidian Chubanshe, 2004.

Wang Liping and Zhang Binchong. *Bishu shanzhuang chunqiu*. Shijiazhuang: Hebei Jiaoyu Chubanshe, 2002.

Wang Qi. "Gugongcang Kangxi huangdi xiaoxianghua—si." *Zijincheng* 126:5 (2004): 99–101.

———. "Kangxi huangdi xiaoxianghua ji xiangguan wenti." *Gugong bowuyuan yuankan* 111:1 (2004): 40–57.

Wang Qi and Wang Siyi, eds. *Sancai tuhui*. 1609; reprint, Shanghai: Shanghai Guji Chubanshe, 1988.

Wang Qianjin and Liu Ruofang. *Qingting san da shice quantuji*. Beijing: Waiwen Chubanshe, 2007.

Wang Shuyun. *Qingdai beixun yudao he saiwai xinggong*. Beijing: Zhongguo Huanjing Kexue Chubanshe, 1989.

Wang Xiqi. *Xiaofanghuzhai yudi congchao*. Zhongguo Nanhai zhu qundao wenxian huibian, 5–6. Taipei: Taiwan Xuesheng Shuju, 1975.

Wang Yuanqi. *Yuchuang manbi*. Edited by Mao Jianbo, Jiang Yin, and Zhang Suqi. Zhongguo lidai shuxue hualun congshu. Hangzhou: Xiling Yinshe Chubanshe, 2008.

Wang Yuanqi, Sun Yueban, Song Junye, Wu Jing, and Wang Quan, eds. *Qinding Peiwenzhai shuhua pu*. 64 volumes. Beijing: s.n., 1708.

Wei Shu, Lü Yaoceng, et al., eds. *Qinding Shengjing tongzhi*. Zhongguo bianjiang congshu 1. Taipei: Wenhai Chubanshe, 1965.

Wellington, Robert. "The Cartographic Origins of Adam-Franz van der Meulen's Marly Cycle." *Print Quarterly* 28:2 (2011): 142–54.

———. "Lines of Sight: Israël Silvestre and the Axial Symbolism of Louis XIV's Gardens at Versailles." *Studies in the History of Gardens & Designed Landscapes* 37:2 (2017): 120–33.

Wen Zhengming and Kate Kerby. *An Old Chinese Garden: A Three-fold Masterpiece of Poetry, Calligraphy and Painting*. Translated by Mo Zung Chung. Shanghai: Chung Hwa Book Co., 1923.

Weng Lianxi. *Qingdai gongting banhua*. Beijing: Wenwu Chubanshe, 2001.

———. *Qingdai neifu keshu tulu*. Beijing: Beijing Chubanshe, 2004.

———. "Xin faxian de Qing Kangxi neifu yong 'Xiyang zhi' yinshu: Fu Kang Yong Qian sanchao yinshu yongzhi de dang'an jizhuan." Weixin, November 23, 2017. https://mp.weixin.qq.com/s/N4eBxEOSXQ-M2unnGlIyYg. Accessed July 4, 2018.

*Wenyuange Siku quanshu* [electronic edition]. Hong Kong: Dizhi Wenhua Chuban Youxian Gongsi, Zhongwen Daxue Chubanshe, 2002.

Wescoat, James L., and Joachim Wolschke-Bulmahn, eds. *Mughal Gardens: Sources, Places, Representations, and Prospects*. Washington, DC: Dumbarton Oaks Research Library and Collection, 1996.

West, Stephen. "Spectacle, Ritual, and Social Relations: The Son of Heaven, Citizens, and Created Space in Imperial Gardens in the Northern Song." In *Baroque Garden Cultures: Emulation, Sublimation, Subversion*, edited by Michel Conan, 291–321. Washington, DC: Dumbarton Oaks Research Library and Collection, 2008.

Whitfield, Roderick, and Wen C. Fong. *In Pursuit of Antiquity: Chinese Paintings of the Ming and Ch'ing Dynasties from the Collection of Mr. and Mrs. Earl Morse*. Princeton, NJ: Princeton University Art Museum, 1969.

Whiteman, Stephen H. "Creating the Kangxi Landscape: Bishu shanzhaung and the Mediation of Qing Imperial Identity." PhD diss., Stanford University, 2011.

———. "From Upper Camp to Mountain Villa: Recovering Historical Narratives in Qing Imperial Landscapes." *Studies in the History of Gardens & Designed Landscapes* 33:4 (2013): 249–79.

Williams, John. "Heroes within Bowshot: Examination Administration, the Lower Yangzi Delta, and the Qing Consolidation of Empire, 1645–1720." *Late Imperial China* 30:1 (2009): 48–84.

Winichakul, Thongchai. *Siam Mapped: A History of the Geo-Body of a Nation*. Honolulu: University of Hawai'i Press, 1994.

Wong, Young-tsu. *A Paradise Lost: The Imperial Garden Yuanming Yuan*. Honolulu: University of Hawai'i Press, 2001.

Wood, Frances, ed. *Chinese Studies: Papers Presented at a Colloquium at the School of Oriental and African Studies, University of London, 24–26 August 1987*. Sponsored Jointly by the British Library, the School of Oriental and Afri-

can Studies, University of London and the China Library Group. London: British Library, 1988.

Woodward, David, ed. *Cartography in the European Renaissance*. Vol. 3, part 1 of *History of Cartography*. Chicago: University of Chicago Press, 1998.

Wright, Suzanne E. "'Luoxuan biangu jianpu' and 'Shizhuzhai jianpu': Two Late-Ming Catalogues of Letter Paper Designs." *Artibus Asiae* 63:1 (2003): 69–122.

Wu, K. T. "Ming Printing and Printers." *Harvard Journal of Asiatic Studies* 7:3 (1943): 203–60.

Wu, Pei-yi. *The Confucian's Progress: Autobiographical Writings in Traditional China*. Princeton, NJ: Princeton University Press, 1990.

Wu, Silas H. L. *Communication and Imperial Control in China: Evolution of the Palace Memorial System, 1693–1735*. Cambridge, MA: Harvard University Press, 1970.

———. "Emperors at Work: The Daily Schedules of the K'ang-hsi and Yung-cheng Emperors, 1661–1735." *Tsinghua Journal of Chinese Studies* (n.s.) 8:1–2 (1970): 210–27.

———. *Passage to Power: K'ang-hsi and His Heir Apparent, 1661–1722*. Cambridge, MA: Harvard University Press, 1979.

Wu Hung. *The Double Screen: Medium and Representation in Chinese Painting*. London: Reaktion Books, 1996.

Xiang Si. "Wuyingdian keben zhi zuanxiu." *Zijincheng* 1 (2005): 46–52.

———. *Zhongguo gongting shanben*. Beijing: Wenwu Chubanshe, 2003.

Xiao Tong. *Wen Xuan, or, Selections of Refined Literature*. Translated by David R. Knechtges. Princeton Library of Asian Translations. Princeton, NJ: Princeton University Press, 1982.

Xiao Yishan. *Qingdai tongshi*. 5 volumes. Beijing: Zhonghua Shuju, 1986.

Xu Jianrong. "Bidi jin'gangchu—Wang Yuanqi yishu jianlun." In *Wang Yuanqi huaji*, edited by Xu Jianrong, 1–5. Shanghai: Shanghai Renmin Meishu Chubanshe, 1996.

———, ed. *Wang Yuanqi huaji*. Shanghai: Shanghai Renmin Meishu Chubanshe, 1996.

Yan Yong and Fang Hongjun, eds. *Tianchao yiguan: Gugong bowuyuan cang Qingdai gongting fushi jingpinzhan*. Beijing: Zijincheng Chubanshe, 2008.

Yang Bin. *Liubian jilüe*. Edited by Yang Lixin. Changchun: Jilin Wenshi Chubanshe, 1993.

Yang Boda. "Leng Mei ji qi 'Bishu shanzhuang tu.'" *Gugong bowuyuan yuankan* 1 (1979): 51–61.

———. *Qingdai yuanhua*. Beijing: Zijincheng Chubanshe, 1993.

———. "Tung Ch'i-ch'ang and Ch'ing Dynasty Academy Painting." In *Proceedings of the Tung Ch'i-ch'ang International Symposium*, edited by Wai-ching Ho et al., 15-1–15.25. Kansas City: Nelson-Atkins Museum of Art, 1991.

Yang Jianfeng. *Wang Yuanqi*. 2 volumes. Zhongguo lidai shuhua mingjia jingdian daxi. Nanchang: Jiangxi Meishu Chubanshe, 2009.

Yang Tianzai. *Bishu shanzhuang beiwen shiyi*. Beijing: Zijincheng Chubanshe, 1985.

Yang Yongsheng, ed. *Wang Yuanqi huaji*. 2 volumes. Beijing: Zhongguo Minzu Sheying Chubanshe, 2003.

Yee, Cordell D. K. "Traditional Chinese Cartography and the Myth of Westernization." In *Cartography in the Traditional East and Southeast Asian Societies*, edited by J. B. Harley and David Woodward, 170–202. Vol. 2, part 2 of *The History of Cartography*, Chicago: University of Chicago Press, 1994.

Yeh, Wen-Hsin. "Introduction: The Spatial Culture of Neo-Confucian China." In *Landscape, Culture, and Power in Chinese Society*, edited by Wen-Hsin Yeh, ix–xv. Berkeley: Institute of East Asian Studies, University of California–Berkeley, Center for Chinese Studies, 1998.

———, ed. *Landscape, Culture, and Power in Chinese Society*. Berkeley: Institute of East Asian Studies, University of California–Berkeley, Center for Chinese Studies, 1998.

Yu, Pauline. *The Reading of Imagery in the Chinese Poetic Tradition*. Princeton, NJ: Princeton University Press, 1987.

Yu Jianhua. *Zhongguo meishujia renming cidian*. Shanghai: Shanghai Renmin Meishu Chubanshe, 2004.

Yuan Senpo. "Qingdai kouwai xinggong de youlai yu Chengde Bishu shanzhuang de fazhan guocheng." *Qingshi luncong* 2 (1980): 286–319.

Yuntao. *Qinding Daqing huidian*. Yingyin Wenyuange Siku quanshu, sec. 619. Taipei: Taiwan Shangwu Yinshuguan, 1983.

Zang Lihe. *Zhongguo gujin diming da cidian*. Hong Kong: Shangwu Yinshuguan, 1982.

Zarrow, Peter. "The Imperial Word in Stone: Stele Inscriptions at Chengde." In *New Qing Imperial History: The Making of Inner Asian Empire at Qing Chengde*, edited by James A. Millward, Ruth W. Dunnell, Mark C. Elliott, and Philippe Forêt, 146–64. London: Routledge, 2004.

Zhang Geng. *Guochao huazheng lu*. In *Zhongguo shuhua quanshu*, vol. 10, edited by Lu Fusheng, 423–59. Shanghai: Shanghai Shuhua Chubanshe, 2000.

Zhang Hongxing, ed. *Masterpieces of Chinese Painting, 700–1900*. London: Victoria and Albert Museum, 2013.

Zhang Lihuan and Wang Xingfeng. "Jianzhu de yuezhang—Bishu shanzhuang gujianzhu yishu tanwei." In *Jinian Bishu shanzhuang jianyuan sanbai zhounian lunwenji*, edited by Zhao Ling, 233–39. Shenyang: Liaoning Minzu Chubanshe, 2005.

Zhang Yajie. "Bishu shanzhuang qishi'er jing mingming de meixu yuanze chutan." *Wenwu chunqiu* 3 (1997): 56–58.

Zhang Yushu. "Hucong ciyou ji." In *Dongbei shizhi*, 1–5. Vol. 7 of *Zhongguo bianjiang shizhi jicheng*. Beijing: Quanguo Tushuguan Wenxian Suowei Fuzhi Zhongxin, 2004.

Zhang Yushu, Cheng Tingjing, et al., eds. *Kangxi zidian*. https://ctext.org/kangxi-zidian.

Zhang Yushu, Wang Hao, et al., eds. *Peiwen yunfu*. 106 volumes. Beijing: Wuyingdian, 1711.

Zhang Yuxin. *Bishu shanzhuang de zaoyuan yishu*. Beijing: Wenwu Chubanshe, 1991.

Zhao Ling, ed. *Jinian Bishu shanzhuang jianyuan sanbai zhounian lunwenji*. Shenyang: Liaoning Renmin Chubanshe, 2005.

Zhao Ling and Niu Bochen. *Bishu shanzhuang ji zhouwei simiao*. Xi'an: Sanqin Chubanshe, 2003.

Zheng Wei. "Wang Yuanqi nianbiao." *Duoyun: Zhongguo huihua yanjiu jikan* 4 (1992): 88–119.

Zhi Yunting. "Bishu shanzhuang ji qi jianzhu yu Kangxi zhu di shaoshu minzu zhengce." In *Qingshi yanjiu yu Bishu shanzhuang*, edited by Dai Yi, 82–84. Shenyang: Liaoning Minzu Chubanshe, 2005.

Zhongguo diyi lishi dang'an guan, ed. *Kangxi chao Hanwen zhupi zhouzhe huibian*. Beijing: Dang'an Chubanshe, 1984.

———. *Kangxi chao Manwen zhupi zouzhe quanyi*. Beijing: Zhongguo Shehui Kexue Chubanshe, 1996.

*Zhongguo gudai banhua congkan erbian*. Shanghai: Shanghai Guji Chubanshe, 1994.

Zhongguo gudai shuhua jiandingzu, ed. *Zhongguo huihua quanji*. Beijing: Wenwu Chubanshe; Zhejiang Renmin Meishu Chubanshe, 2001.

Zhongguo lishi bowuguan tushu ziliao zhongxin, ed. *Zhongguo lishi bowuguancang putong guji mulu*. Beijing: Beijing Tushuguan Chubanshe, 2002.

Zhongguo meishu quanji bianji weiyuanhui, ed. *Zhongguo meishu quanji*. Shanghai: Shanghai Renmin Meishu Chubanshe, 1989.

Zhu Chengru, ed. *Qingshi tudian: Qingchao tongshi tulu*, vols. 3–4, *Kangxi chao*. Beijing: Zijincheng Chubanshe, 2002.

Zhu Saihong, ed. *Qingdai chixiu shuji yuzhi xuba ji banshi liuzhen*. 8 volumes. Beijing: Beijing Tushuguan Chubanshe, 2001.

Zhuang Jifa. "Bishu shanzhuang yu Qingdai qianqi de zhengzhi huodong." In *Shanzhuang yanjiu: Jinian Chengde Bishu shanzhuang jianyuan 290 zhounian lunwenji*, edited by Dai Yi, 42–70. Beijing: Zijincheng Chubanshe, 1994.

Zhuang Yue and Wang Qiheng. "Zhongguo chuantong jieshixue yu Bishu shanzhuang yuanlin yishu chuangzuo." In *Qingshi yanjiu yu Bishu shanzhuang*, edited by Dai Yi, 246–53. Shenyang: Liaoning Minzu Chubanshe, 2005.

Zou, Hui. *A Jesuit Garden in Beijing and Early Modern Chinese Culture*. West Lafayette: University of Indiana Press, 2011.

———. "*Jing* (景): A Phenomenological Perspective on Chinese Landscape and *Qing* (情)." *Journal of Chinese Philosophy* 35:2 (2008): 353–68.

———. "The *Jing* of a Perspective Garden." *Studies in the History of Gardens & Designed Landscapes* 22:4 (2002): 293–326.

———. "The *Jing* of Line-Method: A Perspective Garden in the Garden of Round Brightness." PhD diss., McGill University, 2005.

Zou Ailian, ed. *Qingdai qijuzhu ce, Kangxi chao*. Beijing: Zhonghua Shuju, 2009.

# Index

agriculture, 90–92
Aihu (Tumen) River, 67, 68, 69*map*, 71, 238nn39,63
Aisin Gioro, 67, 74
Alberti, Leon Battista, 142, 144
Allegory Mountain (Yushan), 197–98, 199*fig.*, 203–4. *See also* Qi Biaojia
Almost-a-Villa Hall (Ruoshutang; in garden of Wang Xianchen), 168, 199, 243n51
Altai mountains (Jinshan), 76–77, 78
Ames, Roger, "rhetorical landscapes," 6, 244n6
*Amusements in the Xuande Emperor's Palace* (Zhu Zhanji xingletu; anon.), 194–95*fig.*, 195
Aohan Confederacy, 18, 96
Argent, Pierre d', "View of Besançon," 140–44, 143*fig.*, 145, 146
art history, 10
astronomy, 132, 150, 230
asyndeton, 202, 215
Aurangzeb, 5, 185
auspicious landscapes, 68, 70–76, 82, 91, 114–23, 192, 227
axiality, 36

banquets, 6, 55, 95, 97, 158, 226, 244n5; Zhang Yushu's experiences of, 16, 17, 41, 191
Beijing, 2*map*; Eight Scenes of, 122, 197; Forbidden City, 36, 62, 122; gardens, 36, 37*fig.*, 91, 112, 122, 208, 240n43; Jesuit North Church, 144; as Jin capital, 98
*bi* (natural principles) and *xing* (hidden emotional responses), 226–27
Bianliang (Kaifeng), 2*map*, 111
Bishu Shanzhuang, 32; plaque in Kangxi's calligraphy, 32, 81. *See also* Mountain Estate to Escape the Heat
Bishu Shanzhuang Gate, 23*map*, 34*fig.*, 81, 92, 147
Bishu Shanzhuang Historical GIS, xix
*Bishu Shanzhuang tu*. See *View of Rehe*
Black Mountain (Heishan), 75–76
Blessings of Spring Studio (Chunhaoxuan), 91
blue-and-green (*qinglü*) style, 113, 114–16, 181
Board of Rites (Libu), 67, 118, 132
Board of Works (Gongbu), 22, 118, 132–34

boating, 16–18, 28, 39–43, 40*map*, 41*fig.*, 191; boathouses, 17, 39–40, 218, 236n27; as device in landscape narratives and garden portraits, 198, 203, 206, 220, 236n31
*Book of Changes* (Yijing): Adytum for the Study of the *Book of Changes*, 204; Eight Trigrams, 76; "Great Treatise," 226
border zones, 84
"borrowed views" (*jiejing*), 34, 37
Braun, Georg, *Civitates orbis terrarum*, 140–42, 143*fig.*, 145, 146, 241n76
Buddhism, 51–54; Lamaist, 94; and rule over the Mongols, 52, 54, 93–94
Buddhist painting, 111
Buddhist temples, 16, 24, 46, 51–54, 53*map*. *See also* Temple of Universal Benevolence; Temple of Universal Peace
Bukuri, Mount, 67
Bukuri Yongson, 67
Bulhuri, Lake, 67
Bureau of the Pictorial Record of Longevity (Wanshou shuhua ju), 160

cadastral survey, 65
Cahill, James, 140, 142
Calm and Tranquil, Reverent and Sincere (Danbo Jingcheng; throne room), 34*fig.*, 36
*Capturing the Flag at the Reservoir of Metal's Luster* (Zhang Zeduan), 193, 194*fig.*, 195. *See also* Reservoir of Metal's Luster
cartography: city views, 140–43, 145–46, 241n76; European methods, 131–32; and the Manchu homeland, 65, 67; mapping as critical method, xix; and Qing territorial control, 59–60; Rehe and Qing geography, 76–77, 77*map*, 78; *View of Rehe* and, 138–44, 150. *See also* *Kangxi Atlas*
Castiglione, Giuseppe, 145
center and periphery, 28, 93–95, 102, 193, 225, 228, 245n48
Cézanne, Paul, 243n46
Changbai, Mount (Changbaishan): auspicious landscape of, 68–72; from *Complete Collection of Images and Writings*, 73*fig.*; *fengshan* sacrifices at, 64, 67; in *History of the Jin*, 66; in Kangxi's poetry, 71; on Kangxi's tours, 67; Lake Tamun, 66, 71; in Qing geography, 2*map*, 63–71,

Changbai, Mount (Changbaishan) (*cont.*) 71–74, 77, 94;
in "Record of the Mountain Estate," 79, 82; rivers of, 67,
68, 71–72, 99; as source of mountain veins, 68–69*map*,
68–72, 73, 75, 76–77, 77*map*, 78

*chaojin* (presenting oneself before the throne), 55, 94

Chen Baosen, 24, 26, 30, 235–36n5, 236n9

Chen Ruyan, *Mountains of the Immortals*, 240n27

Chengde, 2*fig.*, 3. *See also* Mountain Estate to Escape the
Heat; Rehe

Cherishing Munificence Pavilion (Hanrunting), 40

Chime Hammer Peak (Qingchuifeng), 118, 136, 147, 217

chorography, 78, 140–46. *See also* cartography

Church of Saint Ignatius of Loyola (Rome), 241n52

cities, districts of, 83, 238n6

city views, 140–43, 145–46, 241n76

Clear Jade Pavilion (Qingbiting), 107*map*, 130, 138

Clear Lake (Chenghu), 23*map*, 38, 40*map*, 43, 101, 236n25

Clear Ripples with Layers of Greenery (Chengbo Diecui):
copperplate engraving signed by Zhang Kui, 157*fig.*, 184;
name-tablet over gate, 16; print by Shen Yu et al., 174,
175*fig.*; shifting of name, 236n11; view noted by Zhang
Yushu, 17, 19; as waterside pavilion and landing, 40

Clear Sounds of a Spring in the Breeze (Fengquan
Qingting), 44, 45*map*, 49–50

Clear Spring Circling the Rocks (Chengquan Raoshi),
213–14, 214*fig.*

Cloud Falls (Yunpu), 48

Clouds and Peaks on All Sides (Simian Yunshan), 26, 29*map*;
depicted by Leng Mei, 107*map*, 133*map*, 137*map*, 138,
139*map*, 147; in *Imperial Poems*, 164–65, 165*fig.*, 214, 214*fig.*

Clouds Remain as Water Flows On (Shuiliu Yunzai), 218,
221*fig.*

Cloudy Pine Gorge (Songyunxia), 18n9, 23*map*, 24, 26,
27*map*, 29*map*, 48

Clunas, Craig, 202

Colorful Painting of Cloudy Mountains (Yunshan Yanhua),
16, 16n3

concubines, compound for, 24

Confucian governance, 34, 75, 85, 93, 94, 110

Confucius, ancestral home of (Qufu), 2*map*, 64

copperplate engravings: "Clear Ripples with Layers of
Greenery," signed by Zhang Kui, 157*fig.*, 184; of *Imperial
Poems*, 151–52, 154, 155–56, 159, 184–86, 187–88, 242n11,
243n34; of *Kangxi Atlas*, 237n33; "Morning Mist by the
Western Ridge," attrib. to Matteo Ripa, 157*fig.*, 184

court paintings: Kangxi period, 112–13, 152, 154–9, 181;
Qianlong period, 116, 144, 242n2; *View of Rehe* as, 150. *See
also* Castiglione, Giuseppe; Dai Tianrui; Dong Bangda;
Fan Kuan; *Fuling*; Gherardini, Giovanni; Guo Zhongshu;
Huang Ding; Jiao Bingzhen; Leng Mei; Li Cheng; Qian
Weicheng; Shen Yu; Song Junye; Wang Yuanqi; Zhang
Zongcang

cranes, 49, 105, 115, 116

Dai Tianrui, 154, 186–87; "*Lingzhi* Path on an Embankment
to the Clouds," 187*fig.*

Daoism, 64. *See also* Daoist temples; immortal realms,
paintings of

Daoist temples, 52. *See also* Pavilion of the Supreme God

Dardess, John, 238n6

de Certeau, Michel, 202, 221, 244nn15,26, 245nn39,43,63

deer, 89, 92, 97, 105, 115–16

*Diaries of Activity and Repose* (Qijuzhu), 54, 55, 132, 236n18

digital elevation models (DEMs), xix, 241n67

*ding* tripod, 75, 203

documentary painting, 195–96

Dong Bangda, 174

Dong Qichang, 156, 158, 163, 170, 243n52

Dong Yuan (Beiyuan), 155, 163, 171, 172, 176

Dorgon, 65

Dragon King, temple of (Lingze Longwangmiao), 18, 24, 26,
27*map*, 29*map*, 45*map*, 52, 53*map*, 107*map*, 138

dragon veins (*longmai*), 68, 71–72, 74, 76, 118. *See also*
mountain veins

Du Qiong, *Befriending the Pines* (Yousongtu), 245n42

dykes, 15, 22, 95, 120, 220

Eastern China, 2*map*; key sites in, 2–3*map*

Eastern Palace (Donggong), 92

Eight Outer Temples (Waibamiao), 51–52, 54

*Eight Scenes of Beijing* (Beijing Bajingtu; Wang Fu et al.),
122

Eight Trigrams (Bagua), 76, 266

*Elegant Gathering in the Apricot Garden* (Xinyuan yaji tu; by
and after Xie Huan), 245n42

Elias, Norbert, 5–6, 235n7

Elliott, Mark, 64

Emerald Spring Cliff (Yongcuiyan), 45*map*, 47*fig.*, 49;
temple, 46, 54

*Emperor Minghuang's Palace to Escape the Heat* (Minghuang
Bishugong tu; attrib. Guo Zhongshu), 108–10, 109*fig.*, 114

Encircling Jade (Huanbi) Island, 16n3, 22, 23*map*, 25*map*,
176

European artistic techniques, 106, 108, 145, 184–85, 228–30.
*See also* city views; copperplate engraving; perspective

Fan Kuan, 114, 128, 163; Wang Yuanqi's landscapes after, 176,
243n66

fan painting, 158, 159, 184

Fangsheng Pavilion (Fangshengting at West Lake), 96

Fe Ala, 98

*fengshan* sacrifices, 64, 67

finger-painting (*zhihua*), 186

Five Sacred Mountains (Wuyue), 64, 67, 70, 77

floating cups pavilion (*liubeiting*), 19, 24, 27*map*, 30, 48, 92,
97, 236n10; gate, 23*map*. *See also* Scent of Lotuses by a
Winding Stream

Fontainebleau, view of, 146, 148–49*fig.*, 185

Forbidden City, 5, 36, 62, 91, 122

Forest of the Law Temple (Falinsi), 24, 25*map*, 52, 53, 53*map*

Forêt, Philippe, 51, 74

Former Liang dynasty, 225–26

Four Masters of the Yuan, 163. *See also* Huang Gongwang;
Ni Zan; Wang Meng; Wu Zhen

Four Wangs (si Wang), 242n23. *See also* Wang Hui; Wang
Shimin; Wang Yuanqi

Fragrant Islet by Flowing Waters (Fangzhu Linliu), 19, 213, 213*fig.*

Fragrant Waters and Beautiful Cliffs (Shuifang Yanxiu), 16, 22, 53, 89, 218–19*fig.*

*Fuling* (anonymous court painting), 118, 118–19*fig.*, 120, 228

Fuling (tomb of Nurhaci), 70, 118

Gao Kegong, 163, 171

Gao Shiqi, 113, 156

garden albums, 196–98, 221, 224, 244–45n36; figures in, 203, 207–8; organization of, 201–10. *See also* garden portraits; *Imperial Poems on the Mountain Estate to Escape the Heat*; Qi Biaojia: *Footnotes on Allegory Mountain*; Wen Zhengming: *Garden of the Artless Official*; Zhang Hong: *Garden to Rest In*

garden design, 32–34, 36–38, 56, 95, 112, 191; imperial gardens, 36, 122, 240n43; mountains in, 99–100; "one pond, three mountain" plan, 121–22, 240n40; private gardens, 38, 54; water in, 38, 42–43. *See also* gardens

Garden of Abundant Benevolence (Fengzeyuan; Beijing), 91

Garden of Joyful Spring (Changchunyuan; suburban Beijing), 36, 62, 91, 242n24; plan of, 37*fig.*

Garden of Perfect Brightness (Yuanmingyuan; suburban Beijing), 36, 112, 159, 208, 240n43

Garden of Ten Thousand Trees (Wanshuyuan), 17, 23*map*, 24, 25*map*, 91, 130, 136, 218; Qianlong's temples in, 52; as representing the steppe, 97, 100, 101; on route to northeast section of park, 27*map*, 28

Garden of the Artless Official (Zhuozhengyuan; Suzhou), 168, 197, 198–99. *See also* Wen Zhengming: *Garden of the Artless Official*

garden painting, 185. *See also* garden albums; garden portraits

garden portraits, 150, 162, 180, 196, 212, 218, 223, 244–45n36, 245n42; of Wang Xianchen, 168, 199, 200, 202–3, 243n51. *See also* garden albums

garden writing, 81, 196. *See also* garden albums

gardens: farm plots, 91–92, 218; French, 146, 185; imperial, 5, 36, 92, 121–22, 185, 192–93, 235n6, 240n43; as metaphors, 3, 200; naming and literary commemoration, 181. *See also* garden albums; garden design; garden portraits

*Gentlewomen in the Shade of a Paulownia Tree* (Tongyin shinü tuping; anon.), 129, 129*fig.*, 130, 143, 144, 146, 149

geomancy, 64, 68–78, 82, 118–20, 240n34. *See also* auspicious landscapes

Gerbillon, Jean-François, 132

Gherardini, Giovanni, 144, 156; studio of, 129, 227

ghost's gate (*guimen*), 118

Gioro Umuna, 67, 71

Girin Ula, 67, 71

*Going Upriver at Qingming Time* (Qingming shanghe tu; attrib. Zhang Zeduan), 111

Gold Mountain (Jinshan), 73–76, 79, 238n66

Gold Mountain island and temple (Jinshan), 23*map*, 24, 25*map*, 40, 52, 74, 107*map*, 236n13; dating of, 24, 30, 31, 147–48; in "The Entire Sky Is Exuberant" (Shen Yu), 30*fig. See also* Pavilion of the Supreme God

Gold Mountain temple (Nanjing), 30, 31, 31*fig.*

Golden Lotuses Reflecting the Sun (Jinlian Yingri), 19, 217, 220*fig.*

Great Wall, 2*map*, 60, 84, 86, 100–1, 239n70. *See also guannei* and *guanwai*

Greater Khingan mountains (Heishan), 76–77, 77*map*, 78

Grimaldi, Claudio Filippo, 132

Guan Tong, 114, 163, 171; Wang Yuanqi's landscape after, 172, 172–73*fig. See also* Jing Guan

*guannei* and *guanwai* (within and beyond the passes), 59–60, 72, 77, 100, 101. *See also* center and periphery

Guanyin, 52

Guizhou, 59

Guo Xi, 128

Guo Zhongshu: *Emperor Minghuang's Palace to Escape the Heat* (attrib.), 108–10, 109*fig.*, 114

Haixi Garrison, 84

Half Moon Lake (Banyuehu), 23*map*, 38, 45*map*, 48, 213

Hall, David, "rhetorical landscapes," 6, 244n6

Han Wudi, 122

handscrolls, 111–12, 122, 154, 160, 193, 196, 202, 215; *Imperial Poems* joined as, 210–11*fig.*, 211; of Wang Yuanqi, 162, 163*fig.*, 211–12

Hanlin Academy, 16, 156

Hazelnut Glen (Zhenziyu), 18, 23*map*, 27*map*, 29*map*, 33*map*, 35*map*, 44, 49

Hetu Ala (Xingjing), 69*map*, 70–71, 72, 77*map*, 98. *See also* Naluwoji

High Qing (Da Qing shengshi), 4, 51

*History of the Jin* (Jinshi), 66

Hogenberg, Franz, *Civitates orbis terrarum*, 140–42, 143*fig.*, 241n76

Hong Taiji, tomb of (Zhaoling), 66, 70

Hua, Mount (Huashan), 2*map*, 68, 69*map*, 77, 77*map*, 78

Huang Ding, 174

Huang Gongwang (Dachi), 113, 115, 156, 163, 171; in *Mustard Seed Garden Manual*, 166, 166*fig.*; Wang Yuanqi's landscapes after, 172, 243n65

Huang Xiangjian, 241n65

*huangye* (open fields grown wild), 83–85, 90, 101–2

Huayugou, 94

Huifa River, 71

Huilan Rock (Huilanshi; Huangzhou, Hubei), 96

Huishan Cizong, 197

hunting, 21, 85, 92, 95, 101, 218; hunting grounds, 63, 97, 192; as part of tours and diplomacy, 22, 54–55, 67, 82, 85, 94, 95, 228. *See also* Mulan Hunting Grounds

hydrology, xix, 20, 22–23*map*, 38–39, 43–44, 44–45*map*, 48–49, 99. *See also* water systems

*Images of Tilling and Weaving. See Imperially Composed Images of Tilling and Weaving*

Immense Field with Shady Groves (Futian Congyue), 19, 218, 221*fig.*

immortal realms, 110; paintings of, 114–15, 240nn24,27

imperial gazetteers, 65; Ming, 74; of Rehe (Qianlong era), 9, 24, 235n14; of Shengjing, 70

imperial gifts, 55, 92, 94–95, 158, 183

Imperial Household Department (Neiwufu), 22, 48, 134, 155, 242n13

imperial modesty, 36, 55, 89–90, 110, 227

imperial patronage, 11, 52, 81; of court art and artists, 158, 162, 171, 174, 182

*Imperial Poems* (scenes in sequence): "Misty Ripples Bringing Brisk Air" (scene 1), 87*fig.*, 208–10, 216–17*fig.*; "*Lingzhi* Path on an Embankment to the Clouds" (scene 2), 20–21*fig.*, 86–88, 187*fig.*, 210, 216–17*fig.*; "Un-Summerly Clear and Cool" (scene 3), 88, 88*fig.*, 210, 216–17*fig.*; "Inviting the Breeze Lodge" (scene 4), 210, 218–19*fig.*; "Fragrant Waters and Beautiful Cliffs" (scene 5), 89, 210, 218–19*fig.*; "Pine Winds through Myriad Vales" (scene 6), 176, 180*fig.*, 181*fig.*, 210–11, 214–15, 214–15*fig.*; "Sonorous Pines and Cranes" (scene 7), 46*fig.*, 49, 214–15, 214–15*fig.*; "Scenes of Clouds and Mountains" (scene 8), 38–39*fig.*, 214–15, 214–15*fig.*; "Clouds and Peaks on All Sides" (scene 9), 164–65, 165*fig.*, 214–15, 214–15*fig.*; "Northern Post Linking Paired Peaks" (scene 10), 74–76, 214–15, 214–15*fig.*; "Morning Mist by the Western Ridge" (scene 11), 153*fig.*, 157*fig.*, 215, 218–19*fig.*; "Sunset at Hammer Peak" (scene 12), 215, 217, 218–19*fig.*; "Southern Mountains Piled with Snow" (scene 13), 174–76, 175*fig.*, 176*fig.*; "The Scent of Lotuses by a Winding Stream" (scene 15), 245n52; "Clear Sounds of a Spring in the Breeze" (scene 16), 49–50; "Untrammeled Thoughts by the Hao and Pu Rivers" (scene 17), 99*fig.*, 100–101, 174, 245n51; "The Entire Sky Is Exuberant" (scene 18), 30, 30*fig.*, 245n51; "Warm Currents and Balmy Ripples" (scene 19), 218–19*fig.*, 236n10; "Fountainhead in a Cliff" (scene 20), 218–19*fig.*; "Verdant Isle of Green Maples" (scene 21), 176, 178*fig.*; "Orioles Warbling in the Tall Trees" (scene 22), 98*fig.*, 100, 101, 174; "Fragrance Grows Purer in the Distance" (scene 23), 245n52; "Golden Lotuses Reflecting the Sun" (scene 24), 217, 220*fig.*; "Sounds of a Spring Near and Far" (scene 25), 47*fig.*, 49, 174, 217, 220*fig.*; "Moon Boat with Cloud Sails" (scene 26), 213, 213*fig.*; "Fragrant Islet by Flowing Waters" (scene 27), 213, 213*fig.*; "Shapes of Clouds and Figures in the Water" (scene 28), 213–14, 214*fig.*; "Clear Spring Circling the Rocks" (scene 29), 213–14, 214*fig.*; scenes 24–29 joined as a handscroll, 210–11*fig.*, 211; "Clear Ripples with Layers of Greenery" (scene 30), 157*fig.*, 174, 175*fig.*, 184; "Clouds and Peaks in the Mirroring Water" (scene 32), 30; "Pair of Lakes Like Flanking Mirrors" (scene 33), 216–17*fig.*; "Long Rainbow Sipping White Silk" (scene 34), 216–17*fig.*; "Immense Field with Shady Groves" (scene 35), 218, 221*fig.*; "Clouds Remain as Water Flows On" (scene 36), 218, 221*fig. See also* Shen Yu

*Imperial Poems on the Mountain Estate to Escape the Heat* (Yuzhi Bishu Shanzhuang shi): absence of figures in, 222–24; as access to emperor, 192–93, 223–24; as autobiographical landscape, 200–1, 218; calligraphy of, 182, 184, 187; compositional models, 174–78; copperplate engravings, 151, 154, 155, 159, 184–85, 187–88, 243n34, 244n79; and European garden depiction, 185; evocation of cultural landscapes, 50, 96, 97; framing device

for, 223; and garden albums, 196–201; and imperial legitimacy, 85–86; Kangxi's involvement in, 182–84, 188; northern zone scenic sites in, 28; "open fields grown wild" (*huangye*), 90, 101–2; order and compositional groupings, 201, 208–18, 218, 245n48; prefaces and verses by Kangxi, 49–50, 74–75, 82, 85–90; as project in several iterations, 6, 151–53, 159–60, 182, 184, 186–88, 243n34; publication and print run of, 32, 183, 242n11, 243n74; Qianlong-era versions of, 174, 243n60; space and place in, 222–23, 245n63; thirty-six scenes of, 32, 100, 151, 154, 174, 201, 211, 223; viewpoints of, 100–101, 210–11, 222–23; as virtual tour of Mountain Estate, 6, 32, 188, 196, 201, 210, 224; water in, 42, 49–50. See also *Imperial Poems* (scenes in sequence); "Record of the Mountain Estate to Escape the Heat"; Ripa, Matteo; Wang Yuanqi

imperial princes' study, 16, 16n3

imperial tombs, 62, 66, 67, 70, 118, 118–19*fig.*, 240n33

imperial tours, 54–55, 62–64, 68, 82–83, 87, 191; depicted by Wang Hui, 110–11*fig.*, 111–12, 113. See also *Kangxi Emperor's Southern Inspection Tour*

*Imperially Commissioned Gazetteer of Shengjing* (Qinding Shengjing tongzhi), 70

*Imperially Composed Images of Tilling and Weaving* (Gengzhi tu; Kangxi; Jiao Bingzhen et al.), 90–91, 116, 149, 152, 155, 160, 186; facing leaves by Leng Mei, 212, 212*fig.*; vantage point in, 129–30, 131*fig.*

*Imperially Endorsed Complete Collection of Images and Writings from Antiquity to the Present* (Qinding Gujin tushu jicheng), 31*fig.*, 65, 71, 73, 73*fig.*, 159

*Imperially Selected Tang Poems* (Yuxuan Tangshi), 243n74

inner and outer circuits, 26–28, 29*map*, 31–32

Inner Asian relations, 52–55, 82, 93–95. *See also* Mongols

Inner Lake (Neihu), 23*map*, 24, 38, 39, 40*map*, 45*map*, 46, 47, 48, 96

Inviting the Breeze Lodge (Yanxun Shanguan), 16, 22, 218–19*fig.*

Islands of the Immortals (Fangzhang, Penglai, Yingzhou), 122

itineraries: described by Zhang Yushu, 15–19, 24–26, 26–27*map*, 30, 31; inner and outer circuits, 26–28, 31–32; made accessible by *Imperial Poems*, 9, 32, 188, 197, 201, 210, 224; by water, 39–41, 40*map*

Jade Peak Temple (Bifengsi, 1764), 44–46, 45*map*, 49

Jesuit Church (Vienna), 241n52

Jesuit North Church (Beitang, Beijing), 144

Jesuits, 129, 131–32, 144, 227

Jiang Shen, 172

Jiang Tingxi, 158–59, 239n61, 243n30

Jianzhang Palace gardens (of Han Wudi), 122

Jianzhou Garrison, 67, 70, 84–85

Jiao Bingzhen, 112, 129, 132, 144, 160, 243n37; *Buildings in Landscapes*, 112, 112–13*fig.*, 130. See also *Imperially Composed Images of Tilling and Weaving*

Jiaqing emperor, 4

*jiehua* (boundary painting), 109–12, 115, 116, 155

Jin dynasty (265–420), 225–26

Jin dynasty (1115–1234), 66, 70, 84, 97, 98, 112

*jing* (scene), xvii, 222

Jing Guan, Wang Yuanqi's landscapes after, 172, 172–73*fig*., 243n65. *See also* Guan Tong; Jing Hao

Jing Hao, 114, 163, 171; Wang Yuanqi's landscape after, 172, 172–73*fig*. *See also* Jing Guan

Jingzong (Liao emperor), 70

Jinshan temple (Nanjing), 30, 31, 31*fig*.

Jiweng, Master, Wang Yuanqi's paintings for, 162, 167, 169, 180–82

Juran, 114, 155, 163, 171; Wang Yuanqi's landscape after, 174–76, 176–77*fig*., 243n66

Jurchens, 65, 66, 67, 74, 82, 84

Kaiyun, Mount (Kaiyunshan), 68

Kalahetun, 94

*Kangxi Atlas* (*Map of a Complete Survey of Imperial Territories*; Huangyu quanlan tu), 59–60, 60–61*fig*., 65–66, 132, 156, 237n33

*Kangxi Dictionary* (Kangxi zidian), 83

Kangxi emperor: as benevolent and virtuous ruler, 85–92, 225–27; calligraphy of, 6, 28, 32, 55, 95, 158; "Mount Tai's Mountain Veins Originate in Mount Changbai" essay, 68–70, 71–73, 77–78, 238n48; poetry of, 6, 50, 71, 75–76, 85–86, 88, 89; project for new summer palace at Rehe, 4–5, 21–22, 93, 95, 235n1(chap. 1); rites for ancestors, 66–67; sixtieth birthday celebrations, 93–94, 105, 149, 154, 160, 183; sojourns at Rehe, 21–22, 94–95, 236n6; temple policy, 51–54. *See also Imperial Poems on the Mountain Estate to Escape the Heat*; imperial tours; *Imperially Composed Images of Tilling and Weaving*; Inner Asian relations; *Kangxi Emperor's Southern Inspection Tour*; *Kangxi Reading*; "Record of the Mountain Estate to Escape the Heat"

*Kangxi Emperor's Southern Inspection Tour* (Kangxi Nanxuntu; Wang Hui): as documentary painting, 195; formal characteristics of, 149, 152, 179; and the Orthodox School, 113, 180; project director, 159; "Shaoxing and the Temple of Yu" (scroll 9), 116–17*fig*.; as symbolic landscape, 116; "Wuxi to Suzhou" (scroll 7), 110–11*fig*., 111–12

*Kangxi Reading* (anonymous portrait), 228–30; "Chinese-style" portrait, 7*fig*., 129–30, 193–95, 227–28; "European-style" portrait, 228–30, 229*fig*.

kilns, 22

*King's Cabinet* (Cabinet du roi), 145–46, 148–49*fig*., 185–86, 186*fig*. *See also* Silvestre, Israël

Korea, 59, 66, 68

Kunlun, Mount (Kunlunshan), 50

lakes, 22, 23*map*, 24, 28, 38–39, 40*map*, 42, 95–96, 236n24; as auspicious landscape, 120–21; trees near, 16–17. *See also* Clear Lake; Half Moon Lake; Inner Lake; Lower Lake; Mirror Lake; Ruyi Lake; West Lake

landscape in motion, 7–8, 198, 202. *See also* space as "practiced place"; "things-in-motion"

landscapes: auspicious, 68, 70–76, 82, 91, 114–23; autobiographical, 200–1, 203–6, 208, 218; circuits or itineraries within, 26–28, 27*map*, 29*map*, 31–32, 40*map*, 236n15; history told through, 9–11; ideological expressions within, 6, 10–11, 56, 62, 225–27, 246n11; and

intimacy, 55–56; Manchu homeland, evocations of, 98–99; as medium (Mitchell), 8; in motion, 7–8, 198, 202; monumental, 114, 123, 128; rhetorical (Hall and Ames), 6, 244n6. *See also* garden albums; garden design; topographic painting

Lantern Festival, 193

Laocai, Master, 50

Leaping Spring (Baotuquan; Shandong), 236n34

Leng Mei: blue-and-green palette use, 113, 115; *Images of Tilling and Weaving*, 160, 212, 212*fig*.; and *Imperial Poems* project, 154; and the *Magnificent Record of Longevity*, 160; *Nurturing Uprightness*, 116, 116–17*fig*.; and Orthodox style, 181; and planning of site, 132–34; as student of Jiao Bingzhen, 132; works of, 105. *See also View of Rehe*

lenticularity, 37–38, 42–43, 51, 56, 99–100

Li Bo, 49, 96; "Shanzhong wenda," 18

Li Cheng, 163, 171, 176

Li Guangdi, 132

Li Song, 245n38

Liao dynasty, 84, 97–98; imperial mausoleums, 70, 72

*lingzhi* fungus, 15, 22, 50, 116, 120, 122; *ruyi* scepter in the form of, 120*fig*. *See also Lingzhi Path on an Embankment to the Clouds*

*Lingzhi* Path on an Embankment to the Clouds (Zhijing Yundi), 23*map*, 25*map*, 107*map*; bridge to lakes, 130, 176; completed in first phase, 22; name of, 120; on route of Zhang Yushu, 19, 191, 210; scene 2 of *Imperial Poems*, 20–21*fig*., 86–88, 187*fig*., 210, 216–17*fig*.; view from, 210, 214; view toward, 95, 97*fig*.

Lion Valley (Shiziyu), 18

Listening to the Waterfall Pavilion (Tingputing), 45*map*, 47*fig*., 48–49, 54

Liu Xie, 226

Liu Zongyuan, "Zhongshu Guo tuotuo zhuan," 19n15

Long Bridge, 18, 19, 27*map*, 38, 41, 216–17*fig*.

Long Rainbow Sipping White Silk (Changhong Yinlian), 216–17*fig*.; as name for Long Bridge, 19

longevity, 49–50, 120, 122

Longye mountains (Longyeshan), 70

Looking Out upon Deer Pavilion (Wangluting), 44, 45*map*, 46*fig*.

lotuses, 17–18, 19, 24, 42, 49, 158; Aohan, 96, 239n61; as crop, 92. *See also* floating cups pavilion; Scent of Lotuses by a Winding Stream

Lou Shou, *Images of Tilling and Weaving* (Gengzhi tu), 90–91

Loudong school, 156

Louis XIV, 5, 132, 185, 188; *King's Cabinet*, 145–46, 148–49*fig*., 185–86, 186*fig*.

Lower Lake (Xiahu), 23*map*, 38; view toward *Lingzhi* Path, 95, 97*fig*.; waterway connecting Lower and Mirror Lakes, 40*map*, 41*fig*.

Lu, Mount (Lushan), 2*map*, 50

Lu Hong, 167–68, 169–70, 172–74, 182, 197; *Ten Records of a Thatched Hut* (attrib.), 167*fig*., 199, 243n50

Macartney, Lord, 3

*Magnificent Record of Longevity* (Wangshou shengdian tu; Wang Yuanqi et al.), 149, 160, 186, 195, 197*fig*., 211–12

Manchu conquest: civilizing influence of, 101; legitimacy of, 81; territorial consolidation, 4, 59, 77, 200–201

Manchu homeland: landscape evoking, 98–99; and Manchu identity, 64–67

Manchu language, 59, 151, 183

Mandate of Heaven (Tianming), 63, 64, 78, 81, 85, 86, 122

*Map of a Complete Survey of Imperial Territories* (Huangyu quanlan tu; *Kangxi Atlas*), 59–60, 60–61*fig.*, 65–66, 132, 156, 237n33

Marici, 52

mathematics, 59, 108, 131–32, 144, 150. *See also* surveying

Mei Yufeng, 154, 155, 167, 182

"melon patch" (*guapu*), 91, 97, 218

Mi Fu, 163, 170, 171, 172

Mi Youren, 163, 170, 171, 172

Mijia. *See* Mi Fu; Mi Youren

Mirror Lake (Jinghu), 23*map*, 32, 38–39, 43; waterway connecting Lower and Mirror Lakes, 40*map*, 41*fig.*

mirrored views ("looking out, looking back"), 210, 215

Misty Ripples Bringing Brisk Air (Yanbo Zhishuang), 87*fig.*, 208–10, 216–17*fig.*

Mitchell, W. J. T., 8, 245n61, 246n11

mnemonic topography, 50, 168–70, 174, 197

Möngke Temür, 67

Mongols: allies and bannermen, 52, 55, 96, 225; in the Ming, 84; rule over, 93–95

monumental landscape painting, 114, 115, 123, 128, 171

Moon Boat with Cloud Sails (Yunfan Yuefang), 16, 17, 25*map*, 42, 213, 213*fig.*

Moonlight and the Sound of Rivers (Yuese Jiangsheng) Island, 16n3, 22, 23*map*, 25*map*, 40, 107*map*, 138, 148

Morning Mist by the Western Ridge (Xiling Chenxia), 19, 153*fig.*, 157*fig.*, 215–16, 218–19*fig.*

Mountain Estate to Escape the Heat (Bishu Shanzhuang): approach to study, 9, 20–21; architectural development, 1703–1708, 22–24, 31–32, 32–33*map*; architectural development of the southeast section, 34, 34–35*map*; architecture described by Zhang Yushu ca. 1708, 15–19, 24–25*map*; artists' tour of, 154, 156; cliff inscribed by Kangxi emperor, 28, 29*map*, 33*map*, 38, 45*map*, 48, 107*map*, 141*map*; development phases, 5*map*, 22–32, 24–25*map*, 27*map*, 29*map*, 32–34, 35*map*, 38–39, 51, 53*map*, 94, 107*map*; emperor's residence, 16, 22, 34–36, 52–53, 191; as empire in miniature, 95, 102; evocation of cultural landscapes, 16, 42, 95–96; evocation of the steppe, 96–97; and imperial identity in the Kangxi era, 8–9, 82, 102, 225–27; in Kangxi's construction of Qing geography, 72–77, 78, 81; labor and expense, 89–90; maintenance of, 48; northeast section of, 24, 26–27*map*, 28; orientation of, 134; as a park, xvii–xviii; public and private zones, 24–28, 28–29*map*, 31–32, 53; as "rear garden," 36; as secondary seat of government, 5, 34, 55, 97, 236n18; as site of rituals of intimacy, 6, 55–56, 192–93, 224; Sixteen Scenes, 19, 24–26, 32, 191; sources for digital mapping of, xix; topographic and hydrological features, 22–23*fig.*; as tourist destination, 3, 235n1(intro.); walls, 5*map*, 23*map*, 25*map*, 27*map*, 29*map*, 32, 35*map*, 51, 53*map*, 100, 107*map*, 239n68. *See also* gardens; *Imperial*

*Poems on the Mountain Estate to Escape the Heat*; lakes; mountains; pavilions and halls; Rehe; *View of Rehe*; water systems; Zhang Yushu; *and individual features by name*

mountain veins (*shanmai*), 68–69*map*, 68–77, 77*map*, 79, 82, 118, 200, 227

mountains, 97–99; in *Emperor Minghuang's Palace to Escape the Heat*, 110, 114; sacred, 63–64, 64, 67, 70, 77; in *View of Rehe*, 110, 113–14, 123–28, 126*fig.*, 136*map*, 136–38, 141*map*; of Wang Yuanqi, 164–65. *See also* Changbai, Mount; Gold Mountain; mountain veins; Tai, Mount

movement and mobility, 24, 41, 206–207; in landscape, 7–8, 20, 24, 32; and experience, 20, 204, 217; and imagination, 32; and perception, 38, 43; in pictorial space, 128, 143, 202, 210, 217, 222

Mukden. *See* Shengjing

Mulan Hunting Grounds (Mulan Weichang), 2*map*, 22, 54, 55, 62, 63, 92

multiethnicity, 4, 7, 60, 93, 228

*Mustard Seed Garden Painting Manual* (Jieziyuan huazhuan; Wang Gai et al.), 166, 166*fig.*, 242n17

Naluwoji, 68, 69*map*, 70–71, 72, 78, 82, 99. *See also* Hetu Ala

names: and literary commemoration, xviii, 181; shifting use of, xviii, 28, 236nn10–11; translations of, xviii

*nanmu* pillars, 236n20

Neer, Richard, "stakes of style," 152

Ni Zan, 163, 171, 174

Nian Xiyao, *Study of Vision*, 145, 147*fig.*

Northeast (Dongbei), 2*map*, 59–60, 63, 66, 68–69*map*, 71, 78, 84, 96; topography of, 68–69*map*, 68–70, 76, 98, 227. *See also* Qing geography

Northeastern Scenic Route (*dongbei yilu shenggai*), 15–17, 24, 26–27*map*, 29*map*

Northern Pole Star, 16, 16n5

Northern Post Linking Paired Peaks (Beizhen Shuangfang), 26, 28, 29*map*, 107*map*, 214–15, 214–15*fig.*; as geomantic pivot, 74–75; in topography surrounding Verdant Isle of Green Maples, 138, 140–41*map*

Northwest Gate (Xibeimen), 18n9, 23*map*

Northwestern Scenic Route (*xibei yilu shenggai*), 17–18, 24, 26–27*map*, 29*map*

Nourishing Harmony Garden (Yiheyuan; suburban Beijing), 36. *See also* Pure Ripple Garden

Nurhaci, 66, 84; tomb of, 70, 118, 118–19*fig.*

Nuti, Lucia, 140

Observing the Fish from a Waterside Rock (Shiji Guanyu), 19

Observing the Waterfall Pavilion (Guanputing), 45*map*, 48–49

Old Masters albums, 170–74, 178, 179, 181, 243n57

"one pond, three mountain" plan (*yihai sanshan*), 121–22

Orioles Warbling in the Tall Trees (Yingzhuan Qiaomu), 19, 27*map*, 41, 107*map*, 133*map*, 134; in *Imperial Poems*, 98*fig.*, 100–101, 174; in *View of Rehe*, 134, 135*fig.*

Orthodox School painting (*zhengpai*), 111–12, 113–14, 155; captured in print, 166–67; color in, 163; dragon veins in, 118; and Old Masters albums, 170–74, 176; and Qianlong

court painters, 174; and topographical subjects, 170, 171, 179–81; Wang Yuanqi and, 156–58, 163–64, 169, 170, 180–81. *See also* Old Masters albums; Wang Hui; Wang Yuanqi

outer temples, 51–52, 54

Owen, Stephen, 226

Pair of Lakes Like Flanking Mirrors (Shuanghu Jiajing), 17, 19, 42, 216–17*fig.*

Palace of Righteousness (Zhenggong): absence from Leng Mei's *View of Rehe*, 105, 107*map*; construction of, 32, 34, 35*map*, 147–48; garden of, 36–38; hall at rear, 37, 208–10; in *Imperial Poems*, 85–86, 87*fig.*; *nanmu* pillars, 236n20; plan of, 34–36, 34*fig.*; relationship with its landscape, 36–37; relative scale of, 36; throne room of, 36. *See also* Misty Ripples Bringing Brisk Air; Scenes of Clouds and Mountains

Palace of the Nine Perfections (Jiuchenggong; Chang'an), 108–9, 114, 240n10

palace paintings, 108–10. *See also Emperor Minghuang's Palace to Escape the Heat*; *View of Rehe*

Pavilion of the Supreme God (Shangdige), 30, 52, 53*map*, 54, 74; in "The Entire Sky Is Exuberant" (Shen Yu), 30*fig.* *See also* Gold Mountain island and temple

pavilions and halls, 22–24, 34, 100–101, 102, 138, 210–11, 213; vistas from, 134–35, 241n66; waterfall, 44, 48–50, 45*map*, 54; waterside, 40, 42; at West Lake, 96. *See also* Looking Out upon Deer Pavilion; Northern Post Linking Paired Peaks; Orioles Warbling in the Tall Trees; Pavilion of the Supreme God; Southern Mountains Piled with Snow; Untrammeled Thoughts by the Hao and Pu Rivers

Peach Blossom Spring, 115, 122–23

Pear Blossoms Accompanied by the Moon (Lihua Banyue), 19, 24, 25*map*, 26, 29*map*, 45*map*, 48, 107*map*, 138

Pear Valley (Lishuyu), 18n12, 23*map*, 24, 25*map*, 26, 27*map*, 29*map*, 33*map*, 49. *See also* Pear Blossoms Accompanied by the Moon

*Peiwen Studio Catalogue of Painting and Calligraphy* (Peiwenzhai shuhuapu), 158, 159

perspective, 123–30, 132, 144–45, 156, 227–28,; accelerated, 129–30, 144, 241n52; aerial, 155, 184; in architectural painting, 112; "perspective views," 140–42, 146; treatises on, 144–45, 147*fig.*, 241n90. See also under *View of Rehe*

Peter the Great, 5, 185

Pine and Cranes Retreat (Songhezhai), 92

Pine Forest Valley (Songlinyu), 18, 23*map*, 25*map*, 27*map*, 29*map*, 44, 45*map*, 48–49

Pine Winds through Myriad Vales (Wanhe Songfeng): depicted by Leng Mei, 107*map*, 130, 133*map*; name-tablet and couplet, 15; by Shen Yu et al., 176, 180*fig.*, 210–11, 214–15*fig.*; in Zhang Yushu's account, 15, 17, 19, 22, 25*map*, 210; by Zhang Zongcang, 176, 181*fig.*

Pinney, Christopher, 235n17

place-names, translation of, xviii

Pozzo, Andrea, S. J., 144, 241n52; *Perspectiva pictorum et architectorum*, 144–45

*Practice of Instruments for Measuring Heights and Distances* (Celiang gaoyuan yiqi yongfa), 144

*Precious Records of the Stone Moat* (Shiqu Baoji), 105, 161, 174, 243n62

primary and secondary sources, 9–10, 235n14

printing and printmaking: in the court, 32, 151, 160, 182–83, 243n74; early modern market, 96, 155, 185; the matrix and "reversal," 152, 184; relationship between painting and, 9–10, 152–54, 155–56, 159–61, 166–67; technologies of, 155–56, 184, 185–86, 187; and vanity publications, 198, 212, 244n16. See also *Imperial Poems on the Mountain Estate to Escape the Heat*; *Imperially Composed Images of Tilling and Weaving*; *Imperially Selected Tang Poems*; *Kangxi Atlas*; *Magnificent Record of Longevity*

Pure Ripple Garden (Qingyiyuan; suburban Beijing), 36, 91, 240n43

purple mists (*qing'ai*), 79, 80, 82, 120, 123

Qi Biaojia: *Footnotes to Allegory Mountain*, 197–98, 200, 203–6, 208, 210, 212; "View of Allegory Mountain," 199*fig.*

Qi Yuanru (brother of Qi Biaojia), 204

Qian Weicheng, 174, 176, 243n60

Qianling (tomb of Liao Jingzong), 70

Qianlong emperor: development of *Mountain Estate* site, 4, 5*map*, 26, 56, 92, 95, 236n11, 237n46; expansion of Palace of Righteousness, 236n20; *Forty Scenes of the Garden of Perfect Brightness*, 208; and Leng Mei, View of Rehe, 240nn2,7; painting in the court of, 111, 144, 152, 174; Pure Ripple Garden, 91; as symbol of Qing imperial glory, 3–4; temple construction, 44, 51–52, 53*map*

Qianlong period sources, 9, 56, 235n14

Qiao Zhongchang, *Illustration of the Second Prose Poem on the Red Cliff*, 114–15*fig.*, 115, 202

Qing geography, 63–67, 68–70, 72–78; directional rule, 63, 70; and Manchu supremacy, 77–78; mountains and water in, 68–72, 74. *See also* cartography

Qionghua Island (Beijing), 122

Qiu Ying, *Garden of Solitary Enjoyment*, 202, 202–3*fig.*

quadratura, 144, 146

Quanyuan Shibi (Cliff at the Spring's Source), 28, 29*map*, 33*map*, 38, 45*map*, 48, 107*map*, 141*map*

Rebellion of the Three Feudatories (Sanfan zhi luan), 62, 63

"Record of the Garden of the Uninhibited Spring" (Changchunyuan ji; Kangxi emperor), 91

"Record of the Garden to Rest In" (Zhiyuanji), 244n36. *See also* Zhang Hong: *Garden to Rest In*

"Record of the Mountain Estate to Escape the Heat" (Bishu shanzhuang ji; Kangxi emperor), 79–80; analogies between landscape and dynastic virtue in, 81–87, 96, 102, 123, 200–201, 225–27; arguments for seasonal touring in, 90; circulation of, 79*note*; on "carved rafters and lacquered columns," 89, 110; on design and planning, 131; as garden writing, 81, 200; "Gold Mountain" in, 73, 74; "open fields grown wild" (*huangye*), 83–85; as preface for *Imperial Poems*, 32, 184

"Record of Traveling at the Invitation of the Emperor" (Hucong ciyou ji; Zhang Yushu), 15–19; as source for earliest state of the Mountain Estate, 20. *See also* Zhang Yushu

Rehe: at the *continental* crossroads, 76–77, 77*map*; duality of, 102; inhabitants of, 82–83; landscape of, 82–83; Lower Camp, 22, 132; mountain veins leading to, 69*map*, 77; in Qing geography, 2*map*, 69*map*, 76–77, 77*map*, 78; Rehe Traveling Palace, 15, 89, 105, 24–25*map*; religious structures built in, 53*map*; origins of imperial complex, 21, 22; as synecdoche for empire, 86; Upper Camp, 22, 32–33*map*; valley of, 132–33*map*. *See also* Mountain Estate to Escape the Heat

Rehe Spring, 19n14, 23*map*, 28, 39, 41, 91–92, 236n10

reign names, xviii–xix

religious architecture, 51–52, 53*map*. *See also* Buddhist temples

Reservoir of Metal's Luster (Jinmingchi; Northern Song garden), 192, 193. See also *Capturing the Flag at the Reservoir of Metal's Luster*

"reversal" (Roberts), 152, 184, 188

"rhetorical landscapes" (Hall and Ames), 6, 244n6

rice, 91, 92

Ripa, Matteo: engravings for *Imperial Poems* project, 155–56, 184–85, 186, 242n11; journal accounts of visits to Rehe, 54, 154, 236n17; "Morning Mist by the Western Ridge" (attrib.), 157*fig.*

Roberts, Jennifer, 152, 184, 188

Ruyi Island (Ruyizhou), 23*map*, 25*map*, 33*map*, 35*map*; auspicious design of, 120–22; Buddhist temples, 24, 52–53, 89; emperor's residence and throne room, 88, 121; in Leng Mei's *View of Rehe*, 107*map*, 120–21, 121*fig.*, 128, 136–38, 240, 240n48; during Matteo Ripa's visit, 236n17; path to, 86, 210, 215; pavilions and halls, 22–24, 34, 42, 138, 210–11, 213; on route of 1708 tour, 16, 17, 41, 191; views of and from, 100–1, 210–11; waterside pavilions, 40. See also *Lingzhi* Path on an Embankment to the Clouds

Ruyi Lake (Ruyihu), 23*map*, 38, 40*map*, 44, 213; experience of, 40*map*, 41–42; pavilions along the edges of, 22–24, 41, 100–101, 102, 213, 213*fig.*, 218, 221*fig.*; water feeding into, 28, 213, 236n9. *See also* Ruyi Island

*ruyi* scepter, 120, 122; in the form of a *lingzhi* fungus, 120*fig.*

Sacred Congregation for the Propagation of the Faith (Sacra Congregatio de Propaganda Fide), 155

sacred geography, 63–64

Santun River, 71

Scenes of Clouds and Mountains (Yunshan Shengdi), 34*fig.*, 37, 38–39*fig.*, 42, 214, 214–15*fig.*

Scent of Lotuses by a Winding Stream (Qushui Hexiang), 19, 24, 27*map*, 48, 245n52. *See also* floating cups pavilion

screening elements, 208, 221–22, 245n61

Second Opium War, 3

Shapes of Clouds and Figures in the Water (Yunrong Shuitai), 18n10, 213–14, 214*fig.*

Sheet of Cloud, A (Yipianyun; theater stage), 16, 17, 27*map*, 41

Shen Nong, 90

Shen Quan, 156

Shen Yinghui, 154

Shen Yu, 154–55, 156, 160, 167, 242nn11,14; "Clear Ripples with Layers of Greenery," 157*fig.*, 174, 175*fig.*, 184;

"Clear Spring Circling the Rocks," 213–14, 214*fig.*; "Clouds and Peaks on All Sides," 164–65, 165*fig.*, 214–15, 214–15*fig.*; "Clouds Remain as Water Flows On," 218, 221*fig.*; "The Entire Sky Is Exuberant," 30, 30*fig.*, 245n51; "Fountainhead in a Cliff," 218–19*fig.*; "Fragrant Islet by Flowing Waters," 213, 213*fig.*; "Fragrant Waters and Beautiful Cliffs," 89, 210, 218–19*fig.*; "Golden Lotuses Reflecting the Sun," 217, 220*fig.*; "Immense Field with Shady Groves," 218, 221*fig.*; "Inviting the Breeze Lodge," 210, 218–19*fig.*; "*Lingzhi* Path on an Embankment to the Clouds," 20–21*fig.*, 86, 88, 187*fig.*, 210, 216–17*fig.*; "Long Rainbow Sipping White Silk," 216–17*fig.*; "Misty Ripples Bringing Brisk Air," 87*fig.*, 208–10, 216–17*fig.*; "Moon Boat with Cloud Sails," 213, 213*fig.*; "Morning Mist by the Western Ridge," 153*fig.*, 215, 218–19*fig.*; "Northern Post Linking Paired Peaks," 74–76, 214–15*fig.*; "Orioles Warbling in the Tall Trees," 98*fig.*, 100, 101, 174; "Pair of Lakes Like Flanking Mirrors," 216–17*fig.*; "Pine Winds through Myriad Vales," 176, 180*fig.*, 210–11, 214–15*fig.*; "Scenes of Clouds and Mountains," 38–39*fig.*, 214–15, 214–15*fig.*; "Shapes of Clouds and Figures in the Water," 213–14, 214*fig.*; "Sonorous Pines and Cranes," 46*fig.*, 49, 214–15*fig.*; "Sounds of a Spring Near and Far," 47*fig.*, 49, 174, 217, 220*fig.*; "Southern Mountains Piled with Snow," 174–76, 175*fig.*; "Sunset at Hammer Peak," 215, 217, 218–19*fig.*; "Un-Summerly Clear and Cool," 88, 88*fig.*, 216–17*fig.*; "Untrammeled Thoughts by the Hao and Pu Rivers," 99*fig.*, 100–101, 174, 245n51; "Verdant Isle of Green Maples," 176, 178*fig.*; "Warm Currents and Balmy Ripples," 218–19*fig.*, 236n10

Shengjing (Mukden; modern Shenyang), 2*map*; auspicious topography of, 69*map*, 70, 74, 76, 77*map*; birthplace of Shen Yu, 154; as eastern capital, 97–98; imperial gazetteer of, 70; imperial tours to, 62–63, 66, 67; in the *Kangxi Atlas*, 66; in Kangxi's construction of Qing geography, 64–65, 70, 71, 72; palace plan of, 36

Shizong (Jin emperor), 66

Shizong (Liao emperor), tomb of, 70

Shunzhi emperor, 62–63, 90

*silai* (imperial gifting), 55

Silver Lake (Yinhu), 23*map*, 32, 35*map*, 38–39, 40*map*

Silvestre, Israël: "Château neuf de St Germain en Laye from the River Side," 186*fig.*; "View of the Château of Fontainebleau from the Garden Side," 146, 148–49*fig.*

Sixteen Kingdoms, 225

Sixteen Scenes (Zhang Yushu), 19, 24–26, 32, 154, 191

sluice gates, 17, 24, 28, 38, 46–47, 48, 215, 236nn9,10

smallpox, 63, 101, 239n73

sociability, 188, 192, 196, 204, 224

Song Junye, 158–59, 160, 243n30

Songhua (Sungari) River, 67, 68, 69*map*, 71, 237–38n39

Sonorous Pines and Cranes (Songhe Qingyue), 44, 45*map*, 46*fig.*, 115, 214–215, 214–15*fig.*

Sounds of a Spring Near and Far (Yuanjin Quansheng), 17n8, 45*map*, 47, 47*fig.*, 49, 54, 236n34; merged view with Golden Lotuses Reflecting the Sun, 217, 220*fig.*

Source of the Waterfall Pavilion (Puyuanting), 44, 45*map*, 48–49

South Mountain (Nanshan), 50

Southern Library (Nanshufang), 158

Southern Mountains Piled with Snow (Nanshan Jixue), 19, 26, 29*map*, 45*map*, 50, 107*map*, 174; by Shen Yu et al., 174–76, 175*fig.*; in topography surrounding Verdant Isle of Green Maples, 138, 140–41*map*; by Zhang Zongcang, 174, 176*fig.*

space as "practiced place," 235n13. *See also* de Certeau, Michel

spatial intertextuality, 8. *See also* paratextual landscapes

St. Germain en Laye, 185, 186*fig.*

steppe landscape, 95, 96–97, 100, 101

Strassberg, Richard, xix, 236n13, 245n48

*Study of Vision* (Shixue), 145, 147*fig.*

Su Dyke (Sudi; Hangzhou), 95, 220

Su Shi, 95; "Latter Prose Poem on the Red Cliffs," 115

Sungari (Songhua) River, 67, 68, 69*map*, 71, 237–38n39

Sunset at Hammer Peak (Chuifeng Luozhao), 19, 26, 29*map*, 215, 217, 218–19*fig.*

surveying, 131–34, 138, 140–42, 143–44. *See also Kangxi Atlas*

Tai, Mount (Taishan), 2*map*; as the "dragon," 68, 72, 76–77; Kangxi's tours to, 63, 64; in sacred geography, 63–64, 67, 69*map*, 70–72, 76–77, 77*map*; and shift of ritual center to Mount Changbai, 64, 67, 94; veins of, 68, 69*map*, 70–72, 76

Taiwan, 59, 101

Taiye Pond: in Beijing, 122; in Jianzhang Palace, 122

Taizong (Jin emperor), 70

Tamun, Lake, 66, 71, 75

Tangquan, 54, 92

Tao Yuanming, 50, 115, 122

Temple of Far-Reaching Peace (Anyuanmiao), 52, 53*map*

Temple of the Dragon King (Lingze Longwangmiao), 18, 24, 26, 27*map*, 29*map*, 45*map*, 48, 52, 53*map*, 107*map*, 138

Temple of Universal Benevolence (Purensi), 51, 53, 53*map*; dedicatory text for, 90, 93, 225; and Inner Asian diplomacy, 93–94

Temple of Universal Charity (Pushansi), 51, 53, 53*map*

Temple of Universal Happiness (Pulesi), 52, 53*map*

Temple of Universal Peace (Puningsi), 133*map*, 134

Temple to the Mother of the Dipper (Doumuge), 26, 28, 29*map*, 52, 53*map*, 141*map*

*Ten Records of a Thatched Hut* (Caotang shizhi), 172, 243n50; album by Wang Yuanqi, 162, 167–70, 169*fig.*, 171*fig.*, 172*fig.*, 172–74, 176, 179*fig.*, 180–82, 210; album by Xie Shichen, 167, 168*fig.*; handscroll attrib. Lu Hong, 167, 167*fig.*, 199, 243n50

Ten Scenes of West Lake (Xihu Shijing), 41, 218–20; "Autumn Moon over a Calm Lake," 42, 220–22, 223*fig.*, 245n61; handscroll by Wang Yuanqi, 160, 161*fig.*, 162, 164, 169, 170, 180–82

territorial integration, 59–62, 64, 77, 81, 83, 85, 237n24. *See also* Qing geography

textual para-landscapes, 34, 81. *See also* spatial intertextuality

"things-in-motion" (Appadurai), 8

thirty-six scenes. See *Imperial Poems on the Mountain Estate to Escape the Heat*

Three Kings and Five Emperors, 93, 94

Three Mountains at the Entrance to the Capital (Jingkou Sanshan), 30

thrones, throne rooms, 16, 19, 88, 192. *See also* Calm and Tranquil, Reverent and Sincere; Palace of Righteousness; Ruyi Island

Tianzhu mountains (Tianzhushan), 70

timber, 22, 89–90

Tongjia River, 68

topographic painting: *Imperial Poems of the Mountain Estate to Escape the Heat* as, 174, 201, 210, 211, 213–14, 215–17; *View of Rehe* as, 118, 138–44; in Wang Yuanqi's oeuvre, 162, 170–74, 179–81. *See also* mnemonic topography

transcultural encounters, 108, 146, 184, 230

traveling palaces (*xinggong*), 4–5, 63, 93, 94. *See also* Kalahetun; Mountain Estate to Escape the Heat; Rehe; Tangquan

Treaty of Nerchinsk, 132

trees, 16–18, 19n15, 43, 79, 92, 203, 226–27. *See also* Garden of Ten Thousand Trees; Naluwoji; Orioles Warbling in the Tall Trees

tributary relations, 55, 93

Tumen (Aihu) River, 67, 68, 69*map*, 71, 238nn39,63

*tuyong* (pictured verses), 131*fig.*, 176*fig.*, 187*fig.*, 196, 202, 212*fig.*, 223*fig.*

Umuna (Gioro Umuna), 67, 71

*Unified Gazetteer of the Great Ming* (Da Ming Yitongzhi), 74

Un-Summerly Clear and Cool (Wushu Qingliang), 22, 27*map*, 36, 134; Kangxi's poem, 88; in Leng Mei's *View of Rehe*, 107*map*, 133*map*, 134, 135*fig.*; by Shen Yu et al., 88*fig.*, 216–17*fig.*

Untrammeled Thoughts by the Hao and Pu Rivers (Hao Pu Jianxiang), 18, 18n10, 99*fig.*, 100–101, 174; shifting of name, 236n11

Upper Lake (Shanghu), 23*map*, 38, 40*map*

vanity publications, 198, 212, 244n16

Verbiest, Ferdinand, 132

Verdant Isle of Green Maples (Qingfeng Lüyu), 26, 29*map*, 107*map*, 176, 178*fig.*; topography surrounding, 138, 140–41*map*

*Veritable Records of the Manchu* (Manzhou shilu), 66, 71

Versailles, 6, 185, 188, 235n7

*View of Rehe* (Leng Mei), 6, 105, 106*fig.*; architectural orthogonals in, 123–28, 125*fig.*; architecture depicted in, 106–7*fig.*, 110, 112; as auspicious landscape, 116–21; boats depicted in, 40; construction of valley and mountains, 126–27*fig.*; and court-style painting, 148–50, 152, 155, 185, 227; dating of, 105, 147–50; location and display, 240n7; measurements of, 240–41n48; as metaphoric landscape for Qing, 123; mountains and water in, 42, 48, 118, 120–21, 138, 142–43; and Orthodox School painting, 113–14; as palace painting, 108–10; pavilions and halls, 145, 147–48; perspective, 123–30, 130–31, 132–33*map*, 134–38, 135*fig.*, 142–45, 206; relation to European "city views," 140–44, 145–46, 241n76; *ruyi* forms in, 120–21, 121*fig.*; seals, 105, 240n2; style and technique, 105–8, 110–16, 123–30, 148–50,

*View of Rehe* (Leng Mei) (*cont.*) 155, 158; title of, 105, 240n4; as topographic painting, 138–44, 179; trajectories of sight in, 135*fig.*; Yang Boda on, 105

viewshed analysis, 134–38, 136*map*, 136–37*map*, 138–39*map*, 241nn66–67

Vinograd, Richard, 182

Visdelou, Claude de, 132

Waley-Cohen, Joanna, 235n18

Wang Cengqi, 159, 161, 184, 187

Wang Gai, *Mustard Seed Garden Painting Manual*, 166, 166*fig.*, 242n17

Wang Hui, 114, 156, 159, 170, 242n23; *Kangxi Emperor's Southern Inspection Tour*, 110–11*fig.*, 111–12, 113, 116, 116–17*fig.*, 149, 179, 180, 195; use of blue-and-green palette, 115, 181

Wang Lü, 241n65

Wang Meng (Huanggheshan), 163, 170, 171; Wang Yuanqi's landscapes after, 171*fig.*, 172, 176, 243nn65–66

Wang Shimin, 156, 163, 170, 243n56

Wang Tingna: *Garden Views of Encircling Jade Hall*, 212, 244n16, 244–45n36; Shaded Seat Garden, 244–45n36

Wang Wei, 182, 197; Wang Yuanqi's landscapes after, 162–63*fig.*, 169*fig.*; *Wheel River Villa*, 162–64, 170, 172

Wang Xianchen, 168, 199, 200, 203, 206, 243n51

Wang Yuanqi: album for *Imperial Poems* project, 151, 156, 159, 160, 161–62, 187, 188, 224; artistic theory of, 114, 118, 158, 163–64, 169, 170, 178; court and private styles, 164; followers of, 158, 174; and the Four Wangs, 242n23; handscrolls, 211–12; and *Imperial Poems* project, 154, 159–60, 164–65, 174–78, 182, 243n34; "Landscape after Jing and Guan," 172–73*fig.*; "Landscape after Juran," 176–77*fig.*; "Landscape after Wu Zhen," 183*fig.*; as lead painter in Kangxi court, 154, 156–60, 174; *Magnificent Record of Longevity*, 149, 154, 160, 186, 197*fig.*, 211–12; Old Masters albums, 170–74, 178, 181, 243n57; as Orthodox master, 113, 114, 156, 158, 163–64, 169; style of, 163–64, 167, 169, 170, 174, 182; topographical painting by, 162, 170, 180–82; *Wheel River Villa*, 162–63*fig.*, 162–64, 167, 169, 170, 180–82. See also *Ten Records of a Thatched Hut*: album by Wang Yuanqi; *Ten Scenes of West Lake*: handscroll by Wang Yuanqi

Warm Currents and Balmy Ripples (Nuanliu Xuanbo), 19, 29*map*; ambiguity about name, 19n14, 28, 236n10; in Leng Mei's *View of Rehe*, 107*map*, 133*map*, 134, 135*fig.*; merged view with "Fountainhead in a Cliff," 218–19*fig.*

Water Clover Fragrance Bank (Pingxiangpan), 17

water routes, 39–41, 40*map*, 41*fig.*

water systems: and chorography, 140; engineering of, 22, 43–48; expansion of, 38–39; extended through naming, poetics, and images, 48–50; landscape design of, 42–43, 99; maintenance of, 48; major hydrological features, 22–23*map*; major potential water flows in the western mountains, 44*map*; reservoirs, 47–48; sites incorporating water as scenic element, 44–45*map*, 44–47; springs and waterfalls, 44–49; viewed as negative space, 51; during Zhang Yushu's visit, 16–18, 38

waterfalls, 17n8, 44–47, 45*map*, 48, 71, 236n34; in *Imperial Poems*, 49

Wei Xiao, *Explanation of Geography*, 72

Wen Zhengming: *Garden of the Artless Official* (album), 168, 169, 197, 198–200, 200*fig.*, 202–3, 205*fig.*, 206, 208, 210, 221, 222, 243n51, 244n27; "Little Azure Waves," 203, 205*fig.*; "Many Fragrances Bank," 199, 200*fig.*, 202; "Xiang Bamboo Bank," 203, 205*fig.*, 222

West Garden (Xiyuan, imperial garden west of Forbidden City), 122

West Lake (Hangzhou), 16, 42, 95–96, 182, 197, 220, 245n38. See also Ten Scenes of West Lake; Wang Yuanqi: *Ten Scenes of West Lake*

West Ridge (Xiling), 18, 19

Wu Zhen (Mei Daoren), 163, 171; Wang Yuanqi's landscapes after, 172, 176–78, 179*fig.*, 183*fig.*, 243n66

Wula, Mount (Wulashan), 68

Wulie River (Wuliehe), 5*map*, 22, 23*map*, 28, 38–39, 44*map*, 53*map*, 51, 215

Wulie valley, 31

*wuwei* (nonaction), 19n15

Xianfeng emperor, 3

Xianling (tomb of Liao Shizong), 70

Xie Shichen, *Ten Records of a Thatched Hut* (Caotang shizhi), 167, 168*fig.*

Xingjing. See Hetu Ala

*xingletu* (portraits of the emperor at leisure), 193–95

Xuande emperor (Ming dynasty), 193. See also *Amusements in the Xuande Emperor's Palace*

Xuanzong (Tang emperor), 167; in *Nurturing Uprightness*, 116*fig.*

Yalu River, 66, 67, 68, 69*map*, 71

Yang Bin, 71

Yang Boda, 105, 240–41n48

Yang Rong, 122

Yiwulu, Mount (Yiwulushan), 69*map*, 70, 72, 74

Yongle emperor (Ming dynasty), 122

Yongling (tomb of Nurhaci's ancestors), 240n33

Yongzheng emperor, 4, 90, 91, 112, 145, 152

Yu, Pauline, 227

Zhang Dai, "West Lake at the Midsummer Festival," 220

Zhang Hong, 123, 140, 142; "Complete View of the Garden to Rest In," 140, 206, 207*fig.*, 245n39; *Garden to Rest In* (album), 197, 206–8, 207*fig.*, 209*fig.*, 210–11, 215, 218, 221, 222, 236n31, 244–45n36, 245nn40,42; *Wind in the Pines of Mount Gouqu*, 123, 124*fig.*, 140, 142

Zhang Kui, 154, 155, 184, 244n79; "Clear Ripples with Layers of Greenery," 157*fig.*

Zhang Ruoai, 240n29

Zhang Tianxi, 225–26

Zhang Ying, 132

Zhang Yushu: on auspicious topography of the Traveling Palace, 15, 120; banquets and entertainment at Mountain Estate, 16–17, 41, 191; features and structures noted by, 15–19, 22–24, 24–25*map*, 27*map*, 29*map*, 36, 38, 42, 53, 96, 239n61; features and structures not noted by, 28–31; Sixteen Scenes, 19, 24–26, 32, 154; surveying visit to

Rehe Lower Camp in 1702, 132; two itineraries of, 24–26, 26–27*map*, 29*map*, 30, 31; visits to Mountain Estate, 20, 24, 41–42, 96, 159, 191–93, 208; written account of Mountain Estate, 6, 15–19, 20, 147, 224

Zhang Zeduan: *Capturing the Flag at the Reservoir of Metal's Luster*, 193, 194*fig.*, 195; *Going Upriver at Qingming Time* (attrib.), 111

Zhang Zongcang, 174; "Pine Winds through Myriad Vales," 176, 181*fig.*; "Southern Mountains Piled with Snow," 174, 176*fig.*

Zhao Boju, *Eight Immortals*, 240n27

Zhao Lingrang (Zhao Danian), 171, 172

Zhao Mengfu (Zhao Cheng), 163, 171; Wang Yuanqi's landscapes after, 172, 176, 243n65

Zhaoling (tomb of Hong Taiji), 66, 70

*zhen* (pillow/hitching post), 75, 238n71

Zhongjing (Liao capital), 98

Zhu Gui, 154, 155, 167, 182

*Zhuangzi*: "Dazongshi," 16n5; "Qiwulun," 15n1